THE CULTURAL INDUSTRIES

SECOND EDITION

David Hesmondhalgh

SAGE Publications
Los Angeles ▪ London ▪ New Delhi ▪ Singapore

 SAGE Publications Ltd
1 Oliver's Yard
55 City Road
London EC1Y 1SP

SAGE Publications Inc.
2455 Teller Road
Thousand Oaks, California 91320

SAGE Publications India Pvt Ltd
B 1/I 1 Mohan Cooperative Industrial Area
Mathura Road, New Delhi 110 044
India

SAGE Publications Asia-Pacific Pte Ltd
33 Pekin Street #02-01
Far East Square
Singapore 0487637

British Library Cataloguing in Publication data

A catalogue record for this book is available
from the British Library

ISBN 978 1 4129 0807 8
ISBN 978 1 4129 0808 5

Library of Congress Control Number 2006930418

Typeset by C&M Digitals (P) Ltd., Chennai, India
Printed on paper from sustainable resources
Printed and bound in Great Britain by The Cromwell Press Ltd, Trowbridge, Wiltshire

The more the antagonisms of the present must be suffered, the more the future is drawn upon as a source of pseudo-unity and synthetic morale.

C. Wright Mills

Things are more like they are now than they've ever been before.

Attributed to Dwight D. Eisenhower

CONTENTS

BOXES, TABLES AND FIGURES

Every effort has been made to trace the copyright holders but if any have been inadvertently overlooked the publisher will be pleased to make the necessary arrangement at the first opportunity.

BOXES

TABLES

FIGURES

PREFACE TO THE SECOND EDITION

This book gives an account of how and why cultural production has changed since the early 1980s. The first edition was written in 2000–2001 and appeared in 2002. Since then, there have of course been numerous further changes in the cultural industries. New phrases representing new phenomena have appeared, including blogging, i-Pods, podcasting, the HBO model, social networking sites and digital rights management. Other processes, already under way when I was writing at the turn of the century, have intensified, with significant implications for our cultural lives, whether we are conscious of them or not. Television and radio channels continue to multiply. Many of us gain more and more of our information from the Web. The dot.com bubble had already burst in 2000 and fewer commentators now speak of 'a new economy', but more and more policymakers and academics claim that culture, information, creativity and intellectual property are going to be, and/or should be, an increasingly important part of future economies and societies. Since I finished writing the first edition, China – already a growing market for the products of cultural industries–has joined the World Trade Organisation, signalling that its integration with global capitalism is beginning in earnest.

I deal with these various terms, concepts and processes in what follows, but, as with the first edition of *The Cultural Industries*, my aim has been to think about these and other developments in the context of long-term historical currents – in economics, in politics and culture. My argument is that cultural production and consumption haven't changed quite as much as some commentators would have us believe. Why write an academic book about this? Because only through a careful consideration of the long term can we understand change and continuity in culture and such consideration takes some time and effort. The media themselves produce a constant babble and chatter about transformations in the way that cultural products are made and experienced. There is little time in the frenetic rush of everyday journalism to consider the long-term historical context. This is one of the reasons academic study of the cultural industries can be valuable.

As well as updating the book, I've dealt with some issues that were neglected or underemphasised in the first edition. A new chapter addresses two vital aspects of policy: changes in copyright and in the relationship between cultural and urban policy on the one hand, and the cultural industries on the other. That chapter includes an assessment of the increasing use of the terms 'creativity' and 'creative industries' in policy and business. Not only in that chapter but also throughout the book, there is more material on intellectual property and the

crucial but dubious concept of the 'Information Society'. Linked to this, the concept of commodification of culture is given the greater billing it deserves. There is much more explicit treatment of the question of the extent to which the cultural industries are an increasingly important component of modern economic life (see Chapters 2 and 6). Throughout, I've tried to learn more and think more about non-Anglophone cultural industry systems.

I've made hundreds of other smaller changes – adding references to old and new sources that I've encountered since the first edition, cutting out unnecessary detail and the odd sloppy phrase that made me wince and making arguments more concise where possible. I've been greatly assisted in this by the conscientious copy-editing of Michelle Clark. In spite of all these many changes, my main goal has remained the same: to provide a research-driven overview of this fascinating area based on my own particular view of things, but one that students and teachers might also use if they wish.

The first edition contained an embarrassingly long list of thankyous, reflecting my many personal and professional debts. I'd like to ask those mentioned there to consider themselves thanked again, but I won't repeat that long list now, other than to restate my gratitude to Jason Toynbee, who provided really helpful comments on most of the original manuscript. I worked on both editions of this book while employed by the Open University. As I now look ahead to a new post at the University of Leeds, I'd like to express my gratitude to the OU for study leave and to express appreciation to some great colleagues there, especially Marie Gillespie, Wendy Lampert and Hugh Mackay, for their friendship and support during the production of the OU's undergraduate media studies course, DA204 *Understanding Media*, which took up much of my working life between writing the first and second editions.

For the second edition, I'd like to thank the following: Des Freedman, Justin O'Connor, Andy Pratt and Chad Raphael for their thoughts on revised chapters; Alan O'Connor and Matt Stahl, and others too numerous to mention, for comments (whether critical or otherwise) on the first edition; the excellent people at Sage, including Julia Hall and Kate Gofton-Salmond; Sarah Baker for very helpful research assistance late in the day; Jen Carter, Kev Grant, Dai Griffiths, Roger Lewins and Nick Thorn for sharing music and good times; the Second Wednesday drinkers and the Thursday night footballers (especially Gary Conway, Simon Mason, Don Redding and Adam Swift) for catharsis; Kersh, Martha, Rebecca and Thomas – wonderful new additions to our extended family since the first edition; and Rosa and Joe for being amazing children, who bring such joy to those who love them. Finally, like the first edition, this second one is dedicated with love to Helen Steward, even though, for some reason, she finds the problem of free will more interesting than my droning on about culture this, commodification that.

David Hesmondhalgh
Oxford, October 2006

INTRODUCTION: CHANGE AND CONTINUITY, POWER AND CREATIVITY

AN OVERVIEW OF SOME CHANGES – AND THE IMPORTANCE OF CONTINUITY

Nearly all commentators accept that the cultural industries have undergone remarkable transformation since the early 1980s. Here are some of the major changes I intend to deal with in what follows.

- The cultural industries have moved closer to the centre of the economic action in many countries and across much of the world. Cultural industry companies can no longer be seen as secondary to the 'real' economy where durable, 'useful' goods are manufactured. Some of these companies are now vast global businesses and are among the most discussed and debated corporations on the planet.

- The ownership and organisation of the cultural industries have changed radically. The largest companies no longer specialise in a particular cultural industry, such as film, publishing, television or recording; they now operate across a number of different cultural industries. These conglomerates compete with each other, but, more than ever before, they are connected – with each other and with other companies – in complex webs of alliance, partnership and joint venture.
- Despite this, there are also more and more small-and medium-sized companies in the business of culture and there are increasingly complex relationships between large, medium and small cultural companies.
- Cultural products increasingly circulate across national borders. Images, sounds and narratives are borrowed and adapted from other places on an unprecedented scale, producing new hybrids but also, for some, reaffirming the value of cultural authenticity. The long-standing domination of cultural trade by the USA may be diminishing.
- There has been a remarkable proliferation of new communication technologies, most notably the Internet, and of new applications of existing technologies.
- The way that the cultural industries conceive of their audiences is changing. There is greater emphasis on audience research, marketing and addressing 'niche' audiences.
- Cultural policy and regulation have undergone significant shifts. Long-standing traditions of public ownership and regulation have been dismantled. Important policy decisions are increasingly carried out at an international level. At the same time, the cultural industries have become increasingly important in local urban and social policy, as a means of regenerating economies and providing competitive advantage over other cities and regions.
- There has been a huge boom in the amount of money that businesses spend on advertising. This has helped to fuel the spectacular growth of the cultural industries.
- The cultural tastes and habits of audiences have become more complex. The production and consumption of cultural texts and the turnover of tastes and fashions has quickened.
- *Texts*[1] (in my view, the best collective name for cultural 'works' of all kinds: the programmes, films, records, books, comics, images, magazines, newspapers and so on produced by the cultural industries) have undergone radical transformation. There is an increasing penetration of promotional and advertising material into previously protected realms, especially in European television, but also across a wide range of other cultural industries. There is more and more product of all kinds, across a wider range of genres, across a wider range of forms of cultural activity than before. Various forms of cultural authority are increasingly questioned and satirised.

1 Throughout this book, I use bold italics to denote key concepts on their first major occurrence, bold to highlight key phrases and italics for titles and ordinary emphasis. The key concepts are defined in the Glossary at the end of the book and usually on their first appearance, too.

To what extent, though, do such changes in the cultural industries really represent major, epochal shifts in the way that culture is produced and consumed? After all, alongside these changes, there are many important continuities that might be obscured by an overemphasis on change. For example, television continues to play a huge role, as a source of information and entertainment, in people's lives; stars continue to be the main mechanism via which cultural industry companies promote their products; the USA is still thought of, across the globe, as the world centre for popular culture; copyright remains fundamental to an understanding of the cultural industries. Because continuities such as these are entangled with the above changes, I refer throughout what follows to **patterns of change/continuity in the cultural industries**. This issue – the interweaving of change and continuity – is the central theme of this book.

WHY DO THE CULTURAL INDUSTRIES MATTER?

THE CULTURAL INDUSTRIES MAKE AND CIRCULATE TEXTS

More than other types of production, the cultural industries are involved in the making and circulating of products – that is, texts – that have an influence on our understanding of the world. Debates about the nature and extent of this influence comprise, in the words of a valuable survey of the concept, 'the contested core of media research' (Corner, 2000: 376). The best contributions to such debates suggest the complex, negotiated, and often indirect, nature of media influence, but of one thing there can be no doubt: the media do have an influence. We are influenced by informational texts, such as newspapers, broadcast news programmes, documentaries and analytical books, but also by entertainment. Films, TV series, comics, music, video games and so on provide us with recurring representations of the world and thus act as a kind of reporting. Just as crucially, they draw on and help to constitute our inner, private lives and our public selves: our fantasies, emotions and identities. They contribute strongly to our sense of who we are, of what it means to be a woman or a man, an African or an Arab, a Canadian or a New Yorker, straight or gay. For these reasons alone, the products of the cultural industries are more than just a way of passing time – a mere diversion from other, more important things. All the same, the sheer amount of time that we spend experiencing texts, however distractedly we might do so, in itself makes the cultural industries a powerful factor in our lives.

So, studying the cultural industries might help us to understand how texts take the form they do and how these texts have come to play such a central role in contemporary societies. Importantly, most texts that we consume are circulated by powerful corporations. These corporations, like all businesses, have an interest in making profits. They want to support conditions in which businesses in general – especially their own – can make big profits. This raises a crucial issue:

do the cultural industries ultimately serve the interests of their owners and their executives and those of their political and business allies?

It is important that we avoid simplistic answers to this vital question. Throughout this book, I argue for a view of the cultural industries and the texts they produce as **complex, ambivalent and contested**. (Some important and influential analyses of the cultural industries have downplayed these aspects – see Chapter 1.) In societies where the cultural industries are big business, cultural industry companies tend to support conditions in which large companies and their political allies can make money: conditions where there is constant demand for new products, minimal regulation by the state outside of general competition law, relative political and economic stability, workforces that are willing to work hard and so on. Yet, in contemporary societies, many of the texts produced and disseminated by the cultural industries do not simply support such conditions. Very often (not just occasionally) they tend to orientate their audiences towards ways of thinking that do not coincide with the interests of capitalism or of structured domination by men over women or institutional racism. (I address this issue further in Chapter 2.)

If this is true, why does it happen? Partly, it is for the simple economic reason that cultural companies have to compete with each other, as well as maintain general conditions in which to do business, and so they attempt to outstrip each other to satisfy audience desires for the shocking, the profane and the rebellious. It is also because of social and cultural factors deeply embedded in many societies regarding what we expect of art and entertainment. This takes us to a second argument for the importance of the subject of this book and into a domain that has been neglected in academic and public debate in recent years.

THE CULTURAL INDUSTRIES MANAGE AND CIRCULATE CREATIVITY

The cultural industries are concerned, fundamentally, with the management and selling of a particular kind of work. Since the Renaissance – and especially since the Romantic movement of the nineteenth century – there has been a widespread tendency to think of 'art' as being one of the highest forms of human creativity. Sociologists and Marxists have argued in response that artistic work is not so different from other kinds of labour, in that both are orientated towards the production of objects or experiences (Wolff, 1993, Chapter 1, provides an excellent summary of these debates). This view is important in countering the idea that 'artists' are different from the rest of us, that they are involved in some mystically special form of creativity. Nevertheless, there is something distinctive about that area of human creativity often called 'art'. The invention and/or performance of stories, songs, images, poems, jokes and so on, in no matter what technological form, involves a particular type of creativity – the manipulation of symbols for the purposes of entertainment, information and perhaps even enlightenment. Instead of the term 'art', with all its connotations of individual genius and a higher calling, I want to use the more cumbersome term *symbolic*

creativity[2] and, instead of the term 'artists', I prefer the phrase *symbol creators* for those who make up, interpret or rework stories, songs, images and so on.[3]

Symbol creators have been pretty much ignored in recent thinking about the cultural industries because of an understandable, but excessive, reaction against the fetishisation of their work as extraordinary. For many years, in media and cultural studies, this took the form of an emphasis on the creativity of audiences, of those who do not, in general, work professionally as symbol creators, but, in the 1990s, a number of writers in these fields began to put symbol creators back in the picture (Born, 1993a, 1993b; McRobbie, 1998; Toynbee, 2000). After all, symbol creators are the primary workers in the making of texts. Texts, by definition, would not exist without them, however much they rely on industrial systems for the reproduction, distribution and marketing of and remuneration for their work. This does not mean that we should romantically celebrate the work of all musicians, authors, film-makers and so on. Ultimately, my interest in symbol creators derives, like that of Born, McRobbie and Toynbee, from a sense that symbolic creativity *can* enrich people's lives, even though it often doesn't.

Other traditions of study have focused on especially talented or fêted symbol creators, at times hardly referring to the means by which authors, musicians and so on have reached their audiences. Some such studies amount to a pious and complacent celebration of the achievements of Western civilisation (Clark, 1969). The work of Raymond Williams (1981) and Pierre Bourdieu (1996), among others, suggests better ways of historicising symbolic creativity, by showing how such creativity has been a more or less permanent presence in human history, but its management and circulation have taken radically different forms in different societies. In Europe, for example, systems of patronage gave way in the nineteenth century to the organisation of symbolic creativity around the market. It was at this point that the cultural industries began to emerge. From the early twentieth century, this market organisation began to take a new, complex form (see Chapter 2). Examining changes in the cultural industries allows us to think about how symbolic creativity has been organised and circulated in our own lifetimes and, crucially in this book, how this might be changing.

Again, I must emphasise here the fundamentally *ambivalent* nature of the cultural industries. The way the cultural industries organise and circulate symbolic creativity reflects the extreme inequalities and injustices (along class, gender, ethnic and other lines) apparent in contemporary capitalist societies. There are vast inequalities in access to the cultural industries. Those who do gain access are often treated shabbily and many people who want to create texts struggle to earn a living. Failure is far more common than success. There are great pressures to produce certain kinds of texts rather than others and it is hard to come across

2 My use of this term is borrowed from Willis (1990), but I differ from him in focusing on industrialised symbolic creativity, whereas he is concerned with the creativity of young people as consumers.

3 In the sense in which I am using the term, journalists and others dealing in the more information-orientated parts of the cultural industries are also symbol creators. Studies of journalism have a long and noble history of focusing attention on key symbol creators – that is, journalists.

information about the existence of organisations and texts that attempt to do things differently. Some types of text are made much more available than others. These are bleak features of the cultural industry landscape, yet, because original and distinctive symbolic creativity is at a premium, the cultural industries can never quite control it. Owners and executives make concessions to symbol creators by granting them far more *autonomy* (self-determination) than they would to workers of equivalent status in other industries and to most workers historically. Paradoxically, this freedom – which is, in the end, a limited and provisional one – can then act as a form of control by maintaining the desirability of often scarce and poorly-paid jobs. However, it may also help to explain the ambivalence in texts referred to above.

Cultural industry companies face another difficulty, too. They have to find audiences for the texts that symbol creators produce. Usually, this is not a matter of finding the greatest possible mass audience for a product. Different groups of people tend to have different tastes, so much of the work of cultural industry companies attempts to match texts to audiences, to find appropriate ways of circulating texts to those audiences and to make audiences aware of the existence of texts. As we shall see, this is a risky business. Many texts fail, even those that companies expect to succeed. The upshot of these processes is that cultural industry companies keep a much tighter grip on the *circulation* of texts than they do on their production.

The importance of symbolic creativity helps to explain the fact that the main focus of this book is on patterns of change/continuity in the cultural industries, as opposed to, say, change/continuity in the texts produced by those industries or in how audiences understand texts. As I should have made clear by now, however, this does not mean that I am interested only in the cultural industries as systems of production. The underlying interest is really **systems of production in relation to texts**. But all writers, given their limited time and energy, must make decisions about where to concentrate their attention and, rather than focusing on the texts themselves and then working backwards from there to the industries, my primary interest in this book is in the cultural industries.

THE CULTURAL INDUSTRIES ARE AGENTS OF ECONOMIC, SOCIAL AND CULTURAL CHANGE

A third and final reason for the importance of examining change and continuity in the cultural industries is that they are increasingly significant sources of wealth and employment in many economies. Measuring this importance is difficult and there are controversies, occasionally useful but sometimes tedious, about how best to do so (see Chapter 6). Much depends on how we define the cultural industries, an issue discussed later in this Introduction. It seems fair to say, though, that the economic role of cultural production is growing, but not nearly as much or as quickly as some commentators and policymakers claim.

That the cultural industries might be providing more wealth and employment is, of course, significant in itself, but it also has implications for how we understand **the relationships between culture, society and economy**. Many of the most important debates about these relationships over the last 30 years have

concerned what we might call theories of transition. Have we moved from industrial societies to post-industrial or information societies, based on a much greater emphasis than before on knowledge? This was a line of thought initiated in the 1960s and 1970s by the work of, among others, Daniel Bell (for example, 1974) and maintained by writers such as Manuel Castells (such as, 1989, 1996) in the 1980s and 1990s. Have we moved from societies best characterised as 'modern', because of their increasing ephemerality, fragmentedness and flux, to a situation better characterised as 'postmodern', where these features become so accentuated that rationality and meaning seem to break down (Harvey, 1989; Lyotard, 1984)? In one version of such debates, some analysts (notably Castells, 1996; and Lash and Urry, 1994) suggested that symbolic creativity and/or information were becoming increasingly central in social and economic life. An important implication of this, drawn out more fully by Lash and Urry than by Castells, was that the cultural industries therefore increasingly provided a model for understanding transformations in other industries. Others claimed that the cultural industries themselves are becoming more like other industries and losing their distinctiveness as an economic sector (Padioleau, 1987).

In the late 1990s, the rise of the Internet and the World Wide Web fuelled these debates. Academic study was echoed by business and management analysts, who placed increasing emphasis on firms' non-tangible assets, especially the value of these businesses' brand names (see Wolf, 1999 for a popularising version). Brands can only be made valuable as a result of massive amounts of work being put into product names and logos and how they are represented and circulated. Cultural industry companies such as Disney, because they were considered so experienced in developing brands (in a sense, every film, every star, every book is something like a brand), were often named alongside companies such as Nike and more traditional firms such as Coca-Cola as leaders in this field.

Brands, however, were only one part of a surge of hype about the increasing role of information, culture and knowledge in modern economies. There was a seemingly unstoppable flow of books about 'the weightless world' (Coyle, 1999), about how, in the future knowledge economy, we would be 'living on thin air' (Leadbeater, 2000) rather than on material goods and so on. Closely related to this, enormous attention was paid, in the USA in particular, to 'the new economy' (see Henwood, 2003, for a critique of this idea) in which the traditional business cycles of boom and slump would be replaced by continuous growth; communication technologies, branding, information and culture were all seen as central to this new configuration. In the early 2000s, such notions were increasingly joined by a new concept, which is also of direct relevance to this book: the so-called 'creative economy' (Howkins, 2001).[4]

It would be very wrong to think that, with the bursting of the so-called dot.com bubble in 2000–2001, such ideas disappeared. The language of the popularising books may not be quite as millennial now as it was at the turn of the century, but

4 I discuss the notion that 'creativity' is increasingly important in modern economies and societies further in Chapter 5. Mosco (2004) has provided a particularly valuable analysis of various ways in which computers and cyberspace have contributed to such 'mythical' thinking about economic and social futures.

new formulations of the idea that we are now living in societies and economies founded on information, knowledge and culture have continued to appear in influential and widely read magazines such as *Wired* and *Newsweek*. The latter, for example, devoted the 2006 version of its annual special issue preview of the forthcoming year to 'The Knowledge Revolution', including much discussion of the new magical word 'creativity' (see also Florida, 2002, 2005). Academic commentators, meanwhile, argued that creativity 'will be the driver of social and economic change during the next century' (Hartley, 2005: 1). If the cultural industries are playing a central part in these supposed transitions – to the information or knowledge society, to economies based on brands, on signs and meanings, on creativity – it is surprising how rarely systematic, historically informed analysis of changes in these industries has been carried out by those involved in such debates. An analysis of this kind may help to cast light on these various notions and on whether they exaggerate change at the expense of continuity.

OUTLINE OF THE ARGUMENT

Two questions seem to me to be of particular importance in relation to patterns of change/continuity in the cultural industries, both involving a set of important subsidiary questions. First, **how might we *explain* them**? What were the forces driving change and ensuring continuity? Which groups of people have made the key decisions in bringing about new patterns of change and continuity? What interests did they represent?

Second, **how might we *assess* change and continuity**? This involves two further moves: considering the *extent* of change and *evaluating* it. Which phenomena represent fundamental transformations in cultural production and consumption and which are merely superficial changes? What political and ethical principles can we draw on to think about what is right and wrong in the way that the cultural industries are structured, governed and organised in the late twentieth century and at the beginning of the twenty-first?

The rest of the Introduction lays out the working definition of the cultural industries I am using in this book. It explains the etymology of the term and my reason for preferring it over other alternatives and it outlines the distinctive features of the cultural industries. These features are important for the argument in the rest of the book because they help to explain changes and continuities in the way that the cultural industries are structured, organised and regulated.

Following the Introduction, Part One consists of three chapters that establish the analytical frameworks for the rest of the book and begin the story of change and continuity in the cultural industries since 1980. Chapter 1 prepares the ground for assessment and explanation by considering **the main approaches to the cultural industries**. It argues for an approach based on a particular type of political economy account, associated with the mainly European cultural industries tradition (rather than with a distinctive tradition in the USA often equated with political economy). I recognise the important contributions of sociology of culture and liberal-pluralist communication studies to studies of the cultural industries, while highlighting some of their limitations. I argue that the best contributions from cultural studies are potentially compatible with the best political

economy approaches. While this chapter can be skipped by readers who feel uninterested in such academic context, it forefronts a number of important assumptions that underlie the analysis and argument in the rest of the book.

Chapter 2 is a key one because it deals with how we might **assess** patterns of change/continuity in the cultural industries. In order to do so, it provides an outline of the key aspects of what, adapting Raymond Williams, I call **the complex professional era of cultural production**. The complex professional form of production took shape in advanced industrial societies in the early twentieth century and, by the middle of the twentieth century, had become the dominant form. The key aspects are discussed in terms of the following categories:

- the overall place of cultural production in economies and societies (including the long-term commodification of culture)
- the ownership and structure of cultural industry businesses
- the organisation of production (including questions concerning the autonomy or independence of creative workers from commercial and state control)
- the nature of cultural work and the rewards for it
- the internationalisation of cultural production and its domination by US businesses
- and, finally, textual changes.

The discussion of each of these aspects generates two types of question. The first type concerns the **extent** of changes since 1980. A key objective of the book is to assess whether changes since 1980 have seen the emergence of a completely new era of cultural production or whether these changes represent shifts *within* the complex professional era and therefore a relatively limited (though still potentially significant) set of transformations. The second type concerns the **evaluation** of changes and continuities. A set of normative principles is laid out, building on the outline of approaches in Chapter 1 and on my summary, earlier in the Introduction, of why I think the cultural industries are important.

Chapter 3 discusses how we might **explain** change, assessing the rival claims of approaches that emphasise economic, political, technological and sociocultural factors. It begins the story of recent change/continuity in the cultural industries by looking at how a number of such factors interacted to produce economic, political and cultural crisis in Western societies in the late 1960s and 1970s. I argue that these intertwined crises initiated many of the key changes discussed in the book. The Long Downturn in advanced industrial economies from the late 1960s onwards is a vital context for understanding even very recent developments. The crises helped bring about an important political and regulatory response, which, in general, was the rise of *neoliberalism*, but, specifically for the information and cultural sectors, was also the rise of *Information Society* discourse. However, the chapter argues that we also need to understand three other forms of change that drove changes in cultural production and consumption. These are changes in business strategy, sociocultural and textual changes and technological change. By stressing these multiple factors, I avoid reductionism.

Chapters 4 and 5 constitute Part Two of the book. In them, I outline policy changes that were fundamental in bringing about many of the changes examined

later. My account in Chapter 4 analyses how governments changed their telecommunications and broadcasting policies in the 1980s and 1990s to encourage the development of the commercial cultural industries by privatising public corporations and 'loosening' the regulation of media and culture. The story of this privatisation and 'deregulation' will be familiar to some readers. My account is different from existing ones, though, because of its international emphasis and its periodisation of change. I outline four overlapping waves of change in the communications policies of national governments:

- the first in the USA in the 1980s
- the second in other advanced industrial countries from the mid-1980s to the mid-1990s
- the third in transitional and mixed societies after 1989
- the fourth, which continues today, across all these regions/polities, involving the mooted convergence of the cultural industries with telecommunications and computers sectors.

Chapter 5 then examines changes in two other key domains of policy: cultural policy and copyright law. Again, these policy changes have been a very important basis for other changes. They represent shifts in how creativity and cultural production are conceived in relation to commerce and capital.

Part Three then builds on the foundations established in Parts One and Two to examine changes and continuities in the various aspects of the complex professional era of cultural production outlined in Chapter 2. Each chapter not only examines the extent of change but also addresses how we might evaluate events.

In Chapter 6, I examine changes and continuities in both business ownership and structure and in the place of the cultural industries in modern economies. In the Long Downturn, cultural industry businesses looked to various forms of company structure and organisational strategy in order to compete effectively with each other and with firms in other sectors. Cultural industries were already prone to domination by a few, powerful companies, but this intensified after 1980. There were important changes in the conglomerates that dominated the production and distribution of cultural goods and services. Independents continued to proliferate – and go bust. New relationships between conglomerates and such independents came into being. It is at this point that I address the question of the extent to which the cultural industries are an important part of national economies and global business. I argue that the steadily growing importance of these industries needs to be understood as a phase in the long-term commodification of culture and I outline the ambivalent consequences of this.

Chapter 7 deals with changes and continuities in **the organisation of cultural production** and in **cultural work**. Perennial questions about how to control risk and manage creativity were being answered in new and important ways from the 1980s onwards. Notably, there was an increasing focus on marketing and market research. There were also significant changes in the terms and conditions of cultural work. Did such changes represent a fundamental shift in the social relations of cultural production?

One of the most important ways in which firms tried to compete in the new business environment created by the Long Downturn and by various sociocultural changes of the period was by internationalising their operations. The consequences of this for the cultural industries are assessed in Chapter 8. *Internationalisation* in the cultural industries has helped lead to a much greater complexity of international flows of culture than before, but it has also meant the increasing global presence of vast corporations. So, the chapter considers whether or not we should think of the new state of play in the cultural industries internationally as a new stage of cultural imperialism or as a sign of a new global interconnectedness with democratising possibilities (the chapter also asks if this dualism between imperialism and interconnectedness is an adequate way of addressing the most important issues).

Cultural industry businesses also attempted to compete by introducing, and using, **new communication technologies**. Chapter 9 focuses on what is generally agreed to be the key technological development of the last 20 years – *digitalisation*. Has digitalisation brought about a fundamental shift in the cultural industries? Particularly significant facets of digitalisation are the rise of the Internet and multichannel television. Digitalisation is often said to be about to change the way that cultural production is organised and experienced. In particular, talk of convergence between the cultural industries, telecommunications and computers is now commonplace, to the point of being humdrum. How can we assess the effects of the Internet and digital television so far? To what extent have these innovations altered the power relations that have generally prevailed in the cultural industries? I also consider the new medium of digital games in this chapter.

Chapter 10 deals with the effects of all these patterns of change/continuity at the point where the cultural industries arguably have their most profound impacts on social and cultural life: **texts**. In what significant ways have cultural texts and their consumption by audiences changed (or not) during the 1980s and 1990s? In what ways has this then had reciprocal effects on the institutions, organisation and economics of the cultural industries? I deal with three particularly important but tricky issues in assessing texts: diversity, quality and the extent to which texts serve the interests of cultural industry businesses and their political allies.

Finally, a concluding chapter summarises the arguments of the book and outlines its importance for understanding changing relationships of power and social justice in relation to cultural production.

MATTERS OF DEFINITION

The term, 'the cultural industries', is surrounded by difficulties of definition. If we define culture, in the broadest anthropological sense as a '"whole way of life" of a distinct people or other social group' (Williams, 1981: 11), it is possible to argue that all industries are cultural industries in that they are involved in the production and consumption of culture. For by this definition, the clothes we wear, the furniture in our houses and workplaces, the cars, buses and trains we use for transport, the food and drink we guzzle are all part of our culture and they are nearly all produced industrially, for profit.

However, it seems to me that such a broad use risks losing any sense of what might differentiate the cultural industries from other industries. The term 'cultural industries' has tended to be used in a much more restricted way than this, based implicitly on a definition of culture as 'the *signifying system* through which necessarily (though among other means) a social order is communicated, reproduced, experienced and explored' (Williams, 1981: 13, original emphasis). To put this a little more simply, the cultural industries have usually been thought of as those institutions (mainly profit-making companies, but also state organisations and non-profit organisations) that are most directly involved in **the production of social meaning**. So, nearly all definitions of the cultural industries would include television (cable and satellite, too), radio, the cinema, newspaper, magazine and book publishing, the music recording and publishing industries, advertising and the performing arts. These are all activities the primary aim of which is to communicate to an audience, to create texts.

All cultural artefacts are texts in the very broad sense that they are open to interpretation. Cars, for example, signify and most cars involve significant design and marketing inputs. However, the primary aim of nearly all cars is not meaning, but transport. What defines a text, then, is a matter of degree, a question of balance between its functional and communicative aspects (see Hirsch, 1990/1972 for a similar argument). Texts (songs, narratives, performances) are heavy on signification and tend to be light on functionality and they are created with this communicative goal primarily in mind. Box 0.1 presents the core cultural industries that are the main focus of this book. They are the core cultural industries because **they deal primarily with the industrial production and circulation of texts**.

BOX 0.1 THE CORE CULTURAL INDUSTRIES

The following industries are centrally concerned with the industrial production and circulation of texts and they therefore constitute what I want to call the core cultural industries for the purposes of this book:

- *broadcasting*: the radio and television industries, including their newer cable, satellite and digital forms
- *film industries*: this includes the dissemination of films on video, DVD and other formats and on television
- *the content aspects of the Internet industry*: other aspects are really part of the computer or telecommunications industries
- *music industries*: recording (which, of course, includes the recording of sounds other than music, but is for the most part centred on music) publishing[5] and live performance
- *print and electronic publishing*: including books, CD-ROMs, online databases, information services, magazines and newspapers

(Continued)

5 While this term seems to be about the printing of sheet music, music publishing is much more than this as it involves the ownership and control of the rights to musical compositions.

(Continued)

- *video and computer games* or digital games as many commentators now prefer to call them.
- *advertising and marketing*: compared with other cultural industries, advertisements and marketing artefacts tend to have a greater functional element as they are intended to sell and promote other products. Nevertheless, they are centred on the creation of texts and require the work of symbol creators (see Chapter 2 for further discussion of how marketers fit into the cultural industries)

All these core cultural industries have their own dynamics and I discuss these at various points in the book, but one of the most important contributions of work on 'the cultural industries' has been to see that these industries interact and interconnect with each other in complex ways. Largely, this is because they compete with each other for the same resources. The most important of these are as follows (see Garnham, 1990: 158):

- a limited pool of disposable consumer income
- a limited pool of advertising revenue
- a limited amount of consumption time
- skilled creative and technical labour.

It is because of this competition for the same resources, as well as their shared characteristics as producers of primarily symbolic artefacts, that the cultural industries can thought of as a sector or a linked production system (there are arguments in economic and business analysis about which term might be better, but these need not concern us here). This point is not always clearly understood, even by academic analysts.

There is another set of cultural industries that I will call 'peripheral'. These are important industries, and the term 'peripheral' is in no way intended to marginalise the creativity of those involved in such work. Like the core cultural industries, these more peripheral cultural industries are centrally concerned with the production of texts. But the reproduction of these symbols uses semi-industrial or non-industrial methods. Theatre, for example, has only recently begun to take on what might be called industrial forms of production and reproduction (see Chapter 7). The making, exhibition and sale of works of art (paintings, installations, sculptures) generate enormous amounts of money and commentary each year, but reproduction is limited, where it exists at all. The art prints industry limits reproduction artificially and uses laborious methods in order to add value to the prints. I refer, in passing, to some of these industries, but, in order to make this book readable – and writable – I have focused on the core cultural industries listed in Box 0.1. It is important to note, though, that the core and peripheral industries interact with each other in important ways. Actors and writers might work in television and theatre, for example, art schools produce artists who might move in and out of various forms of commercial production, including film direction, advertising and music.

As with all definitions of complex phenomena, there are several significant borderline cases.

- *Sport* Industries such as football (soccer) and baseball arrange for the performance of live spectacles that are, in many respects, very like the live entertainment sector of the cultural industries. People pay to be entertained in real time in the co-presence of talented (or not-that-talented, depending on which team you support) performers. But there are notable differences, even from live entertainment in the cultural industries. Sport is fundamentally competitive, whereas symbol making isn't. Texts (in the sense in which I use the term in this book) tend to be more scripted or scored than in sports, which are essentially improvised around a set of competitive rules.[6]
- *Consumer electronics/cultural industry hardware* Making television programmes is based on an intentional act of cultural communication and would be included as a cultural industry in all definitions. But does the making of television *sets* constitute a cultural industry? The consumer electronics industries develop and make the machines through which we can experience texts. These industries are extremely important for understanding change and continuity in the cultural industries because they provide the hardware on and through which texts are reproduced or transmitted (hi-fi, television sets, MP3 and DVD players). These goods and others (fridges, microwave ovens) rely on the crucial input of designers and of often poorly paid assembly-line workers, but they are not centred on the production of primarily symbolic goods in the way that the cultural industries are and so they fall outside what I consider to be a useful definition.
- *Software* The software industry has some very important parallels with the cultural industries. Creative teams work together to try and create distinctive outcomes, but the actual presentation of the software does not take the form of a text. Its functional aspects – to carry out certain computerised tasks – outweigh the very important aesthetic dimensions of its design.
- *Fashion* Fashion is a fascinating 'hybrid' of a cultural industry, in the sense that I use the term here, and a consumer goods industry. The high degree of balance between functionality and signification makes this a complex special case, made all the more interesting by distinctive forms of organisation (see McRobbie, 1998 for an important study).

I could go on for pages more, dealing with borderline cases, which share features with the cultural industries, but which are, I think, sufficiently different to merit separate treatment. I hope by now that my point will be clear: that I am focusing here on industries based on the industrial production and circulation of texts and centrally reliant on the work of symbol creators.

For some analysts, this focus on symbolic creativity represents a problem. Keith Negus (2006: 201–2) has objected to my focus on symbolic creativity as the basis of a definition of the cultural industries on the grounds that creativity and the circulation of potentially influential meanings are just as much a feature of

6 Thanks to Jason Toynbee for clarifying these differences for me.

industries such as 'food, banking, tobacco, insurance' as, say, music and television. Negus is right to say that the cultural industries are not the only place where symbolic creativity takes place and we agree that symbol makers should not be fetishised as more special than the rest of us. And it is certainly true that cigarettes and bank accounts, like television programmes and songs, have cultural meaning. Yet, if we blur the distinction, it seems to me that we miss something vital. In order to understand cultural production adequately, we need to get at the *specificity* of the cultural industries. This means appreciating the difference between activities *centrally* involved with the production of artefacts that are *primarily* composed of symbols and other types of social activity. Bankers, after all, are not like musicians.

ALTERNATIVE TERMS

Clearly, the term 'cultural industries' is a contested, difficult one and, as I have implied, its problems derive from the difficulty of defining 'culture' (not to mention 'industry'). Given all these problems of definition, why not abandon the term 'cultural industries' altogether in favour of an alternative? A number of possibilities spring to mind. A book on 'the information industries' might treat the cultural industries as just one example of the increasing prominence of information in contemporary economies, societies and cultures.[7] An informative book on *The Leisure Industries* (Roberts, 2004) deals with sport and tourism alongside what I call the cultural industries. Business analysts often use the term 'entertainment industries' – especially in the USA. The cultural industries are often referred to interchangeably with the 'media industries', but the concept of media is not without its problems of definition either. Without doubt, though, the most often preferred alternative to 'cultural industries' is ***creative industries***. Many policymakers and some academic analysts now use this term. Chapter 5 provides an account of some of the problems associated with it. This includes discussion of ways in which policy labelled 'creative industries' has generally differed from policy labelled 'cultural industries'.

Leisure, information, entertainment, media and creativity are all addressed in this book, but I prefer to use the term 'cultural industries' than the alternatives. This is because it not only refers to a type of industrial activity but also invokes a certain tradition of thinking about this activity and about relationships between culture and economics, texts and industry, meaning and function.

FROM 'THE CULTURE INDUSTRY' TO THE CULTURAL INDUSTRIES

The term has its origins in a chapter by two German-Jewish philosophers associated with the Frankfurt School of Critical Theory, Theodor Adorno and Max Horkheimer (1977/1944). Although the term may have been used before, 'The

7 The term 'information industry' was in vogue during the late 1980s and 1990s (see Sadler, 1997, for an interesting analysis of the recording industry as an information industry), but even some of those who used it (such as Wasko, 1994) recognised that it marginalised entertainment and the artistic, expressive and cultural aspects of symbol making. See Schiller (1994) for a discussion of the relationships between information and culture.

Culture Industry' was part of the title of a chapter in their book *Dialektik der Aufklärung* (*Dialectic of Enlightenment*), which they wrote in the USA in the 1940s while in exile from Nazi Germany. The book was born out of a conviction that life in the capitalist democracy of the USA was, in its own way, as empty and superficial, if not quite as brutal and horrific, as life in the Germany they had fled. 'Culture Industry' was a concept intended to shock. Adorno and Horkheimer, like many other users of the term 'culture' in the nineteenth and twentieth centuries, equated culture in its ideal state with art, with special, exceptional forms of human creativity. For them, and for the tradition of Hegelian philosophy of which they were a part, art could act as a form of critique of the rest of life and provide a utopian vision of how a better life might be possible. In Adorno and Horkheimer's view, however, culture had almost entirely lost this capacity to act as utopian critique because it had become commodified – a thing to be bought and sold. Culture and Industry were supposed, in their view, to be opposites but, in modern capitalist democracy, the two had collapsed together. Hence, Culture Industry.[8]

By the late 1960s, it was clear that culture, society and business were becoming more intertwined than ever as transnational corporations invested in film, television and record companies and these forms took on ever greater social and political significance. Adorno, Horkheimer and other present and former members of the Frankfurt School became internationally prominent as left-wing students and intellectuals turned to their ideas to make sense of these changes. The term Culture Industry became widely used in polemics against the perceived limitations of modern cultural life. The term was picked up by French sociologists (most notably Morin, 1962; Huet et al., 1978; Miège, 1979), and by activists and policy makers[9] and was converted to the term 'cultural industries'.

Why prefer the plural to the singular form? The distinction is revealing and more significant than may at first appear to be the case. The French 'cultural industries' sociologists rejected Adorno and Horkheimer's use of the singular term 'The Culture Industry' because it suggested a 'unified field' where all the different forms of cultural production that coexist in modern life are assumed to obey the same logic. They were concerned, instead, to show how *complex* the cultural industries are and to identify the different logics at work in different types of cultural production, how, for example, the broadcasting industries operated in a very different way from the press or from industries reliant on 'editorial' or publishing models of production, such as book publishing or the recording industry (see Miège, 1987). As a result, they preferred the plural term 'industries culturelles'.[10]

8 Steinert (2003: 9) clarifies that Adorno and Horkheimer used the term in two different senses: 'culture industry' to refer to 'commodity production as the principle of a specific form of cultural production' and *the* culture industry to refer to a specific branch of production.

9 Internationally, the term was disseminated in policy circles through the United Nations Educational, Scientific and Cultural Organization (UNESCO), based in Paris. UNESCO sponsored a large-scale comparative international programme on the cultural industries in 1979 and 1980, which culminated in a conference in Montreal in June 1980, the proceedings of which were published in English by UNESCO (1982).

10 Many writers (such as Lash and Urry, 1994, and Garnham, 2000 – though not Garnham, 1990) use the term 'culture industries'. The difference is trivial, but I prefer 'cultural industries' because it symbolises the move beyond the Frankfurt School approach.

The cultural industries sociologists rejected the approach of Adorno and Horkheimer on other important grounds, too, as the most important writer in this tradition, Bernard Miège (1989: 9–12), made clear in a foreword to a translated collection of his work.[11] First, they rejected Adorno and Horkheimer's nostalgic attachment to pre-industrial forms of cultural production. Following other critics of the Frankfurt School, including Adorno's friend and contemporary Walter Benjamin, Miège argued that the introduction of industrialisation and new technologies into cultural production did indeed lead to increasing commodification, but that it also led to exciting new directions and innovations. The commodification of culture, then, was a much more *ambivalent* process than was allowed for by Adorno and Horkheimer's cultural pessimism. (As we shall see in the next chapter, this is an insight shared by some cultural studies approaches.) Second, rather than assuming that the process of commodification of culture has been a smooth, unresisted one, the cultural industries sociologists were concerned with the limited and incomplete nature of attempts to extend capitalism into the realm of culture. They saw the cultural industries, in other words, as *contested* – a zone of continuing struggle – whereas there is a constant sense in Adorno and Horkheimer that the battle has already been lost, that culture has been already subsumed by capital, and by an abstract system of 'instrumental reason'.

These modifications of Adorno and Horkheimer's Culture Industry thesis are real advances. The point here is not simply to show that two German intellectuals writing in the mid-century got it wrong. Adorno and Horkheimer are important, amongst other reasons, because they provided a much more interesting and sophisticated version of a mode of thinking about culture that is still common today. Newspaper commentators can often be read or heard dismissing industrialised culture as debased. Writers, teachers and students often lapse into a pessimism similar to that of the Culture Industry chapter, even while they enjoy and feel enriched by many of the products of the cultural industries. Adorno and Horkheimer provide the fullest and most intelligent version of the extreme, pessimistic view of the industrialisation of culture. For Miège and others, however, even this intelligent version of cultural pessimism is lacking. Abandoning extreme pessimism is not the same thing as complacently celebrating the cultural industries as they are. The key words, to repeat, are *complex, ambivalent and contested.* These terms drive my efforts to explain and assess the cultural industries in what follows. Using the term 'cultural industries' signals an awareness of the problems of the industrialisation of culture, but a refusal to simplify assessment and explanation.

INDUSTRIES THAT MAKE TEXTS: THE DISTINCTIVE FEATURES

In the light of work by Miège and others – including, most notably, Garnham (1990) – it is possible to outline the distinctive features of the cultural industries, as compared with other forms of capitalist production. These are summarised in

11 This poorly edited translation forms the most important source in English of Francophone sociological work on the cultural industries, but see also Lacroix and Tremblay, 1997.

Box 0.2.[12] The first four features are the distinctive *problems* faced by the cultural industries and the next five features are the most common *responses*, or attempted solutions, undertaken by cultural industry businesses. These distinctive features have important implications for the rest of the book. They help to explain recurring strategies of cultural industry companies in terms of how they manage and organise cultural production. They indicate potential causes of change. They help us to understand the constraints facing those who want to work as symbol creators or set up their own independent and/or alternative cultural organisations. They also provide a way of understanding the differences between cultural industries, in that certain features are more apparent in some industries than in others or the same features take somewhat different forms.

BOX 0.2 SUMMARY OF DISTINCTIVE FEATURES OF THE CULTURAL INDUSTRIES

Problems:

- Risky business
- Creativity versus commerce
- High production costs and low reproduction costs
- Semi-public goods; the need to create scarcity

Responses:

- Misses are offset against hits by building a repertoire
- Concentration, integration and co-opting publicity
- Artificial scarcity
- Formatting: stars, genres and serials
- Loose control of symbol creators; tight control of distribution and marketing

RISKY BUSINESS

All business is risky, but the cultural industries constitute a particularly risky business (the title of a book on the film industry by Prindle, 1993 – presumably named in homage to the enjoyable 1983 film starring Tom Cruise) because they are centred on the production of texts to be bought and sold. For Garnham,

12 A number of other writers have attempted to define the characteristics of those industries that are involved primarily in the production and circulation of symbolic goods, even if they do not use the term 'cultural industries'. Many of these are ultimately consistent with the terms used by Garnham in his classic outline of the terrain (Caves, 2000, Baker, 2002, Grant and Wood, 2004, are notable examples). My own outline here is distinctive in presenting these characteristics as a set of problems and attempted solutions or responses.

influenced by Bourdieu (1984), this *risk* derives from the fact that audiences use cultural commodities in highly volatile and unpredictable ways, often in order to express that they are different from other people (Garnham, 1990: 161).[13] As a result, fashionable performers or styles, even if heavily marketed, can suddenly come to be perceived as outmoded and, equally, other texts can become unexpectedly successful. These risks, which stem from consumption, from the ways in which audiences tend to use texts, are made worse by two further factors related to production. First, as we saw earlier, companies grant symbol creators a limited autonomy in the hope that the creators will come up with something original and distinctive enough to be a hit. But this means that cultural companies are engaged in a constant process of struggle to control what symbol creators are likely to come up with. Second, any particular cultural industry company (Company A) is reliant on other cultural industry companies (B, C, D and so on) to make audiences aware of the existence of a new product or of the uses and pleasures that they might get from experiencing the product. Even If Company A actually owns Company B or F, they can't quite control the kind of publicity the text is likely to get because it is difficult to predict how critics, journalists, radio and television producers, presenters, and so on are likely to evaluate texts.

All these factors mean that cultural industry companies face special problems of risk and unpredictability. Here are some statistics:

- nearly 30,000 albums were released in the USA in 1998, of which fewer than 2 per cent sold more than 50,000 copies (Wolf, 1999: 89)
- 88 hits in 1999 – 0.03 per cent of releases – accounted for a quarter of US record sales (Alderman, 2001)
- Neuman (1991: 139) quotes a rule of thumb in publishing that 80 per cent of the income derives from 20 per cent of the published product
- Bettig (1996: 102) claims that, of the 350 or so films released each year in the USA at the time of his study, only 10 or so will be box office hits
- Driver and Gillespie (1993: 191) report that only one-third to one-half of UK magazines break even and only 25 per cent make a profit
- according to figures cited by Moran (1997: 444), about 80 per cent of the 50,000 book titles published in the USA each year in the mid-1980s were financial failures.

It is important to realise, nevertheless, that, across the cultural industries as a whole, this risk is successfully negotiated by the larger companies:

- television profits have traditionally run at a rate of 20 per cent of sales, according to Neuman (1991: 136)
- Compaine (1982: 34, cited by Neuman, 1991: 136) claims that profits from motion pictures tend to run at 33 to 100 per cent higher than the US average.

13 Even if we do not think of the problem in this way, it is clear that consumption of texts is likely to be highly subjective and arational.

Profits, though, are highly variable, depending on the degree of competition within and across industries:

- Dale (1997: 20) samples figures from 1992 showing the following profit margins (operating income divided by sales) in different industries:
 - cable, 20 per cent
 - broadcast television, nearly 17.5 per cent
 - the press and books, around 12 per cent
 - music, network television and magazines, just under 10 per cent
 - film and advertising agencies, in the high single digits
- film industry profits fell from an average of 15 per cent in the 1970s to about 10 per cent in the early 1980s, then to around 5–6 per cent in the late 1980s, before making a recovery in the early 1990s (Dale, 1997: 20)
- in the early 2000s, the majors that dominate the cultural industries showed either very high temporary losses, reflecting the huge costs of mergers or investment, or poor profit rates: less than 5 per cent at Disney and less than 3 per cent at Viacom in 2002 (Grant and Wood, 2004: 100).

The cultural industries, then, can be highly profitable in spite of the particularly high levels of risk many businesses face, but it may be increasingly difficult to achieve high levels of profit for individual companies.

CREATIVITY VERSUS COMMERCE

The account on page 6 may have made it sound as though symbol creators work under relatively autonomous conditions in the cultural industries because this relative autonomy is generously granted to them by companies. The reality, however, is more complicated. Such autonomy is also a product of historical understandings of the nature of symbolic creativity and, in particular, the view that art (or, to use my preferred term, creativity – understood here, as elsewhere in this book, as *symbolic* creativity – see above) is not compatible with the pursuit of commerce. Romantic conceptions of art in 'Western' societies established the idea that art is at its most special when it represents the original self-expression of a particular author. At one level, this is a mystification, so to set creativity too strongly against commerce – as a great deal of romantic and modernist thought about art did – is silly. Creators need to be paid and some of the loveliest, funniest, most thought-provoking works have been produced as part of a commercial system. However dubious the romantic conception of opposing creativity or art to commerce may be, it has had the long-term effect of generating very important tensions between creativity and commerce, which are vital to understanding the cultural industries. The creativity/commerce pairing helps to generate the relative and provisional autonomy that many symbol makers attain. It is also adds to the uncertainty and difficulty of the environment in which cultural businesses work. Parallels exist in other fields. There are tensions in science, for example, between the goal of making knowledge publicly available and gaining financial advantage from that knowledge. But it is impossible to understand the distinctive nature of

cultural production without an understanding of the commerce/creativity dialectic. I explore these issues further in Chapters 2 and 7.

HIGH PRODUCTION COSTS AND LOW REPRODUCTION COSTS

Most cultural commodities have high fixed costs and low variable costs: a record can cost a lot to make because of all the time and effort that has to go into composition, recording, mixing and editing to get the right sound for its makers and their intended audience, but, once 'the first copy' is made, all subsequent copies are relatively cheap to reproduce. The important point here is the ratio between production and reproduction costs. Nails, for example, have a low design input, making the first copy cheapish to produce and each further copy costing not much less. This produces a very different kind of market from that which prevails in the cultural industries. Cars are more like the texts that the cultural industries produce, but are still substantially different. The prototype of a car is extremely expensive, with enormous amounts of design and engineering input, and the costs of each new car built from the prototype are very expensive, too, because of the materials and safety checks required. So, even though fixed costs are high, the ratio of variable costs to fixed costs is relatively low. The much higher ratio of fixed costs to variable costs in the cultural industries means that big hits are extremely profitable. This is because, beyond the break-even point, the profit made from the sale of every extra unit can be considerable,[14] compensating for the inevitably high number of misses that come about as a result of the volatile and unpredictable nature of demand. This leads to a very strong orientation towards 'audience maximisation' in the cultural industries (Garnham, 1990: 160).

How, then, do cultural industry businesses attempt to respond to the particular set of issues facing them as they attempt to make profit and generate capital from the production of culture?

SEMI-PUBLIC GOODS

Cultural commodities are rarely destroyed in use. They tend to act like what economists call 'public goods' – goods where the act of consumption by one individual does not reduce the possibility of consumption by others. If I listen to a CD, for example, that doesn't in any way alter your experience of it if I pass it on to you. The same could certainly not be said of my eating a pie. Using a car diminishes its value for another user much more than watching a DVD does the DVD. What is more, the means of industrial reproduction of cultural goods are relatively low in cost. This means that firms have to achieve the scarcity that gives value to goods by limiting access to cultural goods and services by artificial means (see below).

14 Those cultural industries that do not sell goods directly to customers, most notably broadcasting and, increasingly, internet content work in different but related ways. In them, the extra unit is that of audiences, which are then 'sold' on to advertisers.

MISSES ARE OFFSET AGAINST HITS BY BUILDING A REPERTOIRE

This extra emphasis on audience maximisation means that, in the cultural industries, companies tend to offset misses against hits by means of 'overproduction' (Hirsch, 1990/1972), attempting to put together a large catalogue or 'cultural repertoire' (Garnham, 1990: 161) or, to put it another way, 'throwing mud' – or other similar substances – 'against the wall' to see what sticks (Laing, 1985: 9; Negus, 1999: 34). If, as Garnham suggests, one record in every nine is a hit and the other eight are misses, then a company issuing five records is less likely to have the hits that will keep the company afloat than the company with a repertoire or catalogue of 50 record releases. This is one of the pressures towards achieving greater size for cultural companies, though there are countervailing tendencies that favour smaller companies.

CONCENTRATION, INTEGRATION AND CO-OPTING PUBLICITY

Cultural industry companies deal with risk and the need to ensure audience maximisation by using strategies that are also apparent in other sectors.

- *Horizontal integration.* They buy up other companies in the same sector to reduce the competition for audiences and audience time.
- *Vertical integration.* They buy up other companies involved in different stages of the process of production and circulation. A company might buy 'downstream', such as when a company involved in making films buys a DVD distributor, or 'upstream', which is when a company involved in distribution or transmission (such as a cable television company) buys a programme-maker.
- *Internationalisation.* By buying and partnering other companies abroad, corporations can sell massive amounts of extra copies of a product they have already paid to produce (though they will have to pay new marketing costs, of course).
- *Multisector and multimedia integration.* They buy into other related areas of cultural industry production to ensure cross-promotion.
- Also important is the attempt to 'co-opt' (Hirsch, 1990/1972) critics, DJs and various other people responsible for publicising texts, by socialising with them, sending them gifts, press releases and so on.

Such forms of integration have led to the formation of bigger and more powerful companies. Nearly all major industries – from aluminium to biochemicals to clothing – are dominated by large companies. There is only limited evidence that the cultural industries have higher degrees of industry *concentration* than other industries. Arguably, though, the consequences of not succeeding in growth and integration are greater in the cultural industries than in many other industries because there is a very high rate of failure of smaller companies. This, in turn, is explained by the fact that small cultural companies are unable to spread risk across a repertoire. Crucially, the consequences of this size and power are unique

to the cultural industries because of the ability of the goods they produce – texts – to have an influence on our thinking about their operations, about all other industries and, indeed, potentially, about all aspects of life.

ARTIFICIAL SCARCITY

Garnham (1990: 38–9, 161) identified a number of ways in which scarcity is achieved for cultural goods (which, as we saw on page 21, because they often show public good features, tend not to be scarce). Primary among them is vertical integration. The ownership of distribution and retail channels allows companies to control release schedules and ensure the adequate availability of goods. Just as important, however, are:

- advertising, which limits the relative importance for profits of the *sale* of cultural goods
- copyright, which aims to prevent people from freely copying texts
- limiting access to the means of reproduction, so that copying is not easy.

FORMATTING: STARS, GENRES, SERIALS

Another way for cultural industry companies to cope with the high levels of risk in the sector is to minimise the danger of misses by *formatting* their cultural products (Ryan, 1992).[15] One major means of formatting is **the star system** – associating the names of star writers, performers and so on with texts. This involves considerable marketing efforts, in order to break a writer or performer as a new star or ensure the continuation of the star's aura. This type of formatting is reserved for privileged texts that cultural industry companies hope will become big hits. The importance of the star system can be indicated by the following statistic. Of the 126 movies that made more than US$100 million at US box offices in the 1990s, 41 starred one or more of just 7 actors: Tom Hanks, Julia Roberts, Robin Williams, Jim Carrey, Tom Cruise, Arnold Schwarzenegger and Bruce Willis (Standard & Poor's *Movies and Home Entertainment Industry Survey*, 11 May 2000: 14).

Another crucial means of formatting is the use of **genre**, such as 'horror film', 'hip hop album', 'literary novel'. Genre terms operate as labels, not unlike brand names, that suggest to audiences the kinds of pleasure they can attain by experiencing the product. The terms might not be universally understood and might not even be explicitly used, but the important thing is that a type of cultural product is suggested and associated with particular uses and pleasures. Many cultural products promoted and publicised primarily via the use of genre also carry author names, but, until the author becomes a star, genre is paramount.

15 The term 'format' is widely used in the television industry to refer to the *concept* of a particular programme, such as *Who Wants to be a Millionaire?*, *Big Brother* or *Jeopardy*. This is often developed in an initial market and then sold as a copyrighted idea (rather than as a programme) in overseas markets (see Moran and Keane, 2004). That is not the sense in which Ryan uses the term, but this strategy can be understood as a way of attempting to spread the high fixed costs associated with developing a programme idea and reaping the reward from the relatively low variable costs.

Finally, the **serial** remains an important type of formatting, especially where authorship and genre are less significant. This has been an important aspect of publishing – popular fiction, comics and so on – but is also to be found with films, and even in records (such as the huge-selling compilations of the most popular music in the UK, *Now That's What I Call Music*, issued at various frequencies per year since 1983. *Now 63* was the most recent at the time of writing).

LOOSE CONTROL OF SYMBOL CREATORS; TIGHT CONTROL OF DISTRIBUTION AND MARKETING

In discussing symbol creators earlier, I pointed out that symbol creators are granted considerable autonomy within the process of production – far more, in fact, than most workers in other forms of industry. There are cultural reasons for this – namely, long-standing assumptions about the ethical desirability of creative autonomy, which derive from the romantic conception of symbolic creativity, and traditions of free speech – but also economic and organisational reasons. Managers assume that major hits and the creation of new genre, star and series brands require originality. Symbol creators are usually overseen from a certain distance by 'creative managers' (Ryan, 1992), such as editors or television producers, who act as intermediaries between the creators and the commercial imperatives of the company. Those symbol creators who become stars – their names promising certain experiences – are rewarded enormously, but most creative workers exist in a vast reservoir of underused and underresourced talent, picking up work here and there. In many cases, production will actually take place under the auspices of a separate, independent company. Such 'independents' – often, in fact, tied to larger companies by financing, licensing and distribution deals – are to be found in abundance in the cultural industries, mainly because symbol creators and some audiences are suspicious of the bureaucratic control of creativity, again reflecting ingrained cultural assumptions about art. In order to control the risks associated with managing creativity, senior managers exert much tighter control over reproduction, distribution and marketing – what I will call *circulation* – than they do over production in many cases by means of vertical integration.

* * *

An objection might be made to a characterisation of the distinctive features of the cultural industries, such as that above, that some of these features will be shared with other industries. Such an objection entirely misses the point: it is the *collective* nature of these characteristics that matters.[16] Nor, as I stressed earlier,

16 Other industries have been analysed for their distinctive characteristics and Caves (2000: 1) usefully summarises some examples, such as the pharmaceuticals industry, which is marked by the particular intensity of competition over innovation; chemical process industries by rivalry over the installation of new capacity; food processing by product differentiation and the rise of dominant brands.

does the fact that cultural industry businesses are linked to other sets of industries and other businesses invalidate the idea that there are useful if provisional and porous boundaries to be drawn around the sector. Analysing these distinctive features collectively helps to understand the production and consumption of culture. The key point, though, is that whether they do so successfully or not, **cultural industry companies respond in particular (though variable) ways to perceived difficulties of making profits** and these distinctive dynamics play an important role in the account of change and continuity in this book.

AUTHOR TO READER

I outlined at the beginning of this Introduction why I think the cultural industries matter: the power they have to influence people, the varied ways in which they manage the work of symbol creators and their role in bringing about more general industrial, social and cultural change. Relating the fundamental concerns of the book to my own personal background may help to make them more concrete. This will help to provide context for the particular approach I take to the cultural industries, the approach developed in the next three chapters.

As a teenager, I was infuriated by what I perceived as the lies and distortions of television, and of the ultraconservative newspapers my parents read (typically for a certain section of the Northern English, working class/lower middle class). The *Daily Mail* and the *Sunday Express* seemed constantly to be attacking anyone who was trying to achieve social justice in Britain in the late 1970s – trade unions, feminists, anti-racist activists. They wrote as if the British role in Northern Ireland was one of making peace between tribal factions. Even at 15, I knew enough about Irish history to find this difficult to accept. These newspapers were also decidedly lukewarm in their condemnation of far-right neo-Nazi groups, whose graffiti was all over the town where I grew up, directed at the British South Asian community there. It seemed to me, right from my teens, that the cultural industries had a role in maintaining power relations and distorting people's understanding of them.

My other main relationship to the media and popular culture was as a fan, and a fan I remain. Even if some media seemed to take a stance against everything I stood for, there was plenty of exciting, interesting and funny popular culture around. I still find this to be the case today, so I cannot accept the version of the cultural industries to be found in some writing on the subject – a monstrous system for the maintenance of conformity. In the late 1970s and early 1980s, the musical genre of punk seemed to me to embody the most remarkable creative energy. Suddenly, the emotional range of my small record collection was massively expanded: music could be shocking or coolly detached; intelligent or belligerent; hilarious or deadly serious. Punk musicians were always talking about the music industry and were often arguing that it could be changed, to make creativity more widespread and to make sure that more of the money went to those creating the music.

My sense of the importance (and ambivalence) of media and popular culture eventually led me to a career in teaching, where I was fortunate enough to meet

dozens of students who were prepared to share their perspectives with me. My love of US popular culture (particularly classic and Movie Brat Hollywood cinema, black music and Jewish comedy) and my fascinated loathing for the US government's role in global geopolitics took me to the outskirts of Chicago for a postgraduate degree. Teaching and learning provided the impulse to write this book, but it's also informed by my experience, over the last few years, of researching and writing about the cultural industries. There is an assumption among many academics that the most prestigious books will necessarily be more or less incomprehensible to students. I've worked hard to make this book interesting and useful for other teachers and researchers, but I've also endeavoured to make it accessible for students, by explaining difficult concepts as they arise and trying to get across why I think the issues I'm dealing with matter. I've had to assume some knowledge of and interest in the topic, but I've tried not to assume too much.

PART ONE

ANALYTICAL FRAMEWORKS

1 APPROACHES TO CULTURE

How have researchers approached the cultural industries? My aim here is to examine which research traditions provide the most useful tools for addressing the central themes of this book – explaining and assessing patterns of change/ continuity in the cultural industries since the late 1970s. The search is for approaches that address the fundamental issues outlined in the second section of the Introduction (Why do the cultural industries matter?). We need approaches that are sensitive to the potential power of the cultural industries, as makers of texts, as systems for the management and marketing of creative work and as agents of change. I'll begin with two traditions of analysis that promise, at first sight, to make major contributions to such an analysis, but are in fact compromised by their lack of attention to such issues of power.

MEDIA AND CULTURAL ECONOMICS

Cultural economics is the branch of economics devoted specifically to culture and to the arts, while media economics employs economic concepts to analyse the media. Both have been relatively marginal within the field of economics as a whole, but, in recent years, they have experienced something of a boom, especially media economics (see, for example, Doyle, 2002; Hoskins et al., 2004). This may partly be explained by the fact that the influence of the dismal science of economics on media and cultural policy has been profound, as we shall see in Chapter 4.

Since it developed in its modern form in the nineteenth century, economics has been dominated by particular conceptions of its assumptions and goals that have come to be known as 'neoclassical', to distinguish them from the assumptions of the 'classical' economics of the eighteenth century. *Neoclassical economics* is not concerned with determining human needs and rights, nor with intervening in questions of social justice. Instead, it focuses on how human wants might be most efficiently satisfied. Even though its language and procedures are often very specialist and esoteric, neoclassical economics claims to be a practical social science, aimed at understanding how and under what conditions markets best function. It equates the well-being of people with their ability to maximise their satisfactions. It provides methods for calculating how such satisfaction might be maximised, and this shows its roots in utilitarianism – the philosophy of happiness maximisation (see Mosco, 1995: 47–8). Given our concerns, as outlined in the Introduction, with the way that public and everyday life are affected by the products of the cultural industries, such a bracketing of questions concerning power and justice is limiting, to say the least. The equation of human happiness with the optimising of economic satisfactions, an underlying assumption that many media and cultural economics writers inherit from neoclassical economics, provides a limited basis on which to proceed in assessing the cultural industries.

In spite of this, it would be a serious mistake to think that economic concepts are irrelevant or useless to the present analysis of cultural production. A crucial issue here is whether or not and, if so, in what ways and with what implications, analysts recognise the specificity of the realm of culture, symbols and information, as opposed to other forms of activity in society. Media and cultural economists have recognised the distinctive nature of media and culture and incorporated this into their analysis.[1] Such work has influenced the way in which other more critical traditions of analysis have understood the distinctive nature of the cultural industries (notably Miège, 1989, and Garnham, 1990 – see below). The breakdown of distinctive features in the Introduction drew on such work and used economic concepts, such as the distinction between private and public goods, the relationship between production and reproduction costs and the creation of artificial scarcity.

The problem is that even those economists who are concerned to analyse the distinctive nature of media and cultural products often fail to recognise the

1 The most notable recent example is Caves (2000, 2005), but see also, among others, Doyle (2002, 11–15) and Picard (2002: 9–18).

implications of these characteristics and the limitations of the fundamental economic concepts underpinning their approaches. There is no space here to explain these limitations.[2] The key point concerns the way in which economics as a discipline has played a pivotal role in generating forms of public policy. In its most invidious forms, mainstream economics has helped to fuel a *neo-liberal* approach to culture, which plays an important part in the story of change and continuity told in this book (see especially Chapter 3).

Underpinning the neoliberal approach to culture is the idea, derived from neoclassical theory, that 'free', unregulated competition will produce efficient markets. Neo-liberalism takes this a stage further by assuming that the production of efficient markets should be the primary goal of public policy. In some cases, this has involved downplaying or marginalising the specificity of media and culture and arguing that economic models can be used to analyse cultural goods (such as television, books, newspapers) in the same way as other goods. As one major media economist, Ronald Coase (1974: 389) put it, there is 'no fundamental distinction' between 'the market for goods and the market for ideas'. Perhaps the most famous expression of this was the view of Mark Fowler, who was appointed by the ultra-conservative US president Ronald Reagan to run the Federal Communications Commission in 1981, and who said that television was 'just another appliance ... a toaster with pictures' (cited, for example, by Baker, 2002: 3) – provocatively implying that there was no difference between television and a toaster, they were both simply economic goods to be bought and sold. However, even economic analysis that recognises the specificity of media and culture, and some of the limitations of traditional forms of economic analysis, tends to downplay the severity of the problems of cultural markets. The work of Richard Caves (2000, 2005) would be an example of this in my view. Another example would be the way in which the economic concept of 'market failure' has been used to justify continued public intervention in broadcasting markets, but potentially at the cost of relegating non-economic goals, such as democratic and civic participation, to secondary, residual features of market systems (see Hardy, 2004a, for criticism of the use of this concept of market failure).

Economic concepts, then, provide an important lens through which to view culture and the cultural industries, but the nature of economics as an academic discipline and as a form of policy intervention mean that it needs careful handling.

LIBERAL-PLURALIST COMMUNICATION STUDIES

From the 1930s onwards, researchers began to investigate mass communication media using sociological methods. By the 1950s in the USA, there was an

2 Good critiques are provided by the following, in ascending order of technical difficulty: Grant and Wood (2004: 56–61); Gandy (1992); Garnham (2000: 45–54); Baker (2002). None of these writers is an economist, but all use good economic concepts to criticise bad economics. While some economists recognise the limitations of neoclassical models of rational actors pursuing utility maximisation, many media and cultural economics textbooks remain more or less untouched by these developments.

established tradition of communication studies. The subject continues to thrive today and has spread to Europe and elsewhere. For many years, the dominant concern of this field was the 'effects' of media messages on audiences, with a tendency to conceive of those effects as limited and difficult to prove (see Lowery and DeFleur, 1995). This tradition was strongly influenced by behaviourism, the belief that society is best understood by observation of outward behaviour of individuals, rather than by efforts to understand (in psychology or philosophy) mental processes and events or (in sociology) issues of social power and status. What is more, analysis of consumption of messages was cut off from any consideration of cultural production and organisation.

However, more recent work in liberal-pluralist communication studies has been much more concerned with the issues of power and social justice in relation to cultural production, which are the fundamental concerns of this book. An important tradition looks at the way that the impact of the media has transformed political communication. This often puts strong emphasis on the dangers for a society of the way that democratic processes are increasingly run via the broadcast and press media. Jay Blumler and Michael Gurevitch (1995), for example, have written convincingly about a 'crisis of civic communication' and the difficulties of sustaining participatory citizenship in a society where most people gain their knowledge of politics from television. Other writers in this tradition have attempted to develop normative models to assess how well (and how badly) the mass media perform in fostering democracy (such as McQuail, 1992). The work of the Euromedia Research Group (such as1997; McQuail and Siune, 1998) and its individual associates (such as the prolific Jeremy Tunstall) have provided important information about changes in cultural policy and cultural industry organisations. Throughout these strands of communication studies and sociological work, there is an important concern, from an ultimately liberal-pluralist political perspective, with how the cultural industries affect democratic processes and public life.

In spite of the strengths of such work, there are real limitations in the liberal-pluralist communication studies tradition. First, and most important, it fails to offer any systematic account of how the cultural industries relate to more general economic, political and sociocultural processes. This derives from the problems of liberal-pluralism as a form of politics. Structured forms of inequality and power are downplayed in favour of an implicitly optimistic notion of society as a level playing ground where different interest groups fight for their interests (see Marsh, 2002, for a useful critique of this form of political thought).

Second, liberal-pluralist communication studies tends to conceive of the relationship between culture and society primarily in terms of formal democratic procedure. What ultimately counts, for many analysts in this tradition, is information – the idea that participating citizens should be given the tools to make rational decisions about the proper functioning of democratic institutions. Information about citizenship and democratic procedure are indeed important, but we live in societies where we are increasingly saturated with entertainment. It is not enough to dismiss the pleasures of entertainment as a distraction from 'real' politics. We need to rethink how the massive presence of entertainment in people's everyday lives affects not only our notions of how democracy works, but also how we think about other aspects of human life, including ourselves as feeling, emotional, pleasure-seeking beings. I shall suggest later in this chapter

that certain strands of cultural and media theory – in particular, cultural studies approaches – might provide some pointers in the right direction for thinking about these matters. But liberal-pluralist communication studies have, on the whole, been somewhat hostile to such innovations in thinking.

POLITICAL ECONOMY APPROACHES

Political economy approaches have a great deal more to offer than cultural and media economics and liberal-pluralist communication studies in terms of analysing power in relation to cultural production. Political economy is a general term for an entire tradition of economic analysis at odds with mainstream economics, in that it places much greater emphasis on ethical and normative questions. The term has been claimed not only by those on the political left who are critical of the sidelining of questions of power and conflict in mainstream economics. There are strong conservative traditions, too. So, some writers use the term **critical political economy** to distinguish their perspective from the work of classical political economists such as Adam Smith and David Ricardo and their twentieth-century heirs.[3]

Critical political economy approaches to culture (or media or communications – the terms are often used indiscriminately in labelling this tradition) developed in the late 1960s among academic sociologists and political scientists concerned by the increasing role of private businesses in cultural production. Critical political economy approaches to culture are often misunderstood, simplified or dismissed. Because such approaches are so heavily critical of media and cultural corporations and their allies in government, it is no surprise that many who work in media institutions might be dismissive or hostile. More surprising perhaps is the animosity of many elsewhere on the political left to political economies.

One common misunderstanding is to see political economy approaches as a version of orthodox cultural and media economics. In fact, political economies explicitly aim at challenging the lack of an ethical perspective in the neoclassical paradigm discussed above. Peter Golding and Graham Murdock (2005: 61–6) distinguish critical political economy approaches to the media from mainstream economics approaches in four respects:

- critical political economy approaches to the media are **holistic**, seeing the economy as interrelated with political, social and cultural life, rather than as a separate domain
- they are **historical**, paying close attention to long-term changes in the role of state, corporations and the media in culture
- they are 'centrally concerned with **the balance between capitalist enterprise and public intervention**' (p. 61).
- finally, 'and perhaps most importantly', they go 'beyond technical issues of efficiency to **engage with basic moral questions of justice, equity and the public good**' (p. 61).

3 See Mosco (1995: 22–69) for a detailed and informative analysis of political economy approaches in general, as a background to understanding the political economy of communication.

Golding and Murdock's is an important definition of political economy approaches and they certainly clarify the difference between such approaches and cultural and media economics, but two further features will help to delineate the distinctiveness of this analytical tradition even more clearly.

- Critical political economy approaches **see the fact that culture is produced and consumed under capitalism as a fundamental issue in explaining inequalities of power, prestige and profit.** This emphasis in political economy work on capitalism and its negative effects should make it clear that, although you don't have to be a Marxist to work here, it helps.
- A major area of contribution from political economy approaches to the study of the cultural industries has been to put on to the intellectual agenda debates about **the extent to which the cultural industries serve the interests of the wealthy and powerful.** As a result, a central theme in political economy approaches has been the ownership and control of the cultural industries (see Chapters 2 and 6). Does ownership of the cultural industries by the wealthy and powerful ultimately, through their control of cultural industry organisations, lead to the circulation of texts that serve the interests of these wealthy and powerful owners and their governmental and business allies? This has been such an important debate that some writers, teachers and students tend, wrongly, to equate political economy approaches with the view that cultural industry organisations do indeed serve the interests of their owners in this way when, in fact, many political economy writers are concerned precisely with addressing the difficulties and complexities surrounding this issue.

WHICH POLITICAL ECONOMY?

It should be clear that the focus within political economy approaches on ethical and political issues in relation to culture means that they will have important contributions to make to this study, given the concerns outlined in the Introduction. However, certain versions of the political economy of culture provide much more scope for understanding what drives change/continuity in the cultural industries than others. At this point, it is important to delineate political economy more carefully. This will also help us to counter some simplifications and misunderstandings surrounding the term.

Proponents and opponents of a political economy of culture often portray the field as a single, unified approach. Vincent Mosco (1995: 82–134) has provided a detailed account of the differences between the kinds of political economy work developed in three geographical and political settings: North America, Europe and 'The Third World' – that is, developing countries in Asia, Latin America and Africa. I will deal with important work from this last bloc, on cultural dependency and media imperialism, in Chapter 8. Here, though, I want to build on Mosco's useful division by discussing the tensions between two particular strands of North American and European political economy approaches.

- A tradition within North American political economy work exemplified by the work of Herbert Schiller, Noam Chomsky, Edward Herman and

Robert McChesney. This **Schiller–McChesney tradition** has been extremely important in cataloguing and documenting the growth in wealth and power of the cultural industries and their links with political and business allies.
- The **cultural industries approach**, initiated in Europe by Bernard Miège (1989; see also Miège, 2000 for a more recent statement) and Nicholas Garnham (1990), among others, continued by other European writers and writers based in other continents (Straw, 1990; Ryan, 1992; Aksoy and Robins, 1992; Driver and Gillespie, 1993; Toynbee, 2000; Bolaño, Mastrini and Sierra, 2004).[4]

In the Introduction, I referred to the work of Bernard Miège, who helped to popularise the plural term 'cultural industries' (as opposed to Adorno and Horkheimer's singular 'The Culture Industry') as an example of an approach that allowed for complexity, contestation and ambivalence in the study of culture.[5] As my praise for Miège and Garnham's work there suggests, I think that the cultural industries approach has more to offer in terms of assessing and explaining change/continuity in the cultural industries than the Schiller–McChesney tradition. In my view, the cultural industries approach is better at dealing with the following elements, each of which I address below:

- contradiction
- the specific conditions of cultural industries
- tensions between production and consumption
- symbol creators
- information and entertainment
- historical variations in the social relations of cultural production.

CONTRADICTION

The Schiller–McChesney tradition emphasises strategic uses of power. There is no doubt that such strategic uses of power by businesses are common and it is wrong to dismiss the approach of Schiller and others as 'conspiracy theory' (an accusation sometimes levelled at political economy approaches in general). But in emphasising concerted strategy, this tradition underestimates the contradictions in the system. The cultural industries approach's emphasis on problems and contradictions, on the partial and incomplete process of commodifying culture, provides

4 This division leaves out many important contributions to critical political economy work, such as those of James Curran, Michael Curtin, Peter Golding, Armand Mattelart, Vincent Mosco, Graham Murdock and Thomas Streeter. The best work of these writers, cited at numerous points in this book, shares many of the major strengths of the cultural industries approach, while pursuing distinctive agendas.

5 Some teachers and students tend to equate the cultural pessimism of Adorno and Horkheimer and some of their Frankfurt School colleagues with political economy, defining one by the other. However, as we saw in the Introduction, Miège founds his particular approach on a critique of Adorno and Horkheimer. For many in the Schiller–McChesney tradition, the theoretical concerns of the Frankfurt School seem to be more or less irrelevant.

a more accurate picture of cultural production. It allows for contradiction *within* industrial, commercial cultural production, rather than assuming a simplistic polarity *between* corporations and non-profit 'alternative' producers, as in the Schiller–McChesney tradition.

THE SPECIFIC CONDITIONS OF CULTURAL INDUSTRIES

The cultural industries approach's greater ability to deal with contradiction stems from another important advantage: its ability to combine an interest in relations between general economy and cultural industries (which is an important concern in the Schiller–McChesney tradition) with an analysis of what distinguishes industrial cultural production from other forms of industrial production (which isn't). It was work within the cultural industries approach that provided the breakdown of the specific conditions of cultural production laid out in the Introduction.

TENSIONS BETWEEN PRODUCTION AND CONSUMPTION

Although, as its name suggests, the cultural industries approach focuses on the supply side – on cultural production and circulation and their social and political contexts – it does not ignore the activity of audiences, which is a charge that is often levelled at political economy approaches and certain versions of media sociology. Instead, the cultural industries approach sees the business of cultural production as complex, ambivalent and contested largely because of certain problems derived from the way *audiences* behave. Production and consumption are not seen as separate entities, but as different moments in a single process. The connections and tensions between production and consumption are more or less ignored in the Schiller–McChesney tradition.

SYMBOL CREATORS

The processes of concentration, conglomeration and integration relentlessly catalogued by the Schiller–McChesney tradition are important (see Chapter 6 for further discussion), but Schiller, McChesney and others rarely comment on how such issues of market structure affect the *organisation* of cultural production and the making of texts on an ordinary, everyday level. The cultural industries approach puts symbol creators – the personnel responsible for the creative input in texts, such as writers, directors, producers, performers – in the picture, whereas they are almost completely absent in the Schiller–McChesney tradition. The cultural industries approach has emphasised the conditions facing cultural workers as a result of these processes.[6] Its attention to this important

6 Miège (1989), Garnham (1990) and Ryan (1992) were for many years very unusual in paying serious attention to this issue. More recently, cultural studies writers, such as McRobbie (1998) and Ross (1998), have begun to address these questions.

issue makes the cultural industries approach better equipped than the Schiller–McChesney tradition to assess the degree to which cultural production is organised in a socially just manner (see Chapter 2).

INFORMATION AND ENTERTAINMENT

In the Schiller–McChesney tradition, as in liberal-pluralist communication studies, the primary concern is with information media. The cultural industries approach has been more successful in the difficult task of addressing both information and entertainment.

HISTORICAL VARIATIONS IN THE SOCIAL RELATIONS OF CULTURAL PRODUCTION

Finally, both approaches are concerned very much with history (see, for example, McChesney, 1993) but the cultural industries approach is often more sensitive than the Schiller–McChesney tradition to historical variations in the social relations of cultural production and consumption – a concern that some of its writers derive from Raymond Williams' interventions in the historical sociology of culture (see Chapter 2).

SOCIOLOGY OF CULTURE AND ORGANISATIONAL AND MANAGEMENT STUDIES

On the basis of my comments above, and in the Introduction to this book, it should be clear by now that I find critical political economy approaches to culture useful, especially the cultural industries approach. However, even within the cultural industries approach, which is much more interested in the organisational dynamics of cultural production than the Schiller–McChesney tradition, there has been a lack of empirical attention to what happens in cultural industry *organisations*. A certain tradition of work in the sociology of culture – primarily based in the USA, and drawing on Weberian and interactionist traditions of analysis, the 'production of culture' perspective, has made important contributions in this respect. Recent years have seen a notable growth in the intertwined academic fields of management, business and organisational studies and these burgeoning disciplines have inherited some of the main concerns and characteristics of that earlier work.

Some of this work can provide a valuable complement to political economy work on the cultural industries. One of the most useful contributions of the production of culture perspective has been to enrich our notions of symbolic creativity. Instead of understanding culture as the product of supremely talented individuals, writers such as Howard Becker (1982) and Richard Peterson (1976) have helped to make it clear that creative cultural and artistic work is the product of collaboration and a complex division of labour. Particularly useful in the present context is the work of Peterson and Berger (1971), Hirsch

(1990/1972) and DiMaggio (1977) on the distinctive characteristics of the cultural industries. Here, there is important concordance with work in the cultural industries approach on the distinctive strategies of companies that produce texts. Hirsch's work, for example, informed my outline of the distinctive features of the cultural industries in the Introduction. Also valuable are detailed studies of particular industries, such as Coser et al.'s study of book publishing (1982).

The work of these sociologists in the USA, developed in parallel to that of the French cultural industries writers already mentioned, was groundbreaking, but it is only when it is synthesised into a more comprehensive vision of how cultural production and consumption fit into wider economic, political and cultural contexts that an analysis of specific conditions of cultural production really produces its explanatory pay-off. The cultural industries are treated implicitly by some of the US organisational sociologists and their management studies heirs as isolated systems, cut off from political and sociocultural conflict. Issues of power and domination are sidelined. The conditions of creative workers are hardly registered, other than the admittedly important fact that they are granted more autonomy than workers in other industries. The world of the rip-off, the shady deal, the disparity between the glass skyscrapers of the multinational entertainment corporations and the struggle young artists and musicians endure to stay afloat financially are scarcely considered. As with communication studies, I think that these problems derive from the political perspectives underlying the work of these writers. There is undoubtedly a democratising impulse to be detected here. The aim is to demystify creativity and to understand and question hierarchies of taste and value. There is a strong emphasis, particularly in the work of Becker, on the resourcefulness of people in their everyday lives. However, while this is a valuable counter to easy, glib assumptions about our powerlessness in the face of giant cultural industry corporations, much of the sociology of culture and management studies seems, at times, insufficiently concerned with questions of power for our purposes, given the concerns outlined in the Introduction. As Paul Hirsch (1990/1972: 643) put it in an article that has been highly influential in subsequent management and organisational studies, his organisational approach 'seldom enquires into the functions performed by the organization for the social system but asks, rather, as a temporary partisan, how the goals of the organization may be constrained by society'.[7] Acting as temporary partisans of media organisations would be a form of false objectivity for political economists.

RADICAL MEDIA SOCIOLOGY/MEDIA STUDIES

Empirical studies of cultural industry organisations that are more attuned to issues of power than those considered so far can be found in radical media sociology and media studies. I mean 'radical' here in the sense that these approaches see pernicious forms of power and inequality as being rooted in the

7 See Hirsch (2000) for his own reflections on how influential this piece has been.

very structure of contemporary societies rather than resulting from correctable aberrations, as in liberal-pluralist perspectives. From the early 1970s onwards, radical media sociology in the USA and the emergent discipline of media studies in Europe provided approaches that were complementary to the political economy work developing in parallel with them.

Some of the most important work in the USA grew out of a Weberian sociological tradition and concentrated on how news programmes did not so much report reality as reflect the imperatives of news organisations (for example Tuchman, 1978; Gans, 1979). According to this perspective, journalists worked autonomously, but their work was structured by bureaucratic requirements and routines. These routines were seen as producing texts that failed to address existing power relations adequately. The thrust of such work was echoed in important British studies of news (such as Schlesinger, 1978). Studies of entertainment were rarer, but, at their best, provided real insight into cultural industry dynamics. Todd Gitlin's book *Inside Prime Time* (1983), for example, showed, via interviews with television executives and reconstructions of the histories of these organisations, how the commercial imperatives of the networks led to conservatism in the texts produced.

One important contribution from radical sociology to analysing cultural production is that of Pierre Bourdieu. His work is useful to analysis of the cultural industries for a number of reasons, including his account of the development of the tensions between creativity and commerce noted in the Introduction. In *The Rules of Art* (1996), Bourdieu showed how, in the nineteenth century, the idea developed that painters and writers should be autonomous of political power and commercial imperatives. According to Bourdieu, this gradually created a particular structure of cultural production – one divided between large-scale production, for primarily short-term commercial products, and 'restricted' or small-scale production, where artistic success was the main goal (and where, for businesses, the hope was that artistic success would lead to long-term financial rewards). Bourdieu hardly dealt with popular culture at all and failed to show how the rise of the cultural industries affected the structure of the field of cultural production in the twentieth century, but his work has provided the fullest analysis available of the importance of the creativity/commerce pairing in cultural production.[8]

Radical sociological work, such as that of Gitlin and Bourdieu, is, to some extent, compatible with critical political economy approaches to culture. However, critical political economies attempt an overall understanding of the place of cultural production within contemporary capitalism and empirical studies of cultural industry organizations have not been central to this tradition. The great benefit of such radical sociology is that, at its best, it links dynamics of power in the cultural industries with questions of meaning – questions regarding the kinds of texts that are produced by cultural industry organisations. The next section considers this question of texts and meanings in more detail.

8 There is no space here to assess Bourdieu's work on cultural production adequately. See Hesmondhalgh (2006a) for futher discussion.

THE PROBLEM OF MEANING: THINKING ABOUT TEXTS

So far, I have been addressing approaches to the cultural industries that most adequately deal with questions of *power* in relation to cultural industry organisations. How do these various approaches view the other dimension I identified as crucial to the cultural industries – *meaning*? Liberal-pluralist communication studies has, for the most part, operated with a deficient view of texts. There is a branch of this tradition that analyses cultural outcomes using the methods of quantitative content analysis. The aim is to produce an objective, verifiable measure of meaning. As John Fiske (1990: 137) points out, 'this can be a useful check to the more subjective, selective way in which we normally receive messages'. There is, though, a notion of content as *message* in the effects research that has dominated this tradition. A considerably more complex notion of *meaning* needs to be put into operation, which recognises polysemy – that is, the ability of texts to be interpreted in a number of ways. This requires consideration of questions of form as well as content (in practice, the two are never really separate as the one always affects the other).

While liberal-pluralist communication studies has generally had a seriously limited understanding of texts as 'content' or 'message', the production of culture perspective, at least until recently (see Peterson, 1997), often chose to ignore the issue of textual meaning. Richard A. Peterson, for example, in outlining the production of culture perspective, was frank in admitting the approach's lack of interest in the form and content of cultural artefacts, but he claimed that an interest in production can complement such concerns (1976: 10). This suggests that the study of production has no effect on the study of texts – that the two are separate, autonomous domains of analysis. The challenge of the cultural industries, though – if my claims in the Introduction are correct – is to think through these relationships rather than ignore them. We need to think, for example, about how historical transformations in the way that culture is produced and consumed relate to changes in texts.

There is a lack of attention to textual analysis and meaning among writers drawn to political economy approaches to culture. For all its strengths, the work of Miège barely mentions the question of textual meaning. Many of the essays in Garnham's *Capitalism and Communication* (1990) attack the tendency within media studies to 'privilege the text' and 'focus on questions of representation and ideology' (p. 1).[9] In the Schiller–McChesney tradition, the underlying assumption is that most texts produced by the cultural industries are conformist and conservative, but no systematic evidence is marshalled to support this assumption. Indeed, the assumption is rarely made explicit.

CULTURAL STUDIES APPROACHES

On the other side, supposedly, of an intellectual and political divide from the approaches just discussed stands cultural studies. This is a diverse and

9 Garnham's *Emancipation, the Media and Modernity* (2000) addresses the study of texts and symbolic forms in much greater detail than did his work in the 1980s and 1990s.

fragmented field of study, but, at its core, is **the attempt to examine and rethink culture by considering its relationship to social power**. There has been remarkable hostility towards this interdisciplinary field from many of the approaches discussed above. In turn, some cultural studies writers have been extremely negative about the above approaches, including political economy and radical media sociology. Yet, cultural studies approaches, at their best, have much to offer in terms of aiding our understanding of meaning and cultural value in ways that can help fill the gaps left by the lacks in approaches to the cultural industries. What have been the main achievements of cultural studies in this respect?

First, cultural studies has argued convincingly that **ordinary, everyday culture needs to be taken seriously**. This has meant questioning hierarchical ways of understanding culture to be found in public debate and in the more established humanities and social science disciplines. Cultural studies resists this focus on con-secrated, 'high culture' texts, but it does not necessarily 'celebrate' popular culture in an uncritical way.[10] It insists that we need to think broadly about all the different elements in a culture in relation to each other rather than decide in advance which parts need to be analysed and which do not. This broader conception of culture has an international dimension, too. As cultural studies became internationalised in the 1980s and 1990s, writers originally from outside the Euro-American cosmopolitan heartlands, including diasporic intellectuals such as Edward Said (1994) and Gayatri Spivak (1988), created a space for thinking about culture in ways that recognised the complex legacy of colonialism in matters of culture. Because of this, the best cultural studies approaches can be seen as a considerable improvement on the often dismissive attitude to popular and non-Western culture to be found in some political economy and liberal-pluralist communication studies work. The best cultural studies work has achieved in-depth, serious consideration of a much wider range of cultural experience than had been recognised in other traditions of writing about culture. Other anthropological and sociological approaches (including empirical sociology of culture) had this democratising impulse, but cultural studies deals more fully with questions of symbolic power.

Second, **cultural studies has provided considerable refinement of what we might mean by that difficult term 'culture'**. In particular, it has provided powerful criticisms of essentialist notions of culture that see the culture of a particular place and/or people as 'one, shared culture' (Hall, 1994: 323), as a bounded, fixed thing rather than as a complex space where many different influences combine and conflict. Again, work by writers outside the Euro-American metropolitan centre and migrants from former colonies to such centres has been important in developing this understanding. Such challenges to traditional ways of thinking about culture have important implications in what follows. Through its richer understanding of the concept of culture, cultural studies has greatly advanced thinking about the politics of texts. Political economy writers and their allies in media studies and radical media sociology have been much concerned with the question of whose interests might be served by the texts produced by the cultural industries. Cultural studies, however, has

10 Although there are, of course, writers working within the field who might lapse into such 'uncritical cultural populism' (McGuigan, 1992) at times.

extended this conception of interests beyond economic and political ones to include a strong sense of the politics involved in issues of recognition and identity. It has pointed out how certain texts, while seemingly innocent, serve (further) to exclude and marginalise the relatively powerless.

Third, **cultural studies has raised vital political questions about 'who speaks?', about who has the authority to make pronouncements on culture.** Importantly, these questions are applied with equal vigour to those who seek to criticise capitalism, patriarchy, heterosexism, white supremacy, imperialism and so on, as to those who defend these structures. Throughout the best cultural studies writing, there is a relentless probing of authority in culture. Anthropologists working in cultural studies, for example, have scrutinised the apparent objectivity of the traditional ethnographer who observes the culture of indigenous, 'primitive' peoples from a relatively privileged position (see Clifford, 1988). In some respects, this echoes the questioning of positivism and objectivism in the 'interpretative turn' in social thought over the last 30 years. At its worst, it involves a naive constructivism and suspicion of anyone's right to say anything at all about any less powerful social group. Emergent disciplines such as black studies, queer studies and women's studies have brought new voices into cultural studies and have raised serious and important questions about the politics of speaking from one particular subject position (say, white, private school-educated male) about the cultural practices of others.

Fourth, **cultural studies has forefronted issues of textuality, subjectivity, identity, discourse and pleasure in relation to culture.** It has enormously enriched our understanding of how judgements of cultural value might relate to the politics of social identity, especially class, gender, ethnicity and sexuality. This is not just a matter of saying that taste is a product of social background (which is the approach that empirical sociology of culture has tended to take). Rather, cultural studies explores the complex ways in which systems of aesthetic value feed into cultural power. Whose voices are heard within a culture and whose voices are marginalised? Which (and whose) forms of pleasure are sanctioned and which/whose are felt to be facile, banal or even dangerous? These are questions about discourse – about the way that meanings and texts circulate in society. They also concern subjectivity and identity and the often irrational and unconscious processes by which we become who we are. These questions – sidelined in many of the approaches to the cultural industries discussed above – have been investigated with great vigour by cultural studies writers, who have pointed out that the most dismissed and reviled forms of culture are still those consumed by relatively powerless groups in society. Feminist work on such forms as soaps (Geraghty, 1991) and women's magazines (Hermes, 1995) has been extremely important in this respect.

Cultural studies, then, offers potentially valuable tools for the analysis of the cultural industries. Yet, the application of cultural studies approaches to these industries or even to cultural production have been relatively sparse (see Box 1.1 for a discussion of the concept of 'cultural economy'). There are important exceptions to this and one marked tendency is to stress the reciprocal relationships between cultural industries and broader currents of culture within a society. Keith Negus (1999), for example, writes that 'an industry produces culture' but that also 'culture produces an industry' (p. 14). Alternatively, in Simon Frith's words (2000: 27):

popular music isn't the effect of a popular music industry; rather, the music industry is an aspect of popular music culture … [T]he music industry cannot be treated as being somehow apart from the sociology of everyday life – its activities are culturally determined.

A cultural studies approach, then, might involve examining how prevailing patterns of cultural behaviour are reflected in the cultural industries themselves. There is some overlap here with the sociology of culture work discussed earlier, such as that of Howard Becker, but there is more emphasis than in sociology of culture on questions of power and inequality, including ethnicity and gender. These cultural studies approaches also complement the cultural industries approach by asking us to consider more carefully how what people want and get from culture shapes the conditions in which these industries have to do business – for example, the way in which music's ability to negotiate the relations between our private and public selves shaped the way the music business has offered musical commodities to us to own in the same way that we own other commodities. Cultural studies approaches to production may downplay the question of how, in turn, the cultural industries affect music's ability to act in this mediating way between private and public, but it raises interesting and important questions that can complement the issues raised by other approaches.

BOX 1.1 CULTURAL ECONOMY

An interesting cultural studies perspective on economic life known as 'cultural economy' (Amin and Thrift, 2004; du Gay and Pryke, 2002) is sometimes understood as an analysis of the cultural industries, but, in fact, most of the researchers who employ this term have broader ambitions than this. Their aim is to apply post-structuralist cultural studies insights to production and to economic life in general. Cultural economy, in this sense, sees the realm of economic practice – in all its various forms, such as markets and economic and organizational relations – as formatted and framed by economic discourses (du Gay and Pryke, 2002: 2) and makes this the starting point for analysis rather than placing it as a supplement to existing economic or political–economic analysis. This certainly does not preclude analysis of the cultural industries and some work has been published under this banner, but there is still, at the time of writing, too little of such work to constitute a distinctive approach to the cultural industries (as opposed to an approach to production or the economy in general). However, cultural economy raises issues about how to ground critique of developments in the cultural industries. The cultural economy approach encourages us to question the easy dichotomies that some political economists and sociologists of culture draw between the realm of culture and the increasing encroachment of economics on that realm. However, the deconstruction of such binary oppositions can leave unasked important political and ethical questions with regard to relations between culture and commerce. For example, are there potentially harmful

(Continued)

(Continued)

effects to commodification? All societies reserve some aspects of the world – nature, personhood or culture, for example – from commodification. What aspects of culture might contemporary societies shelter from exchange and private ownership and on what grounds? (These issues are pursued, for example, by John Frow, 1997, himself a cultural studies analyst. I return to them in relation to cultural production in Chapter 2.)

A final note on the subject of cultural studies. Some important cultural studies work has been devoted to empirical studies of the ways in which members of television audiences interact with television. In fact, although much commentary was devoted to such studies in the 1980s and early 1990s, there weren't that many of them (the most discussed were Ang, 1985, and Morley, 1986). Few major studies in this vein have appeared in recent years (Gillespie, 1995, and Mankekar, 1999, are two). The tendency in cultural studies has been, instead, towards theoretical work on conceptions of culture and questions of cultural identity. While much of this work has been valuable, the irony is that there has not been enough empirical study of consumption and reception in cultural studies rather than too much.

BEYOND CULTURAL STUDIES VERSUS POLITICAL ECONOMY ... AND THE REST

In the respects discussed above, and others too, cultural studies has made an enormous contribution to our understanding of culture and power. Given its interest in questioning existing power relations, you would expect a vigorous backlash from conservatives who find issues of social justice unproblematic or unchangeable, but cultural studies has also been attacked by potential liberal and radical allies. The strongest attacks on cultural studies have often come from fellow leftists in political economy and radical media sociology who often accuse it of secret complicity with conservatism (for example, Gitlin, 1998; Miller and Philo, 2000 and others). However, cultural studies has given as good as it has got and, again, the main targets have been potential allies on the political left.

Perhaps because of these spats between fellow radicals with different interpretations of how to address and combat social inequality, the idea has sprung up that the field of study of the media and popular culture is evenly divided between two camps – political economy and cultural studies. This idea is reproduced not only in published books and articles but also countless everyday references in seminar rooms, conference bars and so on, along the lines of 'political economy does X, cultural studies does Y'. Even when some writers claim that they want to move beyond the split, they then proceed to attack, from a position strongly identified with one camp, a caricatured version of the other, thus maintaining the myth (such as Grossberg, 1995).

But **political economy versus cultural studies is neither an accurate nor useful way to characterise approaches to the media and popular culture.** It simplifies a

whole web of disagreements and conflicts between the various different approaches discussed in this chapter down to two players. The issue, then, is not cultural studies versus political economy – as if the field of enquiry was divided neatly between two approaches. Nor is it cultural studies, characterised in what-ever caricatured way the writer fancies, versus the rest. The real goal is to find a way of understanding tensions between a whole number of approaches to culture. And in the present context, the key issue is how to synthesise the best aspects of the various approaches already outlined in order to produce a fruitful account of change and continuity in the cultural industries. In this section, I outline my per-spective on the most important controversies between the relevant approaches.

PRODUCTION VERSUS CONSUMPTION

Political economy is often used as a shorthand term for 'studies of production', ignoring the huge differences between attitudes to production taken by cultural and media economics, media sociology, empirical sociology of culture and so on, and sidelining the importance of consumption in the best political economy approaches. Similarly, cultural studies is often treated in caricatured descriptions as if it consists almost entirely of empirical studies of audiences, when far more such studies have been carried out within liberal-pluralist communication studies.

The very fact that I have chosen to concentrate on the cultural industries in this book – for the reasons outlined in the Introduction – suggests that here I will be mainly drawing on those approaches orientated towards the understanding of the dynamics of cultural *production* and *policy* – that is, political economy approaches, some contributions within cultural economics, radical media soci-ology and the empirical sociology of culture.

The decision to focus on production and policy is one of prioritisation in the present context, but we still need to think about them *in relation to* other key processes, such as cultural consumption, identity and textual meaning. As I argued above, cultural studies has important contributions to make to a fuller understanding of textual meaning and cultural value, as do a number of other approaches, but there remain very real difficulties in synthesising analysis of industries, organisations and texts.

TEXTS, INFORMATION AND ENTERTAINMENT

Cultural studies is sometimes accused by advocates of other approaches of being overly concerned with issues of textual meaning. In fact, although cultural studies has contributed in important ways to developing theories of how meaning and identity relate to issues of social power, in its most developed forms it has been relatively little concerned with matters of textual interpretation and evaluation. Help in developing textual analysis is at hand in the form of a number of approaches orientated primarily at the study of texts (for a survey of some of the main techniques for analysing media texts, see Gillespie and Toynbee, 2006). The focus in such studies tends not to be on the revelation of complex meanings the great artist is able to transmit into his or her work, as

in some traditional forms of humanities study, but on the *unintentional complexity* of cultural texts. Good criticism is also a valuable resource (for example, Lane, 2003, or Reynolds, 2005).

Political economy, radical media sociology and liberal-pluralist communication studies, meanwhile, have been much more concerned with informational texts, such as news and current affairs, and with the extent to which the cultural industries provide the informational resources citizens need to act against injustice and abuse of power. These approaches have, however, enormously emphasised informational content over form and have tended to value cognitive and rational modes of thought over the aesthetic, the emotional and the affective (see McGuigan, 1998, for a similar argument). Judged as a whole, these approaches – for all their strengths – can perhaps be fairly accused of treating entertainment as merely a *distraction*, a diversion from what it sees as the most desirable goal of mass communication, which is the activism of the concerned, rational, participatory citizen. The best forms of textual analysis and cultural studies help to counter this bias.

QUESTIONS OF EPISTEMOLOGY

The myth of political economy versus cultural studies overemphasises conflicts between the two sets of approaches and downplays their common differences with other approaches. Some versions of cultural studies and political economy have more in common with each other in terms of being concerned with grounding their understanding in a theory of cultural power than they do with some more empirically orientated studies (empirical sociology of culture, liberal-pluralist communication studies). Nevertheless, there are serious theoretical and epistemological tensions between political economy and cultural studies. Put crudely, political economy writers tend in questions of epistemology towards realism – the 'assumption that there is a material world external to our cognitive processes which possesses specific properties ultimately accessible to our understanding' (Garnham, 1990: 3). This view is crucially linked to the view that we can achieve objective knowledge of that independent reality. Cultural studies writers take a variety of more constructivist and subjectivist epistemological paths, in some cases aiming to gain greater objectivity by recognition of the effect of the observer on the observed (see Couldry, 2000b: 12–14, on feminist epistemology), while in other cases, there is a radical scepticism about truth claims. This is especially true in post-structuralist and postmodernist approaches. Once again, though, this is not just a case of political economy versus cultural studies. The radical constructivist, postmodernist wing of cultural studies is at odds with *all* the approaches to the cultural industries outlined in the first few sections of this chapter, not just political economy. The positivism of communication studies and sociology of culture is just as far from the critical-realist position of political economy as is postmodern cultural studies.

POLITICS AND POLICY

Much of the split between political economy and cultural studies is based on a false political dichotomy. Cultural studies derives much of its inspiration from the

tendency in political activism and thinking since the early 1970s to focus on issues of social identity, such as gender, ethnicity and sexuality, as opposed to issues of economics and the redistribution of resources.[11] For some, this concern with social identity is a retreat from the project of building coalitions to resist the economic and political forces that bring about oppression in the first place. This is why some political economy writers, as mentioned above, think that cultural studies is implicitly conservative: their view is that it misunderstands power (for example, Garnham, 1990). It is not just political economy writers who take this position, though. Writers in radical media sociology (such as Gitlin, 1998; Miller and Philo, 2000) often share this perspective and many within communication studies and empirical sociology of culture might well agree. (Again, the whole idea of political economy versus cultural studies is too crude a way of mapping debates in the field.)

Important issues are reflected in some of these responses to cultural studies. Building a politics around only the oppression and injustice faced by the group to which you feel you belong risks abandoning any notion of solidarity and empathy with others. There are real differences between how the post-structuralist wing of cultural studies grounds its critique of existing social relations and how the more Marxian political economy writers do so. However, little positive purpose is served by the unthinking polemics of some radical commentators. Rather than engaging in a dialogue with important new ways of thinking about politics and culture and finding a common cause against neoconservatism, commentators often seem more interested in mounting sectarian attacks, from both sides.

The cultural industries have a dual role – as 'economic' systems of production and 'cultural' producers of texts. Production is profoundly cultural and texts are determined by economic factors (among others). If we want to criticise the forms of culture produced by the cultural industries and the ways that they produce them, then we need to take account of both the politics of *redistribution*, focused on issues of political economy, and the politics of *recognition*, focused on questions of cultural identity (Fraser, 1997).

QUESTIONS OF DETERMINATION AND REDUCTIONISM

A criticism commonly advanced – within cultural studies but also within communication studies and empirical sociology of culture – against some kinds of political–economic analysis is their supposed **reductionism**. That is, they attribute complex cultural events and processes, such as the form of the Hollywood film industry or the nature of television soap operas or the development of television as a medium of communication, to a single political–economic cause, such as the interests of the social class that controls the means of production or the requirement within capitalism for owners and executives to make profits. There are indeed such reductionist accounts, which fail to do justice to the

11 See Hall (1992) for an account of cultural studies that portrays it as a reaction by the left against certain forms of Marxism, especially those influenced by Stalinism.

complex interplay of factors involved in culture, but the fact that some political–economic accounts are reductionist is no argument against political–economic analysis per se. A necessary concept here is ***determination,*** in its non-reductionist sense of setting limits and exerting pressures, rather than that of an external force, or forces, that leads inevitably to something happening (see Williams, 1977: 83–9 for an exposition of this distinction). A good analysis will set processes of economic determination alongside other processes and pressures in culture and think about how they interact.[12] Other factors that it will be important to stress in examining a cultural moment, phenomenon or process are the:

- role of institutions in the legal and political realm
- forms of discourse, language and representation available at a particular time
- beliefs, fantasies, values and desires characteristic of different groups of people.

Of course, not all accounts will be able to do justice all of the time to the complex mixture of forces at play. Which elements are emphasised will depend 'upon our own subjective purposes, upon the knowledge we think we can assume on the part of our audience, or on the identification of some new piece of the historical jigsaw to which we wish to draw our readers' attention' (Rigby, 1998: xiii). Such eclecticism need not involve the abandonment of political and ethical priorities and concerns, however. The 'subjective purposes' that Rigby draws attention to might, for example, include the identification of particular pressure points for achieving social change. Nor need pluralism of method mean adopting a relativist ethics and a liberal-pluralist model of politics, whereby present systems of democracy are assumed to function more or less effectively.

Too much time has been spent trying to resolve a set of debates couched in impossibly abstract terms. We should abandon tortuous arguments about what Marx intended to say and over whether or not he has been misinterpreted. Instead, we need to think hard about the complex interplay of determinations in any situation, in order to understand how difficult social change might be to achieve and where it might be possible.[13] If it is true that debates about economic determination and reductionism have produced the most significant tensions between political economy and other approaches, an eclectic methodology, allied to a radical social-democratic recognition of the existence of structures

12 A number of prominent neo-Marxist cultural studies writers have continued to emphasise the importance of determination by multiple factors (overdetermination), while still talking about determination by the economic in the last instance (such as Grossberg, 1995). However, it is difficult to find much explicit address of political–economic factors in much of the cultural studies literature other than invocations of the term 'capitalism'.

13 Whether or not Marxism itself is inherently reductionist is an enormously difficult area of debate, which there is no space to address here. See Rigby (1998) for a view that Marxism is not necessarily reductionist, but, where it avoids reductionism, it ends up with a pluralism that makes it indistinguishable from pluralist sociology.

of power, inequality and injustice might provide the possibility of greater convergence. The more pragmatic option advocated here involves identifying particular moments where economic factors are strongly determinant and moments where other factors, such as those listed above, need to be stressed more. This, as we shall see, will be a crucial aspect of Chapter 3, which sets about explaining change and continuity in the cultural industries.

<div align="center">✳✳✳</div>

In this chapter, I have concentrated on identifying the achievements and pinpointing the limitations of the main approaches relevant to study of the cultural industries in terms of the issues identified in the Introduction as central to the book as a whole. I have also attempted to move beyond the idea that the field of study of media and popular culture is split between political economy and cultural studies approaches. My aim here is an overall strategy that might be described as **a particular type of political economy approach, informed by certain aspects of empirical sociology of culture, communication studies and cultural studies.** How this overall approach can be mobilised to produce a framework for assessing and explaining change and continuity in the cultural industries is the subject of the next two chapters.

FURTHER READING[14]

As this chapter has commented on a great deal of writing about the cultural industries, I will confine myself to discussing overviews here.

GENERAL OVERVIEWS OF THE FIELD OF MEDIA, COMMUNICATIONS AND POPULAR CULTURE

Various chapters by Curran are remarkable for their range, synthesising approaches from political economy, communication studies and sociology of culture, while also being attentive to the interventions of cultural studies. His book *Media and Power* (2002) collects some notable interventions.

McQuail's Mass Communication Theory (most recent edition at time of writing was 2005) is the leading overview of the field of mass communication from the point of view of liberal-pluralist communication studies.

Mattelart and Mattelart's *Theories of Communication* (1998) puts much Anglo-American work to shame for its parochialism.

The Schiller–McChesney tradition has shown less interest in theory and more in public activism, but Dan Schiller's *Theorizing Communication* (1997) tells the story of the development of communication research in a distinctive and refreshing way.

14 Full bibliographical details of works suggested in the Further reading section that follows each main chapter can be found in the References at the end of the book.

The best textbook in my view is *Media/Society* by Croteau and Hoynes (2002).

An Open University series, *Understanding Media*, provides an introduction to the study of media – *Media Audiences* (Gillespie, 2006), *Analysing Media Texts* (Gillespie and Toynbee, 2006) and *Media Production* (Hesmondhalgh, 2006b).

SPECIFIC APPROACHES

The best book-length overviews of the political economy approach are Vincent Mosco's *The Political Economy of Communication* (1995) and Richard Maxwell's neglected collection *Culture Works* (2001). Mosco provides a good discussion of the limitations of mainstream, orthodox economics, as does Garnham's chapter on cultural industries in his *Emancipation, the Media and Modernity* (2000).

Peter Golding and Graham Murdock have provided a series of important statements on critical political economy approaches to media and culture, beginning with an essay in 1974 (Murdock and Golding, 1974) and an overview of the changing communications field in 1977 (Murdock and Golding, 1977). In 1991, they published a substantially new version ('Culture, communications and political economy') of the latter essay, which has since been revised three times, in 1996, 2000 and 2005 (see Golding and Murdock, 2005). Changes in the critical political economy tradition can be traced across these essays.

Cultural studies appears to be entering into crisis or decline or both. The best overview I know remains Nick Couldry's *Inside Culture* (2000), which covers a remarkable international range. Simon Frith's essay, 'The popular music industry' (Frith, 2000) is a model for how to apply cultural studies' insights to the cultural industries. Keith Negus' work is also important in this respect – see his *Music Genres and Corporate Cultures* (1999) – but, like many analysts, Negus has become disillusioned with cultural studies.

2 ASSESSING THE CULTURAL INDUSTRIES

In this chapter, I outline some of the main aspects of cultural production in the twentieth century. The purpose of this is to provide a framework that will allow for the assessment of changes and continuities in the cultural industries in Part Three. The discussion of each aspect generates two types of question for Part Three. The first concerns the *extent* of change. Do changes in the major aspects of cultural production in the period that mainly concerns us (1980 onwards) represent fundamental alterations or are they merely surface changes, underpinned by continuity? The second type of question concerns the *evaluation* of change and continuity in these different aspects. The questions relating to each aspect are then addressed in Chapters 6–10. There is a summary of the main aspects, the questions associated with them and an indication of the number of the chapter in which they are addressed in Table 2.1.

THE PLACE OF CULTURAL PRODUCTION IN ECONOMIES AND SOCIETIES

We can begin at the broadest level with the question of the changing place of commercial cultural production in economies and societies. This will enable us to establish a rough periodisation and some crucial terms. My concern here is with the longer-term history of cultural production, which will allow us to think about recent changes and continuities carefully and precisely.

Table 2.1 Aspects of cultural production in the twentieth century and questions about change and continuity

Aspects of cultural production in the twentieth century	Questions concerning *extent* of change since 1980	Questions concerning *evaluation* of change	Chapter in which aspects and questions are discussed
Business ownership and structure	To what extent have changes in conglomeration and integration led to recognisably new and distinct forms of ownership and structure?	What are the effects of the growth in size and power of cultural industry corporations on cultural production and wider society?	6
The place of cultural production in economies and societies	To what extent have the cultural industries become increasingly important in national economies and global business?	What are the implications of further commodification of culture?	6 (but Chapter 5 on copyright is an important introduction)
Organisation and creative autonomy	To what extent have the dynamics of the distinctive organisational form of cultural production changed?	Has creative autonomy been expanded or diminished? What changes have there been in the extent to which creative workers within the cultural industries determine how their work will be edited, promoted, circulated?	7
Cultural work and its rewards	To what extent have the cultural labour market and systems of reward for cultural workers changed?	Have the rewards and working conditions of creative workers – and, indeed, other workers in the cultural industries – improved during this time?	7
Internationalisation and domination of cultural trade by USA	To what extent have international cultural flows changed sufficiently for us to speak of a new era in cultural production and circulation? To what extent has the USA retained its international cultural dominance?	Does the increasingly global reach of the largest firms mean an exclusion of voices from cultural markets? What opportunities are there for cultural producers from outside the 'core' areas of cultural production to gain access to new global networks of cultural production and consumption?	8

(Continued)

Table 2.1 (Continued)

Aspects of cultural production in the twentieth century	Questions concerning *extent* of change since 1980	Questions concerning *evaluation* of change	Chapter in which aspects and questions are discussed
Digitalisation, convergence and new media	To what extent have digitalisation and convergence transformed cultural production and consumption?	Have digitalisation and convergence opened up access to the means of cultural production and circulation? Are barriers between production and consumption breaking down?	9
Texts	To what extent are the texts produced by the cultural industries growing more or less diverse?	Has the overall quality of texts declined? Do the cultural industries increasingly serve the interests of themselves and the wealthy and powerful in society?	10

A good starting point for thinking about long-term historical change in cultural production is provided by Raymond Williams in his book *Culture*. Adapting Williams (1981: 38–56), we can identify three *eras* in the development of cultural production in Europe (which have parallels elsewhere), each of them named after the main *form* of social relations between symbol creators and wider society prevailing at the time.

- *Patronage and artisanal* The term 'patronage' refers to a variety of systems prevalent in the West from the Middle Ages until the nineteenth century. Poets, painters, musicians and others would, for example, be 'retained' by aristocrats or the Church or protected and supported by them. Such systems were dominant until the early nineteenth century and can still be found today. An 'artisan' is a skilled worker or craftsperson who works largely under his or her own direction. Such workers, in their classic form, would sell goods directly to purchasers. These also still exist today (see Box 2.1).
- *Market professional* From the early nineteenth century onwards, however, 'artistic works' were increasingly offered for sale and were bought in order to be owned. Symbolic creativity, in other words, increasingly came to be organised as a *market*. Under this system, more and more work was sold not directly to the public but indirectly, via intermediaries. These were either distributors, such as booksellers, or 'productive intermediaries' (Williams, 1981: 45), such as publishers. This made for a much more complex division of labour in cultural production than before, even if many symbol creators still worked as artisans – that is, largely under their own direction. By the late nineteenth century and throughout the early

twentieth century, both distributive and productive intermediaries were becoming much more highly capitalised than before as leisure time and disposable income expanded in industrialised countries. Successful symbol creators achieved 'a form of professional independence' (Williams, 1981: 48) and, increasingly, were paid in the form of royalties.

- *Corporate professional* Finally, from the early twentieth century, but expanding enormously after 1950, there was a new phase Williams calls 'corporate professional'. Commissioning of works became professionalised and more organised. Increasing numbers of people became direct employees of cultural companies, on retainers and contracts. Alongside older activities, such as writing books, performing music and acting out plays, new media technologies appeared – most notably radio, film and television. Sometimes these new technologies included and altered the older types of cultural activity, sometimes they produced entirely new ones (such as the drama serial or the situation comedy). Alongside direct sales, advertising became an important new means of making money for creative work and an increasingly important cultural form in itself.

The term 'corporate professional' refers to social relations between symbol creators on the one hand and patrons or businesses on the other, but the key point for the argument of this book is that it can be used to describe *an era of cultural production*. This involves a new social and economic significance for commercial cultural production in modern society from the early twentieth century onwards and, in a moment, I will discuss this crucial point further. It also serves, though, as a term that can help us to periodise change across the other aspects addressed in this chapter and Part Three (those summarised in Table 2.1).

I wish Williams hadn't used the term 'corporate' in this context. To the modern ear, it sounds as though the chief issue is the rise of large private companies. Important as large companies are in cultural production from the early twentieth century onwards, Williams, in fact, intends the term in an older sense: 'a number of people in a unified group'. To avoid such confusion, I want to use a modified term – *complex professional* – to label this form (and stage or era) of cultural production. I prefer the word 'complex' because one of the most important features of this era was the increasing complexity of the division of labour involved in making texts.

BOX 2.1 UNDERSTANDING TRANSITIONS

It is important to understand the nature of the historical transitions from era to era that Williams outlines. In particular, we need to avoid understanding the features of one era as completely displacing those of previous eras. The complex professional form was that which dominated cultural production from the 1950s onwards but market professional and even patronage-based forms of cultural production continued to exist alongside the features of this dominant form, together with non-market or less marketised forms of cultural

(Continued)

(Continued)

institution, such as state and public service broadcasting companies. We can think of the cultural industries from the 1950s onwards as being composed of three different forms, each corresponding to terms developed by Williams (1977: 121–7) to refer to the historical variability of any period under examination in an 'epochal' analysis–that is, analysis of the characteristics of a particular time.

- The *complex professional form* was the *dominant* way in which production was organised, which is why it gives its name to the whole era.
- *Patronage and market professional forms*, dominant in previous eras, continued to exist in *residual* forms. Sponsorship of artists is one important and growing contemporary example. Importantly, though, artisanal relations also exist in residue. This situation is produced by, and in turn reinforces, the creative autonomy ceded to cultural workers, as discussed in the Introduction and later in this chapter.
- *State and public service broadcasting* had emerged in the 1920s and 1930s and continued to expand across the world with the spread of television in the 1960s. It can be seen as an *emergent* form within the complex professional era.

So, I use the term complex professional as a heuristic device to describe the whole era of cultural production from the 1950s onwards, but, in fact, it refers to a mix of different forms.

So, we have established, using a periodisation based on Williams, that, beginning in the early twentieth century, but expanding and accelerating as the century progresses, cultural production gained a new economic and social significance. One of the questions we need to ask, then, in considering change and continuity in cultural production since 1980, is whether cultural production has become even more significant. One way to tackle this broader issue is to ask **to what extent have the cultural industries become increasingly important in national economies and global business?** In Chapter 6, I put forward the view that they have, slowly and steadily, become more important, but not to the extent that many commentators claim (see pages 178–84).

A QUESTION OF COMMODIFICATION

How might we *evaluate* the changing social significance of the cultural industries? This is a vast terrain, but one way of apprehending it is to step back and ask what major changes have taken place in cultural production over the last four or five centuries. Writers from a wide variety of perspectives – economists, Marxist political economists and some cultural studies writers – would want to emphasise *industrialisation* and *commodification*. As Lacroix and Tremblay (1997) note, these terms are used 'so often that authors often do not even bother to define them' (p. 68). *Industrialisation* involves significant capital investment, mechanised production and division of labour, but *commodification* involves

transforming objects and services into commodities. This commodification is 'a more encompassing process than industrialization' (p. 69) and does not necessarily entail the use of industrial production techniques. The two processes are intertwined but I emphasise commodification here. Thus is partly because, as Lacroix and Tremblay say, this is a more encompassing process than industrialisation but also because such an emphasis can help to throw further light on the complexities and ambivalences of cultural production under capitalism, as discussed in the Introduction and my survey of approaches in Chapter 1.

What does it mean to transform something into a commodity? At its most basic level, it involves producing things not only for use but also for *exchange*.[1] With the development of capitalism, this involved exchange in markets increasingly extended over time and space, with money as the medium allowing for such extended exchange. This was crucially linked to systems of consumption and production. Production for extended exchange required the investment of capital and paying wages for labour. When commodities were bought, this involved private and exclusive ownership rather than collective access. When feudalism gave way to capitalism, many things became commodified – land and labour among them. John Frow (1997: 143–4) notes that even if we rightly resist the teleological notion of capitalism as necessarily involving endless commodification (for there has been some decommodification, too, such as the sentimentalisation of love and the abolition of slavery), capitalism can nevertheless be understood as a system involving a continual, if uneven, extension of commodification.

The problem is how to judge commodification. This is central to how we judge capitalism itself. This is a big question and one that some writers have, therefore, considered off-limits, but it is one that, it seems to me, still needs to be asked. Some Marxists, and other writers, too, in criticising capitalism, have made simplistic and sometimes romantic assumptions, opposing the commodities of capitalism to visions of a past or future society based on non-commodities. Other writers, including Marx himself, but also Frow (1997: 102–217), have provided a much more complex analysis,[2] seeing commodification as ambivalent, as enabling and productive, but also limiting and destructive. It produces massive proliferations of goods, but there are many problems associated with this proliferation. To take just two here, on the consumption side, there is the problem that commodification spreads a notion of ownership and property as the right to exclude others, leading to huge inequalities, the promotion of private, individual interest and a threat to collective action for the common good; on the production side, there is the problem that labour goes unrecognised and is systematically under-rewarded. (Frow's orientation towards cultural studies is evident in his emphasis on the former rather than on the latter problem. I believe both are important).

What of the commodification of *culture*? This has been a long and highly uneven process. It is entangled with industrialisation, but commodification

1 It can, of course, be used to mean basic goods, such as copper, oil and so on, but that is not the way in which I am using the term here.

2 It is a mistake to think that Marx was simply 'against' commodification. Marx was concerned with a number of aspects of modern commodities – most notably the way in which the immense collection of commodities that surround us conceal the labour that goes into them.

preceded the large-scale industrialisation of culture that began in earnest in the twentieth century. To put this another way, industrialisation intensified and extended the commodification of culture. Again, we need to understand this not as a fall from grace from a non-commodified state of culture, but as fundamentally ambivalent, as enabling and constraining. This is, not least, because the commodification of culture is highly complex, happening in different stages and taking multiple forms.[3] To give an example adapting John Frow (1997: 139), we can distinguish three ways and stages in which printed texts have been commodified:

- the commodification of the material object ('the book') – taking place as early as the fifteenth century
- the commodification of the information contained within the material object as 'the work' in copyright law – from the eighteenth century onwards
- the commodification of access to printed text information via electronic databases and so, on – in the late twentieth century.

Each of these forms and stages of commodification has different implications. There has been a massive profusion of books as a result of their commodification – a proliferation intensified by industrialisation. Copyright underpins the ownership of cultural commodities (and, therefore, the cultural industries as a whole – see Chapter 5) and the protection of works by copyright law has aided this proliferation, but at the cost of placing considerable restrictions on the use of such information. Arguably, such restrictions become more serious in the third stage identified here and inequalities of access become more marked also. As Frow stresses, there is serious conflict between commercial institutions that attempt to make cultural works their private property and common ownership of, or access to, cultural goods. This is a cultural version of the 'consumption-side' problem with commodification referred to above. Equally, however – not so stressed by Frow – there is a cultural version of the production-side problem: the *cultural* labour that is necessary to produce the vast numbers of cultural commodities available to wealthier consumers goes unrecognised (and this cultural work is addressed below).

If exchange of commodities over extended time and space leads to the problems identified above, then to draw attention to commodification raises questions about the line of demarcation between what can be sold and what cannot. All societies attempt to withdraw certain domains from market relations. Examples include religion, personal life, the political sphere and art. The penetration of market relations into culture and the increasing presence of commodification in the cultural sphere cannot be crudely dismissed as a problem in itself. It would be even more problematic, though, to neglect the negative implications for cultural production and consumption of further commodification. It has potentially negative as well as positive implications for people – as producers (even if only potential producers) and as consumers of symbolic goods.

3 This is why a number of political economy writers have sought to distinguish between the different 'logics' involved in different forms of cultural commodity (Flichy, 1980; Lacroix and Tremblay, 1997; Miège, 1989). See Dan Schiller (1994) for a useful discussion of the long-term history of commodification of information and culture.

Commodification, then, can be seen as a long-term and ambivalent process. We can understand the complex professional era as a new stage in the commodification and industrialisation of culture. If this is so, then the question we need to ask about the period since 1980 is as follows: **what are the implications of the further commodification of culture?** This question is addressed in Chapter 6 (see pages 184–86), but, because copyright is so vital to the process of commodification of culture, the groundwork for addressing this question is laid in Chapter 5, where I consider changes in copyright law.

BUSINESS OWNERSHIP AND STRUCTURE

One of the most striking and significant features of the complex professional era was the increasing presence of large corporations in the business of cultural production. The biggest of these companies, such as RCA (Radio Corporation of America) in the USA, were huge *conglomerates*.[4] They dwarfed the publishing companies and newspaper empires that had formed the largest companies of the market professional era. In film, recording, radio and television, significant oligopolies had emerged before the middle of the century. The most famous oligopoly was the eight *vertically integrated* Hollywood studios (see Box 2.2). Rather less famous was the oligopoly that dominated the recording industry – the British companies Decca and EMI, Columbia and RCA in the USA, joined by Warner Brothers and Dutch consumer electronics giant Philips in the post-Second World War period. Many of these companies were vertically integrated, too, producing record players and developing new recording and playback technologies. In radio and television, the US networks, CBS and NBC, were dominant. There was also significant cross-media ownership in the early years of the complex professional era, with film studios such as MGM (Metro-Goldwyn-Mayer) having significant music industry interests and RCA running its own record company and its NBC network.

Beneath this layer of vertically integrated giants, most large companies were involved mainly in one form of cultural production. An important change came in the 1960s as *conglomeration* spread throughout the cultural industries. This was part of a more general trend in business as a whole. Neil Fligstein (1990: Chapter 8) provides evidence of the shared trend towards diversification in all industries from the 1940s onwards. Of the 100 biggest companies in the USA in 1939, 77 concentrated 70 per cent or more of their business in a single industry. By 1979, only 23 corporations concentrated in one industry in this way. Whereas none of the top 99 companies in 1939 produced across different industries that bore no relation to each other, by 1979, more than a quarter followed this strategy (these figures are from Fligstein, 1990: 261). What is more, Fligstein shows that this shift in strategy was adopted across all industries and was driven by the need for senior managers to be seen to be achieving growth.

Conglomeration first hit the cultural industries in the 1960s, as part of this trend towards diversification. In some cases, it took the form of industrial and financial

4 For example, including its non-media interests, RCA was the thirty-ninth biggest company in the USA in 1972 (Murdock and Golding, 1977: 27–8).

and business corporations buying up and investing in media interests. Box 2.2 summarises how conglomeration affected the film industry during the complex professional era. In the 1960s and 1970s, conglomeration mainly took the form of large, general conglomerates, with their businesses based on interests as diverse as oil, funerals and financial services, buying up film production studios and 'libraries' of old films. In other industries, conglomeration was based on projected 'convergences' and 'synergies', although these terms were not invented until later. For example, in the 1960s, big US consumer electronics and manufacturing companies, such as IBM (International Business Machines), RCA, Xerox, GE (General Electric) and GTE, bought up book publishers, anticipating convergence between book publishing and computers (Tunstall and Machin, 1999: 107–8).

However, ownership and structure in the complex professional period is not only about the rise of vertically integrated conglomerates, which, to restate my earlier point, is one of the reasons for my preference for the term 'complex professional' over Williams' 'corporate professional'. Small companies multiplied. The widespread existence of small companies in the cultural industries reflects some of the distinctive features of cultural production discussed in the Introduction. Even while the scale of reproduction and circulation of cultural goods grew during the complex professional period, the conception of cultural works could still take place on a relatively small scale.[5] As small companies proliferated, more and more importance was attached to them as sites of creative independence, which reflects anxieties about the negative effects of big, bureaucratic organisations on cultural production. Commentary about popular culture was booming in the mid-century as, for example, film and jazz, and even rock, criticism began to burgeon as important cultural forms in their own right. By the late 1960s, many young pop and rock critics equated the corporations with commercial control and saw the independents as representative of a hucksterish entrepreneurialism (for example, Cohn, 1989/1969) or more in touch with trends developed in local settings (such as, Gillett, 1971). We will return to the issue of whether or not independents really *do* offer some kind of 'alternative' to the conglomerates in Chapters 7 and 10.

BOX 2.2 THE HOLLYWOOD OLIGOPOLY ACROSS THE COMPLEX PROFESSIONAL ERA

Eight companies dominated Hollywood during its 'classical' period (1925–1950). The major studios owned and controlled many parts of the value chain. They ran production facilities, made the films, had creative and

(Continued)

5 Making up stories and songs, for example, are activities that can be carried out pretty much anywhere. Feature films might be impossible to make without access to considerable capital, but, in economic terms at least, anyone can write a script. Even inscription (putting a magazine design on to disk or making the master copy of a recording, for example) and reproduction (running off copies of magazines or CDs) can be relatively cheap.

(Continued)

technical personnel signed to contracts, owned distribution networks and owned the cinemas where the films were shown. A 'Big Five' both distributed films and owned their own cinemas, while the 'Little Three' had their own distribution arms, but no cinemas. A series of rulings by the US Supreme Court, aimed at breaking the Big Five's oligopoly, forced the studios to get rid of their cinemas from the late 1940s onwards, weakening their power. The studios increasingly subcontracted to independent film production companies from the 1950s onwards in an attempt to lower costs, control risk and outmanoeuvre television by producing new and spectacular genres. The studios acted as national and international distributors and retained great power. All eventually became divisions of large conglomerates (see Chapter 6). As their names recur throughout this book, here is a brief guide to the later history of these important cultural industry corporations.

The Big Five

- Paramount, bought by oil conglomerate Gulf & Western in 1967, now part of the Viacom media conglomerate.
- 20th Century Fox performed disastrously in the 1960s and 1970s, became part of a private corporation and was sold (as Fox) to Rupert Murdoch's News Corporation in 1985.
- Warner Brothers was taken over by general conglomerate Kinney National Services (a business based on funeral directors) in 1969 and merged with Time in 1990 to form the world's largest media group – a position it continues to occupy, even after Time Warner's disastrous merger with AOL in 2000–2001.
- Loew's/Metro-Goldwyn-Mayer – MGM – was just one subsidiary of the most successful film corporation of the classic Hollywood era. It changed hands countless times from the 1960s to the 2000s, merging with UA to become MGM/UA in 1981, but was not involved in the making of films. The libraries and names of MGM and UA were bought by Sony (with cable operator Comcast) in 2004. The MGM brand looks set to become associated with film production and distribution again; the future of the UA brand is unclear.
- Radio-Keith-Orpheum (RKO) was broken up by Howard Hughes in 1954.

The Little Three

- Universal was taken over by MCA in the early 1950s (along with Paramount's film library and Decca Records) and MCA-Universal prospered in the television age to become the biggest film studio. It was taken over by Japanese consumer electronics company Matsushita in 1986, by Seagram in 1995 and Vivendi in 2000, remaining with them when NBC bought other assets associated with the name Universal in 2003.
- Columbia struggled in the 1950s and 1960s, was acquired by Coca-Cola in 1981 and Sony in 1988. It continued to struggle under conglomerate control, but has revived as part of the Sony empire in the 2000s.

(Continued)

(Continued)

- United Artists was acquired by Transamerica Corporation, a 'multiservice' organisation involved in insurance and financial services, in 1967 and merged with MGM in 1981 (see MGM above).

Disney was not part of the classic Hollywood oligopoly. It had no distribution wing, but had its pictures distributed by UA and, later, RKO. When RKO was broken up, Disney set up its own distribution wing, Buena Vista. On the back of its revitalisation as a creative and commercial force in the 1980s, it has grown to become one of the largest cultural industry conglomerates in the world.

Sources: Mainly Gomery (1986), supplemented by Guback (1985) and Dale (1997); 2006 updates from various Internet sources.

The above features of ownership and company structure in the complex professional period raise the following question: **to what extent have changes in conglomeration and integration led to recognisably new and distinct forms of ownership and structure since 1980?** We will see in Chapter 6 (see pages 160–64) that the size and scope of cultural industry corporations expanded enormously from the 1980s onwards.

Again, though, we need to ask how might we *evaluate* this expansion? The role of cultural industry corporations in society has been an important theme in political economy, especially in the Schiller–McChesney tradition. There are striking examples of the exercise of interests via cultural industry ownership by media moguls – that is, individuals with overall control of a company (see pages 202–4), but it can be argued convincingly that they are exceptions. Moguls are more prevalent in the cultural industries than in most other types of industry, but, even there, most companies are governed by a number of different shareholders. It could be argued, therefore, that control is spread over many owners and this prevents particular interests from being served. This, though, misses the point. It is not the interests of particular individuals that are at stake but the interests of the social class to which they tend to belong – wealthy and powerful owners of capital with strong ties to other powerful and influential institutions and individuals.

This wider argument has been disputed. Many commentators on ownership and control in general (not just of the cultural industries) have argued that, since the nineteenth century's 'managerial revolution', control has been delegated to managers, who represent a different social class and do not have such an interest in maintaining power relations (see Scott, 1995, for a survey of these debates). Companies thus become a mixture of fragmented class interests. Again, though, the idea that owners and senior executives represent different social classes is wide of the mark. Senior managers will often be drawn from backgrounds as wealthy and privileged as those of their owners. They might represent a different stratum of the dominant classes, but, given that they, too, are wealthy and privileged, they may well share the interests and political inclinations of the owners responsible for their appointments.

We should be in no doubt about the continued exertion of control by owners and executives. In an important article, Graham Murdock drew on debates in the sociology of business enterprises to clarify a distinction between two types of control in organisations: 'allocative' and 'operational' (all quotations from Murdock, 1982: 122).

- *Allocative control* consists of the 'power to define the overall goals and scope' of the enterprise and to 'determine the general way it deploys its productive resources'. This includes decisions on whether or not and where to expand, the development of financial policy (including share issues) and distribution of profits, but, crucially, it also includes 'the formulation of overall policy and strategy'.
- *Operational control* 'works at a lower level and is confined to decisions about the effective use of resources already allocated and the implementation of policies already decided upon at the allocative level'.

Does this mean, however, that wealthy and powerful owners and senior executives of cultural industry companies are able to pursue their interests via the cultural industries? To answer this means considering what their interests are. We can speak of **three different types of potential interest for owners and executives.** These are in the success of:

- their own business
- companies like their own
- business as a whole.

I explore each in turn here, because they inform the evaluation of the growth of cultural industry corporations in Chapter 6.

The first interest is in maximising the profits, revenues, market share, share price, and so on of their own particular company (or companies – many directors serve on the boards of a number of companies). In this first respect, companies obviously pursue their own interests. Aiming for profit maximisation, all businesses will try to ensure that expenditure on staff pay and other costs is well below the level of revenues generated. Within this system, some companies will offer higher levels of pay and provide better conditions than others. Some industries will have better working conditions than others. As we have seen, there are specific conditions surrounding the business of cultural production, whereby workers have been given greater creative autonomy than is the case in other sectors. However, exploitation is inevitable: the system of capitalist accumulation depends on it. As Miège (1989) pointed out, cultural industry companies subsidise costs by means of pools of reservoir labour and the use of casualised cultural work. Other strategies include moving work overseas to countries where levels of pay are much lower (as is the case for most animation productions – see Lent, 1998).

The second type of interest that owners and executives are likely to pursue is that of companies like their own. Obviously, such companies compete with each other, except when they are involved in cartel arrangements, usually forbidden

by law. Even within a system of mutual competition, though, companies will affiliate to form trade bodies, lobbying groups and alliances. There is a deeply rooted tendency in advanced capitalism for oligopolies of large companies to form in nearly all industries. These oligopolies are particularly effective at forming lobbying groups, campaigning against what they see as obtrusive government legislation and regulation – much of it, in fact, intended to protect workers and consumers. Such corporate lobbying has been an important feature of cultural policymaking (see Chapters 4 and 5). Oligopolies also come to embody a set of conventions for understanding how best to organise business. Non-profit enterprises and smaller commercial companies, including those aiming at lower profit margins and innovative working practices, will tend to be excluded or marginalised. They may even come to appear naive or incompetent because of the greater wealth and prominence of companies in the oligopoly.

That companies pursue the interests of owners and executives in these two ways seems to me to be undeniable. The controversies surrounding such a system of self-interested production are mainly ones regarding the wider system of capitalism as a whole – principally, whether or not the advantages (such as dynamic growth and the production of greater amounts of total wealth) of economic systems based on such actions outweigh the disadvantages (systematic underpaying of most workers, oligopoly, massive inequality, social fragmentation).[6] Here, of course, questions about business ownership and structure overlap with questions raised above about the role of the cultural industries in society. Examination of actual businesses can more clearly locate *agency* – that is, who makes things change and how.

There is, however, a third type of potential interest that owners and executives might pursue. Other things being equal, all businesses tend to want conditions in which businesses as a whole can thrive: political and economic stability and lively demand. This means that businesses will, for example, make huge donations to political candidates they think are likely to achieve these general business environment goals. They will oppose reform and the struggle for greater equality if they perceive that such developments might threaten their business interests. Here, the question of whether or not and how they pursue such interests in the general conditions for profitmaking becomes extremely controversial. The ability of cultural industry corporations to give an account of such issues makes their role the subject of special debate. Do cultural industry companies produce texts that systematically support the interests of businesses? Do they hold back progressive reform and try to prevent the forms of social conflict often necessary to bring it about? These questions are addressed in Chapter 10 and previewed later in this chapter. For now, though, this discussion of interests will serve to inform a further evaluative question that I address directly in Chapter 6, when I survey the growth of cultural industry corporations since the 1980s. The question is **What are the effects of the growth in size and power of cultural industry corporations on cultural production and wider society?**

6 There are also questions of how to imagine and/or bring about alternative systems, but such issues need never imply that criticism should not be mounted.

ORGANISATION AND CREATIVE AUTONOMY

The previous sections considered large-scale questions of how we might assess the ownership and structure of businesses and the place of commercial cultural production within economies. How might we think about change at the smaller-scale level of how cultural work is organised and rewarded? To answer this, we need to consider how such work came to be generally organised and managed during the complex professional era.

Bill Ryan (1992), following the cultural industries approach outlined in the Introduction, has provided a useful way of approaching this question. In the market professional era, the creative stage of making cultural products used to be carried out primarily by individuals, but, in the era of the complex profes-sional form of cultural production, it is nearly always carried out by a *'project team'* (Ryan, 1992: 124–34). Within this team, various people perform the func-tions listed below. Adapting from and building on Ryan's discussion, I will give examples from five particular cultural industries – books, film, magazines, recording and television.

- *Primary creative personnel* such as musicians, screenwriters and directors, magazine journalists and authors (symbol creators). This category also includes 'technicians' who have come to be recognised as taking a creative role, such as sound mixers who, as record producers, have become increas-ingly important in the music industry (see Kealy, 1990/1974).
- *Technical workers* are expected to perform a technically orientated set of tasks efficiently, such as sound engineers, camera operators, copy editors, floor man-agers, typesetters, page designers. Some of these jobs are deemed to be crafts, as they require special skill and workers performing them identify collectively with each other in terms of the work they do. Creativity is involved here, but not the conception of ideas that will be the basis of the finished text – or, at least, that is something like the rationale for designating some workers as 'tech-nical' rather than 'creative' (which is more prestigious).
- *Creative managers* act as brokers or mediators between, on the one hand, the interests of owners and executives, who have to be primarily interested in profit (or, at the very least, prestige), and those of creative personnel, who will want to achieve success and/or build their reputation by produc-ing original, innovative and/or accomplished works. Important examples are artists and repertoire (A&R) personnel in the recording industry, com-missioning editors in the books industry, editors of magazines, and produc-ers in the film industry. I find Ryan's concept of the 'creative manager' much clearer than Miège's term 'editeur' or DiMaggio's 'broker' (1977) for more or less the same role. To add to the confusion, 'editeur' is translated as 'producer' in Miège (1987). The most confusing term of all is 'cultural intermediaries' (see Box 2.3 for an explanation of problems in the way this term has been used and, therefore, of why I avoid it here).

- *Marketing personnel* in the cultural industries aim, along with creative managers, to match the work of primary creative personnel to audiences. They sometimes create symbols to publicise and promote cultural work. It seems right, then, to classify them separately – not just because their work is 'secondary', in that it relies on a separate act of creativity, but also because they act in the interests of owners and executives and often come into conflict with creative personnel. It is often the case that creative managers will actually be mediating between marketers and creative personnel – even if it is the executives' goal of profit maximisation that is ultimately behind the marketers' actions.[7]
- *Owners and executives* who have the power to hire and fire personnel and set the general direction of company policy, but who will have a limited role in the conception and development of particular texts, except in rare cases, such as in the film industry where 'executive producers' may be credited.
- *Unskilled and semi-skilled labour* A vast body of unskilled workers are also involved in the creation, circulation and reproduction of products.[8] So, it could be said, then, are assembly line workers involved in maintaining the machines that reproduce the countless millions of DVDs that are sold each year. Much of this work is poorly paid and is contracted overseas.

Some notes on this breakdown of functions. First, I say 'functions' because these are roles as well as occupational groupings – one person may perform more than one of these roles in any project. For example, the same person might be both a creative manager and responsible for marketing. This is especially the case in small companies or temporary projects on the margins of a cultural industry. On the other hand, the breakdown also reflects occupational groupings as, in many cases, a person will carry out that function (as a publisher, for example) for an entire career.

Second, these functions are, more often than not, organised *hierarchically*, in terms of pay and status, in something like the following way: owners and executives, creative managers, marketers, then most primary creative personnel, craft technical workers and unskilled and semi-skilled labour (see Tunstall, 2001: 14). But this hierarchical ordering is by no means fixed. 'Star' creative personnel and even creative managers can earn more even than fat cat execs.

7 The division of labour within the advertising and marketing industries involves all the categories here, including primary creative personnel ('creatives'), creative managers, but also marketers who try to match marketing messages to the right audience.

8 Sharon Zukin quotes a story told by the eminent cultural commentator Daniel Bell about a circus employee whose job it was to follow the elephant and clear up after it. When asked, she said that her job was in 'the entertainment business' (Zukin, 1995: 12). Zukin also remarks that the same woman might today say that she worked in the cultural industries.

Third, this is a heuristic way of dividing up the functions in the cultural industries. However, the way in which work is conceived in particular industries and on particular projects can itself be a product of status inequalities. For example, the very designation of some staff as 'technical' and others as 'creative' is itself, in many cases, down to decisions about whose work really counts.

BOX 2.3 CULTURAL INTERMEDIARIES AND CREATIVE MANAGERS

'Cultural intermediaries' is one of the most confusing terms in the cultural industries lexicon. It has been widely used in recent debates about changing relations between culture and society (for example, Featherstone, 1991), but also in studies of cultural industry organisations (such as, Negus, 1992, 2002; Nixon, 1997) and cultural policy (O'Connor, 2004). Its use derives from the discussion of the new petite bourgeoisie and the new bourgeoisie in Pierre Bourdieu's *Distinction* (1984). For Bourdieu, at the core of the new petite bourgeoisie – a new social class with distinctive tastes and cultural practices – are 'all the occupations involving presentation and representation (sales, marketing, advertising, public relations, fashion, decoration and so forth) and [...] all the institutions providing symbolic goods and services' (1984: 359). This is important in understanding the development of the cultural industries – not only because the expansion of the cultural industries feeds the expansion of this social class, which has its own distinctive cultural practices, but also because this class constitutes a major new *audience* for certain cultural texts.

Bourdieu seems to have intended the term 'new cultural intermediaries' to refer to a particular type of new petite bourgeoisie profession associated with cultural commentary in the mass media: 'the most typical of whom are the producers of cultural programmes on TV and radio or the critics of "quality" newspapers and magazines and all the writer-journalists and journalist-writers' (1984: 325). Presumably, the 'old' cultural intermediaries were those who acted as critics and experts on serious, legitimate culture in the pre-mass media age. Both new and old cultural intermediaries, I assume, are thus named because they 'mediate' between producers and consumers. But Featherstone (1991) seems to have misunderstood the term. In the context of an interesting discussion of the new petite bourgeoisie as generators of a new consumer culture, based on a general interest in style, he says that 'Bourdieu analyses the new petite bourgeoisie, the cultural intermediaries, who provide symbolic goods and services' (1991: 89). So, Featherstone equates the new petite bourgeoisie with a small subset of that social class, the (new) cultural intermediaries. Negus (1992) and Nixon (1997) appear to have inherited the confusion about the term. Negus (1992: 46), citing Featherstone, says that he will analyse recording industry personnel as cultural intermediaries. His intention is to argue that recording industry personnel contribute to the 'words, sounds and images of pop' and he seems to be using the term 'intermediary' to refer to this added contribution, which takes place between musician and audience. However, in Bourdieu's sense of the term, it is *critics* that act as cultural intermediaries in the recording industry.

(Continued)

(Continued)

Nixon, meanwhile, makes an interesting point about advertising practitioners as members of the new petite bourgeoisie, marked by 'the ambition to establish authority over particular areas of symbolic production' (1997: 216). Like Featherstone, though, Nixon conflates cultural intermediaries with the new petite bourgeoisie as a whole. For example, he presents the famous passage from Bourdieu, quoted above, about the new petite bourgeoisie being concerned with representation and symbolic goods as if it were an analysis of the 'social make-up of cultural intermediaries' (1997: 211). In fact, Nixon seems to see all advertising practitioners as cultural intermediaries (1997: 216). By this point in its history, then, the term is being used to refer very generally to those involved in the production of symbols, of texts.

All these writers are making useful efforts to make connections between changes in cultural production and consumption and more general sociocultural changes. Bourdieu's analysis of the new petite bourgeoisie is potentially fruitful, especially with the modifications helpfully suggested by Nixon (1997: 216–7). My point is not the pedantic one that Featherstone, Negus and Nixon have been untrue to Bourdieu's intentions, but that the term 'cultural intermediaries' has become confusing and unhelpful due to its wide range of uses. Ryan's analysis and his term 'creative manager' seems to me to capture the role of the A&R personnel discussed by Negus much better than the confusing term 'cultural intermediary'. As for the creative practitioners discussed by Nixon, they might best be described as symbol creators. Or even as creative practitioners.

Box 2.4 adapts Ryan's analysis (1992) of the stages in making and circulating texts and the division of labour within each stage. The stages themselves are not unique to the cultural industries – many industries involve the conception of an idea, its execution and reproduction of an object, followed by its circulation – but what happens within each stage, and the relations between the stages, reflects the distinctiveness of the cultural industries. One key feature is that the project teams involved in creation and conception **are given a large degree of autonomy**. At the time that the cultural industries were developing in the early- and mid-twentieth century, such creative autonomy was rare in other industries. So, one of the defining features of the complex professional era of cultural production is this unusual degree of autonomy, which has been carried over from preceding eras where artists, authors and composers were seen as working more independently of business imperatives than other workers. This autonomy is by no means complete autonomy, however, as it is carried out under the supervision of creative managers. It is not unique to the cultural industries and it was not so even in earlier periods of strict Taylorist control over work, but such autonomy is of huge significance in cultural production.

BOX 2.4 'STAGES' OF CULTURAL PRODUCTION

Note: These stages do not necessarily follow on from one another, as in the popular image of a factory production line. Instead, They overlap, interact and sometimes conflict.

Creation

- *Conception* – design, realisation, interpretation; writing of screenplays and treatments, composition and improvisation of songs and so on.
- *Execution* – performance in recording studios, television sets and on film.
- *Transcription on to a final master* – Involving editing (film, books and magazines), mixing (music, film).[9]

Reproduction

- *Duplication* – in the form of printing, copying of CDs from a master recording, making multiple copies of a film from a negative (there is no equivalent in television). The text now takes the form that the audience will experience.

Circulation

- *Marketing* – including advertising and packaging (each of which has its own processes of conception and reproduction), but also aspects that might take place alongside conception or between transcription and reproduction of the main text, such as market research.
- *Publicity* – involving trying to ensure that other organisations provide publicity for the commodity.
- *Distribution and wholesaling* (or the broadcast of a television programme).

Retailing/exhibition/broadcast

Source: Adapted from Ryan (1992).

The notion of creative autonomy is absolutely crucial for an understanding of the cultural industries in the late twentieth century. It shows that the metaphor of the traditional factory production line – often used in critiques of industrial cultural production – entirely misses the point (see also Negus, 1992: 46). Because of the history of attitudes towards symbolic creativity discussed in the Introduction, factory-style production is widely felt to be inimical to the kinds of creativity necessary to make profits. Even in the Hollywood studio system,

9 Ryan includes this in the reproduction stage but, although these tasks might be undertaken by skilled, technical professionals, they will often be carried out under the supervision of creative personnel, as this is a vital part of the creative stage.

which developed at the beginning of the complex professional era and exerted very tight control over the conception and execution of films compared with the control over these stages in other cultural industries, there was still considerable autonomy for screenwriters and directors within certain formats and genres.

Crucially, companies in the business of cultural production exert much stricter control over the other stages of making texts after the creation stage (see Box 2.4) – reproduction and circulation.[10] The reproduction stage is heavily industrial, often and increasingly reliant on technically complex electronic systems and strictly controlled, especially in terms of when master copies of films, books, records and so on are *scheduled* to be copied and released or when a programme is scheduled to be broadcast. In terms of circulation, a very few superstars may have some bargaining power regarding which works get promoted and which do not, when texts are released or scheduled and so on, but it is senior management personnel within the cultural industries who usually decide these matters.

This combination of loose control of creative input and tighter control of reproduction and circulation constitutes **the distinctive organisational form of cultural production during the complex professional era.** The form developed in the early twentieth century persisted and became much more widespread. I have referred to this organisational form in the present tense throughout the discussion above, but the key issue for the argument of this book is **to what extent have the dynamics of this distinctive organisational form changed since the late 1970s?**

Once again, this question is tied to a more explicitly evaluative set of questions. If I am right in focusing attention on the role of the cultural industries as systems for the management of symbolic creativity (see Introduction), then a key issue here will be the relationship between symbol creators and cultural industry organisations. This focus is not intended to devalue the lives of those workers deemed to be 'technical' workers. As noted above, some such workers have considerable creative input, but are designated 'technical' for reasons of status. Nor is it intended to demean those workers who objectively have no creative input into final products. The decision to put the spotlight on creativity derives from the recognition that symbol creators are crucial to determining the final outcomes and they have a central place in fantasies and beliefs about what 'good work' might involve in modern capitalism (see Stahl, 2006, for a superb examination of this issue).

We saw in the Introduction that thinking about symbolic creativity has a long history and tensions between commerce and creativity are a fundamental feature of the cultural industries. The influences of the romantic movement and modernism have been profound and helped establish a widespread view in the West that symbolic creativity can only flourish if it is as far away from commerce as possible. This view is embodied in prevailing myths about great artists. We often think of the greatest symbol creators as either being unrecognised, having little or no commercial success in their lifetime (such as Van Gogh) or being

10 This stage is often referred to as 'distribution' (Garnham's seminal discussion, 1990: 161–2), but I find this term confusing. It sounds as though it refers to wholesaling, which is the transfer of products to retail outlets. 'Circulation' includes this wholesaling aspect, but also more clearly includes the equally problematic and important issue of marketing than does the term 'distribution'.

driven to despair by the superficiality of the commercial world they came to inhabit (Kurt Cobain, for example). This polarisation of creativity and commerce can confuse and mystify our understanding of the media and popular culture. In everyday conversation, various texts, genres, performers, writers and so on are often judged on the basis of assumptions about whether or not the symbol creators had commercial intentions. Often, the assumption is that those creators who reject commercial imperatives most entirely are the best. This, though, is an overly polarised view of the relationship between creativity and commerce. All creators have to find an audience and, in the modern world, no one can do this without the help of technological mediation and the support of large organisations. Moreover, we can't assume that the input of creative managers (as mentioned earlier, the professionals who mediate between the interests of cultural industry companies and those of symbol creators) is negative in terms of textual outcomes. Take, for example, the tendency of creative managers to push symbol creators in the direction of genre formatting in order to facilitate marketing and publicity for a particular audience. This isn't necessarily a bad thing in and of itself. Genre can be a productive constraint, allowing for creativity and imagination within a certain set of boundaries and enhanced understanding between audiences and producers.

Yet it remains the case that the relationship between creativity and commerce is a matter of negotiation, conflict and struggle. However rewarding they find their work, nearly all symbol creators seem at some point to experience the constraints imposed on them in the name of profit accumulation as stressful and/or oppressive and/or disrespectful. Many are forced to do 'creative' work that they hardly experience as creative at all. What's more, the fate of the symbol creator's work is in the hands of various other workers, especially creative managers, marketers and senior executives. This can function well, of course, as marketing can ensure the widespread dissemination of creative work, to the satisfaction of all concerned. Alternatively, texts can sink without trace as these managers and marketers prioritise other projects.

Here we encounter a contradiction. However mystifying and confusing the polarised view of creativity versus commerce can be, it has some positive effects. It allows people who want to work creatively (this includes journalists) to argue for more time, space and resources than they might otherwise get from their commercial paymasters. Whether this results in better work or not can only be judged in particular cases, but the goal of producing work that is autonomous of the demands of profit accumulation helps to produce richer and more varied communications. This is not to celebrate or romanticise symbol creators but simply to grant them due recognition.

So, two evaluative questions regarding the status and conditions of cultural workers follow from this. **To what extent has creative autonomy been expanded or diminished since 1980? What changes have there been in the extent to which creative workers within the cultural industries get to determine how their work will be edited, promoted, circulated?** I explore these issues in Chapter 7.

CULTURAL WORK AND ITS REWARDS

Clearly, the distinctive organisational form of the cultural industries has considerable implications for the conditions under which symbolic creativity is carried out.

But how has such creative work been rewarded in the complex professional era? In order to address this question, we need to consider the cultural labour market.

All human beings are symbol creators at least some of the time. Billions of us sing, dance or write every day (and if you think I can't write, you should hear me play the piano). Professional creativity has been merely the tip of the iceberg, but, like many iceberg tips, it is the bit that is most visible. As the media came to dominate symbol-making in the twentieth century (see Hesmondhalgh, 2006b), more and more people have aspired to work in the supposed glamour of the cultural industries. One feature of cultural work in the complex professional era is that many more people seem to have wanted to work professionally in the cultural industries than have succeeded in doing so. Few make it and, surprisingly, little attention has been paid in sociology to the means of, and barriers to, entry.

Nevertheless, some do make it. As with most forms of work, it has tended to be older, whiter, able-bodied people who have done best and earned most and, as elsewhere, men generally earn more than women (Tunstall, 2001). What may be unique to the cultural industries is a particular type of split between waged and unwaged work. In the 1945–1980 period, waged work became the norm in advanced industrial countries. Many in the cultural industries worked on this basis. This included:

- workers in *craft/technical occupations*, who increasingly formed themselves into relatively strong trade unions
- symbol creators in what Tunstall (2001: 14) calls *the 'professionalising' occupations,* such as journalism and advertising
- *creative managers*, who were also professionalising to some degree, so, for example, being an editor in a publishing company was increasingly understood to involve a particular set of procedures with a certain social prestige attached (see Coser et al., 1982).

Many symbol creators, however, worked on a casual or contract-by-contract basis – in many cases trying to get by on royalties from previous jobs.

We can turn to Bernard Miège for a picture based on 1970s research, which can serve as a picture of the labour market for creative personnel in the complex professional era of cultural production. Miège (1989: 82–3) argued that creative workers bear the costs of conception on behalf of cultural industry companies by being willing to forgo the benefits of secure working conditions and, in nearly all cases, earning relatively little when they do. Creative labour within the cultural industries, claimed Miège, is underpaid because of a permanent oversupply of artistic labour, which takes the form of 'vast reservoirs of under-employed artists' (1989: 72).[11] The biggest reservoir or pool is composed of non-professional cultural workers, who work occasionally and have to take other jobs to subsidise their artistic activities. Wages are also kept down by the ready availability and willingness of creative professionals in other cultural industries to transfer across into another field (such as journalists who might want to publish books or pop musicians who might want to compose film scores).

11 Elsewhere, Miège, or his translator, uses the term 'tank'.

The result, in the complex professional period, has been a labour market in which most creative workers are either underemployed – at least in terms of the creative work they actually want to do – or underpaid. This should not be seen as a natural phenomenon: it is a result of specific economic and cultural conditions. These conditions include the failure of creative workers to come together to defend their interests against such forms of low pay and exploitation – this is in part because symbol creators are permanently competing with each other for recognition and rewards (Miège, 1989: 87).[12] The main exceptions are difficult-to-enter professional guilds, such as actors' unions.

For those relatively few creative workers who do succeed in having their works released on to the market, and for the cultural industry companies who undertake the circulation of such works, copyright law is vital (see Box 2.5). In the complex professional era, copyright law and practice has been the arena in which the rewards for creative cultural labour have been determined and battles over these rewards between creative worker and company are resolved in the form of contracts. Overseen by national copyright laws, these contracts determine which creative workers get what percentages of revenues or profits, how long for and who has the right to say what happens to the cultural work produced under the terms of the contract. These contracts, except in very rare cases (superstars), strongly favour the companies rather than the artists.

BOX 2.5 COPYRIGHT AND CULTURAL WORK

Copyright law developed in the seventeenth and eighteenth centuries in book publishing and took its modern form in the nineteenth century. In the twentieth century, this already contradictory and complex legal framework became vastly more complex as new media forms developed, such as film and recorded music, requiring their own modifications to the national copyright laws and international conventions originally developed for publishing. Nearly all the new media forms by this point involved a much more complex division of labour than before, creating further problems concerning who the 'author' of a cultural work is.

Copyright law adjudicates between the interests of three groups: *creators*, *users* and *owners*. *Creators*' expressions of ideas are protected from plagiarism under copyright, but the *owner*ship of copyrights is assigned to companies (initially book publishers, but, increasingly, film studios, recording companies and so on) for a fixed term. Different legal systems have provisions

(Continued)

12 Caves (2000), writing from a mainstream economics perspective, discusses differential success for creative workers by referring to the A list/B list property of the creative industries. B lists still comprise very successful creative personnel – stars who are not superstars. Miège's reservoirs or pools, referred to above, suggest the existence of C, D and other lists right down to Z, involving levels of inequality that Caves fails to address.

(Continued)

that are more or less protective of authors' rights, in terms of their 'moral rights' to say how the work might be further modified or reproduced, but the tendency in all modern copyright systems is for cultural industry companies to become the owners of rights. By the late twentieth century, this was creating important contradictions as corporate owners were increasingly successful in broadening the scope of their ownership in various ways, including the extension of the periods for which they could own works under national laws (see Chapter 5). As we shall see in Chapter 7, many commentators believe that this situation has now developed to the extent where the interests of both *users* and 'primary' symbol *creators* are threatened.

The poor working conditions and rewards for creative cultural work have been obscured by the fact that, in the complex professional era, very generous rewards are available for symbol creators who achieve name recognition in the minds of audience members. This over-rewarding of stars derives in part from the way that cultural businesses counter risk by formatting their products with 'author' names (see Introduction and Chapter 7). However, the situation for the majority of people attempting to make a living out of cultural production in the complex professional era has contrasted strongly with the small number of highly rewarded superstars.

All this should make it clear, I hope, that the emphasis on the relative creative autonomy of symbol creators in the complex professional period should not be taken to mean that I think modern symbol creators have had a wonderful life, idling about in recording studios and on film sets while everyone else toils and/or watches the clock. On the contrary, I know that most creative workers make very little money. Great sacrifices have to be made to achieve even the limited and provisional autonomy that is available. The question we need to confront, then, when thinking about the extent of change and continuity in the cultural industries, is **to what extent have the cultural labour market and systems of reward for cultural workers changed since the late 1970s?** This question about the extent of change is, as throughout the book, tied to an evaluative question, which is **have the rewards and working conditions of creative workers – and indeed, other workers in the cultural industries – improved during this time?** The latter part of Chapter 7 looks at these issues.

INTERNATIONALISATION AND DOMINATION BY THE USA

International movement of cultural texts and cultural workers goes back many centuries. The first global media corporations, however, date from the nineteenth century, in the form of the British and French imperial news agencies (Reuters and Havas), which, 'in the 1870s established a world cartel in fast news by ocean cable' (Tunstall, 1994: 14). Tunstall also provides other examples of internationalisation, including:

- *cultural forms* – the spread of the daily entertainment newspaper from the USA, where it was introduced by moguls such as Hearst and Pulitzer, into Europe and across the world
- *cultural technologies* – such as the sound film, which spread across the world in the 1930s
- *cultural industries* – in particular, the 'speedy capture of the world movie market by the young Hollywood' from 1914 to the 1930s.

As Tunstall notes, these waves of internationalisation in the twentieth century mainly emanated from the USA.

So the decades preceding the complex professional era of cultural production had already seen considerable amounts of international traffic in cultural goods. This grew in the post-Second World War period. Alongside developments in communication and transport, it led to much higher levels of transnational flows of texts, genres, technologies and capital. This can be seen, for example, in the phenomenal spread of Anglo-American rock music and pop music culture across much of the world in the 1960s and 1970s, including even the Stalinist states of Eastern Europe. The television industry in the USA developed ahead of most other countries and the USA's system was dominant internationally in the early years of television. In particular, most countries drew heavily on US programming during the television boom years of the 1960s (very few countries had developed television systems before the late 1950s). Television exports from the USA reached their peak in the late 1960s and then 'in the early 1970s remained at around US$100 million a year – meaning a real decline against inflation' (Tunstall, 1994: 144). In film, domination by the USA was even more impressive. In 1925, films from the USA accounted for over 90 per cent of film revenues in the UK, Canada, Australia, New Zealand and Argentina, and over 70 per cent in France, Brazil and Scandinavia (Jarvie, 1992: 315). This domination remained robust throughout the complex professional period.

Nevertheless, as Tunstall (1994: 62) notes, there were other international cultural flows, too. These included long-standing flows of texts within particular regions, often dominated by a regional 'media imperialist', such as Egypt in the Arab world or Sweden in Scandinavia. Britain reaped the benefits of empire, even after its empire went into decline. There were also cultural flows from Latin America and Africa into the USA and other advanced industrial countries, especially in music and dance. The 1980s and 1990s saw intensified global cultural trade and, indeed, economic, political and cultural contact across the globe – the phenomenon of globalisation. These issues are discussed in Chapter 8, where the following questions are addressed. **To what extent have international cultural flows changed sufficiently for us to speak of a new era in cultural production and circulation? To what extent has the USA retained its international dominance?**

We see in Chapter 8 that the last 30 years have seen a further intensification of the internationalisation of cultural industry businesses and texts, but how should we evaluate this internationalisation? The neo-liberal view is that 'free trade' in cultural goods will be beneficial for all. This is usually based on the neo-classical economic notion of the *theory of comparative advantage*. This holds that 'every

nation is better off specialising in goods in which it has a comparative advantage and trading some of these goods for others in which it possesses no such advantage' (Hoskins et al., 2004: 328). Economists aim to show through their demand and supply curves that when protectionist measures such as tariffs and quotas are introduced, then there is a net economic loss for the country imposing those measures. Social and cultural losses in forgoing production in a particular area are seen as 'externalities' – costs or benefits 'not taken into account by either of the parties' (Hoskins et al., 2004: 290) in an economic transaction. In the general economy, externalities might include environmental damage, unemployment and so on. These are often sidelined by economists because they are hard to measure, but these factors are often crucial. For example, cultural goods make an important contribution to the diversity of a particular space, be it that of a nation or region. Not having an effective domestic film, television or recording industry is likely, other things being equal, to reduce that diversity.

We need to move beyond the narrow vision of neo-liberalism and focus on the social and cultural implications of international movements of cultural goods, especially power and identity. So Chapter 8 asks the following questions. **To what extent does the increasingly global reach of the largest firms mean an exclusion of voices from cultural markets? What opportunities are there for cultural producers from outside the 'core' areas of cultural production to gain access to new global networks of cultural production and consumption?**

DIGITALISATION, CONVERGENCE AND NEW MEDIA

Of all the aspects of cultural production in the twentieth-century discussed in this chapter and this book, it is probably those related to new media technologies that have produced the most commentary. As cinema, radio and television were introduced into more and more societies, they were always accompanied by enormous speculation and debate. This has, of course, been echoed in the introduction of the Internet since the mid-1990s. But the Internet is best understood as part of a broader process of *digitalisation* – the increasing use of digital, as opposed to analogue, systems of storage and transmission (see page 241 for an explanation). And this in turn is related to the issue of *convergence* – the idea that telecommunications, computers and media are converging. Chapter 9 provides the longer-term history of these phenomena, and addresses both of them in some detail; pages 241–4 explain how it goes about doing so. For now, it is enough to say that Chapter 9 addresses a set of questions concerning changes associated with digitalisation and convergence. One concerns the extent of change. **To what extent have digitalisation and convergence transformed cultural production and consumption?** The other, related, questions are more evaluative. Many proponents of the Internet and other digital technologies claim that they are opening up access to the means of cultural production and circulation in a positive, democratising way, and that barriers between production and consumption are being eroded. Chapter 9 evaluates digitalisation and convergence in the light of such claims. **Is access really opening up? Are barriers between producers and consumers really breaking down?**

TEXTUAL CHANGE

I now turn to the most difficult and controversial aspects of the cultural industries – their output, in the form of texts. There are three main ways in which the relationships between cultural industries and textual outputs tend to be discussed, which are in terms of:

- diversity and choice
- quality
- social justice – in particular whether or not the interests of the wealthy and powerful are served (the question deferred from earlier).

Here, questions about the *extent* of change are especially entangled with questions of *evaluation*, so I treat them together (they have been handled separately up to now in this chapter).

CHOICE, DIVERSITY, MULTIPLICITY

The issue of diversity has been particularly important in discussions of oligopoly, concentration and conglomeration. Mainstream economics has argued for many years that markets tend to oversupply products in 'the middle of the market' (Hotelling's Law – see Hotelling, 1929). Liberal-pluralist communication studies scholars and others have tried to show that concentration leads to homogenisation and standardisation, or at least reduced diversity, but with contradictory results (see Chapter 10). Even in the rare cases where decreasing diversity is clear, it is very difficult to show that concentration *causes* homogenisation. Indeed, it is possible to make the argument that concentration can – at least in particular cases at particular times – be beneficial for diversity. As Richard Collins and Christina Murroni (1996: 58) put it, 'risky new media markets require venture capital and market power in order to launch new products'. As they also point out, challenging, authoritative reporting needs lots of money to back it up.

In fact, there is evidence that the complex professional era has seen a marked increase in the range and diversity of cultural goods on offer. The high street record shops, newsagents and bookshops seem awash with products and nearly everyone in the developed world can receive more radio and television stations than ever before. How can we possibly speak of a lack of diversity? One political economy writer (Mosco, 1995: 258) has responded to this criticism by making a distinction between *multiplicity* – the sheer number of voices – and *diversity* – whether or not these voices are actually saying anything different from each other.[13] This is an important point. There are hundreds of magazines available in the USA and Europe catering for every kind of interest imaginable, from needlework to the mercenary soldier business, from gay porn to religious affairs. No doubt many of these magazines add pleasure and interest to their readers' lives, but is there real diversity when it comes to the expression of viewpoints about how we might

13 A similar argument runs through Adorno and Horkheimer's analysis of '[the] Culture Industry'.

understand public life? Similarly, are audiences exposed to a wide range of voices or are we increasingly encouraged to stay tuned only to those channels of communication that we have already decided we are interested in? These questions suggest the very real difficulties involved in providing any objective assessment of what constitutes diversity in the cultural industries. This is a great problem because much writing that is critical of the present formation of the cultural industries assumes the assent of readers regarding these questions. Nevertheless, the question remains on the agenda: **to what extent are the texts produced by the cultural industries growing more or less diverse?** I return to this issue in Chapter 10.

QUALITY

It is common to hear claims that the quality of the texts produced by the cultural industries is in decline. Indeed, there is a huge tradition of cultural commentary devoted to this view (for example, Bloom, 1987; MacDonald, 1963; see Ross, 1989, for a brilliant overview of this terrain). The most recent version of this approach has it that the faster, more frenetic way in which we read, watch and listen to texts has led to a decline in the quality of our cultural experiences and the actual texts themselves. According to such views, the cultural industries can 'get away with' investing less energy, time and resources in high standards because we are too distracted to appreciate quality anyway. Closely related to this is the view that overall quality is declining because of a drive to make profit. As I will show in Chapter 10, such arguments are extremely difficult to prove. This is not simply because judgements of quality are subjective. The real problem is that many of those who argue for overall decline in a particular industry offer very little substantial argument (in the form of explicit reference to aesthetic criteria) to back up their case. Nevertheless, the question remains an interesting one: **has the overall quality of texts declined?**

TEXTS, SOCIAL JUSTICE AND THE SERVING OF INTERESTS

Here we return to the question raised earlier in the discussion of the interests of cultural industry corporations – specifically their owners and executives. Let me take the breakdown of goals that cultural industry companies might pursue provided in the section on the role of large corporations in the cultural industries and society. In each case, I raise the question of whether or not cultural industry companies serve powerful interests without anticipating too much the evidence to be discussed in Chapter 10. The main aims here are to clarify and justify the evaluative criteria that I will bring to bear on textual developments in the cultural industries in that chapter.

- *Companies promoting their own interests as companies via texts* In one obvious sense, cultural industry companies clearly serve their own interests via texts. Whatever the mixture of motivations among individuals and across different roles, cultural industry companies produce and circulate texts primarily in order to make money. In terms of content, though, it is less

clear that they can do so, except by advertising. Cross-promotion represents one important way in which companies do promote their own interests and an interesting question for policy and regulation is the degree to which companies should be prevented from doing so (see Hardy, 2004b).

• *Companies promoting the interests of cultural industry companies as a whole (or those of fellow members of an oligopoly of major corporations) via texts* There is a strong tendency for texts made by the largest corporations to refer to products of other corporations. This is not always the result of conscious and deliberate attempts by large companies to reinforce each other's positions; it is sometimes simply because these corporate products tend to dominate in modern capitalist culture. The main way in which cultural industry companies act as joint interest groups is evidenced in their lobbying activities. Naturally, such lobbying can, at times, be supported by texts. An example would be attacks on the BBC in British newspapers with broadcasting and Internet interests.

• *Companies promoting the interests of businesses in general and of the social class that owns them* The cultural industries have, for many decades, via advertising and marketing, served the interests of businesses as a whole by creating a context in which consumption is stimulated and satisfaction becomes associated with the buying of commodities, again, via advertising and marketing. It isn't nearly so clear that non-advertising messages systematically support the business environment, however. Many texts celebrate selfish consumerism as a means to happiness, but many prioritise other values over acquisition. Promoting the interests of businesses above the interests of people as citizens and workers can lead to a deterioration in the quality of working life, the environment and personal relationships. The most difficult question of all is whether or not texts promote the interests of businesses and the dominant social class by encouraging political and economic stability and discouraging progressive social change. I assess the mixed evidence about this question in Chapter 10. Any increasing tendency for the cultural industries to support these powerful interests would clearly be negative.

Clearly, the textual products of the cultural industries do not come about purely as a result of conscious efforts by owners and executives to serve their own interests. There are many mediating and contingent factors at work. The complex systems of modern commercial production produce many unintended consequences. It is possible, for example, that the pursuit of market segments by cultural industry businesses, in the interests of profit, helps to bring about processes of social fragmentation, but such fragmentation is not necessarily in the interests of cultural industry companies. In Chapter 10, I discuss these issues of social justice and the serving of interests under three headings:

• advertising, promotion and commercialism
• the politics of entertainment
• the new news
• social fragmentation and market segmentation.

The overall question guiding the discussion in that chapter is **do the cultural industries increasingly serve the interests of themselves and the wealthy and powerful in society?**

* * *

My claim in this chapter has been that the complex professional form represented a new era in cultural production, beginning from the early twentieth century onwards and consolidating from the middle of the century. If this is right, then one way of differentiating fundamental transformations from superficial changes in the cultural industries since 1980 (so that continuity can be recognised) is to ask the following questions. **Has the period since 1980 seen the emergence of a completely new era of cultural production? Alternatively, do the changes represent shifts *within* the complex professional era?** These questions represent a refinement of the central question of the book, outlined in the Introduction. This chapter has broken down these broader questions into more manageable ones, summarised in Table 2.1. In so doing, it lays the ground for the assessment of change and continuity in Parts Two and Three. Before answering these questions, though, we need to consider the question of how to *explain* changes and continuities in the cultural industries. This is the task of the next chapter.

FURTHER READING

Raymond Williams is usually named as one of the 'founding fathers' of cultural studies, based on early works such as *Culture and Society* (1958) and *The Long Revolution* (1961), but his later sociological and theoretical work is just as important. It is compatible with political economy and radical media sociology approaches to the extent that he can be seen as a parent of those approaches, too. *Culture* (1981) is probably his most neglected major work. It provides the basis of the attempt here to construct a *historical* sociology of cultural production.

Bill Ryan's *Making Capital from Culture* (1992) picks up Williams' Marxian, historical analysis of the 'corporate professional' form of capitalist cultural production and brings an organisational studies perspective to bear on it. His book is specialised, exhaustive and difficult, but I have found it invaluable.

Jason Toynbee's *Making Popular Music* (2000) is much more readable than Ryan's. Its focus on symbol creators (that is, in the case of the music industry, musicians) has been a major influence on my thinking in this book.

Philip Elliott's (1977) discussion of media organisations and occupations is still useful – especially its subtle treatment of the creativity/commerce (or art/commerce) dialectic.

I have found the work of Jeremy Tunstall (for example, *Communications Deregulation*, 1986, and *The Media Are American*, 1994, originally published in 1977) helpful in providing historical detail on the cultural industries, in spite of its empiricist lack of interest in theorising historical developments.

3 EXPLAINING THE CULTURAL INDUSTRIES

THREE FORMS OF REDUCTION: TECHNOLOGICAL, ECONOMIC AND CULTURAL

Why have the cultural industries changed so much over the last 30 years? What are the forces driving these changes?

We will need to avoid easy answers as we negotiate these questions. In complex societies, adequate explanations of social processes are rarely going to be simple. It would be wise, therefore, to avoid answers that *reduce* complicated, interwoven webs of causality to a single driving force. Of course everyone thinks that her or his account avoids such reduction, yet the need to achieve coherence and directness often drags such accounts into an overemphasis on one particular factor at the expense of others.

The term most widely used in sociological and historical writing to refer to such an overemphasis on one factor is **technological determinism**, which obviously suggests that the factor being given too much weight at the expense of others is the causal role of technology. I prefer the term 'reduction' or *reductionism* to determinism because the problem is not that technology is given a determining role but this determining role is overemphasised, thus reducing complexity to simplicity. The term 'technological determinism' was introduced to social and cultural studies by Raymond Williams in his book *Television: Technology and cultural form*

(1974), where he provided a critical account of such thinking as it applied to television and, indeed, technologies in general. However, it is often forgotten that Williams was also criticising what he called 'symptomatic technology' (Williams, 1974: 13) – the view that technologies are merely byproducts of wider social processes. What mattered for Williams was that technologies should never be seen in isolation, but always be understood *in relation to* other processes and factors.

Obviously, technologies have effects. The introduction of the telephone has helped to transform the way that we communicate. The introduction of video recorders into homes played an important role in changing the experience of television. These are relatively uncontroversial statements, involving no reduction. Reduction would come in if we were, for example, to answer the question, 'What has caused the transformations in the way we experience television over the last 30 years?' with a broad response, such as 'new technologies, such as video, cable and satellite'. This begs a number of questions. What caused these technologies to be introduced in the way that they were? How did they take the particular form they did? In accounts that are afflicted by the technological reductionism of their authors, the relationship of technologies to economic, political and cultural forces becomes obscured or even lost altogether.

It is also common to hear charges of **economic determinism**. Again, I think that reductionism is a more accurate term here too. Such charges tend to be levelled particularly against political–economic accounts, for their supposed reduction of social and cultural events and processes to ultimately economic driving forces, such as the imperative of companies to make profit or the interests of the social class who control the means of production. Indeed, some cultural studies analysts and many pluralist communications studies scholars (such as Neuman, 1991: 16) make the claim that Marxism is more or less inherently reductionist. However, economic reductionism is by no means confined to Marxists – orthodox, mainstream economics often makes strong claims for the explanatory power of its economic models. As with technological reductionism, the issue here is not whether or not economic forces have any causal effect. It is clear, for example, that the behaviour of companies in pursuit of profit does have important social effects. The question is whether or not an overemphasis on economic explanation means that the analyst fails to provide an adequate account of the relationship of such economic factors to other processes.

Neuman (1991: 17) has drawn attention to the much less often heard charge of '**cultural determinism**', which he defines as the view that systems of values and beliefs have causal primacy.[1] Although it is not nearly so common to hear this phrase as it is to hear about technological and economic determinism, a belief in the causal primacy of culture is very widespread. A version of such cultural determinism underlies the commonly expressed, but mistaken, view that 'the media give people what they want' – that is, the shape of the media is determined by its audiences' culturally shaped desires and expectations. Few people are bold enough to go into print to attempt to justify such a view (an exception is Whale, 1977). However, this view can be heard with alarming regularity in cultural

1 Neuman uses the concept of 'monism' – accounts of determination based on single factors.

industry organisations and among public commentators and politicians. The main problem with it is that it ignores the huge role the media themselves play in shaping the desires and expectations of audiences.

Once again, the objection to cultural reductionism is not that it attributes causal properties to cultural processes. Clearly, for example, changes in leisure time and practices have an enormous influence on what cultural industry companies can do. The problem here, as with any reduction, is the begging of further questions about causality, such as, 'how did these cultural practices come to take the form that they did?' There are added difficulties in discussing the causal effects of cultural processes that are connected to the difficulties of definition surrounding the term 'culture', discussed in the Introduction. 'Culture' has become such a widely used word in contemporary societies, whether in academic writing or journalism and popular publishing, that it has come to mean everything and nothing. Does it mean the prevalent attitudes, beliefs and values within a particular society or the ordinary, lived experiences of people or the general conditions of living within a particular place, organisation or institution? Everyone agrees that the term is difficult and contested, yet it is commonly invoked as a means of explanation superior to an approach centred on 'technology' or 'economics', without any recognition of these difficulties. As should be clear from the Introduction, I prefer Williams' definition of culture as 'the *signifying system* through which ... a social order is communicated, reproduced, experienced and explored' (1981: 13). This at least helps to avoid the clumsiest invocations of culture and draws our attention to the concept of the 'sociocultural' – an inherently non-reductionist concept, involving interactions between such cultural dimensions and more broadly *social* systems and behaviours (for discussion of this difficult and neglected terrain, see Williams, 1981: Chapter 8).

CONTEXTS FOR CHANGE AND CONTINUITY IN THE CULTURAL INDUSTRIES, 1945–1990

In what follows, I develop an account that attempts to combine analysis of economic, technological and cultural processes with other important dimensions, including politics, legal and regulatory frameworks and the internal dynamics of cultural industry organisations themselves. When I began thinking about issues of determination and change in the cultural industries, I thought that I would be able to summarise political economy work in order to provide a concise and coherent historical account as a lead-in to my assessment of change and continuity. However, political economy approaches have, to a remarkable degree, lacked an explanatory account of such changes. Even Nicholas Garnham and Graham Murdock, whose writings are scattered with insightful nuggets of explanation, have not provided any systematic, overall view of the relationship between economic and cultural change via a historical examination of the cultural industries. This chapter takes some steps towards an overview of change, turning to a broader literature in social theory, politics and economics, to do so.

Having said that, social theory and social science have neglected the cultural industries. Some major contributions have attempted to deal with them, but nearly

always in a very limited way. David Harvey's *The Condition of Postmodernity* (1989: 284–307), for example, attributes considerable importance to the cultural industries in terms of mastering and controlling sign systems in an era of new cultural volatility and unpredictability. Harvey, though, gives no space to their distinctive organisational forms (apart from a brief reference on p. 290) or conflicts and contradictions within cultural production. Manuel Castells' chapter on media in *The Rise of the Network Society* (Castells, 1996) is the weakest in his remarkable trilogy on *The Information Age* (of which *The Rise of the Network Society* forms the first part). Castells resorts to futurology and simplistic descriptions of a previous era of media (1996: 327–75 – see my comments in Chapters 7 and 8). A significant exception to such neglect of cultural production in social theory is Scott Lash and John Urry's book *Economies of Signs and Space* (1994). In it, an entire chapter is devoted to the cultural industries and they have interesting things to say about the relationship between the cultural industries and wider economic and social changes.

Where to begin? In my view, the most promising starting point for understanding changes in the cultural industries is the ***Long Downturn***, which affected much of the world from the late 1960s onwards. A number of accounts (most notably, for my purposes, Castells, 1989, and Harvey, 1989) have shown how corporations and governments responded to this economic crisis in a number of ways in an attempt to fix the problem. In beginning my narrative from an economic event, am I guilty of economic reductionism? No, because I use the term 'starting point' advisedly here. This economic crisis was itself produced in part by social, cultural, organisational and technological factors. There is no single point of origin for the chain of cause and effect. The Long Downturn has served as a catalyst to accelerate and consolidate certain processes that were already under way. So, while this is an account that begins from the political–economic, it recognises the fact that these political–economic events were tangled with a large number of other factors.

POLITICAL–ECONOMIC CHANGE: THE LONG DOWNTURN

It would be wrong to portray the era following the Second World War as one of global peace and prosperity. Disease and poverty were widespread and, outside Europe, there was unprecedented military conflict. There is no doubt, though, that, for the 'advanced', capitalist economies of Europe, North America and Australasia, the period from the 1950s to the early 1970s was one of steady economic growth, rising standards of living and a relatively stable system of liberal democratic government. The Stalinist economies of Eastern Europe and the Soviet Union also achieved significant growth. There was even evidence that the increasing inequality in wealth and social opportunity that had marked feudal and capitalist societies was beginning to be reversed (see Hobsbawm, 1995: 257–86, for an overview of this period). Because of the relatively strong macroeconomic performance of advanced capitalist economies, some economists have referred to this period as 'the golden age of capitalism' (Marglin and Schor, 1992). In the late 1960s, mainstream economists were predicting an end

to the cycles of boom and bust that, in the views of all commentators, be they from left or right, had characterised industrial capitalism for 150 years.[2] However, in the early 1970s, after decades of these relatively favourable conditions, the advanced capitalist economies hit the beginning of the Long Downturn that continued into the 1990s, marked by particularly severe recessions in 1974–1975, 1979–1982 and 1991–1995. In the G7 countries between 1970 and 1990, profits fell significantly across all sectors, but especially in manufacturing. Other key economic indicators also showed a significant downturn, as can be seen in Table 3.1, which is drawn from Brenner (1998: 5).

There is some controversy over the causes of the Long Downturn. For David Harvey (1989), international financial movements began to undermine the stability of financial system from the early 1960s onwards. For other scholars (such as Armstrong et al., 1991), the primary cause was that the increasing power of working-class wage-earners disturbed the balance of capital and labour that had been sustained during the 'golden age'. As labour solidified its power, a 'wages explosion' squeezed profits, leading to crisis. For Robert Brenner (1998), the main cause of the decline in profits associated with the Long Downturn was not the increased pressure brought about by labour, but the tendency by capitalists to compete with each other without any regard for what happened to the system as a whole. As German and Japanese corporations increased their successful involvement in manufacturing, the world's key economy, the USA, experienced a crisis of overcapacity and production in manufacturing – which was, and remains, its key sector (see Brenner, 2000: 8) – and this triggered an international crisis, exacerbated by the OPEC oil price rise of 1973.

POLITICAL AND REGULATORY CHANGE: THE RISE OF NEO-LIBERALISM

Whatever the precise causes of the Long Downturn, there is widespread consensus that it had profound consequences. One set of consequences was political and these provide important contexts for understanding changes in the regulation of the cultural industries (discussed in detail in the next chapter). The various advanced capitalist states responded to the crisis that hit capitalism in the 1970s by attacking the institutional strength of labour movements and moving away from the arrangements for state intervention in economic life that had prevailed in the post-war period, whereby government spending was used to supplement consumer spending whenever it was inadequate to sustain economic growth (see Harvey, 1989: Part II). Employers and governments ensured a long-term reduction in real levels of pay, but this was not sufficient to restore profits. From 1979, after some years of attempting to reflate

2 See, among other examples quoted by Brenner (1998: 1), the remark by Paul Samuelson–one of the most eminent mainstream economists of the twentieth century–that the National Bureau of Economic Research had 'worked itself out of one of its jobs, the business cycle'.

Table 3.1 Comparing the post-war boom and the Long Downturn (average annual rates of change, except for net profit and unemployment rates, which are averages)

Manufacturing

	Net profit rate		Output		Net Capital Stock		Gross Capital Stock		Labour Productivity		Real Wage	
	1950–1973	1973–1993	1950–1973	1973–1993	1950–1973	1973–1993	1950–1973	1973–1993	1950–1973	1973–1993	1950–1973	1973–1993
US	24.35	14.5	4.3	1.9	3.8	2.25	–	–	3.0	2.4	2.6	0.5
Ger	23.1	10.9	5.1	0.9	5.7	0.9	6.4	1.7	4.8	1.7	5.7	2.4
Jap	40.4	20.4	14.1	5.0	14.5	5.0	14.7	5.0	10.2	5.1	6.1	2.7
G7	26.2	15.7	5.5	2.1	–	–	4.8	3.7	3.9	3.1	–	–

G7 net profit rate extends to 1990; German net capital stock covers 1955–1993; Japanese net profit rate and net capital stock cover in manufacturing 1955–1991.

Private Business

	Net Profit Rate		Output		Net Capital Stock		Gross Capital Stock		Labour Productivity		Real Wage		Unemployment Rate	
	1950–1973	1973–1993	1950–1973	1973–1993	1950–1973	1973–1993	1950–1973	1973–1993	1950–1973	1973–1993	1950–1973	1973–1993	1950–1973	1973–1993
US	12.9	9.9	4.2	2.6	3.8	3.0	–	–	2.7	1.1	2.7	0.2	4.2	6.7
Ger	23.2	13.8	4.5	2.2	6.0	2.6	5.1	3.0	4.6	2.2	5.7	1.9	2.3	5.7
Jap	21.6	17.2	9.1	4.1	–	–	9.35	7.1	5.6	3.1	6.3	2.7	1.6	2.1
G7	17.6	13.3	4.5	2.2	–	–	4.5	4.3	3.6	1.3	–	–	3.1	6.2

G7 net profit rate extends to 1990; German net capital stock covers 1955–1993.
Source: Brenner, 1998: 5

Western economies, governments made permanent a set of anti-inflation strategies that had been tried in 1974–1975. Emergency cutbacks in public spending and the stripping away of regulation by democratically elected governments were promoted from emergency measures to permanent policy. The view that human needs are best served by an unregulated 'free market' – a view that had been popular with various nineteenth-century liberal economists, but had mostly been confined to cranks and nutcases for much of the late twentieth century – made a comeback, hence the terms *neo*-liberal economics and ***neo-liberalism***.[3]

Such neo-liberal free market thinking took particularly extreme forms in the UK and USA, where far-right conservative governments were elected (by a small minority of the eligible-to-vote population) in 1979 and 1980 respectively. These governments were re-elected with bigger majorities in 1983 and 1984 respectively, partly because an influential minority of people benefited from such policies, but also because the labour movements in the USA and the UK– traditionally the basis of leftist politics in both countries – were in complete disarray and this chaos on the left helped make the rightist governments look competent, in spite of record levels of unemployment and inequality. This was an era in which the cultural industries had an especially important role in legitimising political and economic strategies, as press and television news portrayed trade unions as regressive.

From the late 1970s, most governments of whatever political persuasion attempted to weaken the bargaining power of labour in order to lower wage costs. Credit was restricted by the raising of interest rates, which forced unprofitable firms out of business and weakened labour still further as a result of the spread of unemployment (Brenner, 1998: 181). Following the second election victories of Margaret Thatcher and Ronald Reagan in 1983–1984, however, extreme neo-liberal dogma spread into elected social democratic, reformist governments, such as New Zealand from 1984 onwards (see Gray, 1998) and most governments of advanced capitalist countries in the late 1980s. When Stalinist communism collapsed in Eastern Europe, the Soviet Union and many of their client states in 1989–1991, it was neo-liberalism rather than social democracy that was adopted as a political model.

Within these general shifts towards neo-liberalism in government policy, there was a specific set of policy shifts that were to have a particularly profound impact on the cultural industries and their status within contemporary societies. In this book, I use the term *information society* to denote the thinking and rhetoric behind this specific set of policies. This refers to the view that information and knowledge are now central, as never before, to the way that modern societies operate. Box 3.1 explains why this idea is so important. (Some writers

3 In the USA, 'liberal' has come to mean politically centrist (as opposed to conservative or radical), but that is not the sense of the term used when writers refer to nineteenth-century liberal economics or neo-liberalism. The primary meaning here is that these doctrines advocate minimal state intervention in societies, in the interests of individual freedom.

use the term 'knowledge society', but they are usually referring to pretty much the same idea with slightly different emphases.[4])

BOX 3.1 THE INFORMATION SOCIETY

The idea of the information society is that we live in societies that are as different from those based on industry as industrial societies were different from agricultural societies. There is an implicit teleology – that information societies will succeed industrial ones, just as industry displaced agriculture as the main basis of global economic life. In the industrial era, work and prosperity were based on manufacture and manual labour, while in the information era they are supposedly based on information and knowledge. For information society discourse, in the words of one of its critics, the goal of production is much less to make and circulate things that can be touched – oil, steel, cars – and much more about producing changes in 'relationship, image and perception' (Webster, 1995: 1). In some formulations, this is a way of interpreting the shift in employment from manufacturing to services, discussed in the next section, but the idea of the information society also derives from the increasing importance of research and development and science and technology in modern economies.

These were big issues as information society discourses took root in the 1960s and 1970s. Marc Porat's massive study published in 1977, *The Information Economy*, estimated that information accounted for 46 per cent of the USA's GDP. However, this figure could be arrived at only by separating the information and non-informational elements of massive industries such as oil and automobiles and assigning a value to each – an operation that rests on very difficult and always controversial value judgements, as Webster (1995: 12) points out. Moreover, such statistics say relatively little about how information is supposed to operate within supposed information societies. Even if we accept the value of quantifying information in this way, other studies have suggested that information accounts for much less economic activity than Porat estimated.

Nevertheless, such accounts laid the basis for the popularisation of the idea of the information society in Peter Drucker's notion of the 'knowledge economy' (1992/1968) and Daniel Bell's notion of 'post-industrial society

(Continued)

4 Some writers and politicians use 'economy' interchangeably with 'society' in these debates and a great deal of information society thinking and rhetoric is indeed about the economy, but, as Webster (1995: 6–29) shows, 'information society' thinking incorporates other dimensions – technological, occupational, spatial and cultural – and this is a reason for preferring 'society' here. Another is simply that it is more widely used.

(Continued)

(1974), where theoretical knowledge, especially in science and technology, was seen as a new, emerging 'axial principle' of society. There was intense debate over these ideas, but, by the 1980s in government policymaking, the idea that information and knowledge were key to future prosperity and employment in industrial societies, faced by new competition from newly industrialising countries outside Europe and North America, had become absorbed as a kind of commonsense notion, backed up by dozens of reports and committees, many of them drawing on emerging neo-liberal forms of policy (a good example is the British Cabinet Office report of 1983, *Making a Business of Information*).

According to information society thinking, the cultural industries are based on information and knowledge and therefore, are, part of the burgeoning 'knowledge economy'. Significantly, they are a highly visible part of this economy, which allows their role perhaps to seem greater than it is. In the 1990s, with the rise of the Internet and the World Wide Web, discourses about the information society, and the role of communications and media within it, were proliferating ever more wildly and an array of quite different assumptions and claims fed into the vision of the information society. These have tended to be blurred when politicians, business executives, journalists and academics use the term. The idea of an information society is a confused one, but it has had real effects on policy and the role and status of the cultural industries in contemporary societies. It became widely accepted among policymakers and academics that the cultural industries were going to form very important parts of future economies and their growth needed to be supported in various ways – usually in order to give nations or regions a competitive advantage or avoid a disadvantage in relation to other nations or regions. This had a considerable role to play in spreading the view, which I discuss in Chapter 5, that intellectual property needed to be more rigorously policed and laws changed so that cultural industry businesses could make more money out of their copyrights. More indirectly, the general emphasis on the importance of information and communication technologies in the various types of information society discourse fuelled the 'deregulation' of telecommunications and government efforts to boost the growth of the IT industries (both hardware and software). This was to lead to a massive proliferation of the channels through which cultural content could be carried, as we shall see. These developments were certainly not without contradiction – in fact, some people argue that the increased policing of copyright, in ways that have favoured the oligopolistic corporations dominating cultural production, actually inhibits creativity rather than promotes it.

Neo-liberalism and the information society are the vital *political* contexts for understanding changes in communications and telecommunications law and policy since the 1980s. Neo-liberalism has framed the view underlying a great deal of policy that human needs are best served by the 'free' market. Such

marketisation has been fundamental to bringing about a whole series of other changes in the cultural industries. I trace the paths of marketisation in a number of different contexts in Chapter 4 and analyse their effects in more detail there.

CHANGING BUSINESS STRATEGIES

A second major consequence of the decline in productivity and profits associated with the Long Downturn was that capitalist businesses across the developed world began a period of intense innovation. There were three main aspects to this:

- a shift towards service industries – that is, away from the extractive (for example, mining and agriculture) sector and, to some extent, the transformative (mainly manufacturing) sector and towards the various industrial sectors, which deal primarily with services, such as distributive, producer, social and personal services, to use the terms adapted by Castells (1996: 311) from Singelmann (1978)
- internationalisation
- organisational innovation and restructuring.

INVESTMENT SHIFTS TOWARDS SERVICE INDUSTRIES

There was a significant overall move – on the part of businesses in advanced industrial countries – away from agriculture, raw material extraction, construction and

Table 3.2 The shift to services

Industry	US 1970	US 1991	Japan 1970	Japan 1990	France 1968	France 1989	UK 1970	UK 1990
Extractive	4.6	3.5	19.8	7.2	15.6	6.4	3.6	3.3
Transformative	33.0	24.7	34.1	33.7	39.4	29.5	46.7	27.3
Distributive services	22.4	20.6	22.4	24.3	18.8	20.5	18.7	20.6
Producer services	8.2	14.0	4.8	9.6	5.0	10.0	5.0	12.0
Social services	22.0	25.5	10.3	14.3	15.1	19.5	17.7	27.2
Personal services	10.0	11.7	8.5	10.2	8.2	14.1	8.1	8.1

Figures refer to the percentage of total workforce.

Sector definitions
Extractive: agriculture and mining
Transformative construction, utilities and manufacturing
Distributive services: transport, communication and wholesale
Producer services: banking, insurance, estate agency, engineering, accounting, legal services, miscellaneous
Social services: medical, hospital, education, welfare, religious services, non-profit-making organizations, postal service, government, miscellaneous
personal services: domestic service, hotels, eating and drinking places, repairs, laundry, barbers and beauticians, miscellaneous and unclassifiable services
Source: adapted from Castells, 1996: 282–93

manufacturing and towards service industries. This had been a longer-term trend, as Harvey (1989: 157) shows, but it became irreversible in the wake of the Long Downturn. Companies in advanced industrial countries faced rising wages and increased competition, especially from the newly industrialised countries of the Asia-Pacific region (most notably South Korea, Taiwan, Hong Kong and Singapore) but also Latin America (principally Mexico and Brazil). However, this shift is often simplified or exaggerated. The figures in Table 3.2, based on Castells' data (1996: 282–93) provide some indication of the overall patterns. These figures are useful in providing a much more sophisticated picture of industrial change than the old primary–secondary–tertiary model of agriculture, manufacturing and services. Castells, drawing on industrial historian Joachim Singelmann's work, instead uses the broader terms 'extractive' and 'transformative' to describe the primary and secondary sectors and breaks services up into four constituent sectors.

The decline of manufacturing tends also to be exaggerated. In Japan, for example, the transformative sector – including construction, utilities and manufacturing – showed only a very small decline in the proportion of employment during the post-1973 period. However, there were substantial declines in the USA, France and the UK. Even more significant was the decline in the extractive sector (agriculture and mining) in countries such as Japan and France with sizeable rural populations.

The 1980s and 1990s boom in the cultural industries needs to be seen in the context of this shift in investment strategies. Unfortunately, Singelmann and Castells' categories are not flexible enough to include figures specifically on the cultural industries. Chapter 5, however, takes the view that there is slow, steady growth in the relative size of the cultural industries. This growth can be understood as an aspect of a general shift towards investment in service industries in advanced industrial countries. Let us examine the forces driving that shift in more detail. Nicholas Garnham argues (1990: 117) that demand for labour-saving domestic consumer electronic goods had helped fuel the 'golden age' of the 1950s and 1960s, but Western markets were fast becoming saturated by the beginning of the 1970s. Companies had the chance to use the vast amount of high-tech research generated by the US government in defence and space as a result of the Cold War.[5] By the early 1980s, as Europe and North America faced economic recession and newly industrialised countries in Asia continued to achieve high levels of economic growth, the perceived advantages for Euro-American corporations of moving into high-tech and cultural industries were even more overwhelming, in spite of high research and development costs.

The cultural industries were profoundly affected by these changes. As competition in the new consumer markets intensified, there was increasing demand for advertising and marketing opportunities. This has been crucial in fuelling a growth in media outlets that continued into the 2000s. Here are some relevant data.

5 For example, although the Internet cannot be explained entirely as a defence-driven phenomenon – the familiar story is that it developed as a means of maintaining computer systems in case of a nuclear strike – Brian Winston's account (1998: 321–36) makes it clear how the development of key research into switching protocols was primarily funded by defence spending.

Table 3.3 Increases in advertising expenditure, 1980–1990 (This table shows the percentage of gross domestic product spent on advertising)

Country	1980	1990
Austria	0.47	0.63
Belgium	0.47	0.65
Canada	0.98	1.05
Switzerland	1.02	1.07
Germany	0.75	0.82
Denmark	0.76	0.84
Finland	0.71	0.94
France	0.48	0.78
UK	1.11	1.37
Greece	0.26	0.77
Ireland	0.65	0.82
Italy	0.37	0.62
Japan	0.95	1.12
Norway	0.77	0.74
Netherlands	0.87	0.87
Portugal	0.19	0.77
Sweden	0.64	0.80
Turkey	0.20	0.38
USA	1.32	1.51
Europe	0.70	0.91

Source: Sánchez-Tabernero et al., 1993: 125, drawing on Zenith Media Worldwide

- Table 3.3 shows how the proportion of gross domestic product (GDP) devoted to advertising in a wide range of countries increased significantly during the 1980s.
- Between 1984 and 1989, advertising expenditure in the European Union (EU) increased by more than 6 per cent every year. In 1988 alone it increased by 10 per cent (Howard, 1998).
- EU growth continued at a reduced rate in the early 1990s, but picked up again from 1993. Growth was 73 per cent in real terms between 1980 and 1996, reaching £58 billion, or US$74 billion, in the latter year (Howard, 1998: 117).
- The most striking growth figures were to be found in the developing markets of the Middle East and Latin America. Middle Eastern advertising expenditure increased by over 1000 per cent in real terms between 1987 and 1996 (IJOA, 1998a: 515). In Latin America, growth was 377 per cent in the same period (IJOA, 1998b).
- Growth in advertising expenditure in the USA in the 1980s and 1990s was slower, but the USA already had phenomenally high advertising expenditure in the early 1980s. In 1998, 42.9 per cent of all advertising investment was spent in North America and the USA accounted for roughly 95 per cent of this figure (IJOA, 2000).

Such figures indicate the increasing economic rewards afforded by the cultural industries during the period under examination. The cultural industries were more than just another investment opportunity, though. Increasingly, they came to be seen as a *prestigious* form of making profits as the entertainment industries came to be perceived as a key economic sector, at least in North America and Europe (see Wolf, 1999). Vast companies in other sectors, such as General Electric in the USA or Sony in Japan, made significant investments in cultural production during the 1980s. Such industrial conglomerates had intervened in the cultural industries before, especially in the 1960s, but, in the 1980s, they were entering the very core of the cultural industries: the television networks that dominated the cultural landscape in the USA (NBC and CBS). Meanwhile, companies already involved in the cultural industries grew and come to operate across different cultural industries. This meant that, more and more, the production of culture was the concern of ambitious and well-resourced sectors of economic activity. The implications of these changes for the cultural industries are discussed throughout this book, but especially in Chapter 6.

INTERNATIONALISATION

A second major type of industrial and organisational restructuring in response to falling profits in advanced industrial countries was what Harvey (1989: 183) calls a 'spatial fix'. Owners and operators of capitalist enterprises attempted to restore higher profits by investing abroad in order to spread fixed costs and make the most of cheaper labour markets, as real levels of pay rose in advanced industrial countries. Such internationalisation has a long history, as David Held et al.'s (1999: 242–55) account shows admirably. There had been a massive expansion in foreign direct investment (FDI) – a significant marker of business internationalisation – during the Gold Standard period, from 1870 to 1914, but this was dominated by the UK, highly concentrated in certain areas and primarily concerned the extractive industries. Cartels focused on raw materials, such as oil, began to form during the inter-war period. Consumer goods were increasingly sold on an international basis, but production tended to be organised nationally. In the post-war period – particularly in the 1960s – there was huge expansion in the role of the multinational corporations, especially on the part of manufacturing corporations based in the USA. Internationalisation of production began to be expressed in the emergence of global production and distribution networks, marking a qualitatively new phase of internationalisation.[6]

The last two decades have seen an acceleration of such internationalisation in response to the Long Downturn. Internationalisation was slowed by the severe recession of the early 1980s, but the next decade saw very large increases in the annual growth rates of foreign direct investment. The annual growth rate in FDI flow was 7.3 per cent in the period 1980–1985 and 19.4 per cent between 1986

6 Held et al. (1999) use the popular, but, in this context, confusing term of globalisation; but I prefer internationalisation, for reasons that I explain in Chapter 8.

and 1994.[7] Meanwhile, the neo-liberal economic policies of the 1980s and 1990s led to the removal of protection measures for national industries. The GATT rounds – a series of negotiations between nations aimed at reduction and eventual elimination of tariffs and other barriers to 'free trade' – culminated in the Marrakesh agreement of 1993 and the formation of the World Trade Organisation (WTO) in 1995. The removal of trade restrictions helped to fuel the internationalisation of business activity by corporations of all kinds. A concurrent internationalisation of financial markets – beginning in the 1950s, but culminating in the deregulation of international financial flows in the 1990s – helped further to delegitimate the role of national governments in managing economies, as such governments became apparently helpless when faced with speculators on currency markets. Vast regional trading markets were formed in Europe (the European Union), North America/Mexico (NAFTA) and the Asia-Pacific (APEC), forcing a rush to locate in these regions. There was a massive wave of mergers and acquisitions as transnational corporations bought up overseas companies to expand their production and distribution networks. By 1995, overseas affiliates accounted for 7.5 per cent of world GDP – in 1970, the figure had been 4.5 per cent (Held et al., 1999: 246).

The cultural industries internationalised their operations, too, and there were sound economic reasons for their doing so – most notably the low marginal costs of some of their key products (see Introduction). However, the general internationalisation of businesses as a whole affected the cultural industries in key ways. International communications became crucial for business in general and developments in the telecommunications industry came to have profound effects on the cultural industries.

International communications became vital for multinational corporations of all kinds as the different parts of these vast companies needed to communicate with each other, quickly and securely via public and, increasingly, private networks. Partly to provide for these needs, high-tech companies began a wave of technological innovation in communication technologies in league with the huge European public telecommunication operators (PTOs) and private corporations in the USA. This culminated in the development of digital 'intelligent networks' in the 1970s and 1980s. Besides servicing the needs of multinational corporations, the development of these networks was, in large part, aimed at protecting the positions of public and private monopolies as new entrants came into the telecommunications market (see Mansell, 1993).

Such innovations in telecommunications technologies have been vital in providing new distribution forms for the cultural industries, including, of course, the Internet and World Wide Web but also digital television and private information networks. In fact, a more accurate way to put this is that the cultural industries have been able to expand – indeed, have had to expand – to fill the huge capacity created by the telecommunications industries. Up until the 1970s, most telecommunications traffic was voice only; now images, text, graphics and music flow through the intelligent networks alongside phone conversations.

7 These growth rates were considerably higher than the rates of growth of gross world product, indicating that growth in international activity was outstripping economic growth.

Internationalisation in another industry – consumer electronics – also had important knock-on effects on the cultural industries. Spreading fixed costs across many national markets funded expensive research and development for new hardware devices (see the section Technological change: information technology and consumer electronics, below).

ORGANISATIONAL INNOVATION AND RESTRUCTURING

A third form of industrial and organisational change relevant for an account of the cultural industries was that new forms of organisational innovation were introduced in order to achieve higher profits, reduce labour costs and win market share over competing firms. Writers from a number of perspectives have examined the general restructuring of businesses that took place in the 1970s and 1980s and many of them attribute this to a response to the Long Downturn. Various phrases have been used to label this restructuring – most notably 'flexible specialisation' (Piore and Sabel, 1984), 'flexible accumulation' (Harvey, 1989) and 'post-Fordism' (Hall and Jacques, 1990). Castells (1996: 151–68) provided a valuable breakdown of some of the main elements of this restructuring.

- *The 'decline' of the large corporation and the rise of interfirm networking*
 Castells argues – following commentators such as Bennett Harrison, whose 1994 book *Lean and Mean* argued for the continuing importance and vitality of the large corporation – that the large corporation is not nearly so much in a state of crisis as some 'post-Fordist' commentators suggested in the 1980s. Rather, says Castells, the traditional, vertically integrated large corporation is in decline as a *model* for how to organise production, but is still very much in existence. Corporations have changed their organisational structures and, increasingly, subcontract to small- and medium-sized firms. These smaller firms are potentially more dynamic and able to innovate than large ones, but they are often involved in close relationships with the corporations that subcontract to them.
- *Corporate strategic alliances* An important emergent pattern has been the formation of strategic alliances between corporations – not as in traditional cartel arrangements but, rather, for specific projects. This is especially relevant, says Castells, in high-tech sectors where research and development costs are enormously expensive. For Castells, the self-sufficient corporation is increasingly a thing of the past. What is more, small- and medium-sized firms are often drawn into such alliances as an extension of interfirm networking.
- *New methods of management, and corporate restructuring* Many discussions of organisational innovation concern forms of production developed in Japanese car production (thus sometimes labelled 'Toyotism'). Much of this involves using information sensibly to reduce inventories by delivering supplies just in time and improving quality control. Most significant for the management of labour, however, is the idea of involving workers in production by reducing hierarchies and creating autonomous working units. Castells

also points to developments in the organisation of corporations – in particular, the tendency to move away from traditional, hierarchical forms of organisational structure and towards the setting up of decentralised, sometimes semi-autonomous working units – even to the point, at times, of having these units compete with each other. The corporation becomes a network. The job of the corporate centre is to make sure that the network communicates adequately. Castells says that such arrangements originally developed as cost-saving devices during the economic restructuring of the 1980s and the horizontal corporation of the 1990s represents an extension of such arrangements. Closely related to such changes is the idea of flexibility. The idea was that, as markets become ever more volatile and unpredictable, firms need to be able to switch production rapidly to conform to changing tastes. These changes are particularly interesting in the present context because, as we saw in Chapter 2, the cultural industries have had this network form for much of the complex professional era.

- *Changing work patterns* In a separate discussion, Castells (1996: 264–72) notes the new working conditions associated with new organisational forms. In particular, he notes the increasing disintegration of workforces, with substantial rises in temporary, part-time and self-employment. This may take the form of increased work options for the relatively privileged, but also of casualisation and insecurity for the less well-off and those with fewer skills and less education.

The discussion here of changes in businesses of all kinds paves the way for the discussion of industrial and organisational shifts in the cultural industries that I undertake in Chapter 6 and 7. An important theme there is the extent to which the cultural industries are becoming more or less distinct from other sectors. Are the cultural industries losing their distinctiveness as they become increasingly important in advanced industrial economies? Alternatively, are, as some writers (for example, Lash and Urry, 1994) argue, other industries becoming more like the cultural industries as, for example, companies increasingly organise themselves into semi-autonomous divisions?

SOCIOCULTURAL AND TEXTUAL CHANGES

Understanding changes in the cultural industries over the last two decades needs, then, to lay great emphasis on restructuring in response to the economic crisis of the 1970s. An adequate account, however, needs to go beyond restructuring, too. We must avoid a model whereby economic change 'happens to' politics and production organisations and this then brings about changes in the cultural industries and then in cultural life more generally. There are three main ways in which we need to go beyond such an account.

First, an account of changes in the cultural industries since 1980 needs to acknowledge the complex interplay of, on the one hand, economic and political processes and, on the other, the social, cultural and institutional processes that are sometimes conceived as being by-products of events at the macro level. The

cultural industries could hardly evade the effects of the accelerating sociocultural transformations taking place in advanced industrial societies from the 1960s onwards, including the dismantling of many forms of social authority in educational, religious and other institutions, changes in family life, sexuality, relationships between women, men and children, the very meaning of what it is to be a person and an increasing emphasis on, and reflexivity about, issues of personal identity. In order to gain audiences in time-rich and/or newly prosperous constituencies, such as the baby boom teenager and student in the 1960s or working women in the early 1980s, cultural firms had to appeal to changing values – at least in some market sectors. Not that cultural industry corporations were answering the pre-existing needs of consumers: they were simultaneously helping to shape these new needs. Obviously enough, citizens affected by these sociocultural changes, imbued with new ways of being and thinking, were allowed to enter the cultural industries and were able to transmit their values into the texts they created. One striking example is the development of new genres, forms and narrative modes in the New Hollywood cinema of the early 1970s. This was partly the result of organisational and institutional factors, in that the old studio system had broken down and film studios perceived that the core audience for cinema was young baby boomers. However, the shift was also sociocultural as film-makers of a new generation brought new ideas and values into film production (see Tasker, 1996).

Second, an adequate analysis of the cultural industries needs to take account of continuity and multiple and coexisting processes of change occurring at different rates. An overemphasis on restructuring exaggerates short-term transformation at the expense of these different temporalities. The increasing centrality of the cultural industries in economic life, for example, was certainly not caused *exclusively* by post-crisis restructuring. Culture was already becoming increasingly central to modern social life throughout the twentieth century as leisure time expanded and consumer culture began to pervade advanced industrial economies. When Stuart Hall (1997: 209) refers to the increasing importance of culture as a long-term 'cultural revolution' – taking place throughout the twentieth century, whereby 'the domain constituted by the activities, institutions and practices we call "cultural" has expanded out of all recognition' – he is surely right to think that this process predates the restructuring processes under discussion earlier.[8] We might be wise, then, to think of the transformations since 1980 as *accelerating* processes that were already in train.

Third, all histories need to recognise the possibilities of contingency and chance. An account of the cultural industries that sees transformations there as a seamless response to economic and political crisis may well fail to acknowledge such contingency. This is particularly important in an account of industries that are based on irrational (or at least arational) aesthetic experiences. This brings us back to the unpredictable ways in which people make use of aesthetic and informational products (see Introduction). This dimension of the cultural industries makes it especially likely that certain changes in the cultural industries

8 In his important chapter, Hall uses what I believe is far too broad a definition of 'culture' which he seems at times to equate with 'discourse' or even 'meaning' (Hall, 1997: 225–6).

might come about as a result of sudden, unexpected cultural phenomena rather than be outcomes of structural economic patterns.

It would be impossible to do justice to the immense sociocultural changes taking place across the world in the late twentieth century, but we can point to those aspects of most direct relevance to the cultural industries. Two crucial issues are, first, working time versus leisure time and, second, disposable income. Harold Vogel (1998: 6) cites figures showing the huge decline in the USA in average weekly working hours between 1850 (70 hours a week) and 1940 (approximately 44 hours a week) – the years of growth during which the cultural industries made their transition from the market professional era to the complex professional era. Meanwhile, as disposable incomes have risen, the proportion of that income spent on essentials, such as food, has tended to fall (this phenomenon is often referred to as Engel's Law) and more money is spent on non-essentials, such as cultural products of the kind produced by the cultural industries.

US working hours worked per year stayed roughly even during the 1970s and 1980s. But in most countries, according to the Organisation for Economic Co-operation and Development (OECD) figures, the trend in working hours was markedly downwards during the 1970s and 1980s (see Vogel, 1998: 8). Even in the USA, though – with its relatively stable working time versus leisure time split – the time spent on media consumption has increased enormously, from 50.7 hours to 65.5 hours per week (Vogel, 1998: 9). Leisure time was dominated, to a quite remarkable degree, by one activity: television. The amount of television watched by the average American increased considerably between 1970 and 1995, from 1226 hours per person per year to 1575 (Vogel, 1998: 9). Americans, on average, spent 30 hours a week watching television (Webster and Phalen, 1997: 108). This made television by far the most heavily consumed medium in the 1990s. It represented over 46 per cent of the 65.5 hours per week spent consuming media, about the same proportion as in 1970 (Vogel, 1998: 9).

What is more, expenditure on recreation increased out of proportion to the increase in non-working time. In the USA, the figure rose from $93.8 per person per year in 1970 to $395.5 per year in 1995, expressed in 1992 dollar terms and, therefore, adjusted for inflation. This represented a doubling of the percentage of total personal consumption spending made up by such recreation spending, from 4.3 per cent to 8.6 per cent. These are the factors that most directly helped to bring about growth in the cultural industries during the period under discussion, at least in the USA. It is likely that similar developments are under way elsewhere.

TECHNOLOGICAL CHANGE: INFORMATION TECHNOLOGY AND CONSUMER ELECTRONICS

Finally, we return to the factor of change most commonly invoked in journalism and popular publishing. Technological reductionism saturates everyday discourses about the cultural industries. This means that we need to be particularly cautious in addressing technology as a causal factor, for technologies are themselves the effects of choices, decisions, contingencies and coincidences in the realms of economics, politics and culture.

Technological innovation is nothing new. It is one of the main ways in which companies (and nations) try to outdo each other in competitive markets. Technologies are more than just economic opportunities, however. Some become the repositories of hopes for a better life or symbols for anxieties about the future. Since 1980, information and communication technologies have spawned huge amounts of commentary and debate. The key development that helped to fuel media obsession with 'the information society' was the development of computer-compatible and computer-mediated communication. The resulting waves of 'digitalisation' in various cultural industries (discussed in Chapter 9) represent the most important technological development of the period under discussion in this book.

The development of the computer is, then, a vital context for understanding change and continuity in the cultural industries (the following account draws mainly on Augarten, 1984). Intensive levels of research and development in microelectronics enabled the key transformations in information technology in the post-war period. The transistor – first produced in 1948, but developed in the 1950s – allowed for the cheap and efficient control and magnification of electrical current. Computer firms realised that such transistors could provide a much more efficient way of storing and moving information than previous devices, which had been mainly based on the vacuum tube. The crucial technical challenge was to get many transistors (or their equivalents) on the same circuit in order to multiply this ability to control and magnify current and, therefore, more information more efficiently and cheaply them before. A key development, therefore, was the integrated circuit (IC), which was first produced in workable form in 1957, but was rapidly developed in the early 1960s. The IC allowed for the placing of dozens of transistors (devices which amplify electrical current) on the same surface without mutual interference. In the early 1970s, engineers at Intel developed the microprocessor, which is a whole set of integrated circuits (ICs) on one very small silicon chip. The entire functioning part of the computer could now be stored on a very small surface. It was only in the mid-1970s, however, that businesses realised miniaturisation, in the form of the microprocessor, would allow for the development of *personal* computers. Even so-called 'minicomputers' were, up until this point, envisaged as smaller versions of the vast, centralised mainframe computers that dominated the industry.

These remarkable technological developments were possible because of vast research expenditure. Why were such huge amounts of research resources diverted to advances in computing?

- First, because there were many perceived military uses for computing. The high-tech computer and communications sectors benefited from vast defence spending on computer-mediated communication. This was especially the case in the USA, where the Department of Defense was, for many years, 'centrally concerned in the development strategies of the entire US computer software business' (Tunstall, 1986: 41).
- As we have already seen, transnational corporations were expanding rapidly during the post-war period and they needed faster, more efficient communication technologies to bind their operations.

- There was the later context of the downturn in Western economies from the late 1960s onwards and, in particular, the threat to manufacturing industries in Europe and the USA from newly industrialising countries in Asia. Many Western governments and enterprises invested enormous amounts of money and resources in the development of high-tech sectors.
- The Information society discourse discussed above (see Box 3.1). This helped to feed the idea that the onward march of the computer was either beneficial or inevitable – or both. Importantly, there was a strong sense of the private and public benefits of a **do-it-yourself** (DIY) attitude as a means of countering the control of new information and communication technologies by corporations. Ironically, many of the computer enthusiasts inspired by this DIY ethos became entrepreneurs and ended up as part of large corporations themselves. The countercultural enthusiasm for hands-on computing was absorbed into capitalism, but its effects were not entirely neutralised, as we shall see in Chapter 9.

Thinking about the causes of technological innovation in this way takes us away from technological reductionism. Technologies should not be thought of as the best answers to pre-existing needs, which is the way we are often encouraged to think about them by media coverage. Instead, their evolution is determined by many choices and decisions and unintended consequences of dynamics external to the companies developing them.

To repeat the point made towards the beginning of this chapter, in the discussion on technological reductionism, conceiving technologies in this way – recognising that they should hardly ever, if at all, be thought of as the main engine of transformation – is not to deny that they have important effects. Without a doubt, the impact of the computer on the cultural industries has been profound. Computers became increasingly central to many people's working and leisure lives during the 1980s. The cost of personal computers fell sharply in the early 1980s, when Apple launched as a public company and IBM entered the market (using Microsoft software). According to Tom Forester (1987: 134), sales of personal computers went from none in 1975 to 7 million in 1983, 1.4 million of which were sold in the USA. In a decade, the number of personal computers installed worldwide grew from 200,000 to over 50 million in 1987.[9] The explosion in discussion of 'new media' dates from this period, when ownership of computers became sufficiently widespread for industry analysts, policymakers and so on to envisage a future where digitalisation would become the basis of home-based information and entertainment.[10] By the late 1980s,

9 The rise of the personal computer, mainly used for work, should not be confused with the rise of the home computer, which were fewer in number – 6 million in the USA by 1985 (Forester, 1987: 151) – and often underused.

10 Debates about new media took distinctive forms in continental Europe, where there was also great emphasis on public 'videotex' systems. Most notable was the French Minitel network. See Castells, 1996: 343–5, who as part of his celebration of American entrepreneurialism and individualism, denigrates Minitel in spite of his interesting and frank comments about his own involvement in the 'democratised sexual fantasy' of Minitel chat lines in the 1980s.

commentators were increasingly discussing the idea of convergence between three information/communication technologies and their industries: media, computers and telecommunications. I question this idea in Chapter 9 and challenge the view of digitalisation as progress.

There were other important technological developments besides those related to computers and information technology. Particularly significant were developments in consumer electronics, especially new technologies for the storage and retrieval of texts. The most notable were:

- various tape formats, of which the audio cassette and its players (Philips) triumphed
- the video cassette recorder, where a battle was fought between Matsushita's VHS format and Sony's Betamax and Philips' V2000 formats
- the personal stereo – most notably, Sony's Walkman
- the various compact disc technologies (initially developed by Philips), especially music CDs, but also CD-ROMs, as personal computers developed, and, later, DVDs.

The effects of such technologies on the way that consumers experience cultural industry products have, of course, been profound. Their success has drawn on the individualisation of social life noted by many commentators, but they have also made important contributions to extending such individualisation. Again, production contexts are important in order to avoid seeing these technologies as 'solutions' to our need for more flexibility in cultural consumption. Consumer electronics transnationals were a significant part of manufacturing internationalisation from the 1950s onwards. Such new technologies were enormously expensive in terms of research and development, but these costs were spread by selling the devices across the world. The 'best' technology did not always win. Matsushita's VHS format, for example, triumphed over Sony's superior Betamax format because of Matsushita's more effective marketing and because they agreed to license the technology rather than manufacture it under their own name.

The replacement of old formats – such as vinyl records by CDs – and the appearance of new ones has helped to create new selling opportunities for the cultural industries. The new technologies also represented threats, though. For example, they made the problem of controlling scarcity considerably more difficult. Seeing that money was to be made from text production, many consumer electronics companies were drawn into the cultural industries from the late 1980s on, with sometimes disastrous consequences (see Chapter 6).

<p style="text-align:center">***</p>

In this chapter, I have been discussing the major contexts for understanding patterns of change/continuity in the cultural industries in the last 30 or so years. The emphasis has been on factors external to the cultural industries: the end of the supposed golden age of growth and the beginning of the Long Downturn, the neo-liberal political-economic response, general changes in the business environment, of which the cultural industries were a part; social and cultural transformations; and technological developments outside the cultural

industries. I have been concentrating here on transformation, but we should note that there was also important economic, political, organisational, sociocultural and technological continuity alongside these changes. Economies continued, for the most part, to be run by national governments, even if there were increasing interconnections between different parts of the world; liberal democracy remained the model for government in the advanced industrial countries; the legal frameworks governing businesses remained fundamentally intact in these countries; people continued to work hard, worry about their children and seek pleasure in watching and participating in cultural events; radio and television remained dominant as cultural technologies throughout most of the world.

Much of this chapter has been concerned with what explains change, but what explains such continuity? Even in a time of remarkable transformation, certain structures are hard to shift. Powerful groups feel threatened by change and fight for the retention of the status quo. There is the force of habit – it often seems easier to just carry on doing things the same way. Then there are aspects of human life that are hard to change and may even be rooted in long-standing characteristics of human beings across many different societies. One such is the pleasure of having a story told to us, which can be found across many different societies, in many different contexts, even if the characteristic forms of stories vary. There are powerful forces for continuity in the internal dynamics of the cultural industries, too.

A key argument of this book, outlined in the Introduction (see pages 17–24) and expanded in Chapter 2, is that certain distinctive properties of the production and consumption of cultural goods, as opposed to other commodities, help explain why cultural production tends to be organised in particular, recurring ways. To recapitulate, the main dynamics are the high levels of risk to be found in the cultural industries, high production costs and low reproduction costs, the tensions between creativity and commerce, the way that cultural products act as semi-public goods and various distinctive responses to these conditions, including off-setting misses against hits, concentration and integration, the creation of artificial scarcity, formatting and loose/tight control of production and circulation. For all the changes of the last 30 years, including the massive expansion of the cultural industries and their increasing centrality in social and economic life, cultural businesses still have to manage these problems, which derive from the difficulties of managing creativity and information. Because the ways in which creativity and information are understood have very deep historical roots, problems and complexities surrounding the task of managing them persist and are not going to be blown away by new technologies, new organisational strategies or new market conditions. The growth and huge profitability of the cultural industries suggest that owners and managers have been largely successful in their strategies for controlling cultural production and consumption. But the management of creativity remains a fraught business. And the problems faced by cultural industry corporations continue to push business strategies in certain directions rather than others.

Part Three attempts to distinguish fundamental changes from superficial changes in a number of key aspects, setting continuity against transformation and separating out different types and rates of alteration. Before then, though,

Part Two outlines crucial policy changes that were to have an important effect on cultural production from the 1980s onwards.

FURTHER READING

David Harvey's book, *The Condition of Postmodernity* (1989), remains a scintillating read about the relationship between economic, political and cultural change, even if it sometimes overemphasises the causal effects of economic dynamics and underplays cultural effects (see Meaghan Morris' brilliant 1992 cultural studies critique).

Scott Lash and John Urry's *Economies of Signs and Space* (1994) has a similar breadth, although it drifts into social theory jargonese at times.

I am critical of some of the work of Manuel Castells elsewhere in this book, but his trilogy *The Information Age* (1996) is immensely exciting and stimulating.

David Held et al.'s *Global Transformations* (1999) is an important contribution to debates about globalisation and a treasure trove of information.

I have found Robert Brenner's work in *New Left Review* (1998; 2000) cogent and informative about economic change in the post-war era.

An enjoyable and provocative book about technological change relevant to the cultural industries is Brian Winston's *Media Technology and Society* (1998), which even manages to be funny at times.

Raymond Williams' opening chapter in *Television: Technology and cultural form* (1974) has no jokes whatsoever, but still has more to say about technology than most of the books published about the Internet put together.

PART TWO

POLICY CHANGE

4 MARKETISATION IN TELECOMMUNICATIONS AND BROADCASTING

It is impossible to understand the cultural industries and the changes in them over the last 30 years without knowledge of shifts in government policy. The changes in policy with the most far-reaching consequences for the cultural industries since 1980 have been in the telecommunications, media (especially broadcasting) and cultural policy domains, so this chapter and the next are devoted to them (see Box 4.1 for the definition of 'policy' being used here). In outlining these changes, I draw on the account in the previous chapter of contexts for change and continuity in the cultural industries. The most important of these contexts are the rise of neo-liberalism and, more specifically, the rise of neo-liberal information society thinking and rhetoric.

BOX 4.1 DEFINING POLICY IN COMMUNICATIONS, MEDIA AND CULTURE

In all areas of commercial life, governments intervene. The free market does not exist in modern, complex societies but is merely a goal aspired to by those who believe that the market, in its ideal state, is the best way to distribute resources and answer human needs. Even those national economic systems based most on private enterprise, such as the USA, are built on a huge foundation of laws concerning competition, tax, contracts, the obligations of companies and so on. They also rely on government funding of infrastructures (transport, energy, money and communications) and regulation of companies to ensure that market powers are not abused. As Thomas Streeter (1996: 197) suggests, however, the false opposition between government and markets often prevails, with the frequent result that 'political action of any kind is popularly assumed to be "government interference"', at least in the USA.

Governments intervene in communication, media and cultural markets in three main ways. They:

- *legislate*: that is, they create laws concerning the general issues mentioned above, such as competition and contracts, plus more specifically cultural issues, such as copyright, obscenity, privacy and so on, and these are subject to constitutions and to the decisions of courts
- *regulate*: via these laws, governments create agencies that monitor a particular industry or group of industries and have powers to affect the behaviour of companies and other institutions and actors
- *subsidise*: directly, via grants in order to supplement the provision of texts provided by the private sector, in areas such as theatre, ballet, opera, fine art and so on, or indirectly, by allowing research and other knowledge created in the public sector (especially defence) into the private sector.

These constitute the three main elements of **government policy** in telecommunications, media and culture. Government policy operates at the international level (for example, the EU), national level (individual national governments), subnational regional level (for example, state government in the USA or Germany, or the North West region of England), and at the level of cities and towns.

The relations between the three domains of policy that I focus on here – telecommunications, media and cultural policy – are complex. The terms are used in different ways in different countries and the boundaries between them are often vague or porous.

Telecommunications, like the other major economic infrastructures (transport, money, energy), have long been fundamental to the operation of businesses within modern societies, but in a world where government economic, education and even social policy fields are increasingly affected by information society discourse (see Chapter 3) telecommunications have become even more central than before. Policymakers have generally accepted the information society view that those nations with the most advanced telecommunications systems are likely to be most competitive in a new global information-driven market. Telecommunications is not a cultural industry in the sense that I define it in this book; but developments in telecommunications policy have had a profound impact on cultural production.

In many countries, what is generally referred to as media policy has in fact consisted of a number of distinct policy areas directed towards individual industries – broadcasting, the press, film and so on. Many information society visions of the economic future placed considerable emphasis, from the 1970s onwards, on multimedia convergence between telecommunications, computers and media – especially, in the latter case, broadcasting. Broadcasting has dominated people's leisure activities in advanced industrial countries and still does so, even in an era where the PC and the Internet are increasingly important (see Chapter 9). For this and other reasons to be explained in what follows, governments have made fundamental changes to broadcasting policy and so I concentrate on these changes here. These changes have been closely intertwined with transformations in telecommunications policy.

Understanding the various overlapping policy shifts that have most affected developments in cultural industries requires consideration of the relationship between the state and private businesses in the formation of government policy in general. Box 4.2 briefly outlines my assumptions, borrowing terms from David Marsh's critique of pluralist political theory (2002) and Robert Horwitz's impressive discussion of regulation in the USA (1989).

BOX 4.2 HOW POLICY WORKS

I assume in what follows that policy is shaped by a number of factors that have complex relations with each other (see Marsh, 2002).

- Particularly important is the balance between social forces, which is in turn deeply affected by structured inequality (along class, gender, ethnic and other dimensions) within and between societies and by the different resources available to agents.
- But policy is not utterly at the mercy of the wealthy and powerful. Political institutions and processes have some autonomy. To some extent at least, democratic governments need to retain legitimacy with those classes and groups (the working classes, peasants, ethnic minorities) excluded from the political 'mainstream'.

(Continued)

(Continued)

- Political problems and solutions are discursively constructed and this construction is an important site of contestation, but here, too, structured inequality is at play.
- An important, but not determining, feature of public policy formation is the strategic alliances made by political parties with other social institutions. Large corporations, with their enormous financial and communication resources, are particularly significant in this respect. Political parties in advanced industrial countries are unlikely to achieve power without the support of such businesses.
- However, there is no need to assume that businesses necessarily intervene directly in the policy process (although, of course, they often do)as policy on key matters is often formulated *in anticipation* of corporate business reaction. Also, businesses often clash on what policies they prefer – especially businesses in different industrial sectors.
- In general, policy bodies in modern capitalism work towards combining the accumulation of capital on the part of businesses with a certain degree of popular legitimation, as emphasised by neo-Marxian state theory. However as Horwitz (1989) points out, an analysis of the origins of state policy agencies in particular balances of social forces does not always account for how they operate in practice.
- Policy needs to be understood as operating at both national and international level (see Sinha, 2001).

Throughout this chapter and the next, in outlining policy changes that were to have a significant effect on cultural industries,[1] I refer to these relationships between the state, political parties and businesses at both national and international levels. The story I tell is one of a general but not total victory of neo-liberal marketisation, especially in the form of information society discourse. First, I discuss what I mean by marketisation of telecommunications and broadcasting and why I prefer the term to 'deregulation'. Then, I examine the rationales for state intervention in telecommunications and broadcasting that had prevailed for much of the twentieth century (focusing here on advanced industrial countries) and explain the process by which neo-liberal discourse dismantled these rationales in the 1980s, clearing the way for the onset of marketisation. Chapter 5 then goes on to address the importance of changes in copyright law and practice and how the neo-liberal information society discourse operated in arts and cultural policy.

Throughout, I emphasise conflicts over all these processes. The triumph of information society neo-liberalism had to be struggled for. It is not a complete victory for all time – it can be reversed – but, as I discuss at the end of Chapter 5, it has interacted in complex ways with other changes to be discussed in later chapters – in some cases paving the way for them. There has also been a shift in

1 Effects that are explored in Chapters 6–10. Of course these changes had reciprocal effects on policy, but, because I believe that policy was so important in creating initial dynamics, and for the purposes of clear exposition, I deal with policy first here.

the relations between culture and economics, art and capitalism. Whether this is an epochal change, of the kind claimed by information society rhetoric, is more doubtful, but this can only be judged after considering those other changes.

DEREGULATION, RE-REGULATION AND CULTURAL MARKETISATION

We saw in Chapter 3 how neo-liberal political doctrine spread across the world in response to the Long Downturn. During the 1945–1973 period, there had been some consensus among political parties across the political spectrum about the need to protect workers and consumers from actions undertaken by private companies in pursuit of profit. In some countries and in some sectors, this involved the nationalisation of private companies. Neo-liberalism, from the 1970s onwards, using the false government/market dichotomy discussed in Box 4.1, presented public ownership and close regulation as the causes of the economic downturn and undertook programmes of privatisation and regulatory change. The neo-liberal term for such programmes was often *deregulation*, but in some cases the term *liberalisation* was preferred.

The rhetoric of deregulation and liberalisation was particularly powerful in the cultural industries because the notion of freedom from government intervention fed on anxieties about government interference in personal and political expression. The right to free expression of views is a fundamental aspect of democratic liberal thought and, superficially, government regulation might appear to undermine such rights. However, terms such as deregulation and liberalisation can potentially confuse the removal of censorship with measures that are actually intended to increase the access of citizens to a wider variety of personal and political expression, such as restrictions on how many local stations a national network might own (in the USA) or what percentage of the national newspaper market one company's newspapers might reach (in the UK).

Some analysts of the cultural industries have argued, in response to this use of the term deregulation, that **re-regulation** is a more appropriate name for changes in media and communications policy in the 1980s and 1990s (such as Murdock, 1990: 12–13). The term 're-regulation' points to the fact that legislation and regulation were not removed by these changes and highlights the introduction of new legislation and regulation, much of which favoured, as we shall see, the interests of large, private corporations and their shareholders. As governments tried to negotiate competing interests during the deregulatory years of the 1980s and 1990s, in many cases they actually introduced new and more complex sets of regulations. The UK, as Peter J. Humphreys showed (1996: 191), introduced a number of new regulatory bodies, including the Broadcasting Complaints Commission (1982) and the Cable Authority (1984) during an era when it was supposedly beginning to deregulate. Equally France's deregulatory legislation of the mid 1980s created a complex network of rules.[2] For all its advantages,

2 Digital television has involved very high levels of government intervention. Hernan Galperin (2004) calls this 'the digital paradox': why were such high levels of government regulation considered necessary in an era of 'deregulation'? I consider digital TV policy in Chapter 9.

however, the term 're-regulation' also disguises an important issue, as Humphreys points out. This is that much new legislation and regulation did in fact legitimate 'a lighter touch' – the creation of a business environment in which commercial cultural industry companies could operate in a relatively unhindered way. Often, the interests of such companies are not necessarily conducive to a fair and equitable system of cultural production, in the terms developed in Chapter 2.

The terms 'loose' and 'tight' and 'light touch', as opposed to 'tight' regulation, may go some way towards avoiding the misleading implications of the terms 'deregulation', 'liberalisation' and 're-regulation', so I use them here, but these terms, too, have misleading positive connotations, as if governments should just lighten up, get loose and let businesses get on with what they do (business as teenager, government as oppressive parent). The term I prefer to describe the main thrust of policy changes of the period from 1980s onwards is *marketisation*. In general, the term refers to 'the permeation of market exchange as a social principle' (Slater and Tonkiss, 2001: 25), a long-term process taking place over many centuries, involving commodification, the increasing use of money as the basis of exchange and increasing division of labour. Different theorists stress these and other elements to different degrees. In modern capitalist societies, market and non-market relations coexist, but market relations dominate in terms of how society is coordinated and organised. Here, though, I use the term more specifically to refer to the process by which market exchange increasingly came to permeate the cultural industries and related sectors. This involved a number of processes, but three stand out:

- *privatisation* of government-owned enterprises and institutions, many of which were once privately owned
- *lifting of restraints* on the activities of businesses so that they can pursue profit more easily
- *expansion of private ownership* as a result, together with other changes in law and regulation that allow this to occur.

There is nothing wrong with markets in themselves. They can potentially act, in certain cases and in certain social systems, as efficient and equitable allocators of resources. For many critics of neo-liberal marketisation, thought, markets in modern complex capitalist societies need managing carefully by governments to ensure efficiency and equity. For a Marxian perspective, marketisation is closely linked to the steady commodification of more and more areas of social life – a commodification that, as we saw in Chapter 2, is viewed by Marxian analysts as an essential but highly problematic feature of capitalism. A different view prevailed among policymakers from the 1980s onwards as outlined in Chapter 3 – the neo-liberal view that the production and exchange of cultural goods and services for profit is the best way to achieve efficiency and fairness in the production and consumption of texts.

Let's now examine how such neo-liberal marketisation entered telecommunications and broadcasting policy. First, we need to establish the prevailing situation in a previous era of policy – that is, prior to the 1980s.

TELECOMMUNICATIONS AND BROADCASTING: – WHY WAS THE STATE SO INVOLVED?

Until the 1980s, in liberal democracies as well as authoritarian states, most of the world's broadcasting and telecommunications organisations were owned and controlled directly by the state. Even in the USA, with its long tradition of preferring private enterprise to public ownership, broadcasting and telecommunications were, for many decades, subject to tight regulation by government bodies.

Why were broadcasting and telecommunications more subject to public ownership and tight regulation than cultural industries such as newspapers, film and music? We can divide the reasons into three, generalising broadly across very different political and cultural contexts:

- an understanding of telecommunications as a public utility
- an understanding of broadcasting as a limited, national resource
- an understanding of broadcasting as powerful and, therefore, in need of control.

TELECOMMUNICATIONS AS A PUBLIC UTILITY

In most nations in the early twentieth century, telecommunications (mainly telegraphs and telephones) were widely recognised as something that, in principle, the state would want to make available to their entire populations in order to foster national identity and encourage economic development. In most liberal democratic states and their colonies, the responsibility for organising telecommunications was passed to the authorities charged with dealing with the postal system. In some European countries, national post organisations expanded to become postal, telegraph and telephone authorities (PTTs): for example, the General Post Office in the UK, the Reichpost and, after the Second World War, the Bundespost, in Germany, the Direction Générale des Telecommunications in France, and so on. In the USA, where businesses were especially fervent and successful in their resistance to democratic regulation of markets, the private company AT & T (American Telephone and Telegraph Company) was allowed to act as a private monopoly covering nearly all of the USA. US policymakers used their own distinctive language, whereby telecommunications were treated, like the roads and railway lines, as a 'common carrier' – that is, a system or network that had to carry any messages, vehicles and so on, paid for by customers, within certain legal boundaries. The justification for AT&T's monopoly was that the high costs of installing telephone infrastructure meant it was a 'natural monopoly' and that such a monopoly, closely regulated by government, was the best way of achieving standardisation, high quality and, thus,'universal service' in providing a common carrier.[3] In return for being granted such a monopoly, until its partial

3 'Universal' did not mean that everyone had equal access. It took decades for poorer sections of the population to reach high rates of installation and then it was as a result of lowering costs rather than commitment on the part of government or company (Aufderheide, 1999: 16; Garnham, 1996: 3.)

break-up in the 1980s, AT&T accepted close regulation of its prices and a ban on its being involved in the production and distribution of programming.

BROADCASTING AS A NATIONAL RESOURCE AND A LIMITED ONE

Radio was developed as a form of one-to-one communication, envisaged as something like a telephone or telegram of the airwaves, rather than as the broadcasting (one-to-many) form it became. It was widely used by the military and increasingly by amateurs for personal communication in the 1910s and was essentially unregulated. In the early 1920s, private companies in a number of countries began to experiment with broadcasting music and other entertainment. In the USA, a radio craze developed, but the airwaves remained unregulated for years, causing chaos and bad reception more or less everywhere.

In many countries in Europe, however, the public ownership and regulation of national resources and utilities, such as gas, water, electricity and postal services, were considered desirable. The responsibility to provide a public service was an increasingly important part of many national cultures, even if, in many cases, such as that of the UK, this involved a 'paternalist definition of both service and responsibility' (Williams, 1974: 33). It seemed natural in many European states, therefore, that radio should be run, or at least overseen, by PTTs. This seemed particularly the case given *spectrum scarcity* – that is, the situation that frequencies used to transmit radio messages were very limited. Even in the USA, with its already strong tradition of resistance to regulation, it became widely accepted that the state had to be closely involved in the allocation of spectrum space, so that broadcasters did not overlap on the same frequencies, ruining the radio experience. As a result, a Federal Radio Commission was finally introduced in 1927.

Eventually, in most countries, new bodies were formed to govern broadcasting. Many were initially under the auspices of PTTs, but eventually developed their own autonomy, including the British Broadcasting Corporation (BBC) and various similar organisations (some of them modelled after the BBC), such as the CBC (Canadian Broadcasting Corporation). When television, which of course relied on radio waves for transmission, was introduced, its regulation was often passed on to these state organisations or, in some countries, a dual system of public service and commercial television was established, as in Australia and Japan in the 1950s.

THE POWER OF BROADCASTING

When radio became a broadcasting technology rather than one for point-to-point communication, its potential social power quickly became apparent, both commercially (in terms of its power to advertise and promote goods) and politically (in terms of its power to affect people's voting habits and attitudes towards democratic goals and procedures). In nearly all countries, it was accepted that the state, again via democratic accountability, should be the agency to ensure that these powers were not abused. In some countries, such as post-1945 France, this meant very strong and direct state control of the main broadcasting organisation. In the UK, the BBC was (from 1926) a public corporation, governed by a Royal Charter that laid out its

mandate and by governmental appointees. Even in countries such as the USA or in post-war Luxembourg, which favoured private enterprise, high levels of government regulation were widely accepted compared with those in operation in other business sectors, largely because of radio's perceived power. When television became widely popular and available in the 1950s and 1960s, its obvious potential social power meant that it inherited legislative and regulatory frameworks from radio.

THE 1980S: THE RATIONALES ARE DISMANTLED, MARKETISATION FOLLOWS

By the 1980s, the rationales behind such high degrees of government intervention in broadcasting and telecommunications were breaking down. We saw in Chapter 3 how the rise of neo-liberalism in the 1980s helped to delegitimate public ownership and certain forms of regulation in nearly all forms of economic activity. We also saw how commercial companies in Europe and North America, observing diminishing margins in manufacturing, were becoming increasingly aware of the potentially greater profits to be made in the cultural, communication and leisure industries. They put increasing pressure on national governments to remove restrictions on access to certain markets – in particular telecommunications and broadcasting, which had previously been very closely regulated.

All of the major rationales for broadcasting and telecommunications policy came under ferocious attack in the 1980s and 1990s – especially from private corporations and from policymakers and commentators who supported their interests. These interest groups argued instead for marketisation. They attacked each of the rationales listed above in the following ways.

CHALLENGE TO TELECOMS AS UTILITY RATIONALE

Various agencies and interests (along with influential academic analysts, such as Pool, 1983) argued, especially from the 1970s onwards, that the need to provide telecommunications as a national utility (or common carrier, as the concept is called in the USA) no longer applied because telecommunications services were now already widespread among the populations of the advanced industrial countries. They increasingly argued that telecommunications needed to be opened up for national and international competition. This would, claimed the neo-liberal proponents of marketisation, increase the efficiency of the sector by exposing it to the rigours of the market. This would, in turn, provide more advanced services that could help to drive the economies of these countries out of their Long Downturn. Large telecommunications companies and senior executives of PTTs (who stood to become enormously wealthy out of privatisation) were particularly keen to make such arguments. They nearly always claimed that they also needed protection from the rigours of the market in the form of limitations to the entry of new rivals, so that they could compete with other large companies in the international market. Such contradictions in the discourses of marketisation have been a consistent feature of the policy landscape in the past 30 years.

CHALLENGE TO BROADCASTING AS SCARCE, NATIONAL RESOURCE RATIONALE

Instead of the limited part of the electromagnetic spectrum available for analogue broadcasting, new cable, satellite and digital technologies potentially offered almost limitless capacity for the transmission of information and entertainment. The proponents of neo-liberal marketisation claimed that new communication technologies meant that spectrum scarcity was coming to an end and state intervention in broadcasting on the grounds of ensuring clear signal reception could therefore no longer be justified. These claims were based on a highly strategic use of technological reductionism. Technology did not delegitimise existing policy in itself. Rather, these technologies should be seen as the result of investment decisions by private corporations. Cultural industry corporations and their political allies were able to present such new technologies as inevitable motors of change, which required new forms of looser regulation to allow companies to compete in national and global markets.

CHALLENGE TO THE POWER OF BROADCASTING RATIONALE

It became increasingly difficult for the advocates of public service and/or the public interest to argue that public ownership or tight regulation of television was justified by the medium's power of influence and persuasion. By the 1980s, corporations were involved in an enormous range of cultural enterprises. Why, they asked, were they excluded from entry into television – the most important (and lucrative) of all media forms? Television had become thoroughly absorbed into the fabric of everyday life. Although television was still authoritative and the cause of great concern over its social and behavioural effects, arguments that viewers needed to be protected from the medium were increasingly difficult to sustain. However, calls for the ending or relaxing of public ownership and regulation tied this sense of television's declining power to a different and much more problematic rhetoric – that existing systems of broadcasting provided insufficient choice for the viewer and the best way to increase choice was to provide more (commercial) channels (the Peacock Report, 1986, was one important British formulation of such a view).

FOUR WAVES OF MARKETISATION

As a result of the successful delegitimation of rationales for public ownership and regulation, the 1980s and 1990s saw extremely important historical changes in the policy landscape.

- telecommunications authorities were privatised and national telecommunications markets were opened up to competition, in particular from cable and mobile operators.
- some public broadcasting institutions were privatised
- even where public broadcasting institutions remained in place, television systems were opened up to other terrestrial, commercial broadcasters and, increasingly, to cable and satellite providers.

- regulatory 'walls' between telecommunications, broadcasting and new media (such as cable and satellite) companies came down, so telecoms and cable companies were allowed to enter into television markets, cable television companies were allowed into telephony and so on
- marketisation created new contexts for the understanding of cultural policy in an era of technological innovation, so, when new communication technologies were introduced or disseminated more widely, they were often assumed to need minimal legislation and regulation beyond competition laws and rules
- restrictions on content were significantly relaxed, such as on the amount of advertising allowed per hour, and how much educational programming broadcasters were required to transmit and at what times
- laws and regulations governing media ownership were removed or relaxed
- subsidies to non-profit and public-sector cultural institutions, such as libraries, museums, theatre, film and so, on were reduced (see the discussion of cultural policy in Chapter 5), which made further space for private companies in cultural markets by opening up new market opportunities (for example, in providing private information databases) and reducing competition (for example, by reducing the number of films made in most European countries and, therefore, allowing Hollywood films even more access to European markets).

Specific examples of such changes in different countries are provided in the historical account that follows. These changes in cultural industry policy played a crucial role in initiating and accelerating many of the changes that are the subject of the rest of this book. It cannot be emphasised enough that these changes were consciously and deliberately brought about in order to support the interests of large, commercial, cultural industry companies. Governments did this because they wanted their own cultural industry companies to be able to compete in a new global cultural industries sector. Any suggestion that they were made inevitable by, for example, technological change or some external process known as 'globalisation' disguises the willed and intentional nature of these changes (though they had many unintended and unanticipated consequences).

The next four sections discuss four waves of marketisation, as follows (see also Figure 4.1).

- The policy changes with the most profound consequences in terms of marketisation initially took place in the USA from 1980 onwards.
- Changes there had an important influence on changes in other advanced industrial states, in Western Europe, Canada, Australasia and Japan from the mid-1980s, but, of course, with significant national and regional variations.
- Then, a number of countries with more authoritarian traditions of state control and ownership initiated policies of marketisation and 'liberalisation'.
- Finally, a further round of policy changes involved paving the way for convergence between telecommunications, media and computers. Especially important here have been trade agreements and policy bodies that have pursued marketisation at an international level.

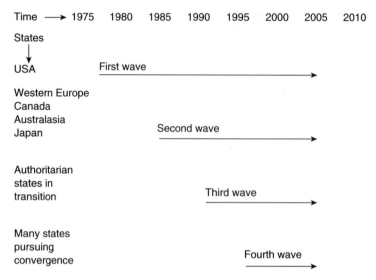

Figure 4.1 Four waves of marketisation

THE FIRST WAVE: CHANGES IN COMMUNICATIONS POLICY IN THE USA, 1980–1990

The state had a significant role in the development of radio in the USA and the setting up of RCA (later, owners of the television network NBC and the record company that released Elvis Presley's records). However, in its 1934 Communications Act, the USA radically departed from the norm in other liberal-democratic countries, whereby governments would have a very pronounced role in media and telecommunications ownership and regulation.[4] The Act set up the Federal Communications Commission (FCC) to monitor 'public interest, convenience and/or necessity' (originally a phrase used in the 1927 Radio Act). A dual system of media and telecommunications regulation was created In radio and, later, television, broadcasters were given access to scarce spectrum in return for promising to serve this 'public interest, convenience and/or necessity'. There were restrictions on how many television stations these programme-making broadcasters could own nationally, but locally owned stations across the USA affiliated themselves to what eventually (from 1955 to 1985) became a trio of major networks: NBC, CBS and ABC.[5] These companies formed a de facto vertically integrated national oligopoly. Their revenues came mainly from

4 Robert W. McChesney has shown how various commercial and right-wing interest groups played a crucial role in ensuring this outcome during debates over the best way to organise telecommunications, during the 1927–35 period (see McChesney, 1993, 1999: Chapter 5).

5 A fourth network, Dumont, lasted until 1955. News Corporation's Fox network began in 1985, and had established itself by 1991. Time Warner and Viacom established new networks in the 1990s – WB and UPN respectively.

advertising rather than a radio or television licence fee, which was the system favoured in Europe and elsewhere.

Meanwhile, in telecommunications, as we saw earlier, AT&T was granted monopoly control in the interests of efficiency. In return, they agreed not to have any involvement in content creation and circulation. The first big change in telecommunications regulation relevant to the main period covered by this book came in 1982, as a result of a Justice Department case against AT&T first brought in 1974 (which is typical of how slowly US regulation works – see Box 4.3). AT&T agreed out of court to be divested of their local business and opened up for competition in long-distance markets. In 1984, as a result of this divestiture, seven 'Baby Bell' local phone companies were formed. Some of these have become key players in the 'converging' telecommunications, media and information technology markets of the late 1990s and early 2000s. In return for agreeing to this divestiture, AT&T were allowed access to information and computer markets that they were previously forbidden from entering. Developments in the regulation of telecommunications took many years to have an effect, so I return to these in the chapters that follow.

BOX 4.3 THE PECULIARITIES OF BROADCASTING REGULATION IN THE USA

One notable feature of broadcasting policy in the USA is that very little legislation has ever been passed by Congress. Indeed, the Telecommunications Act of 1996 was the first major piece of legislation since the Communications Act of 1934. Many of the biggest decisions affecting communications have been 'made by Federal Judges adjudicating in merger and anti-monopoly cases' (Tunstall and Machin, 1999: 41). Such cases are often brought by the Federal Trade Commission or Justice Department rather than the Federal Communications Commission. (FCC)

Chad Raphael (2005) adds a new twist to the view that the role of the FCC is sometimes overstated. He argues that the recent history of regulation in the USA should be seen not as a move from stringent government oversight to a long process of deregulation, but as the gradual *privatisation* of regulation. Raphael shows that television journalism is now overseen less by the FCC, Congress and the executive branch of the government, than it is by tort law, public relations campaigns and market pressures.

Changes in broadcasting were more immediate in their impact than those in telecommunications. The most significant changes in policy took place in regulation rather than legislation (with the exception of the 1984 Cable Act) and were brought about by a change of personnel at the FCC. During the period in which television developed into a national mass medium, (1945–1970), the FCC clashed with the broadcasters on a number of issues, most notably over 'the Fairness

Doctrine' – the rules by which the FCC tried to ensure that broadcasters would not abuse their power by acting as biased advocates. By the 1970s, the FCC had moved away from tight regulation of media content, but in general retained strong controls of structural issues, such as restrictions on concentration, cross-media ownership and convergence.

The far right administration of President Ronald Reagan (1981–1989) appointed a zealous neo-liberal conservative, Mark Fowler, as chair of the Commission. Fowler's FCC did away with numerous controls on concentration, leading to a surge in merger and takeover activity in broadcasting in the 1980s (Sterling and Kittross, 2002: 500, 575–7). It largely repealed the Fairness Doctrine in the late 1980s and, among other consequences for content, this helped to lead to the rise of right-wing talk show hosts on radio. Meanwhile, it took a harder line on issues of obscenity than ever before, leading to a series of conflicts with shock-jocks such as Howard Stern. Limits on the amount of advertising allowed per hour were relaxed and, in general, the FCC encouraged an atmosphere in which the public interest – never defined – was equated with the economic prosperity of US commercial enterprises.

The shift towards marketisation in the USA was the result of a struggle over how to regulate and organise cultural production at a time when capitalists were increasingly looking to invest in culture as a means of returning profit. Jeremy Tunstall (1986) showed in a contemporary study how this struggle was to a very large degree waged within specific areas of Washington DC by interest groups and their lobbyists. The pro-marketisation interests included, for example, the broadcasters, represented by their trade association, the National Association of Broadcasters and the various cable companies, who succeeded in gaining ground in the early 1980s. Against them were ranged various groups seeking to represent the 'public interest', such as civil rights, consumer groups and church activists (see Aufderheide, 1999: 18–19 for details on such public interest groups). Some of the pro-marketisation forces had, in certain respects, competing interests and most were in favour of marketisation as it would serve their own interests, above all else (see Chapter 2). However, they were united by a shared neo-liberal commitment to the free market – that is, unregulated private business, the notion of supposed consumer sovereignty and choice (as opposed to citizens' rights) and the goal of economic efficiency by means of competition. We have already seen the core arguments mobilised by these interest groups and their political allies on the radical right against traditional forms of communications policy – the need for competition to encourage efficiency, the supposed breakdown of spectrum scarcity as a rationale for regulation and the privileging of consumer choice over citizens' rights. They drew on and provided an important part of, the turn to neo-liberalism.

Together, these changes made it clear that government policy was moving in a direction that would be highly favourable to corporations looking to expand their interests in the cultural industries. What is more, the success of companies and conservative politicians in dismantling special regulatory apparatuses in the USA, especially in broadcasting, gave great encouragement to companies and policymakers elsewhere with similar goals.

THE SECOND WAVE: CHANGES IN BROADCASTING POLICY IN OTHER ADVANCED INDUSTRIAL STATES, 1985–1995

Historically, the liberal democracies of Western Europe, Australasia, Canada, Japan and other countries have followed a very different route from that taken by the USA in telecommunications and broadcasting policy. In these countries, to different degrees, telecommunications have been run essentially as public utilities and, rather than a very loosely defined notion of public interest, as in the USA, the key concept in broadcasting policy has been *public service*. One of the most significant changes in the cultural industries in the 1980s and 1990s has been the dismantling of this public utility/public service mix. Marketisation in telecommunications is addressed in the section on the fourth wave of marketisations, which was towards convergence and internationalisation, but, here I focus on the challenge to non-commercial broadcasting in advanced industrial states.

In advanced industrial countries, television was the most important cultural industry of the late twentieth century, in terms of both the sheer amount of time people spent watching it (see Chapter 3) and its cultural significance. The marketisation of television in these countries has already had enormous effects on the cultural industries, not only in the states themselves, but in many other places, too. The pulling apart of public service television has important implications for the social relations of cultural production and for the texts produced by the cultural industries.

DEFINING CHARACTERISTICS OF PUBLIC SERVICE BROADCASTING SYSTEMS

The key features of public service broadcasting (PSB) as outlined by its advocates (see Blumler, 1992: 102; Brants and Siune, 1992; Tracey, 1998: 26–9) include the following.

- *Accountability to the public* (via their political representatives) beyond that provided by market forces.
- *Some element of public finance* mainly carried out via a licence fee. In 2004–2005 this was about £10 (about US$16) per month in the UK, and about 17 euros per month (US$20.64) in Germany. Revenue for public broadcasters can include commercial income from advertising and the sale and licensing of programmes and formats to other broadcasters. But, importantly, all profits must generally be fed back into programming or administration, whereas in a private system a large chunk must be paid to shareholders. In the UK, the annual TV licence fee pays for the BBC's public service radio and Internet provision, as well as television.
- *Regulation of content* including restrictions on advertising, violence and pornography (a feature of regulation of private broadcasting), but also rules concerning balance, impartiality and the serving of minority interests,

the obligation to provide educational programming and programming for all regions of a country.

- *Universal service* across all the territory of a nation and a 'comprehensive remit' (Blumler, 1992: 8) requiring public service broadcasters to encourage and satisfy the tastes of the full range of people in a society.

- Perhaps the most important feature of all in this context is that *audiences are addressed primarily as citizens*, rather than as consumers – at least at some key moments. This is reflected in the provision of mixed and pluralistic schedules, whereas in a consumerist system schedules would be determined primarily by the imperative to maximise ratings and/or profits. In Blumler's terms, public broadcasters were charged with the responsibility of maintaining the cultural wealth and diversity of a nation. This concern with citizenship is also apparent in the way that, in Blumler's words (1992: 12), PSB 'assumed some responsibility for the health of the political process and for the quality of public discourse generated within it'. This meant, in general, a commitment to 'distance from vested interests', even if that was not always achieved, especially in times of war, conflict or crisis.

VARIATIONS IN PUBLIC SERVICE SYSTEMS

Of course, there were many variations on this generalised system of PSB. As Humphreys (1996: 177–8) observes, many of these differences can be explained by the very different political cultures in the countries involved. There is no space to provide a full classification of national differences here (details can be found in many comparative studies, including Humphreys, 1996; Hoffman-Reim, 1996; Raboy, 1997; Goldberg et al., 1998; Kelly et al., 2004), but the most important variations include the following.

- *Funding of the television system and public service channels within it* In most liberal democracies, television began as a public monopoly, funded only by a licence fee, consisting of just one channel. Further channels were added in the 1960s and 1970s. By 1980, most of these channels had begun to mix advertising with the licence fee. By 1990, as part of the changes to be discussed in this chapter, many countries had shifted to a mixed revenue (licence fee/advertising) public monopoly, but a roughly equal number had shifted to a dual system of public broadcasters alongside commercial channels (see Table 4.1). This represented a huge expansion of opportunities for cultural industry corporations in the television market, with important consequences for the cultural industries as a whole.

- *State control of public service broadcasters* In some liberal democracies, such as France (up to 1982) and Greece, there was direct state control of the broadcasting organisation. Much more commonly, public corporations, such as the UK's BBC, Australia's ABC, NHK in Japan and CBC in Canada, were set up in order to be generally autonomous of the state, though key appointments might be made by the government.

- *Relationship to political institutions* In some countries, such as Austria, the governors of public broadcasters were appointed in proportion to the

Table 4.1 Changes in television funding systems

System	1980	1990	1997
Public monopoly/ licence fee only	Belgium, Denmark, Norway, Sweden		
Public monopoly/ mixed revenue	Austria, Finland, France, Germany, Greece, Iceland, Ireland, The Netherlands, Portugal, Switzerland, Spain	Austria, Denmark, Iceland, Ireland, The Netherlands, Portugal, Switzerland	Austria, Ireland, Switzerland
Private monopoly/ advertising only	Luxembourg	Luxembourg	Luxembourg
Dual system	Italy, UK	Belgium, Finland, France, Germany, Greece, Italy, Norway, Spain, Sweden, UK	Belgium, Denmark, Finland, France, Germany, Greece, Iceland, Italy, The Netherlands, Norway, Portugal, Spain, Sweden, UK

Source: Siune and Hultén, 1998: 27

strength of the political parties in the country. In many countries, there were places on boards for non-political appointees from other sectors, such as trade unions, church groups and universities.

- *Programming styles* It would be a mistake for readers from countries such as the USA – where public service broadcasting is positioned as a worthy supplement to an overwhelmingly commercial, weakly regulated system – to think that public service broadcasters served up a programming diet consisting purely of highly serious, educational programming. The whole point of PSB was that it should be mixed and diverse, though how this worked on a day-to-day level varied from country to country.

THE SOCIAL AND CULTURAL ROLE OF PSB

To what extent did PSB systems promote social justice in the terms presented in the model in Chapter 2? From the 1950s right into the 1980s, PSB was subjected to considerable criticism from the political left. It was criticised for its pseudo-objective notion of balance and impartiality in current affairs coverage (Glasgow Media Group, 1976), for management policies and labour relations that reproduced class power (Garnham, 1990: 128–31) and for its failure to provide programming that appealed to working-class or non-elite audiences (Ang, 1991). In the 1950s and 1960s, in countries where advertising was not allowed but government support was low (such as the Scandinavian countries), lack of funds meant a heavy reliance on imported television programming and, often, low-quality domestic TV production.

Yet, the achievements of PSB should not be underestimated. One laudable result was near-universal service. Huge amounts of money were spent ensuring

Table 4.2 Marketisation interest groups in Europe

The pro-market actors	Their interests
The electronics industry	To exploit markets for new TV sets, pay-TV decoders, satellite reception equipment, etc.
The cable and satellite television lobbies	Freedom to provide commercial services
PTTs	To develop and diffuse new media technologies and maintain monopoly or dominant market position in telecoms provision
Newspaper publishers	To diversify media operations and pre-empt further competition for advertising revenue[1]
Advertisers	To gain outlets and strengthen market position
Governments	To promote the economy and attract media investors
Parties of the Right	Pursuit of neo-liberal agenda and promotion of business interests
European Commission	To liberalise European markets

Public service supporters	Their interests
Public service broadcasters	Self-defence, continuance of public resources, etc.
Unions	Protection of employment and conditions of employment
Parties of the Left	Promotion of public service ethos and communitarian values, promotion of labour interests

[1] Not universally the case. In some countries the press remained a force resisting commercial broadcasting.

Source: Humphreys, 1996: 176

that remote regions were given access to national broadcasting systems, which would have been unthinkable in a commercial system. There was also a constant commitment to providing regions with access to the national system. Some public service broadcasters even achieved occasional flashes of high-quality broadcasting. The UK's BBC is an often-discussed example, with its sometimes high-quality drama, situation comedy and music radio in the 1960s and 1970s. The quality of broadcasting in other European countries prior to marketisation in the 1980s and 1990s is hard to ascertain. Work on PSB tends to have little to say on this topic. For advocates of PSB, however, there may be a good reason for this. The point is not necessarily to defend PSB as it was (often under-funded, paternalist in tone and substance) but as it could be.

PSB UNDER ATTACK: CASE STUDIES OF CHANGE

As with the shift towards marketisation in the USA, the pulling apart of the PSB system in liberal democracies was based on a struggle over how best to organise cultural production in an era when its perceived economic importance was on the rise. Peter J. Humphreys (1996) has provided a very useful outline of the key actors in reformulating broadcasting policy in Western Europe in the 1980s and early 1990s (see Table 4.2).

The pro-market coalition worked via lobbying and public relations with policy makers and key opinion formers in the media. Again, this echoed

developments in the USA, but, in Europe, the pro-market coalition's task was more substantial. In the USA, deregulation mainly comprised the breaking down of an unpopular private monopoly (AT&T) and important but obscure changes in concentration policy. In Europe, public ownership and programming was sometimes popular. Elsewhere, while public broadcasting was not loved, it was at least felt by some elite groups to represent a bulwark against dubious forms of commercialism.

In Western Europe, significant changes in broadcasting policy began in earnest in the mid-1980s, following an early and disastrous experiment in Italy in the late 1970s, where quality plummeted and hucksterism ruled the airwaves. These changes took different forms in different places, but there is only space for a brief survey of a few countries here.

THE UK

Very much under the influence of communications 'deregulation' in the USA, the UK was very quick to privatise telecommunications, and introduce 'light touch' cable policy. The far-right Conservative government of Margaret Thatcher and the newspapers of her political ally Rupert Murdoch, launched an attack on British broadcasting in the early 1980s. Thatcher appointed a right-wing economist to run a public enquiry into broadcasting (Peacock Report, 1986). The resulting legislation, the Broadcasting Act of 1990, however, was far less radical in its marketisation of British broadcasting than public service advocates feared. The BBC was not privatised, nor was Channel 4 – set up by the previous Labour administration (1974–1979) to serve minorities, and introduced early in the Thatcher years, in 1982. The BBC was not, as many had feared, forced to take advertising. This was for economic, not cultural, reasons: the commercial companies did not want the BBC taking their market. The marketising thrust was weakened by strong support on the traditional, paternalist wing of the Conservative Party for the mix of licence fee and commercial television that had existed in the UK since the 1950s. Moreover, strong controls were retained on concentration and cross-media ownership – eventually weakened in the 1996 Broadcasting Act. Nevertheless, the impact of Thatcherite legislation should not be underestimated, especially on ITV – the network of closely regulated commercial franchises established in 1955, operating under a public service remit. In the 1990s, ITV moved quickly from 14 regional franchised stations, dominated by 6 companies, towards effective monopoly control by 2 companies, Granada Media Group and Carlton.[6] A lot of advertising money went not on making national programmes but, instead, to shareholders and on the 12-yearly auction system for franchises set up by the Broadcasting Act of 1990 (Tunstall, 1997: 247). To fend off political hostility, the BBC was forced to introduce 'internal markets and a ruthless regime of cost-cutting dressed up in the rhetoric of Thatcherite management consultancy, allied to a play-safe news and current affairs policy' (Garnham, 1998: 216). The Labour government of 1997 onward was considerably more generous in its funding of the BBC, but continued to apply political pressure – most notoriously in the furore over a news report

6 The process of concentration was completed when these two companies merged in 2004 to form ITV PLC.

implying that a government adviser had interfered with documents purporting to outline the security threat posed by Iraq in the run-up to the Gulf War of 2003.

An important development in the 1980s was that cable and satellite were introduced to the UK on terms that allowed Rupert Murdoch's British Sky Broadcasting (BSkyB) to gain a virtual monopoly over new television technologies in the UK. The Cable Act of 1984 attempted to introduce cable under a very 'light touch' regulatory regime, but cable failed abysmally because the Thatcher government of the 1980s gave none of the state support to the incipient cable sector that was provided by some other Northern European countries.[7] As a result of the failure of cable, by the mid-1990s, News Corporation's BSkyB satellite package was completely dominant in the UK pay-TV sector, helped by its purchase of key sports rights, providing a powerful base from which to launch its bid to dominate digital television (see Chapter 9).

FRANCE

France had a long tradition of state intervention in the cultural industries – not only in broadcasting but also in the form of ambitious communications and audio-visual strategies and programmes. This included enormous investments in a very modern and efficient telecommunications infrastructure in the 1960s and 1970s, including the popular and widely used, state-run videotex system, Minitel.

In the 1980s and early 1990s, France was in some ways more radical in its marketisation of broadcasting than the UK, even though France was headed by a socialist president, François Mitterrand, from 1981 to 1995. Communications policy is very strongly influenced by presidents, but is officially a matter for governments and, for crucial periods in 1986–1988 and 1993–1995, Mitterrand cohabited with right-wing governments under Chirac and Balladur respectively. In any case, the leftist governments of 1981–1986 and 1988–1993 were also involved in commercialisation. One reason for this was that the very direct nature of state intervention in broadcasting helped to discredit French public service TV. The state broadcasting system had been modified into a public service system in 1982 with an independent regulator (fierce battles were fought over the name, make-up and status of this body throughout the 1980s and early 1990s), but this was too little, too late to save the reputation of French PSB. Another was the general drift across Western Europe towards marketisation in all areas of public policy – even in France, with its long statist traditions. Commercial channels were launched in 1984[8] and 1986 to create a dual system, but then the right-wing Chirac government of 1986–1988 went much further

7 In 1995, only 6 per cent of UK TV homes were connected to cable (Collins and Murroni, 1996: 92, citing UK government figures). According to Zenith Media figures, 95 per cent of Netherlands TV homes were connected in the same year. Only Turkey and Portugal had lower connection figures than in the UK in Western Europe. From the mid-1990s, however, marketisation allowed cable companies to compete with British Telecom in the telephone market and cable penetration rates increased.

8 Canal Plus, privatised in 1986, originally seen as a challenge to US cultural imperialism and stuffy French public service programming, later a major player in the European subscription television market as part of the doomed Vivendi-Universal conglomerate and, for the last few years, in some trouble.

and privatised a key public channel, TF1, along with other publicly owned communications companies, including the TV and advertising company Havas.

An ambitious plan to cable France using public money was abandoned and cabling was turned over to the private sector. New commercial terrestrial and satellite channels appeared in the late 1980s and the socialist government of 1988–1993 did not reverse earlier privatisations. The result was that, from 1990 onwards, France 'had one of the most marketised broadcasting systems in Europe' (Humphreys, 1996: 181) with its public service channels comparatively marginalised.

GERMANY

The third major European media market, West Germany, launched a new commercial sector in 1984 – later than many other economically powerful countries – and its decentralised public service system remained intact, confirmed by a ruling of the Federal Constitutional Court in 1986. This ruling was partly a result of campaigning by the leftist Social Democratic Party (SPD). Nevertheless, the rapid growth of commercial channels had a huge impact on the German media landscape after unification in 1990. This growth was largely due to central state funding of a massive cabling programme in the 1980s. Relatively weak ownership laws have meant strong and significant links between publishing and broadcasting. Two 'families' dominated both publishing and television for many years: Bertelsmann and Kirch (the latter going bankrupt in 2002 after a disastrous attempt to dominate pay-TV).

The growth in commercial channels has made German television extremely reliant on English-language imports from the UK and, especially, from the USA (Tunstall and Machin, 1999: 198). However, Kevin Williams notes (2005: 58) that, after a crisis in the mid-1990s, public service broadcasters have consolidated their position 'without copying the formats of commercial channels'. Indeed, commercial channels showed the influence of the public service model in the relatively low amount of human interest news and current affairs programming. All major stations must allocate windows in their schedules to independent film-makers. While the commercial channels have relied on light entertainment, news and sports coverage has been innovative (Burns, 2004: 73). This relatively successful version of the mixed public service/commercial ethos is a result, says Williams (2005: 59), of the way that broadcasting in West Germany was shaped by 'efforts to use the media as instruments of democracy'.

AUSTRALIA

Australia's television system was a dual one from its inception in the 1950s. It represented a distinctive mix of British public service and US commercialism – the latter in the form of regulated, advertiser-supported city-based stations and networks. Consequently, events in the period 1985–1995 were concerned not so much with the introduction of commercial channels, as in much of Western Europe, but with changes in ownership laws, which determined how much a particular company could control the television market and to what extent these interests could be combined with press ownership.

In 1987, strict limits on how many stations a particular company could own (two), were considerably loosened. This was partly in order to generate improved

television facilities in the less-populated areas by allowing the wealthy stations of Southern Australia to expand. The new limit was 60 per cent of national audience, but this was in any case breached (by Network Seven). To pacify anti-concentration campaigners, new rules forbade cross-media ownership across print and broadcasting – traditionally a strong feature of the media landscape. As magnates such as Kerry Packer and Rupert Murdoch chose print, their stations were sold at huge prices to, as it turned out, corrupt and incompetent bosses (with the result that Packer bought back his Nine Network for a song in 1990).

However, the main deregulatory act came in 1992, with the Broadcasting Services Act, which weakened restrictions on broadcasters, abolished radio ownership laws almost entirely and introduced pay-TV in such a way as to favour satellite, dominated by Packer and Murdoch. The 1980s and 1990s, then, can be seen as a period in which commercialisation was intensified, PSB was weakened and Australia added to its reputation as the (advanced industrial) country 'with perhaps the greatest degree of media concentration in the world' (Hoffman-Reim, 1996).

JAPAN

For decades, the Japanese public service broadcaster NHK, established on the BBC model, has been closely linked not just to the state but also a political party – the conservative Liberal Democratic Party that has ruled Japan for much of the post-war period (Sugimaya, 2000).

Commercial television came early to Japan. Numerous commercial TV stations operated in the country from the 1950s onwards, adapting the apolitical stance of NHK (Kato, 1998). 'Deregulation' has not been considered as significant in Japan as elsewhere as the worrying standards of news journalism there are related to other factors, such as loose professional codes, different assumptions about authority and personal privacy and the massive cultural presence of sensationalist weekly magazines. (There are parallels here with the way in which British broadcasting is often forgiven for some of its poor practices because of the much worse news journalism of the tabloid press.)

The most significant act of marketisation has been the entry of satellite channels, but this has had relatively little impact. Most academic surveys of broadcasting hardly mention deregulation. Since the early 1960s, Japan has imported very little television and has more recently exported a great deal, including television formats (Iwabuchi, 2003). This has been partly because the country has a large, prosperous audience and partly because Japan has an image in other countries in South East Asia as embodying a distinctive and desirable kind of Asian modernity. It is also because of the considerable economic and political power of the companies that have dominated the public service–commercial mix. This strength should not be celebrated as a counter to 'Western' cultural imperialism, however. It is based on strong control by an oligopoly of companies and the very close ties between the country's influential subscription-based newspapers and its main television stations. There have been frequent scandals about the quality of journalism, including recent ones that have severely dented NHK's credibility. Japan is a further reminder that there was no golden age of PSB prior to marketisation. But neither has marketisation democratised Japanese broadcasting.

In some countries, PSB remains relatively strong, but often there is a strong drift towards a cosy consensus between businesses and governments that the best way to run a broadcasting system is to have a vigorous private sector with some kind of corrective provided by a public service broadcaster. The ethos of public service, as outlined above, can only become more marginal with such a consensus in operation. There can be little doubt that the new system has produced more choice and diversity for viewers, compared with the underfunded public service monopolies that prevailed in some countries in the 1950s and 1960s, and there is still programming of high quality. However, this has generally been the case where the notion of public service has retained its presence within mixed systems. I return to these issues in Chapter 9, where I discuss the arrival of cable, satellite and digital television, and in Chapter 10, where I discuss notions of quality and diversity more fully. The key point here is that, as the public service ethos became increasingly marginalised and beleaguered and, for the most part, unable to gain the resources to reinvent itself, market-driven broadcasting began to look like an inevitable future. Marketisation was never inevitable, though – it was fought for by interested parties. The success of marketisation advocates in achieving this appearance of inevitability has led to a huge growth in the commercial opportunities available for businesses in the key cultural market of television.

THE THIRD WAVE: TRANSITIONAL AND MIXED SOCIETIES, 1989 ONWARDS

Marketisation spread throughout the world's telecommunications and media systems in the 1990s. The 'success' of neo-liberal measures in advanced industrial countries helped bring this about, but it was by no means the only factor. In India, a bureaucratic democracy attempted to reinvent itself by means of market reforms. In the former Soviet Union and Eastern Europe, the fall of Stalinist regimes, where state intervention had become discredited, brought about an unfettered marketisation of economies, including communications, media and culture. In China, the Communist party bureaucracy held on to power by letting go of communism, producing a distinctive form of 'bureaucratic monopoly capitalism' (Zhao, 2003: 62) in which the cultural industries played a growing part. In Latin America (and also in other countries, such as South Korea), there were transitions of a different kind in the 1980s and 1990s – from military authoritarianism to liberal democracy – and cultural markets were opened up to global competition. Although not addressed here, many Arabic countries, while maintaining strict controls over content, opened up their media systems to penetration by transnational media corporations (see Sakr, 2005).

As Colin Sparks (2000) has remarked in the context of Eastern Europe, these various mixes of private media ownership and political influence can actually be seen as the global norm, rather than an aberration from European models of a mix of public and commercial broadcasting under arm's length regulation. Of course, the idea that political influence is neatly separated from 'free enterprise' in advanced industrial countries is just as much a fiction in the realm of culture as it is in economies as a whole. We have already seen evidence of the great

influence that cultural industry corporations can have on national governments and policy makers in Europe and the USA. Nevertheless, it is fair to say that, as the end of the Cold War coincided with the rise of neo-liberalism, a great number of the world's economies were brought under the aegis of marketisation, including their cultural sectors. As the brief survey of some major territories in this section suggests, vast new markets for cultural industries have opened up, but this has not been a process without conflict or contradiction. Concerns about national identity and cultural standards continued to clash with marketisation in complex ways. Whether marketisation in these countries has involved any significant shift in the global balance of cultural power is the main subject of Chapter 8.

I begin this brief survey with India because, for all its unique cultural and political features, it echoes the way that neo-liberalism was introduced in many advanced industrial countries. The post-war Indian state was a compromise between traditional Indian conceptions of state power and aspirations to model a secular nation state on the European model (I draw on the valuable account in Sinha, 2001 here).

A highly interventionist, quasi-socialist state presided over a market economy that favoured rich farmers, industrial capitalists and professionals. These different groups fully supported the state's protectionist measures, but, via deficit financing, the state was able to pursue some ameliorative populist measures and gain sufficient legitimacy among the vast numbers of urban and rural poor.

This tense settlement was falling apart by the 1980s and, when a serious economic recession hit in 1990–1991 and much of the rest of the world turned to marketisation as a supposed cure for economic ills, the Indian state accepted a neo-liberal package proposed by the International Monetary Fund (here we see how national and international forces combine in shaping policy transformation) in return for a loan. There was opposition from left and right, but it was enough. The result was massive deregulation, privatisation and liberalisation and the opening up of markets to global competition.

Telecommunications was 'liberalised' from 1994 onwards and broadcasting was included in the package. It had become perfectly clear in the spread of neo-liberalism in advanced industrial countries that telecommunications marketisation was a prerequisite for developing opportunities for the private sector in the cultural industries.

India is not only the largest democracy in the world, it also has the world's largest middle class, estimated to be 200–250 million in number (Thussu, 1999: 125) – a potentially huge and lucrative market for multinational cultural industries conglomerates. The marketisation of Indian broadcasting from 1991 onwards is extremely significant, then, for these conglomerates and Indian audiences. Up until that date, Indian television was essentially a single-channel state system, often criticised for its close relationships to the dominant Congress Party and its worthy dullness, but with important and sometimes effective commitments to public service ideals, including national spread and the provision of education (Thomas, 1998). Commercials were allowed on the Indian state channel, Doordarshan, from 1976 onwards, but, in a country dominated by cinema,

the massive potential of television as a cultural industry only began to be realised with the transmission of two serials based on Hindi religious epics, *Ramayana* and *Mahabaratha* (1987–1990).

By 1991, transnational satellite transmissions, including CNN and the Hong Kong based STAR TV before its takeover by Murdoch's News Corporation in 1993, were being received in India in large numbers (Sinha, 1997). The result was a huge explosion in television channels throughout the 1990s, especially of pay-TV. By 1998, nearly 70 cable and satellite stations were operating in India (Thussu, 1999: 127). Many, including STAR, initially transmitted 'Western' programming, but were increasingly orientated towards local content by the late 1990s.

There were debates within India about whether or not this explosion represented a new diversity or the strangling at birth of an incipient public sphere. There is no space to assess those debates fully here, but India indicates how global marketisation has helped to trigger significant internationalisation. This can be seen not only in the investment by multinational conglomerates, such as News Corporation in India, but also in the increasing presence of Asian broadcasters, such as India's Zee TV, in Europe and the USA. The significance of such complex and new flows of culture, which, to a significant degree, are a result of marketisation, will be addressed in Chapter 8.

RUSSIA AND EASTERN EUROPE

A vision of liberal democracy as the basis of a prosperous and stable global future spread across much of the world during the 1980s and 1990s. This, though, was a version of liberal democracy with a very strong emphasis on neo-liberal notions of markets being as unhindered as possible by political action. The cultural industries play an important part in such visions, for cultural production is closely linked to ideas of freedom and self-expression in many countries. The mistake, encouraged by neo-liberal thinking, is to confuse freedom of expression with lack of government regulation. Regulation can promote freedom.

With the collapse of post-Stalinist systems in the Soviet Union and Eastern Europe, a generally well-educated population of nearly 400 million people became potential consumers of cultural goods and services. However, events in Eastern Europe and other 'transitional' societies have not justified optimistic projections of benign globalisation and this is true of the cultural sector.

In all Eastern European countries, the press moved from subsidy and state control to advertising and subscription, and telecommunications and broadcasting were soon privatised. Regulatory authorities had to be created from scratch and the regulatory vacuum created powerful local monopolies and relationships between government and businesses that often bordered on illegality and, in some cases, were thoroughly corrupt (see, for example, Goldberg et al., 1998 on Hungary).

Efforts to introduce a PSB ethos in these countries have floundered, as Jakubowicz (2004) usefully but depressingly shows. Political structures and traditions do not exist that could bring about a successful inculcation of these new systems. Governments give lip-service to freedom, but are keen to exert control and this appears to be undermining popular legitimacy. PSB is under such threat in Western European countries where it has been long-established that success in the longer term looks unlikely.

CHINA

Marketisation in the cultural and media sectors began in the 1980s, but accelerated after Deng Xiaoping's landmark 'Tour of the South' in 1992. State and market have become thoroughly intertwined. In Eric Kit-wai Ma's words, 'lively and commercially vibrant media are actually essential to the continued governance of the state' (2000: 28). Leisure is encouraged in order to stimulate consumption and the burgeoning Chinese cultural industries are essential to this.

The development of the cultural industries as a strategic economic and cultural objective was signalled in the Chinese Communist Party's proposals for its tenth Five Year Plan in 2001 – the year in which China joined the World Trade Organization. A principal aim of media policy – as with much else in Chinese government policy,– is to build big Chinese corporations that can compete in the global economy.

The party state, which retains very close control over communication, is introducing various reforms. These are very much contested and there are real tensions within the Party and the state. The results of these reforms are clear though: a distinctive form of marketisation, on a vast scale, and a 'bureaucratic monopoly capitalism' (Zhao, 2003: 62) with huge numbers of new entrants, often in league with non-Chinese businesses, but under control of the party state. Meanwhile, non-Chinese cultural industries rub their hands gleefully at vast new markets in the country – not for outright ownership just yet, but with the possibility of further vast new opportunities after gaining toeholds in joint ventures.[9]

Zhao (2003) convincingly argues against two dominant frameworks for understanding these changes. The first is the Chinese nationalist one, emphasising the need to build Chinese conglomerates, which fails to notice that the 'popular classes' (workers and peasants) are doubly marginalised by political control and economic inequality. The second is the democracy framework, especially strong in Hong Kong and beyond China, which overestimates the conflicts between global capitalism and Chinese bureaucratic capitalism.

LATIN AMERICA

Latin America, meanwhile, underwent transitions of a related, but different, kind in the 1980s and 1990s. The USA's Cold War propaganda often contrasted the Soviet bloc with the 'free world', but, in the mid-1970s, more people were living under military, authoritarian regimes in Latin America – the USA's 'back yard'– than in the whole of the Soviet Union and Eastern Europe together. Most television systems were thoroughly commercial, after the USA's model, but they were subject to authoritarian, rather than public service, monitoring and private owners were often in close alliance with military rulers (see Chapter 8 on the Brazilian company, Globo).

9 Media scholar Colin Sparks wrote a few years ago (2003) that Western media companies, apart from News Corporation, were uninterested in China. This now appears to be changing. Viacom and CNBC Asia Pacific have signed agreements with Shanghai Media Group, HBO and National Geographic have also entered joint ventures and Rogers Broadcasting (Canada) has joined Sun Wah Media (Little, 2005).

Under the influence of critiques of 'cultural imperialism', many democratic and authoritarian Latin American governments sought to protect their nascent television industries from US imports and direct investment in the 1960s and 1970s. However, by the time of the neo-liberal 1980s and 1990s, as television internationalisation intensified, experiments with state-funded alternatives were largely discredited due to their association with the military authoritarian regimes of the 1960s and 1970s (Waisbord, 1998).

The result has been a lack of substantial resistance to cultural marketisation in the region, even on the left. The introduction of satellite television is transforming the broadcasting environment in Latin America, but very much on terms favourable to partnerships between dominant Latin American companies and transnational cultural industry corporations (see Sinclair, 2004: 87–90).

SUMMARY OF MARKETISATION IN TRANSITIONAL SOCIETIES

These changes have either consolidated processes under way or brought huge new swathes of the Earth's population into the ambit of companies that aim to make profit from the production and dissemination of culture. All this has increased the importance of the cultural industries in the projections of financiers and business people.

THE FOURTH WAVE: TOWARDS CONVERGENCE AND INTERNATIONALISATION, 1992 ONWARDS

In the last two sections, I have concentrated on developments in broadcasting policy, but we should not forget the important role that telecommunications marketisation has played in the story of this chapter. The changes brought about have been longer-term ones and they happened in conjunction with longer-term effects of changes in broadcasting and crucial changes in the computer and IT industries. A key issue here is the prospective convergence of the cultural industries with telecommunications and information technology. Crucial policy decisions were made in the late 1990s that effectively treat this notion of convergence as inevitable. These can be seen as part of a fourth wave of marketisation. Also apparent in this period is the increasing significance of international policy making institutions – that is, those above the level of the nation state.

CONVERGENCE

From the early 1980s onwards, policymakers and analysts had raised the future prospect of convergence between telecommunications, computers and media (one influential example was Pool, 1983, already referred to above). Information and entertainment would, it was envisaged, increasingly be consumed via some kind of hybrid of the computer and the television set and transmitted via cable, satellite and telephone lines as well as, or instead of, via the airwaves. Such convergence is still a long way from happening, even in the most prosperous countries, but the idea of convergence fuelled many of the more recent changes in the cultural industries that

I deal with in this book. It is now sufficiently advanced that extremely important mergers and alliances have been formed across the different sectors, including most notably AT&T's purchase of TCI (1999) and the merger between AOL and Time Warner (2000–2001). Many new technologies have been introduced because companies perceive that profits will be made out of such convergence. The most important of these are various forms of digitalisation and the provision of broadband telecommunications channels (see Chapter 9). Because powerful companies that provide jobs and prestige envisage such profits, national policymakers have introduced policies clearing the way for further rounds of convergence-led activity.

The most important piece of legislation at the national level in this respect has been the 1996 US Telecommunications Act (see Aufderheide, 1999, for indispensable context and overview). The Act solidified perceptions of emergent convergence and paved the way for it in three main ways.

First, it freed the local Bell telephone companies created by the AT&T divestiture to enter long-distance markets, in return for allowing competition in their own regions. This allowed these enormous companies access to huge markets in new communications technologies. In the wake of the Act, these Baby Bell companies became major players, as a series of massive telecoms mergers 'seemed to presage a reduction from about 10 or 12 big telecoms companies to about four major survivors. The seven regional Baby Bells were melting down to only two or three big regional telecoms players' (Tunstall and Machin, 1999: 56).[10]

Second, it provided legislation enormously favourable to the cultural industry corporations that dominate broadcasting in the USA. Free spectrum was allocated to the main broadcasters for digital television, with only minor and difficult to enforce legislation preventing them from using this spectrum for non-media services. New rules made it easier to renew broadcasting licences, and the period for holding them was extended, giving broadcasting companies new control of a vital node in the new, converged cultural industries. These changes made them key partners in future convergence mergers and alliances.

Third, the Act favoured existing cable companies by relaxing the regulation of charges and it allowed phone companies to enter the cable market to provide content. The 1984 Cable Act had removed cable price regulation and reduced the powers of local government to demand public interest facilities from cable operators. By 1992, cable had to be re-regulated as its prices had soared and the cable industry had become deeply unpopular with the public and policy-makers. The 1996 Act took away these regulations once again, with effect from 1999, leading to big increases in rates in that year.[11]

The Act was immediately followed by massive consolidation and frenetic trading. It helped pave the way for a wave of megamergers in the late 1990s (see Chapter 6) as it drastically reduced barriers to consolidation, cross ownership and vertical integration. It represents the culmination of the trend towards

10 This is what has happened in a series of complex mergers, in which the Bell name has all but disappeared. One of the Baby Bells took over its old parent, AT&T, in 2006.

11 On this and numerous other important points of detail in this chapter, I owe thanks to Chad Raphael.

marketisation in policy in the USA – enshrined in legislation rather than embodied in regulation.

INTERNATIONAL POLICY BODIES

Another key component of the fourth wave of marketisation in cultural industries policy has been the increasing importance of international policy bodies. These bodies have increasingly tended towards pro-convergence policies in the name of marketisation. They have also been involved in reconfiguring intellectual property rights (see next chapter). The most important of these organisations are outlined in Box 4.4.

BOX 4.4 MAIN INTERNATIONAL POLICY AGENCIES

EU European Union, comprising 25 countries as of 2006.
NAFTA North American Free Trade Association, comprising the USA, Canada and Mexico.
MERCOSUR Southern Cone Common Market, comprising Argentina, Brazil, Uruguay and Paraguay, established in 1991.
ASEAN Association of South East Asian Nations and its organisation for developing free trade in the area, Asia Pacific Economic Cooperation (APEC).
GATT General Agreement on Tariffs and Trade, originally signed in 1947 and developed and expanded over a series of rounds, most recently the Uruguay Round (1986–1993), culminating in the Marrakesh Agreement of 1993. This last round set up the much more powerful and formalised WTO.
WTO World Trade Organisation, which consists of 149 members, as of 2006, and can make binding judgements on cases where trade rules are subject to dispute. China joined in 2001.
GATS General Agreement on Trade in Services, which, together with the agreement on Trade-Related Aspects of Intellectual Property Rights (TRIPS), form the most important elements within GATT/WTO's operations related to the cultural industries. TRIPS integrates intellectual property into a world trade regime governed by free trade principles (see next chapter for further discussion).

These bodies have fuelled business internationalisation of all kinds by encouraging trade between countries, but they have also, in some cases, provided regulation to protect industries by setting quotas on how much content can be exported to limit concentration and so on. All of them work in the direction of enabling free trade between member countries. Because such marketisation tends to favour the wealthier and more powerful companies and nations, some of these organisations have been opposed by activist groups – most famously in the form of the actions against the WTO in

Seattle in November and December 1999. The cultural industries have been exempted from some of these free trade agreements in order to protect cultural diversity by insulating national cultural industries from the effects of cultural exports from the USA. The most notable such instances were the exemption of Canadian cultural industries protection measures in NAFTA and the provision in GATS for cultural industries (argued for by the EU under French pressure). However, the general drift of policy in these bodies has been heavily towards marketisation.

This can be illustrated by the case of the EU, which, of all the international bodies named, is the organisation most informed by social democratic notions of public interest. Advocates of the public interest have put constant pressure on proponents of deregulation and achieved occasional victories, but there has been a relentless drift towards marketisation. EU policy bodies have moved away from sector-by-sector legislation regarding the social impacts of the media and towards regulation whereby telecommunications, computers and media are governed by general competition legislation and regulators ensure compliance (Østergaard, 1998).

The *Television Without Frontiers* initiative of the 1980s (Commission of the European Communities, 1984) aimed to develop European audio-visual industries that could form a power bloc to match those of the USA in the global market, while respecting national diversity. It may be that this was always going to be an impossible goal to achieve, given the national diversity within Europe (Collins, 1998; Galperin, 1999), but, after years of discussion, a directive based on the policy (Council of the European Communities, 1989) finally came into effect in 1991 to try to make it happen. It was widely condemned as an ineffective and confused failure. It set quotas for the proliferating television channels of Europe, in terms of how much they could import from outside the EU, but rendered the policy useless by including the qualifying phrase 'if practicable'. Its fudged attempts to combine economic growth and cultural diversity contrast with the supposed 'success' of EU telecommunications policy. Here, because the implications for content were not fully understood, there was consensus over policy, and the consensus was pro-marketisation. Ten years of EU telecommunications marketisation culminated in the agreement of all EU member states to open up their telecommunications markets to privatisation and free competition from 1 January 1998.

Meanwhile, public service advocates continue to do battle with the marketisers over 'information society' policy and these often take the form of battles between different sections of the EU's vast bureaucracy.[12] This was particularly apparent in debates over the EU's evolving information society policy. The Bangemann Report of 1994 (Commission of the European Communities, 1994) advocated an extreme pro-marketisation approach, but a High Level Group of Experts (including Manuel Castells) appointed by the Commission focused on issues of access and exclusion to this information society in their response. Nevertheless, the Green Paper on Convergence issued by the Commission of

12 Such as the battles between Directorate General (DG) X for Communication, Culture and Audiovisual Media, and DG XIII on Telecommunications.

the EU in September 1997 (European Commission, 1997) was heavily pro-marketisation and, while public interest advocates succeeded in having it revised more in the direction of public interest, it remains the thrust of EU information society policy.

Underpinning EU policy is the assumption that convergence on corporate terms is inevitable and, therefore the EU's role should be to allow European corporations to compete on equal terms with other companies in the global economy. So, convergence functions as a self-fulfilling prophecy: policy change is both brought about by perceived convergence and, at the same time, is likely to accelerate it. The drive to marketise telecommunications across Europe in the 1990s has been very much propelled by such convergence talk, although advocates of public interest and PSB continue to fight hard to resist such notions (see Downey, 1998; Murdock and Golding, 1999). The consequences for the cultural industries are profound, as we shall see in Chapter 8.

The EU illustrates the pressures towards marketisation that exist in even those policy bodies that are most amenable to being influenced by social democratic notions of the public interest. It suggests that the pressures towards globalisation and convergence are proving extremely difficult for policymakers to resist. International policy bodies are pushing the global cultural industry landscape in the direction of conglomeration and commodification, with convergence increasingly accepted as some kind of technologically driven fact rather than a product of policy in itself. Whether such convergence of telecommunications, computers and media is inevitable and/or desirable will be discussed in Chapter 9.

The push towards marketisation has not gone unresisted. Activist groups and national governments have put many obstacles in its way at different times. PSB has been surprisingly resilient in the face of barrages from its commercial rivals. Nevertheless, the four waves of marketisation suggest that, across very diverse national and regional contexts, neo-liberalism and the neoclassical conception of the market have made huge advances in the cultural sphere. Much of the world seems to have looked increasingly towards the USA as a model for how to regulate culture. Policy changes have had massive consequences for the cultural industries as a whole. Policies are responses to, and products of, sociocultural, economic and technological conditions, but they are also fundamental in triggering and/or inhibiting transformations in the cultural industries. This is particularly the case with broadcasting and telecommunications policy, where there have been strong traditions of public ownership and regulation, but where such traditions were abandoned or severely limited during the neo-liberal turn of the 1980s and 1990s. The changes described above have played a vital role – in conjunction with the changes and continuities described in the next six chapters – in determining the new landscape of the cultural industries at the beginning of the twenty-first century.

FURTHER READING

The study of communications policy, law and regulation in the USA has been well served. I have found the following books very valuable: Patricia

Aufderheide's *Communications Policy and the Public Interest* (1999); Robert Horwitz's *The Irony of Regulatory Reform* (1989); Sterling and Kittross' textbook history of broadcasting in the USA, *Stay Tuned* (3rd edition, 2002); Thomas Streeter's *Selling the Air* (1996).

Useful statements of the principles underlying PSB include those in Michael Tracey's book, *The Decline and Fall of Public Service Broadcasting* (1998), chapters by Jay Blumler (1992) and by Kees Brants and Karen Siune (1992). Of the many useful comparative accounts of national media policy published in the 1990s, the most valuable (and readable) is by Peter J. Humphreys (1996).

The work of Jeremy Tunstall provides many insights into cultural and media policy, though it lacks theoretical contextualisation. *Communications Deregulation* (1986) and *Liberating Communications* (written with Michael Palmer, 1990) are now very outdated, but provide historical detail, while *The Anglo-American Media Connection* written, with David Machin, on (1999) updates this earlier work.

An encouraging development in media studies is the publication of collections that deal with policy and media histories in countries outside Europe and North America. The following collections are particularly helpful: Anthony Smith and Richard Paterson's *Television: An International History* (1998), James Curran and Myung-Jin Park's *De-Westernizing Media Studies* (2000) and Nancy Morris and Silvio Waisbord's *Media and Globalization* (2001).

Communications policy in the era of international policy organisations is an important area for future work. Hernan Galperin's 1999 article was groundbreaking. Richard Collins' *From Satellite to Single Market* (1998) is a rigorous study of key aspects of EU policy. Ó Siochrú and Girard's *Global Media Governance* is an excellent resource.

Finally, a chapter by Nicholas Garnham (1998) on 'Media policy' provides a characteristically crisp and astute overview of issues in this important area.

5 CULTURAL POLICY AND COPYRIGHT LAW

This chapter investigates two further types of policy change that have irrevocably transformed the place of the cultural industries in modern societies. The first change is in cultural policy. The cultural industries have become an object of great attention in cultural policy in recent years. There has been an increasing interest in the idea that the cultural industries are a particular type of industrial activity with their own dynamics (this, of course, is a key part of the analysis in this book – see Introduction). This concern with commercial cultural production has been evident among policymakers and analysts whose main aim is to boost cultural businesses. It has also been apparent among progressive activists and politicians whose principal concerns are questions of citizenship, identity and democracy. Policymakers have increasingly come to use the term 'creative industries' and that term has had its own role to play in transformations in cultural policy.

The second type of policy change discussed in this chapter is that in copyright law and practice. Changes here are closely linked to the dynamics of internationalisation and supposed 'convergence' that were discussed in the final section of the previous chapter. The international trade agreements and policy bodies introduced there – most notably the WTO and the EU – have played an important part in bringing about key changes in copyright. As indicated in Chapter 2, copyright is fundamental to the cultural industries and so changes in how it functions can really matter.

In this chapter, I want to suggest that changes in these domains have important interconnections with broader changes in the relations of creativity and commerce (or culture and economics, art and capital and so on) in modern societies. These interconnections are complex. Copyright and cultural policy are changing because relations between creativity and commerce are changing, but these are such important domains of policy that transformations there may in

turn have considerable impact on the creativity–commerce pairing. Information society rhetoric once again plays a key role here.

CULTURAL POLICY

Relations between the cultural industries and cultural policy (see Box 5.1 for a definition of this term) need to be understood in their long-term historical context. In many countries, government subsidy has tended to go to the 'classical', legitimated arts.[1] Throughout the post Second World War era, in many countries, there were various struggles to include more groups in the ambit of funding in the interests of democratisation (see Looseley, 2004, on the French version of this). In the UK, for example, funding for the 'fine arts' was gradually expanded to the arts, then further to include traditional crafts, such as pottery and 'folk' arts. In the 1970s, there were 'community arts' movements and, in the 1980s, an increasing emphasis on multiculturalism. The content of subsidised 'legitimated' culture has shifted over time – arts cinemas came to be funded and subsidised alongside the opera and regional theatres, for example. One of the reasons that Jack Lang became an internationally famous Minister of Culture in the 1980s and 1990s was that he attempted to extend French cultural policy to forms previously excluded, such as rock, hip hop and rai (Looseley, 2004: 19).

BOX 5.1 WHAT IS CULTURAL POLICY?

To start with, it's a term used to refer to two overlapping but different fields. As with definitions of the cultural industries, much depends on how you define 'culture' and culture is notoriously difficult to define. In its broadest use, it can designate all those forms of policy that might directly have an impact on the forms of cultural identity within a particular space, be it international, national, regional or urban, but, if we start to include too much (food and drink as well as films), then the word 'culture', as in so many other instances, starts to lose its usefulness. The term has tended to be used for policy that has an impact on the primarily symbolic domain. In a similar way, my definition of the cultural industries in the Introduction emphasised the relationship of symbolic to functional elements in their products. Broadcasting and telecommunications policy, as discussed in the previous chapter, might be seen as forms of cultural policy in this broader sense, in that they can have a vital impact on culture (as can film policy). Cultural policy in this broad sense could include public broadcasting, the use of quotas and scheduling limitations to protect 'national' culture, national ownership rules, subsidies and so on (see Grant and Wood, 2004, for one breakdown of elements).

However, the term 'cultural policy' is often used, in the anglophone world at least, in a second and somewhat narrower sense, to refer to the subsidy,

(Continued)

1 The two principal exceptions were public broadcasting systems, as discussed in the previous chapter, and film.

(Continued)

regulation and management of 'the arts', which I define here as those inventive, creative, non-scientific forms of knowledge activity and institution that have come to be deemed worthy of this elevated title – the visual arts, 'literature', music and dance, theatre and drama and so on. It is primarily in this second, more restricted, sense that I use the term here, though, as we shall see, the broader definition often impinges on this narrower one.

THE GLC MOMENT

The seminal introduction of the concept of the cultural industries to cultural policy represented a more radical revision of cultural policy than the democratic spreading of arts funding described above. This took place at the left-wing Greater London Council (GLC) from 1983 until the Council's abolition by the British Conservative government in 1986.[2] This policy thinking was directed against elitist and idealist notions of art, but was also a challenge to those activists and policymakers who had concentrated on expanding the field of arts subsidy to include new groups. Instead, it was argued by some at the GLC, cultural policy should take full account of the fact that most people's cultural tastes and practices are shaped by *commercial* forms of culture and by PSB. The aim was not to celebrate commercial production, but simply to recognise its centrality in modern culture. One key position paper (written by Nicholas Garnham and reprinted in Garnham, 1990) argued that, rather than on an artist-centred strategy that subsidised 'creators', policy should focus on distribution and the reaching of audiences. This argument reflected the emphasis on the centrality of circulation in the cultural industries tradition of political economy and the importance of thinking about the distinctive characteristics of primarily symbolic production and consumption, as opposed to other forms (see the Introduction). The practical implications of such thinking, according to Garnham's paper, were that 'debates, organisational energy and finance' ought to be redirected towards broadcasting – the 'heartland of contemporary cultural practice' – the development of libraries – the recipients of over 50 per cent of all public expenditure on culture – and providing loans and services to small- and medium-sized cultural businesses in London for the marketing and dissemination of their products (Garnham, 1990: 166).

There was a second major element to the GLC strategy, which was the use of investment in cultural industries as a means of economic regeneration. As Garnham pointed out in a later retrospective (2001), this had no necessary connection to the quite separate argument about shifting the focus of policy from the artist to the audience. It was also less novel, in that the use of cultural initiatives to boost the image of cities was under way elsewhere (Bianchini and Parkinson,

2 There were important precedents at the international level, in discussions of the cultural industries as part of UNESCO (see UNESCO, 1982), but this had no direct impact on national and urban policy in the advanced industrial countries.

1993). Such policies were often directed towards the boosting of tourism and/or retail in an area or making an area attractive as a location for businesses, rather than the democratisation of cultural provision. In the late 1980s and 1990s, such strategies boomed and spread across the world. Notable cases included Glasgow's remarkable success in becoming European City of Culture for the year 1990 and reinventing its image. Super-expensive flagship projects, often based on adventurous architecture, proliferated – the best-known of which is probably the Guggenheim Museum in Bilbao, opened in 1997, which succeeded in making post-industrial Bilbao a tourist attraction. Such projects have been controversial locally, but voices of criticism are rarely heard internationally.

LOCAL CULTURAL INDUSTRIES POLICY

Because the GLC was abolished, its cultural industry policies were never implemented in London. All the same, the idea of local cultural policy based on the cultural industries had a big impact during the next decade. In many cities, cultural industries policies became bound up with broader strategies to use culture for urban regeneration. However, the rise of local cultural industries policy, initially in the form of 'cultural quarters' in post-industrial cities, was not entirely a result of the appeal of GLC's pragmatic anti-idealist egalitarianism. In fact, in many cases, the idea of cultural industries policy chimed with a fast-growing desire in the 1980s and 1990s to think about all areas of public policy, including culture and media, in terms of *a return on public investment*. This linked up with an increase in questioning – as a result of the sociocultural changes discussed in Chapter 3 – of the legitimacy of 'high cultural' forms. In this context, the use of money to promote 'ordinary' culture was seen as anti-elitist – and this contributed to the popularity of cultural industries policies with many left-wing councils in Europe. So it was that, in the late 1980s, shaped by economic neo-liberalism and a breaking down of long-standing forms of cultural hierarchy (though by no means the end of cultural hierarchies themselves), the notion of the cultural industries or the cultural sector became increasingly attached, in a new era of local and regional development policy, to the goals of regeneration and employment creation. It was this second element of GLC policy that was often emphasised, not the first, now bound up not only with culture-led urban regeneration strategies but also an increasing emphasis on entrepreneurialism in the private and public sectors. In a pamphlet written for the think tank Demos, for example, Kate Oakley and Charles Leadbeater (a figure associated with the GLC, who, by the late 1990s, was closely linked to Tony Blair's 'New Labour' project) outlined the way that entrepreneurs in the cultural industries provided a new model of work and a key basis for local economic growth in that their local, tacit know-how – 'a style, a look, a sound'– showed 'how cities can negotiate a new accommodation with the global market' (Leadbeater and Oakley, 1999: 14). The view that independent cultural production might be connected to wider movements for progressive social change, implicit in at least some of the GLC work, was by now being steadily erased.

A very important further connection was with new developments in arts policy, whereby institutions increasingly sought to legitimise their funding on the

basis of its contribution to a somewhat uncomfortable and potentially contradictory mixture of economic and social goals. An influential, though not uncontroversial, report by economist John Myerscough (1988), for example, put the cultural industries together with the arts and analysed how they contributed to job creation, tourism promotion, invisible earnings and urban regeneration (see Belfiore, 2002, for a survey of arts policy developments in this domain in the UK).[3] Alongside such developments, many arts policymakers also sought to justify arts subsidy on the basis that the arts – and the cultural industries increasingly linked to them in policy discourse – could contribute to combating social exclusion – a new term that spread like wildfire through European social policy in the 1990s. Some analysts see social exclusion as being a term that allows those who use it to avoid consideration of deep-seated structural inequalities, including class (see, for example, Levitas, 1998). These developments were to have an important effect at the national policy level, as we shall see.

This is not to say that all such local cultural industries policies were ineffective and represented an accommodation with neo-liberalism or with new centrist forms of policy. In some cases, policymakers with a genuine desire to promote new and interesting forms of cultural activity within an area and provide support for struggling entrepreneurs and practitioners, could persuade local government to provide funding by talking about the regenerative possibilities of cultural industries' development.

In some cases (for example, in Sheffield, in the north of England), such policies were able to support local infrastructures, to the lasting benefit of symbol creators who wanted to work in the city (see Frith, 1993). However, the economic and social effectiveness of local cultural policies orientated towards the cultural industries remains controversial. It surely made sense to emphasise the importance of the cultural industries to a news and entertainment hub city, such as London, and it may make some sense even in some smaller but substantial cities where the cultural industries have some growing presence, but, in other places, the idea that investment in the cultural industries might boost local wealth and employment has proven more problematic.

Mark Jayne (2004) for example, has written about the difficulties a local council has had in developing an effective cultural industries development policy in Stoke-on-Trent, in the English Midlands – a city with an overwhelmingly working-class population. The issue of class is significant here. Much of the burgeoning policy discourse (and associated academic literature) seems implicitly to portray working-class populations as regressive, holding back cities from entering into competition with the thriving metropolises of the West. What are the dangers of foisting inappropriately metropolitan policies on predominantly working-class or rural places? This question seems to have been considered all too rarely in social policy debates.

Nevertheless, cultural industries policies can, it seems, make a contribution to people's lives in 'unlikely' areas. Chris Gibson and Daniel Robinson (2004) have

3 Myerscough's study used the economic concept of multiplier effects to understand the contribution that policy might make. However, as Garnham (2001: 451) points out, if this is taken to be the main basis of the efficacy of funding given scarce resources, then the question of whether or not other investment – for example, in public transport – might be a more effective option is unavoidable.

written about a small entertainment industry association on the far north coast of New South Wales, Australia, hundreds of miles from Sydney and other urban areas further south. They acknowledge that the effects of such an association on employment and economic activity are very hard to ascertain because of the perennial data problems in this area (see Chapter 6). However, they say that the association's campaigns (keeping venues open, putting on events, getting better remuneration for musicians, publicising activity by means of awards and so on) helped to encourage young, aspiring creative workers to stay and thereby encouraged a sense that there might be an interesting and rewarding cultural life in the region. In other words, funding such grassroots cultural industries institutions may have other, less directly economic but nevertheless positive benefits.

THE CREATIVITY CULT: CITIES AND CLUSTERS

By the mid 1990s, two related concepts had grown out of cultural quarter policies, each of which has been the subject of a great deal of policy interest: *creative cities* and *creative clusters*. These terms represent an important shift in the policy vocabulary surrounding the cultural industries. The former idea was strongly associated with the Comedia consultancy group. In Comedia booklets and policy documents (for example, Landry, 2000), creativity was presented as the key to urban regeneration and the main reason given was that 'the industries of the twenty-first century will depend increasingly on the generation of knowledge through creativity and innovation matched with rigorous systems of control' (Landry and Bianchini, 1995: 12). Television, software and theatre were examples of such industries, but so was dealing in stocks and shares, and the claim was that they all needed creative cities to help them thrive. A number of examples of creativity in local planning and policy were offered by Landry and Bianchini, including the culture-led urban regeneration strategies referred to above. How these were to induce creativity in a city's inhabitants was not made clear, but, by the turn of the century, the cultural industries were being thoroughly incorporated into a more general notion of creativity as a boon to a city's ills (see Box 5.2).

BOX 5.2 CREATIVITY: BUSINESS WITH FEELING

The adoption of the term 'creativity' in cultural industries policy in the late 1990s and 2000s was no accident. There had been a keen interest in the concept among managers, management gurus and business academics for many years. Innovation is the basis of business success, went the thinking, and innovation is dependent on creativity. However, the term had a sheen of non-elitism, too, because of its associations with humanist psychology, which stressed the broad distribution of creativity (for example, in the work of Abraham Maslow). It was these connotations that the consultancy Comedia drew on when advocating 'the creative city' for the left-of-centre British policy think tank Demos. It seems likely, too, that these dual associations – business-orientated but with feeling – were behind the influential adoption by the British Labour government of the term 'creative' to replace the 'cultural' in cultural industries (see below).

The idea of creative clusters has been even more significant in local policy than that of creative cities. The concept of the business cluster is derived from the work of economist Michael Porter, which attempts to explain how nations and regions gain competitive advantage over others. An important element, which distinguishes it from older theories, such as that of the nineteenth-century economist Alfred Marshall, in Porter's explanation of why firms from the same industry tend to gather in the same places, is its emphasis on the notions of innovative entrepreneurialism and competitiveness fetishised in neo-liberal discourses of the 'new economy' (Martin and Sunley, 2003). This has made 'business clusters' a hugely influential concept across the world. Unsurprisingly, perhaps, in the late 1990s, policymakers concerned with the development of the cultural industries adapted the term business clusters by linking it to the rising cult of creativity in management, business and government and using the term 'creative clusters'.[4]

For Hans Mommaas (2004: 508) 'cultural clustering strategies represent a next stage in the ongoing use of culture and the arts as urban regeneration resources'. Once all major cities had developed their festivals, major museums and theatre complexes in the culture-led urban regeneration boom of the 1990s, the action moved on to creating milieux for cultural production. However, like 'business cluster', creative clusters is an idea built on a shaky conceptual foundation. Mommaas distinguishes between a number of discourses, which have tended to be merged together in policy discussions of the benefits of creative clusters and which, in his view, are in danger of undermining and contradicting each other:

- promoting cultural diversity and democracy
- strategies of place marketing, in the interests of tourism and employment
- stimulating a more entrepreneurial approach to the arts and culture
- generally encouraging innovation and creativity
- finding new uses for old buildings and derelict sites.

Mommaas notes that, while some clustering strategies are limited to artistic cultural activities, most of them incorporate many other leisure and entertainment elements – bars, health and fitness complexes and the like. In another critical study, Ivan Turok (2003) shows that the concept of cluster – implying networks of small knowledge-intensive firms generating regional growth by means of an endogenous process – is belied by Scotland's film and television industries, which are largely dependent on the television channels based in London.[5]

Development strategies based on the cultural industries have proliferated across the world in the late 1990s and early 2000s. It cannot be automatically assumed that such strategies are entirely about a dubious form of gentrification. They need to be assessed case by case and it remains important to distinguish between top-down versions of such strategies, which come close to simply making cities more accommodating for businesspeople who want a funky

4 This continued into the 2000s as, for example, the British government put its national creative industries strategy (see below) into operation in 'the regions' via the increasingly important Regional Development Associations. Clusters remained a key concept in this new phase.

5 Pratt (2004) also notes that claims for the effectiveness of cluster strategies often rely on dubious forms of statistical evidence.

lifestyle, and bottom-up approaches, which take account of the needs of people across a range of social classes and ethnic groups. Nevertheless, it seems to be the case that the democratising intent in the original GLC strategy, by this stage of cultural industries policy, had become deeply submerged.

Cultural policy analyst Justin O'Connor has reflected on this latest stage in local cultural industries strategy.[6] He seeks to correct a number of misconceptions in what he sees as an overly celebratory literature concerning the insertion of local – especially urban – sites of cultural production into the global circulation of cultural products. One is the view that clusters of local cultural producers deriving their success from creativity depend on local, tacit knowledge (including the genius loci of the place, such as Manchester, where the cultural production takes place). According to such views, which can be found in the work of Comedia but also in other work, cities and regions can gain competitive advantage because such knowledge cannot easily be codified and therefore transferred. In fact, says O'Connor, successful clusters are increasingly predicated not so much on 'creativity' but, rather, on access to a range of *formal* knowledge about global markets, larger companies and distribution networks. To miss this is to ignore the reality of local policy: few of the agencies set up to help nascent cultural industries have this kind of knowledge (O'Connor, 2004: 139). O'Connor is making a broader point, too. The emphasis on using 'creativity' and urbanity for the competitive advantage of cities risks going beyond a reconciliation of economics and culture to being an annexation of the latter by the former (p. 146). As we shall see, it is not just at the local level that this issue of the relationship between economics and culture is relevant. It is also raised by creative industries policies at the national level and the adoption of certain assumptions about the role of creativity in the 'new economy'.

UK CREATIVE INDUSTRIES POLICY

We saw above that the terms 'creative' and 'creativity' were becoming increasingly popular in local cultural policy in the 1990s. By the late 1990s, they had spread to the national policy level. 'Creative industries' is a concept that has been widely adopted in the spheres of cultural policy and higher education. Its first major use in policy appears to have been by the British Labour government elected in 1997, though there were important precedents in other countries, notably the Australian Labour government's *Creative Nation* initiative of 1994. The adoption of the term 'creative industries' was, in part, a way for cultural policymakers (whether concerned with arts, crafts or film production) to legitimise their concerns at the national level. Local policy had shown that, by linking arts to the cultural industries, even these most refined of activities could be made to seem part of economic development, the *sine qua non* of most government policy in the era of neo-liberalism.

Nicholas Garnham (2001: 25; see also Garnham, 2005) has identified two major claims implicitly made by the mobilisation of the term 'creative industries':

6 In his time at the Manchester Institute for Popular Culture, a research institute at Manchester Metropolitan University, O'Connor worked closely with local entrepreneurs, creative practitioners and policy agencies to develop bottom-up cultural industries strategies.

- the creative industries are the key new growth sector of the economy, both nationally and globally
- they are therefore the key source of future employment growth and export earnings.

For Garnham, the use of the term 'creative' achieved a number of goals with regard to these claims in the British context. In the first instance, it allowed for a very broad definition. Various documents issued by the UK Department for Culture, Media and Sport (for example, DCMS, 1998, 2001) included the industries that I call the 'cultural industries' in this book (see Introduction), but also dance, the visual arts and the more craft-based activities of making jewellery, fashion, and furniture design. This made it possible to link these subsidised sectors to the supposedly booming commercial creative industries of music and broadcasting. It also, crucially, included computer software, which made it possible to present the creative industries sector as a much larger and more significant part of the economy than would otherwise have been possible.[7]

According to Garnham, this broad definition, in turn, had two valuable policy consequences for the interest groups involved. First, it enabled software producers and the major cultural industry conglomerates to construct an alliance with smaller businesses and cultural workers concerned with strengthening intellectual property protection. Crucial here was the way that the defence of intellectual property became associated with 'the moral prestige of the "creative artist"' (Garnham, 2005: 26). Second, it enabled the cultural sector to use arguments for the public support of the training of creative workers originally developed for the ICT industry. This argument, in turn, had much wider implications, in that it pushed education policy much more strongly in the direction of an often dubious discourse of skills, on the basis that future national prosperity depended on making up for a supposed lack of creative, innovative workers. The result is that UK creative industries policy is based on an 'artist'-centred notion of subsidy, rather than an audience-orientated policy of infrastructural support – the very opposite, in other words, of the original GLC vision.

British creative industries cultural policy at the national level (as outlined, for example, by government culture minister Chris Smith in his 1998 book *Creative Britain*) claimed to resolve a long-standing dilemma facing social democratic cultural policy in the post-war era: that, given limited resources, there were hard choices to be made between *raising* (promoting the most prestigious, for example, by attracting the best orchestral conductors, museum curators and theatre directors to its national cultural institutions) or *spreading* (touring productions, supporting local groups). The British Labour government's creative industries policy sought to resolve this contradiction by eliminating the high/low distinction by supporting the whole sector, thus combining access (spreading) with excellence (raising). For Garnham, however, this is to miss the entrenched nature of contradictions in structurally unequal societies. Excellence smuggles the high/low

7 This of course relates to the broader question of how to measure the changing role of culture, or the cultural industries in modern economies. I address this question in the next chapter.

distinction back, but in the form of a celebration of the highly skilled creative artist as a model worker in the new 'creative economy'. This goes against access and inclusion because, as Garnham (2001: 457) puts it, it is likely to be the case that 'a key element in social exclusion is the existing hierarchy of cultural forms and experiences and the very definition of excellence itself' and this problem can be thought of, at least in part, as being a product of the creative industries now deemed worthy of support under the new regime. It could be argued that the working classes and other excluded groups consume mainly commercially produced culture and this reinforces their position in cultural hierarchies. If this is the case, then supporting the growth of the creative industries on the grounds of economic regeneration may not in fact solve the problem of access to excellence, but exacerbate it. The contradictions of class society will not be easily resolved.

CREATIVITY, EDUCATION AND THE 'NEW' ECONOMY

In the 2000s, there has been a rising tide of interest in creativity and the creative industries and the latter term has come to be widely used in academia as well as in policy circles in preference to 'the cultural industries'. 'Creativity' is an even looser word than culture, however, and so a series of confused claims are being made concerning the role of creativity in the 'new' economy.

For some analysts – because creativity is set to become a more and more important part of future economies – the creative industries may provide a key to unlocking valuable secrets concerning creativity in other industries (see, for example, Davis and Scase, 2000, and the claims in Leadbeater and Oakley, 1999: 15–16). Some, such as policy consultant and journalist John Howkins (2001: vii), even claim that 'the creative economy will be the dominant economic form in the twenty-first century'. Howkins sustains this claim by defining the creative economy and the creative industries as those involved in intellectual property. This allows him to include not only those industries based on copyright, which is the form of intellectual property that is the basis of the cultural industries as they are defined in this book, but also those industries that produce or deal in patent. This allows him to include massive sectors, such as pharmaceuticals, electronics, engineering and chemicals. Even the impossibly nebulous categories of trademark and design industries are included. Howkins is right to stress the importance of intellectual property in modern economies, across both symbolic and scientific domains (see below for discussion of copyright), but he extrapolates from this importance to make dubious claims about a transition to a new economy based on creativity.

Perhaps the most ardent treatment of the role of creativity in modern economies (see also Box 5.3) has come from the US academic and policy consultant Richard Florida. Florida (2002: 4) makes the cheering assertion that, while most transition theories tend to see transformation as something that is happening to people, in fact, society is mostly changing because we want it to and the driving force of these desired changes is 'the rise of human creativity as the key factor in our economy and society'. This has led to a change in the class system itself, with the rise of 'a new creative class', comprising an

astounding 30 per cent of all employed citizens in the USA – a creative core of people in science and engineering, architecture and design, education, arts, music and entertainment and then an outer group of creative professionals in business and finance, law, healthcare and related fields. As will be clear from this, the inflated claims about creativity again derive from lumping together a very diverse set of activities, but such claims clear the way for Florida to address himself to policymakers. In a version of the Comedia argument about creative cities, Florida says that creative people want to live in creative cities and, if cities want to attract these often wealthy and influential creative people to live and spend their hard and creatively earned money on local taxes and local services, then governments will need to foster 'a creative community' in their cities. Florida offers his services as a consultant to advise city governments on how to create such communities.

BOX 5.3 THE ROLE OF CREATIVITY IN THE NEW ECONOMY

Kieran Healy (2002) has identified a number of questions that might be asked about the role of creativity in the new economy as identified by writers such as Howkins and Florida. In particular, he separates out four claims concerning why the relationships between the so-called creative sector and the new economy might matter to policymakers.

- The 'creative sector' will continue to grow, justifying more policy research in this area. This is the easiest claim to defend, says Healy, but it establishes little in itself. What kinds of policies? Can there be any shared policy agenda among the very varied interests involved?
- The creative sector is a miner's canary for the wider economy because of its uncertain labour markets, flexible collaboration and project-based work (see also the reasons for interest in the cultural industries outlined in the Introduction). However, is the project work of a project-based stage actor really relevant to those of a project-based systems administrator? Is the artistic labour force a good model, given the problems of labour markets there (see Chapter 7)?
- Creativity in general is becoming increasingly important to competitiveness. This, says Healy, is not established and demand for different kinds of creative people will be very unequal across different industries and sectors.
- The so-called 'creative class' is intensely interested in cultural goods of many kinds, so cities should invest in culture. As Healy says, this is unlikely to be uniform (especially, we might add, given how absurdly broad-ranging this category of culture is).

The effects of the discourse of creativity are also having impacts on how societies are educating people about culture. Creative industries (and in some cases

cultural industries) faculties and departments have been springing up around the world. A notable example can be found at Queensland University of Technology (QUT) in Brisbane, Australia. John Hartley and Stuart Cunningham (2001), two academics based at QUT, have explained how they see the importance of the term 'creative industries'. First, it offers an opportunity to move beyond the elitist wastefulness of arts subsidy. Second, it moves beyond limitations in the concept of 'cultural industries', which, in their view, is a term associated with arts-orientated policy. 'Creative industries', however, fits with the political, cultural and technological landscape of globalisation, the new economy and the information society (and, to justify this view, Cunningham and Hartley reproduce inflated or hazy estimations of the importance of creative industries; see also below). Echoing writers such as Howkins, creativity and innovation are presented as the basis of the new economy. Governments need to look beyond science and engineering conceptions of innovation, say Hartley and Cunningham. Policy needs to combine the promotion of this growing sector of local economies with the fostering of creative urban spaces. Education needs to change, too – arts and humanities faculties should be reorientated towards training students in the production of content.

Cunningham and Hartley were writing a manifesto for policymakers and higher education managers. Terry Flew, also at QUT, has provided a fuller rationale for an emphasis on creative industries in both cultural and educational policy (here I concentrate on one piece, Flew, 2005). Flew questions, from a perspective informed by Foucauldian governmentality theory, the emphasis on citizenship among social democratic policymakers and academic advocates of reform. For Flew (2005: 244), 'there is a need for caution in too readily invoking cultural citizenship as a progressive cultural goal' because citizenship conceptions underestimate the degree to which culture has been used by states as part of top-down nationalist projects, and the degree to which rights have involved exclusions as well as reciprocal obligations between state and subject. Such policies – as in postwar France – have also tended to neglect the commercial sector in favour of elitist arts subsidy (here, Flew invokes Garnham's advocacy of cultural industries policies at the GLC – but to very different ends than those Garnham was proposing). What is more, globalisation, the rise of new media technologies, such as satellite and the Internet, and the increasing incorporation of culture into economic life (which seems to be something to be accepted rather than questioned) mean a new set of challenges for policy institutions. In Flew's view (2005: 251), rather than protecting national and local content, the aim should be to promote the ability of a nation to create content in a way that avoids 'top-down nationalism and pre-ordained conceptions of cultural value'. Flew advocates forms of cultural and educational policy that would treat creative industries development as a form of R&D investment. Rather than grounding cultural policy in an opposition to the market or cultural protectionism, Flew offers the Open Source software movement as an alternative paradigm, based on the decentralising force of the Internet and on new conceptions of the public interest, where the state acts as a guarantor of competition, innovation and pluralism rather than a buttress against the market and the idea is to let a million multicultural and globalised publics bloom rather than advocate particular directions for cultural policy.

From my perspective, there are some flaws in Flew's argument (Flew's flaws). First, Flew and other advocates of new conceptions of the public interest place great faith in the democratising impact of the Internet, but, as I show in Chapter 9, there are reasons for wondering if the Internet might validly be seen in this way.

Second, although the idea of a policy that would move beyond the dubious imposition of cultural value is likely on its surface to be attractive to anyone but the most ardent cultural conservative, the problem of aesthetic value will not simply go away. If the role of cultural policy (and arts and humanities education) is to act as an R&D wing of the creative industries, then it may well be that it is the market's (that is, in this case, the cultural or creative industries') conceptions of value that will prevail. Like those of nation states, these values are multiple and contradictory, as I emphasised in the Introduction. However, in a context where massive corporations control the circulation and dissemination of culture (even in the era of the glorious Internet), we may be unwise to opt too quickly in favour of a strongly market-orientated system over a 'top-down nationalism' that is portrayed in monolithic terms, characteristic of much globalisation theory, as a force for oppression and exclusion.

Third, much depends here on the degree to which we emphasise the downsides of the marketisation and commodification of culture (see the discussion in Chapter 6). Flew shows the influence of cultural studies and, in particular, post-structuralist versions of it, focusing on questions of difference and identity. These are indeed important, but this focus is at the expense of considering the way that capitalist markets systematically (though not in any predefined way) produce inequalities of access and outcome.

COPYRIGHT

I turn now to the second element of policy change considered in this chapter. *Copyright* is a vital, but often neglected, aspect of the cultural industries. It is one of the three main areas of modern ***intellectual property***, each of which protects a particular type of 'knowledge' or idea:

- *patents* protect ideas that are new, non-obvious and useful or applicable to industry
- *trademarks* protect symbols intended to distinguish the products of companies from one another
- *copyright* protects those expressions defined in law as 'literary and artistic works' (the principle is that it protects the expressions, not the ideas; patent supposedly protects ideas).

Since the nineteenth century, copyright has underpinned the ownership of cultural commodities and, therefore, the cultural industries as a whole. Mainstream economists and policymakers describe its function as providing an incentive for authors to create. If authors wrote books and they could simply be copied without paying the author, then there would be less incentive to produce books, so the argument goes.

For some political economy approaches (Bettig, 1996; Garnham, 1990: 38–40), copyright law is better understood as an attempt to regulate one of the distinctive problems facing the cultural industries, which is that cultural commodities often tend to act like public goods, in that the act of consuming them does not diminish their value (see Introduction). Copyright law responds by limiting the right to copy, thus making cultural goods scarcer than they might otherwise be.

Other, more recent, political economy approaches stress copyright as part of intellectual property, whereby new markets are opened up for commodification as capitalists search for new areas of life to gain a return on investment (see May, 2000). According to this view, intellectual property is the main means by which culture becomes commodified. If this is the case, then investigating developments in copyright is a vital way in which to understand and evaluate recent events in the cultural industries, in terms of the questions about commodification raised in Chapter 2.

THE WTO ENTERS THE FIELD

As one book on international media policy has commented, the World Trade Organisation (WTO) is 'the most powerful global trade institution ever created' (Ó Siochrú and Girard, 2002: 51). It grew out of the General Agreement on Tariffs and Trade (GATT) – a temporary body formed in 1947 to administer and negotiate the treaty of the same name. The WTO was formed in 1993 by a treaty and has considerably more powers than GATT. It covers three main areas:

- *goods* covered by the ongoing GATT
- *services* covered by a new agreement called the General Agreement on Trade in Services (GATS)
- *intellectual property* covered by the agreement on Trade-Related Aspects of Intellectual Property Rights (TRIPS).

The fact that there is an agreement specifically devoted to intellectual property is in itself a sign of the importance governments and big business place on the role of intellectual property in the modern global economic system.

Prior to 1995, intellectual property rights were covered by a series of multilateral treaties overseen by the World Intellectual Property Organisation (WIPO). This organisation continues to exist and is important, but intellectual property was brought under the much more powerful WTO because the USA wanted to avoid revisions to treaties on industrial (patent and trademark) properties that might hinder its advantages and wanted much more rigorous international enforcement of control of piracy and the settlement of disputes. GATT had shown that this was possible and the WTO has come to embody this kind of policing (Ó Siochrú and Girard, 2002: 90). Corporations in the USA played a major role in these developments and, as Dave Laing (2004) has outlined, the changes to national legislation regimes around the world that

have been brought about by TRIPS are complemented by the actions of the United States Trade Representative (USTR), who, under Special Provision 301 in the 1988 Omnibus Trade and Competitiveness Act, can blacklist countries that have intellectual property practices that are harmful to copyright industries in the USA. This list is announced each year and the USTR draws heavily on information provided by the International Intellectual Property Alliance (IIPA), which, effectively, is a lobbying arm for the major cultural industries in the USA (Laing, 2004). This is cultural neo-liberalism, buttressed by the trading power of the USA.

Compliance with TRIPS and the Special 301 list means huge adjustments have to be made in countries that have no notion of intellectual property in the sense in which it is enshrined in 'Western' copyright law. Christopher May (2004) has shown how developing countries are receiving extensive technical support in training legislators and administrators from a variety of international, government and non-governmental organisations. This is double-edged because it means that developing countries will have more expertise that they can use to take advantage of flexibilities in TRIPS. Many symbol creators and policymakers in developing countries welcome copyright because they believe it will protect their work from exploitation by others within their own society and Western corporations. However the spread of TRIPS means that a neo-liberal vision of culture is becoming normalised and legitimated across the world. This vision sees copyright as a necessary incentive for symbolic creativity. It portrays individual compensation as the main driving force of human activity.

Information society discourse (see Chapter 3) is fundamental to this neo-liberal vision. The major cultural industry corporations have used it to argue that their economic base needs building for the sake of national prosperity in an increasingly globally competitive marketplace. The supposed threat offered by digital technologies – in particular the Internet – has brought about a legislative response that has 'vastly increased the scope of copyright but also has done so in a way which benefits corporate interests at the expense of those of both artists and consumers' (Frith and Marshall, 2004: 4).

The first major response to the rise of the Internet came with the WIPO conference in Geneva in 1996. Signatories agreed to update their national laws to allow rights holders to extend their rights to cover the Internet and other computer networks. The result was the Digital Millennium Copyright Act in the USA in 1998 and the EU Copyright Directive of 2001, with various European countries making this law in their respective countries in 2002 and 2003. Such an extension of copyright law into digital terrain was to be expected, but these acts also contained clauses making it illegal to develop software that can counter the digital rights management (DRM) systems being used by cultural industry corporations to protect their content (see Chapter 9 for further discussion of this in the context of controversies over the digitalisation of music). This was a sign that the copyright industries, such as the music industry, were becoming adept at presenting the digital environment as a threat and arguing that they needed legislation to protect them from this danger.

LONGER, BIGGER, STRONGER
COPYRIGHTS

A whole series of extensions to copyright terms have taken place in this new environment. An EU directive of 1993 aimed to 'harmonise' the copyright terms of all its member states, but it chose as its template the law in Germany, which had been extended to take account of the 'interruption' to copyright caused by Nazism. Once the various nations had changed their laws, this meant that copyright ran until 70 years after the date of the author's death. This has the consequence that, if an author writes a great book at 25, which becomes a part of many people's lives and that author lives until she is 100, it will be 145 years before the book is out of copyright (the 75 remaining years of the author's life, plus 70 years).

When the US Congress passed the Sonny Bono Copyright Term Extension Act in 1998, copyright industry lobbyists argued that it was only fair to match the EU figure. The British Statute of Anne of 1710 – the first to grant copyright to authors – provided a term of 14 years, renewable for another 14 years. Under the Sonny Bono Copyright Term Extension Act (named after the hallowed writer and performer of 1960s pop hits, who, as a Republican congressman, strongly supported the bill), protection for works was extended from 75 years to 95 years and the 'neighbouring rights'[8] protections granted to works made by corporations, including films and most popular music recordings, were also extended. The Act was the result of significant lobbying of Congress by agencies briefed by corporate copyright holders, such as Disney. There are now campaigns by copyright holders in the EU for it to 'harmonise' its neighbouring rights provision to 95 years (one has been fronted by another hallowed creator of pop hits, Sir Cliff Richard). Cultural industry corporations are busy lobbying for similar changes to other national copyright legislation.

It is not just the duration of rights that has expanded over time and with lobbying but also their scope. When copyright was introduced to the USA in the eighteenth century, it was necessary to register. With compulsory registration removed, 'every creative act reduced to a tangible medium is now subject to copyright protection' (Lessig, 2001: 107). As Lawrence Lessig shows (2001: 4), this has created a system whereby, for example, film-makers have to seek permission and often pay a fee to include any piece of artwork, furniture, sculpture, architecture, music in their works. Copyright, intended to foster creativity, has become an almost insane restriction on it in many cases.

Not all creative works that have been fixed in a tangible medium are subject to copyright. Some works are in *the public domain* – a body of works that can be used by anyone because no one can claim exclusive rights to their use.

8 Neighbouring rights are not, strictly speaking, copyrights. In music, for example, they are the rights of ownership in the performance of a composition, rather than the composition itself. It is the recording that is owned rather than the composition underlying it. Nearly all recordings are owned by the companies that produce them, rather than by individual performers. In spite of this important difference, I follow the convention of treating all the various rights in cultural works under the heading 'copyright'.

National copyright laws determine when a work passes out of copyright and into this public domain. Cultural creativity is dependent on the public domain because acts of creation work by an often unconscious process of borrowing from and referring to other works. The result of extensions to the scope of copyright is that this public domain shrinks, other things being equal, with detrimental effects on creativity. While the industrialisation of culture has undoubtedly expanded the amount of cultural work in circulation in modern societies, the move towards lengthening copyright terms potentially shrinks the number of works that are available for creative recontextualisation. This is particularly important given that corporations routinely monitor any use of their copyrighted materials, even uses that seem trivial or incidental. This has implications that reach considerably beyond the cultural industries themselves – in education, for instance. To give one example of this, I was involved in producing a new media studies course for the Open University. We wanted to use a British daytime chat show, *Trisha*, as an example, to make various points about how working-class families are represented in such programmes. We wrote an analysis and wanted to provide the students with a clip from the show to make things clearer. The Open University's rights department wrote to the rights holder (ITV) to ask for permission. Permission was denied and no explanation given. Rights holders can have an important influence on what is taught in public education systems and they do not even have to provide an account of their reasons.

Copyright law and practice also limits copyright holders' power by allowing exceptions to the requirement that copyright holders authorise use of 'their' materials. In some countries, notably the USA, this is known as *fair use*.[9] Exceptions are stipulated in statutes or judged in the context of cases. Examples include parody, copying a certain restricted portion of a work (perhaps you're reading a photocopy now?) and educational use. As copying technologies (such as photocopiers, video recorders and digital samplers in music) have proliferated, this has become a big issue. Holders have become increasingly keen to protect their copyright and so fair use is also increasingly under threat. Even where fair use might be claimed, many institutions advise creators against using material in such a way in marginal cases – which are legion – because they fear action by rights holders. This might involve the withdrawal of a product or even litigation. Remember that the purpose of copyright is supposedly to provide an incentive to create works within a society. Ruth Towse (2002: xvii) summarises the economic perspective on balancing fair use with the incentives provided by copyright:

- a too strong copyright regime that tolerated little fair use would favour holders over users, but would increase the costs for holders of creating more works
- a too weak regime would not provide sufficient incentive.

9 The equivalent term in the UK is 'fair dealing', but it covers a much narrower set of exceptions than does 'fair use'. 'Fair use' is increasingly used as a generic term to cover the principle of such exceptions in debating the scope of rights.

'Fair use' in this broad sense also includes public domain material. It is hard to believe that the hugely increasing scope of copyright is necessary to protect creativity. Indeed, many writers are now arguing for a weakening of copyright.[10]

Perhaps an even greater price to be paid for the spread of copyright, both within advanced industrial countries and other societies, is that in more and more places the prevailing conceptions of what constitutes creative or cultural work begin to shift towards the individual property model and away from a notion of social or collective creativity. While Western copyright law in theory protects the individual creator in the interests of creators and users, in practice, as indicated in Box 2.5, copyright tends to be owned by corporations (which, in another of the bizarre contortions of modern law, are defined as individuals for the purposes of contracts). This then feeds into a vicious spiral in which cultural corporations become more powerful and more effective in lobbying governments and this then increases their power – a dynamic that will be investigated further in Chapter 6.

* * *

These various developments concerning creativity and the cultural or creative industries, often built on conflicting and imprecise notions of creativity (see Box 5.3), raise important questions about how we see culture in relation to economy and society and how we understand relations between creativity and commerce. So, too, do the changes in copyright law surveyed in the second part of the chapter. Together with developments in telecommunications and broadcasting, these developments provide an important basis (but not, as Chapter 3 stressed, the *only* basis) for the various changes discussed in the next five chapters. I have indicated some of the more problematic aspects of these policy developments, such as the restrictions on fair use and the public domain brought about by changes in copyright law and the confused and contradictory thinking underlying some cultural policy, but I defer a fuller evaluation of these changes until after we have begun to see other ways in which their effects have been played out.

FURTHER READING

On cultural policy, the terms of the academic debate on the left in the late 1990s and early 2000s were set by Jim McGuigan (*Culture and the Public Sphere*, 1996) and Tony Bennett (*Culture: A reformer's science*, 1998) – the former from a Habermasian and political economy perspective, the latter from a Foucauldian cultural studies one.

The work of Terry Flew, discussed above, provides the most thorough and intelligent rationale for a Foucauldian cultural studies approach to cultural policy in relation to the 'cultural industries'.

My own preference, as will be clear from the above chapter, is for Garnham's hard-headed appraisals of contradictions in cultural policy (see the chapters and articles cited in the chapter).

10 Many of these voices come from the left (such as Toynbee, 2004), but they come from the libertarian right, too. For example, *The Economist* favours much shorter copyright terms.

Reading *The International Journal of Cultural Policy* is a good way to follow debates from around the world.

There is a massive, and often difficult, body of legal studies literature on copyright, but the best way in for many readers interested in the cultural industries will be provided by the polemical literature on intellectual property produced by US academics, notably Lawrence Lessig's *The Future of Ideas*, Kembrew McLeod's *Owning Culture* and Siva Vaidhyanathan's *Copyrights and Copywrongs*, all of which were first published in 2001 – clearly a significant year for the analysis of rights. All these authors have produced further works since then, which essentially reiterate and update their earlier contributions. Even better than these compelling books though is James Boyle's brilliant and groundbreaking treatment of intellectual property in relation to the idea of the information society, *Shamans, Software and Spleens* (1996).

Richard Haynes' *Media Rights and Intellectual Property* (2005) provides a decent, but more sober introduction than the above.

The neglect of copyright in the political economy literature is an absolute disgrace. An honourable exception is Ronald Bettig's *Copyrighting Culture* (1996).

John Frow (1997) is the most intellectually impressive writer on copyright and intellectual property from a cultural studies perspective.

In my view, the best combination of historical analysis and information is Simon Frith and Lee Marshall's edited collection *Music and Copyright* (2004). Frith and a fellow popular music studies scholar, Dave Laing, have been arguing for the vital importance of copyright since the 1980s.

PART THREE

CHANGE AND CONTINUITY IN THE CULTURAL INDUSTRIES, 1980 ONWARDS

6 OWNERSHIP, STRUCTURE AND SIZE

The changes in government policy discussed in Part Two created a new business environment for the cultural industries from the late 1980s onwards. Marketisation meant that the cultural industries became an increasingly important sector for business investment. Chapter 3 provided the vital context for this: in response to the Long Downturn of the 1970s and 1980s, private corporations began to shift investment towards service industries, including the cultural industries.

Part Three now considers the changes and continuities that followed from these shifts. The present chapter considers how to understand changes in the ownership, structure and size of the cultural industries in this new environment. It is guided by the following questions, introduced in Chapter 2 (see Table 2.1). The first two primarily concern the *extent* of change; the second two how to *evaluate* developments.

- To what extent have changes in conglomeration and integration led to recognisably new and distinct forms of ownership and structure?
- To what extent have the cultural industries become increasingly important in national economies and global business?
- What are the effects of the growth in size and power of cultural industry corporations on cultural production and wider society?
- What are the implications of further commodification of culture?

I begin by providing evidence of the considerable growth in size and scope of large cultural industry corporations and then go on to examine trends in the strategies of these corporations, especially conglomeration and vertical integration. This might suggest that the cultural industries are marked by increasing levels of

market concentration, but, as I explain in the next section, the measurement of concentration is a fraught issue. Nor does the undeniable fact of bigger and more integrated companies mean that small companies are less important, so the next sections consider the continuing presence of such companies and new forms of relationship between them and the corporations. Naturally, the question of how to evaluate this change is tied in with establishing the facts about it. Corporate growth is important and should concern everyone interested in cultural production. Nevertheless, the picture regarding changing patterns of ownership and structure is, I think, more nuanced and complex than some critics of developments in the sector would have us believe.

I then go on to examine the question of whether or not the cultural industries are becoming more central to global business and national economies and argue that many claims regarding the growth of the cultural industries need to be treated with scepticism. Otherwise, we risk reproducing inflated language regarding change that potentially promotes the interests of the big cultural industry companies. The final section evaluates the continuing commodification of culture, of which the growth of the cultural industries is a sign.

OWNERSHIP AND CORPORATE STRUCTURE: THE BIG GET BIGGER

One of the most important transitions from the market professional era of cultural production to the complex professional era involved the increasing presence of large corporations in cultural markets (see Chapter 2). This long-term trend intensified in the 1980s and 1990s. There has been a massive growth in the size and scope of cultural industry corporations. A small number of transnational corporations have enormous power.

The increasing size and conglomeration of cultural industry companies were part of a trend towards more and larger mergers and acquisitions in all industries, which quickened during the 1980s in response to the Long Downturn. There were 4900 mergers in the USA between 1968 and 1973, and this number increased in the 1970s and 1980s. There were over 3300 corporate acquisitions in 1986 alone (Greco, 1995: 229–30). This was the period of marketisation in broadcasting policy in the USA and two of the three great broadcasting networks (CBS and NBC) changed hands in huge deals in 1985–1986.

Following the Wall Street Crash of October 1987, the House of Representatives eliminated certain tax breaks that encouraged acquisitions. As a result, mergers of all kinds substantially decreased in the USA in the following years (Greco, 1995: 230), though this move did not put an end to spectacular international mergers. Consumer electronics company Sony purchased CBS Records in 1988 (US$2 billion) and Columbia Pictures Entertainment (US$3.4 billion) in 1989. Time-Life and Warner Communications merged in 1989, in the form of a 'friendly' US$14.9 billion buyout by Time-Life. Then, after a brief hiatus in the late 1980s, the 1990s saw an explosion of mergers in industry as a whole. For example, 1997 saw the highest ever figures for mergers and acquisitions in the USA up to that point – US$912 billion worth of deals (*Business*

Table 6.1 Some major cultural industry acquisitions and mergers

Date	Acquiring firm	Acquired firm (new name in brackets)	Price (US$ billions)	Strategic motivation
1994	Viacom	Paramount Communications	8.0	Conglomeration across publishing, film, broadcasting, cable, theme parks
1994	Viacom	Blockbuster	8.5	Distribution control
1995	Disney	Capital Cities/ABC	19	Vertical integration and control of content creation
1995	Time Warner	Turner Broadcasting	7.4	Vertical integration and conglomeration/synergy
1995	Seagram	MCA (Universal)	5.7	General conglomerate moves into diversified media
1995	Westinghouse	CBS	5.4	General conglomerate moves into broadcasting
1999	Carlton*	United*	8.0**	Merger of major European media groups
1998	Seagram	PolyGram	10.6	Recording market share plus European film interests
1999	Viacom	CBS	22	Media conglomerate consolidates broadcasting power
2000	Vivendi	Seagram/ Universal	35	Very diversified European leisure conglomerate diversifies further
1998	AT&T*	TCI (including Liberty Media)*	48**	Telecoms and media convergence
2000	AOL*	Time Warner* (AOL Time Warner)	128**	Internet service provider merges with media conglomerate
2002	Comcast	AT&T Broadband	47.5	Cable company expands via acquisition
2003	General Electric/NBC	Vivendi Universal (NBC Universal)	5.5	'Merger' between two media giants, but with NBC by far the dominant partner
2003	Sony*	BMG (Sony-BMG)		Music arms of two majors merge

(Continued)

Table 6.1 (Continued)

Date	Acquiring firm	Acquired firm (new name in brackets)	Price USD billions	Strategic motivation
2004–5	Sony	MGM	4.9	Massive acquisition of back catalogue; cable company Comcast also involved as outlet for these films
2006	Disney	Pixar	7.4	Studio buys production company with strong affiliations to it

Key
* a merger
** evaluation of new merged company rather than price

Note: Prices and values are based on reports at the time that the merger or acquisition was announced, except for AOL Time Warner, which was evaluated at US$350 billion in January 2000 when the merger was first reported but US$128 billion when the merger was approved by the US regulatory body the Federal Communications Commission. The fall in value reflected the fall in share values over the year, as Internet and new media hype subsided.

Week, 30 March 1998: 47). This was echoed in the cultural industries. According to Greco (1996: 5), there were 557 reported media business acquisitions between 1990 and 1995 – only just short of the entire total of such deals between 1960 and 1989. Particularly significant were two waves of mega-acquisitions, in 1994–1995 and in 1999–2000. See Table 6.1 for details of major cultural industry mergers and acquisitions in the 1990s and early 2000s. According to one source, in 2000, 40 per cent of the mergers and takeovers of companies on a global scale (worth US $3.5 trillion) took place in the areas most relevant to the cultural industries – telecommunications, new technologies and media (Sánchez-Tabernero and Carvajal, 2002: 7).

There was another important context for the growth of cultural industry corporations in the late 1990s besides the general trend towards more and larger mergers and acquisitions. The economy in the USA began to boom from 1995 onwards – finally, the Long Downturn seemed to be in reverse. There was rapid growth of gross domestic product, labour productivity and investment. Even real wages went up (though inequality continued to increase). This boom led to what Robert Brenner (2000: 5) has called 'the greatest financial bubble in American history', as equity prices lost touch with reality and household, corporate and financial debt all reached record levels, leading to an explosion in consumption. All this helped to fuel increases in the advertising spending that is central to profitability in many cultural industry businesses. This encouraged mergers and acquisitions in the cultural industries, but so did the general sense that the world – or at least the most developed parts of it – was becoming a global information society. Between 1992 and 2002, the biggest corporations were involved in hundreds of mergers and acquisitions. Bertelsmann, for example, took part in 249 as an acquirer and 137 as a seller or target (Chan-Olmsted and Chang, 2003: 223).

Table 6.2 The Big Seven cultural industry corporations

This list ranks the biggest companies by revenue gained from cultural-industry activities, as defined in this book. Revenue is in US$ billions for fiscal years ending in 2005. The figure for Sony is for its games, music and films divisions. See Table 6.6 for further details of the companies involved.

Company	Revenue
Time Warner	43.7
Walt Disney	31.9
Viacom	27.0
News Corporation	23.9
Bertelsmann	21.6
Sony	16.0
NBC Universal	14.7

Source: company reports.

Partly as a result of such mergers and acquisitions, by the late 1990s, a small group of corporations were clear leaders in terms of the revenues they gained from global cultural industry markets. The organisational structures of these companies change regularly, as further mergers, acquisitions and sell-offs take place or are put on hold by regulators. These structures are very complex – in many cases spanning hundreds of business units, and dozens of production sectors (see below on conglomeration).[1]

Table 6.2 lists the seven biggest cultural industry businesses, as they stood in mid-2006, based on figures for fiscal years ending in 2005. These seven corporations have a significant presence in both North America and Europe, the world's two largest continental cultural industry markets. However, only Rupert Murdoch's News Corporation can be considered a truly global corporation as it has significant market share across numerous cultural industries in three continents (North America, Europe and Asia/Australasia).

Below these seven vast corporations, each with annual revenues of over US$14 billion from their cultural industry activities, sits a 'second tier' (Herman and McChesney, 1997: 53) of regional giants, consisting of dozens of companies with revenues in excess of US$1 billion per year from cultural industry operations. Apart from a small number of Latin American and Australian concerns, all are based in North America, Europe or Japan.

From time to time, one of these second-tier corporations joins the elite of cultural industry mega-corporations. This is what Viacom achieved in the 1990s. Comcast, a company based in the USA primarily involved in cable television, attempted to do this in the early 2000s but has so far failed. Nevertheless, its massive cable holdings, combined with an increasing interest in content, gives it tremendous power in the cultural industries sector.

1 From time to time, following the most spectacular deals, even the names of the parent companies change. The most recent case was when Vivendi Universal sold most of its cultural industry interests to General Electric in 2003 and the relevant division of GE became known as NBC Universal.

Collectively, the first and second tiers of companies have an enormous impact on the cultural industry landscape in terms of policy lobbying and the standards they set for what constitutes standard practice in the cultural industries. Concentrating only on the very largest, internationally famous corporations can distract attention from the huge importance, in particular nations and regions, of the wider range of corporations. Take, as one example, Grupo Clarín, an Argentinian corporation with annual revenues of over US$7 billion per year, which, at the time of writing, runs Argentina's leading newspaper but also has significant holdings in broadcasting. It is entering into Argentina's expanding broadband market and, because of Argentina's economic and cultural position in the Southern Cone of the Americas, is important in Uruguay and Paraguay, too. Alternatively, consider the USA's Clear Channel Communications, which earns over US$8 billion in annual revenues. This is small compared with Time Warner and Disney, but the company has a massive portfolio of radio companies, including a presence in just about every major urban space in the USA, since the massive wave of takeovers that followed the 1996 Telecommunications Act. This links up with significant investments in advertising and in live music. It is both the first *and* second tiers of companies that we should focus on to get a real sense of the expanded role of large cultural industry corporations within nation states and regions, not just the Big Seven.

Even below these two tiers of global giants, there are many other companies exerting a sizeable influence on particular markets. A report by Zenith consultants (cited by Sánchez-Tabernero et al., 1993: 100) usefully classified the biggest cultural industry companies using the following categories:

- companies dominant in one cultural industry in one country
- companies influencing one cultural industry across several countries
- companies having interests across more than one cultural industry in one country
- companies with interests in more than one cultural industry internationally.

Nearly all the biggest 50 or so cultural industry corporations are in one or more of the first three categories. With conglomeration and internationalisation, more and more companies are entering, or moving into, the final category.

CHANGING CORPORATE STRATEGIES I: CONGLOMERATION

An important feature of the complex professional era from the 1960s onwards was conglomeration (see Chapter 2). This continued into the 2000s. The extent of conglomeration in the Big Seven global media corporations is indicated in Table 6.3. Corporate strategy with regard to conglomeration has changed in important ways. The recent fashion has generally been to build a portfolio of *related* industries, whereas in the 1960s and 1970s, as we saw in Chapter 2, the trend was for non-cultural industry conglomerates to buy into the cultural industries.

Table 6.3 Conglomeration in the Big Seven

Diversification Measures	Vivendi Universal	Bertelsmann*	Sony	AOL Time Warner	Disney	Viacom	News Corporation
Extent of diversification							
Number of business units** (ranking)	316(2)	531(1)	150(4)	190(3)	113(5)	30(7)	71(6)
Number of SIC sectors involved (ranking)	80(1)	29(4)	32(3)	28(5)	15(7)	17(6)	
Directions of diversification							
BSD (ranking)	30(1)	na	13(4)	18(2)	16(3)	8(6)	9(5)
MNSD (ranking)	2.67(1)	na	2.46(2)	1.83(5)	1.75(6)	1.88(4)	1.89(3)
Overall ranking***	1	2	4	3	5	7	6

Note: SIC = Standard Industrial Classification; BSD = Broad Spectrum Diversity; MNSD = Mean Narrow Spectrum Diversity. Source: OneSource.

*Because of the lack of specific SIC codes for the German based Bertelsmann, a proxy system was used to measure its product diversity that is consistent with the SIC measure used for other conglomerates. Drawing on Bertelsmann's annual reports, its list of divisions (e.g., television group) was treated as the 2-digit SIC group and its subdivided sets of businesses under each division (e.g., pay-TV) as unique SIC codes. Over 500 business units were reviewed to derive the proxy measures. Because of the proxy system, it was not possible to calculate the BSD and MNSD for Bertelsmann. However, because of the extensiveness of Bertelsmann's business units and its sectors were comparable to those of other conglomerates, except for Vivendi, it is still considered number two in the overall ranking assessment.

**A business unit is a subsidiary business entity of a parent company (e.g., MTV as a business unit of Viacom).
***The overall rankings are based on the averages of BSD, MNSD and business unit/sector rankings.

Source: Chan-Olmsted and Chang (2003: 221)

The Long Downturn of the 1970s and 1980s forced a rethink in terms of the ways in which businesses operated. One of these was that there was an increasing emphasis on the notion of *synergy*. This was originally a medical term, referring to how two elements (such as two drugs or two muscles) might work together to produce a result greater than the sum of the two parts. The idea behind the metaphor was that the different parts of a corporation should relate to each other in such a manner as to provide cross-promotion and cross-selling opportunities, so that sales would exceed what was possible when they acted separately. As the popularity of such ideas spread from business schools and management gurus and into corporations, conglomerates began to specialise again. This time, though, it was not in one activity – as in the prediversification era of the early twentieth century – but in a set of related ones.[2]

The form of conglomeration that received the most publicity in the late 1980s was the purchase of media producers by consumer electronics companies – so-called hardware/software synergy.[3] Sony's purchases of CBS Records and Columbia Pictures Entertainment in 1988 and 1989 respectively were widely assumed to represent the future shape of cultural industry corporations. The idea was that Sony would be able to use prestigious US rock music and cinema to help persuade consumers to buy new consumer technologies, such as the minidisc.

Other significant purchases in the 1980s were based on very different strategies. For example, general conglomerate General Electric's purchase of NBC in 1985 was about spreading investment across a range of sectors. This strategy was deemed somewhat outmoded in an age where the fashion in business was for synergy, so this purchase gained relatively little attention compared with acquisitions by Japanese corporations of US cultural industry businesses in the USA. Acquisitions such as that of MCA Records by Japanese conglomerate Matsushita in 1990 fed recession-fuelled fears on the part of US businesses in the USA about a loss of global economic domination, but also cultural fears about the loss of supposedly distinctive US cultural production.

By the mid-1990s, however, such hardware/software synergies were widely viewed as a failure. Some commentators have explained this apparent failure by referring to the different production cultures needed to produce consumer electronics on the one hand and music/films/TV programmes on the other. Some of these accounts were convincing (Negus, 1997), but some press versions of this view bordered on racism as the implication was that the Japanese were incapable of producing entertainment; they could only produce efficient machines.[4] When

2 Very diverse general conglomerates continue to be a feature of the South East Asian business landscape. Some North American general conglomerates, such as General Electric, thrived in the late 1990s and early 2000s.

3 Such hardware/software synergies were not unprecedented by any means. The Dutch consumer electronics group Philips had its own record division (PolyGram) for decades until it sold it to Seagram in 1995. The networks in the USA were also founded on such synergies as NBC, for example, was part of the communications conglomerate RCA, which made radio equipment.

4 To provide just one of many possible counter-examples, there have been many fine animated features coming out of the USA over the last ten years, but Hayao Miyazaki's enthralling *Spirited Away* (2001) and *Princess Mononoke* (1997) can match any of them.

hardware/software mergers were deemed to be a failure, the electronics companies began to sell off their media properties and form alliances and joint ventures with media producers on particular projects.

There is no fundamental reason for mergers – as opposed to alliances and joint ventures – between electronics companies and media producers not to become fashionable again, but the 1990s were dominated by three more tenacious forms of synergy-based cultural industry conglomerate. (The following typology is adapted from a study by consultants Booz, Allen & Hamilton, summarised by Sánchez-Tabernero et al., 1993: 94.)

- The first was **the media conglomerate**, based almost entirely on a set of core media interests (for example, News Corporation).
- The media are also important for the second category, **the leisure conglomerate**, but take their place alongside other leisure interests, such as hotels and theme parks (for example, Disney).
- From the mid-1990s onwards, however, a third type of cultural industry conglomerate looked set to become increasingly significant: **the information/ communication corporation**. This category was perhaps best typified by AT&T's 1998 takeover of cable group TCI, including the Liberty Media Group. Media, telecommunications and computer corporations merged and acquired each other in anticipation of further convergence between these markets (see Chapter 9). However, there were signs in the early 2000s that telecommunications corporations such as AT&T were withdrawing from the media sector.

Trends and strategies in conglomeration in the cultural industries are often prone to revisions and even reversals, but one trend is undeniable – a constant tendency towards greater and greater overall conglomeration.

The marketisation of broadcasting was an important foundation for this conglomeration as it meant that many new cultural industry sectors, including radio, plus terrestrial, cable, satellite and digital television, became available as targets for purchasing and investment for conglomerates wishing to extend their portfolios. As governments removed restrictions on market concentration and cross-media ownership, the cultural insdustries came to be perceived as major new growth areas for business.

Conglomeration clearly entails an increase in the scope and power of individual cultural industry corporations, in that the same corporation can have stakes in many different forms of communication. Fewer companies, therefore, come to dominate the cultural industries as a whole, other things being equal (though in fact they rarely are – new industries tend to appear). This has an effect on the lobbying power of the corporations and their general influence on the ways in which cultural production is carried out. Internal dissent among the major conglomerates is less likely as they decrease in number. It undoubtedly allows the corporations to cross-promote their products, whether texts or other services. One notorious case was the way in which News International's newspapers in the UK promoted the services operated by Rupert Murdoch's BSkyB (see Hardy, 2004b). Such cross-selling reinforces the power of the oligopolies dominating the cultural industries and promotes commercial imperatives at the expense of artistic values (in fiction

and entertainment) and objectivity and professionalism (in journalism). Some also assert that conglomeration leads to diminished diversity and quality, but there are problems surrounding the evidence for this (see Chapter 10).

CHANGING CORPORATE STRATEGIES II:VERTICAL INTEGRATION

The imperative towards vertical integration is strong in the cultural industries because of the vital importance of circulation, discussed elsewhere in this book. The importance of this, in turn, derives from the need to control relationships with fickle audiences and create artificial scarcity for cultural products with 'public good' characteristics (see Introduction). That is why so many of the key industries have been dominated by an oligopoly of vertically integrated companies. However, it would be wrong to portray developments in the cultural industries as a relentless march towards vertical integration. As with conglomeration, vertical integration strategies are subject to change and there are signs of partial disintegration in some industries and new forms of integration.

Whereas in the late 1980s commentators thought that Sony would be the archetypal cultural industry corporation, in the 1990s the future seemed to be represented by Disney. The success of Disney in the 1990s was based on an understanding of the importance of intellectual property – that the cultural industries increasingly operate according to the ownership of rights to films, TV programmes, songs, brands. By circulating these symbols across many different media, Disney characters, icons and narratives become increasingly present in the public consciousness. New characters and icons can be launched by means of intensive cross-promotion. Crucial to this strategy, though, was vertical integration. Disney not only owns a remarkable back catalogue of films and recordings, its theme parks, hotels and so on, it also has its own television network and cable channel (it has had its own international distribution company, Buena Vista, for decades). With its purchase of Capital Cities/ABC in 1995, Disney became one of the largest cultural industry companies in the world. But it was not just the size of the corporation that made this a significant event. The perception was that Disney had understood the nature of the new cultural industries – that combining ownership of content and distribution was the way forward. In its list of the biggest media companies in 1998–1999, *Screen Digest* (July 1999: 176) noted that 'the top companies are all highly diversified – vertically and horizontally integrated'. Yet, by 2001, analysts were speculating that Disney's fortunes were in reverse after the poor performance of the blockbuster film *Pearl Harbor*. Vertical integration based on the marriage of content creation and distribution was suddenly out of favour.

Moreover, there has been plenty of movement in the last 30 years *away* from vertical integration. One of the major organisational forms of the early complex professional era – PSB – represented a striking example of vertical integration in the public interest, justified on the grounds that it ensured a coherent schedule of entertainment and information for national citizens. Many of the PSB monopolies had programme-makers of all kinds, technical and creative, on permanent contracts, made programmes, controlled broadcasting distribution and, in some

cases, even made television sets. In the 1990s, however, there was a boom in independent television production across much of the world, driven mainly by two processes: PSB organisations dealt with budget cuts by subcontracting production and policymakers wanted to encourage growth in the independent sector by measures such as setting quotas for how much production had to be outsourced. This led many commentators to talk of a new era of post-Fordist television, involving flexible working arrangements and networks of interdependent firms rather than monolithic organisations (Lash and Urry, 1994: Chapter 5; see also Robins and Cornford, 1992 for a more sceptical account). Whether this resulted in greater creative autonomy for programme-makers or not is another matter. We shall return to this issue in the next chapter.

The trend in the audiovisual industries in the USA has been towards vertical integration. It is ironic that while classical European PSB organisations permitted vertical integration, the system in the USA, associated with a more market-orientated approach to cultural production, aimed to discourage it. With marketisation, the disintegration found among European broadcasters has been reversed in the USA. One of the main ways in which policymakers in the USA sought to control the mighty power of the networks was to restrict vertical integration by limiting how many local stations the networks could own. From the early 1960s on, the broadcasters bought nearly all of their TV and radio programmes in packages from independent production companies, such as MTM (which made *The Mary Tyler Moore Show* and *Hill Street Blues*), Lorimar (*Dallas, Knots Landing*) and Tandem (*All in the Family, Sanford and Son*) (see Sterling and Kittross, 2002: 722). Some Hollywood studios acted as 'independent' producers in this system – most notably Warner Brothers.

In the late 1990s, all this changed. The networks in the USA were increasingly part of the same media and leisure conglomerates as the major Hollywood studios and, consequently, turned to these sibling companies for most of their productions. Those networks not owned by studio-owning conglomerates followed suit as the studios gained in prestige. According to a report cited by McChesney (1999: 21), the six major Hollywood studios produced 37 out of 46 new prime-time shows scheduled for autumn 1998. Such integration was apparent further downstream, too. Not only were companies such as Columbia (that is, Sony) buying up cinemas but also the studios were now owned by the same companies that owned the other major outlets for films – broadcast and cable television, plus video hire networks. Disney owned ABC, plus numerous cable networks, News Corporation owned Fox and had launched a new television network of the same name in the mid-1980s, Viacom owned Paramount Studios and the fledgling network UPN and, in 1999, bought CBS, one of the big three networks, while Time-Warner dominated cable networks and, as a result of its purchase of Ted Turner's company TNT in 1997, owned the key cable channels.

Even so, in the case of the USA, such transformations cannot be portrayed as an entirely new era of vertical integration. The integration of Hollywood studios with television networks represented a return to the strategies Hollywood used during the classic studio era, from the 1920s to the 1950s (see Box 2.3).

The recording industry also shows high levels of vertical integration. For decades, the major companies have owned pressing and distribution facilities, as

well as contracting musicians to record for them. However, the majors have rarely attempted to own retail outlets – in part because of the complexity and multiplicity of the markets for music. What is more, the relationship with independent production is more complex in the music industry than in any other industry (see the section on small companies, below).

Vertical integration is best seen, then, not as a constant process – whereby companies get more and more vertically integrated over time – but something that is historically variable for different industries. Changes in government policy, the arrival of new technologies and new business fashions can all bring about shifts either towards or away from vertical integration. Nevertheless, vertical integration is a significant factor in the market and media power of the major cultural industry corporations.

ARE CULTURAL MARKETS BECOMING MORE CONCENTRATED? DOES IT MATTER?

The issue of market concentration has been central to work on the cultural industries in liberal-pluralist communication studies and political economy approaches to culture. Chapter 2 noted high levels of market concentration in the cultural industries, but pointed out that, in some cases, the arrival of corporations in new markets actually reduced the level of market concentration. Good, historically comparative statistics on market concentration are hard to find. Instead, we have to rely on snapshots of particular times and these still need to be treated with caution.

What have been the effects of conglomeration on corporate domination of cultural markets? Ben Bagdikian (2004) has provided something of an indication of the effects of such conglomeration in terms of general cultural market concentration. For the first edition of his book *The Media Monopoly*, Bagdikian compiled an apparently unpublished list of the dominant media firms in the market in the USA in 1983 in the following industries: newspapers, magazines, television, book publishing, motion pictures. For each industry, he worked down the lists of dominant companies, counting how many companies it took to account for more than 50 per cent of market share (measured in different ways for different media). He then added the figures together and calculated a total of 50 dominant corporations across the media as a whole. Bagdikian has repeated the exercise for every subsequent edition of his book and the count has come out as follows.

- 1983–50
- 1987–29
- 1990–23
- 1997–10
- 2000–6
- 2004–5

This is a crude method of measuring overall cultural industry concentration and conglomeration, but it draws attention to the increasing size and scope of the biggest corporations and their increasing tendency to work across all the different cultural industries.

Similarly, also writing about the USA, McChesney (2004: 178–9) provides a number of examples of concentration in recent years, with some historical comparisons:

- following the 2003 merger of Sony and Bertelsmann's music divisions, 4 firms sell almost 90 per cent of US recorded music by revenue
- the 6 largest film companies account for over 90 per cent of box office revenues
- the 2 largest firms in radio broadcasting do more business than the firms ranked 3–25 combined
- in 1990, the 3 largest publishers of college textbooks had 35 per cent of the market in the USA and they had almost doubled their share by 2002
- in cable, which was once a market without significant oligopoly control, according to McChesney, 6 cable companies had effective monopoly control over local markets across 80 per cent of the USA by 1998.

The accumulation of evidence presented by McChesney suggests an irresistible tide sweeping the cultural industries towards ever-greater levels of market concentration, but much depends on the historical framework we decide to examine. In the USA, radio became more concentrated in the light of the 1996 Telecommunications Act, but it was still much less concentrated than in the days of network control (in 1945, 95 per cent of all radio stations were affiliated with one or more of the four national networks – Sterling and Kittross, 2002: 283). Concentration levels in cinema exhibition are still relatively low compared with other industries and certainly compared with the days when the major studios owned them – that is, prior to 1948, when government antitrust action resulted in the studios selling off their cinema interests.

As for new industries, such as cable, there is bound to be a process of oligopolisation as such industries mature and smaller firms are snaffled up by those aiming to increase their market share. That's capitalism.[5] This is not to be complacent about existing levels of market concentration, but such statistics do not prove, in themselves, the existence of long-term processes of *increased* concentration in US markets. Market concentration levels are high across all industries, but, even in the wider economy, there is evidence that market concentration does not always go up in advanced industrial economies as a whole.[6]

What about European figures? In their study of media concentration in Europe, Meier and Trappel (1998: 51) provided some figures on concentration based on EU sources (see Table 6.4). They suggested very high levels of concentration in book publishing, newspapers and television. However, again, these

5 There might be very real grounds for being concerned about the possibility of increasing integration between telecommunications and cable companies, however, as Cooper (2002) shows. This, though, is a problem of integration and the removal of entry barriers between sectors rather than concentration per se.

6 Ghemawat and Ghadar (2000), arguing against global mega-mergers as a business strategy, present evidence to show declining global concentration levels in automobiles, oil and other key industries, including even high-tech industries. Systematic comparisons of market concentration in the cultural industries with levels elsewhere are extremely rare. Murdock and Golding (1977) is an obviously outdated exception.

Table 6.4 Media concentration in Western Europe

Country	Circulation share of top five publishing companies	Circulation share of top five newspaper titles	Audience market share of top two TV channels
Austria	45	69	68
Belgium (fr)	77	55	47
Belgium (fl)	–	–	58
Denmark	50	49	78
Finland	42	39	71
France	–	–	60
Germany	–	23	31
Ireland	–	–	60
Italy	–	–	47
Luxembourg	100	–	–
The Netherlands	95	–	39
Norway	53	38	80
Portugal	55	91	88
Spain	–	–	51
Sweden	49	33	55
Switzerland (d)	–	–	45
Switzerland (fr)	–	–	49
UK	95	–	68

Source: Meier and Trappel, 1998: 51, based on EU statistical sources

were non-historical and, given that in many countries television was entirely dominated by one or two channels until the 1980s, there may even be significant reductions of concentration now, at least in the terms used here.

Sánchez-Tabernero et al. (1993: 102) compiled statistics comparing the market share of the two largest daily newspaper groups in 1975 and 1990 across 17 European countries (see Table 6.5). Even then, however, the trends were mixed across the 15 countries for which figures were available. Five recorded significant increases, four small increases, three large decreases and three small decreases. This certainly does not point to a Europe-wide trend towards significant market concentration in this cultural industry.

So, it is difficult to prove that levels of market concentration have substantially increased in the cultural industries since the late 1970s. In fact, economists even find it difficult to agree on any reliable measure of market concentration for the same period (see Iosifides, 1997). For example, one issue, among many others, is whether or not different divisions of the same corporation – which, at least in principle, compete with each other – should be counted as competitors.[7] (Even more difficult to prove via reliable statistics is that increased levels of

7 Christianen (1995: 89–91) argues that concentration in the music industry should take account of different record company divisions as separate entities, so that all the different labels under each conglomerate's control would be counted separately because they are in internal competition with each other. This would make concentration figures much lower and help account for the greater diversity of product that followed from some periods of apparent market concentration (see Chapter 10).

Table 6.5 Changes in newspaper market concentration

Country	1975(%)	1990(%)
Austria	55	68
Belgium (fl)	26	59
Belgium (fr)	52*	68
Switzerland	20	21
Germany	35**	29
Denmark	38	48
Spain	24	29
Finland	26	39
France	15	35
UK	53	58
Greece	61	36
Ireland	n/a	75
Italy	n/a	32
Netherlands	36	35
Norway	48*	45
Portugal	60	30
Sweden	30	31
Turkey	46	34

The figures refer to the share of circulation held by the two largest newspaper groups.

*estimate
**1976 figures

Source: Sánchez-Tabernero et al., 1993: 102, reporting European Institute for the Media figures.

market concentration lead to reduced levels of diversity of output. I return to this issue in Chapter 10).

These problems and ambiguities mean that the political economy critique of concentration is highly vulnerable to attack from the right and the political centre. Compaine and Gomery (2000), for example, have been able to amass a vast body of statistics, complicating the polemical portrayals of never-ending concentration. The specific points can be argued over, but, overall, Compaine and Gomery's approach is more nuanced than the simplistic analysis to be found on many media activist websites.

There is another reason to think that too much attention has been paid to market concentration by political economists and other issues should be prioritised. Nicholas Garnham (2004: 100) has observed that 'the critique of concentration per se is more of a liberal than a left critique'. The 'per se' is significant here: market concentration is important as a fact, but only because it leads on to other connected questions. Garnham (2004: 100) continues, urging pragmatism: 'the mass media are by their very nature, for better or worse, the products of economies of scale and scope and thus are by their very nature concentrated'. I would not want to go quite as far as this because policies to limit certain forms of concentration can act as curbs on the worst abuses of corporate power in certain situations. However, in arguing for such policies, critics of the cultural industries need to be sure of what the problem is. As Chapter 2 suggested, it is on the presence of large cultural industry corporations that analysis should focus, rather than on the red herring of

market concentration (the two are often blurred together, but are distinct points). A number of factors related to this presence are of greater significance than market concentration itself. These include the ways in which such corporations can influence public policy in the direction of marketisation and, connected to this, their ability to pursue commodification and limit public access to culture and creativity, as well as their relentless pursuit of financial rewards in an era where shareholders rule.

THE CONTINUING PRESENCE OF SMALL COMPANIES

We saw in Chapter 2 that independent producers proliferated – and became important to debates about cultural production – even as large corporations became dominant in the cultural industries in the middle of the twentieth century. As cultural corporations have become bigger and more dominant, small companies have continued to boom in number. According to one analyst, 80 per cent of the Hollywood film industry is made up of companies with 4 employees or fewer (Jack Kyser, cited by Magder and Burston, 2002). Even during the period when the book industry was involved in successive waves of mergers and acquisitions, the number of book companies active in the USA increased from 993 in 1960 to 2298 in 1987, according to Department of Commerce figures (Greco, 1996: 234).

The continued importance of small companies can partly be explained by the factors analysed in Chapter 2 – that is, the conception stage of texts remains small-scale and relatively inexpensive and still takes place in relatively autonomous conditions. However, there are other factors – more specific to the period since 1980 – accounting for the still prevalent role of small companies.

- *The onset of new media technologies brought about by the combined factors of government marketisation policy and intensified business interest in leisure and culture* This has created new types of cultural industry and, before industries 'mature', there is often more room for manoeuvre for independents than is possible in established industries. Key examples of such independent-friendly new cultural industries over the last 30 years are computer games, multimedia production (for example, educational CD-ROMs) and website design. However, the introduction of new technologies is also a product – and, in turn, a cause – of a proliferation of new subsectors within longer-established industries. For example, as live performance by successful rock acts has become more and more important, from the 1970s onwards, a host of new companies have sprung up providing technical and other forms of support, including amplification specialists, but also lighting and set designers and so on.
- *The rise of a discourse of entrepreneurialism in the economy as a whole (Keat and Abercrombie, 1991)* There has been increasing emphasis since the 1970s on the value of 'going it alone', working separately from large bureaucratic organisations. This has not only made people willing to set up their own businesses but has also made large businesses more willing to interact with them.

- *Venture capital has become much more available to small- and medium-sized cultural businesses* as culture has become recognised as a valid form of profitmaking.
- *Dominant vertically integrated companies have seen some disintegration* As we have seen, these have been industries such as television. This has not only brought about an independent production sector but also created many ancillary and technical support companies, from film and television catering specialists to companies that rent out editing suites and personnel.
- *There has been an increasing emphasis in cultural industry companies on marketing* So, there are also scores of design studios, independent advertising agencies and so on aimed at servicing companies that are increasingly willing to pay more to market their goods and services in innovative ways. What is more, in this way, actors, performers and other symbol creators can subsidise their other work, which they may feel is their 'real' work. This has happened for a long time, but now more than ever.

Accounts that focus on conglomeration, integration and the increasing size of the cultural industry corporations (such as many accounts from the Schiller–McChesney tradition of political economy) often understate the importance of small companies. Such companies may account for small levels of market share, but they are important in terms of the numbers of people they employ and their potential to foster – or at least act as a conduit for – innovation. This, along with other factors, has meant that a strong ethical and aesthetic premium has been placed on institutional independence.

This is particularly apparent in the film (I discuss indie films in Chapter 10) and recording industry. Crucial in many music genres has been a discourse of independence among musicians, fans and journalists. This has allowed independent record companies, in some exceptional cases, to serve as the centres of commercial networks that form something of an alternative to prevailing systems of cultural production and consumption.

For Jason Toynbee (2000: 19–25), the particular importance attached to independent production in popular music derives from a long-standing history of 'institutional autonomy' in popular musicmaking that cuts against the efforts of large companies to make profits out of music. This autonomy is based on the dispersed, decentralised nature of musicmaking. It means that not only do companies cede control of production to musicians (as in all cultural industries) but there is also a tendency towards 'spatially dispersed production in small units' (rock groups, swing bands) and 'a strong continuity between production and consumption' in musical subcultures (Toynbee, 2000: 1). Audiences and performers come together in 'proto-markets', which are only partially commodified, and where there is a great deal of resentment towards the industry and 'selling out'. The possibility of institutional autonomy and the high value attached to it in musical subcultures means that spaces have been created where alternative arrangements for the management and marketing of creativity can be tried out. I discuss an important example of such an 'alternative' dynamic in the next chapter (see Box 7.2).

INTERDEPENDENCE, INTERFIRM
NETWORKS AND ALLIANCES

Small companies, then, not only continue to exist; they are multiplying. However, there is a vital caveat, already referred to in passing in the above discussion of independent record companies. A key change in the cultural industries in the years since the 1970s has been that small and large companies are increasingly interdependent: they are involved in complex networks of licensing, financing and distribution.

One of the most important ways in which corporations have changed their organisational structures, in nearly all major areas of business, is that they increasingly subcontract to small- and medium-sized firms (see Chapter 3 on organisational innovation in the wake of the Long Downturn). These smaller firms are potentially more dynamic and able to innovate than the large conglomerates but they are increasingly involved in close relationships with the corporations that subcontract to them. This is true, too, of the cultural industries.

Such webs of interdependence are not entirely new in the cultural industries. In film, as the Hollywood corporations lost their control over production in the 1950s, new, independent production companies entered the market to cater for specialist products, but the Hollywood studios still acted as distributors and financiers of independently produced films (see Aksoy and Robins, 1992). Even in an era in the recording industry when 'majors' and 'independents' were seen by fans, musicians and critics as polar opposites, in truth they were often linked in licensing, financing and distribution deals. Such arrangements, whereby small and large companies form interdependent webs, became increasingly prevalent in the 1980s and extended into new areas of the cultural industries, most significantly in European broadcasting, where traditionally production had been handled 'in-house' by large state and public service broadcasters (Robins and Cornford, 1992).

There are rewards for both corporations and small companies in such systems of interfirm networking. For the corporations, acting as distributors and financiers of independent producers is an extension of what they already do, acting as distributors and financiers of their own semi-autonomous divisions. A large multidivisional corporation might get a lower cut of revenues from a text produced by an independent company than from the sales of a text created within one of their own divisions, but the arrangement means that they can get independent companies to bear some of the risks associated with the difficult business of managing symbolic creativity. What is more, symbol creators might well *feel* as though they are more autonomous of commercial pressures, especially in those cultural industries where there is a mistrust of corporate bureaucracies.

This makes interdependence sound very rosy. However, in the eyes of many, increasing levels of interdependence in the cultural industries mean the end of an era when independents could provide an alternative to the majors – another sign of corporate takeover. Many forms of interfirm networking involve links between very large companies in different industries and, increasingly, in different sectors. These involve strategic alliances between corporations not as in traditional cartel arrangements but on the basis of specific projects. Such 'alliance capitalism' has been a feature of a very wide range of businesses over the last 30 years. It is especially relevant, noted Manuel Castells (1996: 162–4), in high-tech sectors,

where research and development costs are enormously expensive. For Castells, the self-sufficient corporation is, more and more, a thing of the past.

While cultural industry companies compete with each other, at the same time, they operate complex webs of joint ventures and ownership. Auletta (1997: 225) lists a number of reasons for such alliances with potential rivals:

- avoid competition
- save money and share risks
- buy a seat on a rival's board
- create a safety net, as technological innovation makes for increasing uncertainty
- make links with foreign companies to avoid 'arousing the ire of local governments'.

The interconnections between the Big Seven conglomerates and the 'second tier' of corporations are almost impossible to encapsulate neatly. One of the best attempts at doing so was printed in *The New Yorker* in 1997 (see Figure 6.1). It shows the 'web of collaboration' between six of the most powerful cultural industry corporations in the world at the time, plus Microsoft, and lists some of the many joint ventures between them. In the rapidly changing world of the cultural industries, this diagram is already a historical document, but it gives a good sense of how closely intermeshed the major companies are in terms of joint ventures and ownership. Auletta (1997) describes such links as an American version of *keiretsu* – the 'ancient Japanese custom of co-opting the competition' by creating structures of collaboration with rivals – a system of 'co-opetition' (Murdock, 2000: 48, quoting the *Financial Times*) rather than competition. As Auletta (1997: 226) suggests, such alliances have implications for texts. As more and more companies become tied to one another, will their journalists cover controversial stories about other companies in the web? Without question, it helps to reinforce the economic power of the biggest corporations and entrench the way that they do business.[8]

ARE THE CULTURAL INDUSTRIES GETTING BIGGER?

The figures involved in mergers and acquisitions and the now massive size of revenues accruing to the biggest cultural industry companies, suggest that the cultural industries are an increasingly important component of global business and, therefore, of national economies. If this is so, it has potentially important consequences for understanding the relationships between economics and culture, art and commerce, which are a key topic of this book. Potentially, for example, this new centrality might threaten the autonomy that has been traditionally ceded to creative work. It may quicken commodification, with all its complex consequences.

8 Such alliances have been further encouraged by speculation about future convergence of the telecommunications, computers and cultural industries (see Chapter 9). Herman and McChesney (1997: 56–8) and Murdock (2000: 47–51) provide further coverage.

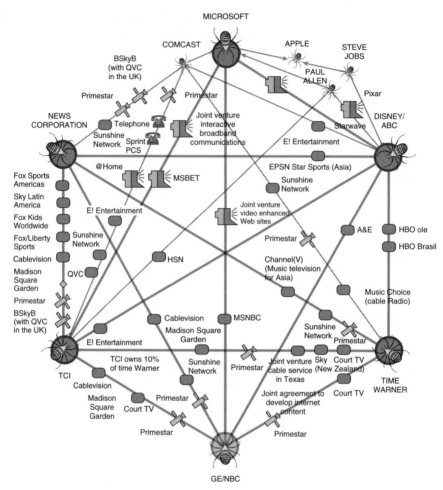

Figure 6.1 A web of collaboration between corporations. This diagram, reproduced from a 1997 edition of *The New Yorker*, illustrates the many complex connections existing at the time between a number of companies in the cultural industry and IT businesses (Auletta, 1997: 227)

CULTURAL INDUSTRIES IN MODERN ECONOMIES

So just how significant are the cultural industries in national, regional and urban economies? There is no shortage of government-commissioned reports claiming that the cultural industries are important. Many of them are a product of the policy developments discussed in Chapter 5, whereby governments, often consumed by information society fever, have seen the cultural industries as new potential sources of employment and national or regional competitive advantage. Here are just a few of the conclusions from some of these reports. (Note

the range of terms used here and recall the discussion in Chapter 5 on the motivations behind the shift to the term 'creative' industries.)

- The proportion of employment in Hong Kong in the creative sector grew from 5.0 per cent in 1996 to 5.3 per cent in 2002 (CCPR, 2003).
- Between 1998 and 2002, cultural employment grew in Austria by 6 per cent (Kulturdokumentation et al., 2004) and, from 1995 to 2000, there was a 49 per cent rise in revenue from cultural industries (KMU Forschung, 2003).
- Employment in creative industries made up 20 percent of Iceland's labour market in 1991 and 23.4 per cent in 2002 (Einarsson, 2005).
- Between 1996 and 2001, employment in the cultural industries in Australia increased from 167,000 to 190,000 – an average growth rate of 2.62 per cent (Queensland Government, 2005).
- The proportion of Singapore's GDP accounted for by copyright industries rose from 2.0 per cent in 1986 to 2.8 per cent in 2000 (ERC Services Subcommittee, 2002).
- In 2003, creative industries in the UK accounted for 8 per cent of gross value added (GVA) in the economy as a whole – equivalent to £56.5 billion. These industries grew by an average of 6 per cent per annum between 1997 and 2002, compared to growth rates of 3 per cent per annum for the UK economy (DCMS, 2005).

Fascinating stuff. Are you still awake? There are dozens and dozens of such reports available. (Occasionally, some even suggest *decreases* in cultural industry employment or revenue.) The problem is, of course, how to define the industries concerned.

The categories used by the British Department of Culture, Media and Sport in its 'mapping documents' (DCMS, 1998, 2001) have been very widely adopted internationally. As we saw in the previous chapter (see page 145), this included peripheral (in my terms) but significant industries, such as dance and the visual arts, but also industries as diverse as jewellery, fashion and furniture design. Most significantly of all, it included software (not just 'leisure software' – games – but software for business applications). This was included in order to bolster figures and provide a more powerful alliance around the 'creative industries' banner. Developing such software is a very different activity from the artistic-expressive (or journalistic-informational) pursuits evoked by the term 'creative industries'. It is this artistic-expressive element – the aura of the 'artist' – that is in large part the source of the sexiness of the concept for politicians and other policymakers.

Other definitions are much broader than the UK model. The Chinese definition includes gambling, education, sports, tourism and consultancy services (CCPR, 2003). Similarly, in Taiwan, the term 'cultural creative industries' is used and includes such things as tea houses and wedding photography (CCPR, 2003). Finland's definition, according to the same source, includes amusement parks, games and recreational services. In each case, definitions are shaped by local political and business interests.

As I made clear in the Introduction (pp. 11–15), I prefer a more restricted definition of the cultural industries, centred on those industries that are chiefly concerned with the social production and dissemination of meaning. This is because, as I explained there, one of the main reasons the cultural industries matter, I think, is that they make and circulate texts. Other definitions may have other motivations, but the point is that when we read figures purporting to show that an entity called 'the cultural industries' has grown, we need to think carefully about what that entity is. It may sound as though a nation or a city is populated by musicians, writers, games designers and their ilk, but, in fact, such activities are likely to be dwarfed by activities such as computer software, gambling and education, which may well have sneaked into the definition because of political pressures and tensions. (This is not to say that all efforts to 'expand' definitions are aimed simply at legitimating narrow interests; see Box 6.1 for a discussion of 'depth' models of defining cultural industries).

BOX 6.1 DEPTH VERSUS BREADTH IN DEFINING CULTURAL INDUSTRIES

Cultural geographer Andy Pratt has argued for a number of years that, when it comes to defining cultural industries, 'depth' is as important as breadth. This means including those activities that are necessary for cultural outputs to take place, including back- and front-of-house staff in theatres, cinemas and music venues, those involved in the manufacture of items, archiving and education and training. Pratt (2005: 34) argues that such an approach brings into view a range of institutional structures that have been invisible in much policy.[9]
This is reasonable when considering how interlinked systems of employment are necessary to get cultural products to audiences. However, when such an expanded depth definition is used, we need to bear in mind that most of the work included in this expanded definition has little effect on the form and content of the texts and it is the potential of such texts to have a particular type of influence on society that distinguishes the cultural industries from all others. We should not lose sight of the fact that the making of DVD players is a very different kind of industrial activity from the making of the films and television programmes that we might use these players to watch.
 One possible partial solution to this problem is to try and distinguish in figures between those having *direct* creative input and other workers *associated* with cultural products. However, the data in many countries scarcely supports the most general of definitions, let alone these more specific breakdowns.

9 The British DCMS has adopted something like this idea for its definition of 'the culturalsector' in more recent documents. The 'creative industries' are considered a subset of this broader sector.

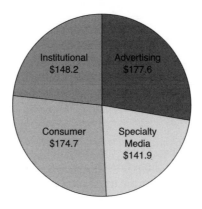

Figure 6.2 Sectors of the U.S. Communications industry

Source: VSS, 2003: 38

The diversity of concepts and measures that have been used at national and local levels makes comparisons between the presence of the cultural (or creative) industries in different countries, regions and cities very difficult. Even if everyone agreed a single definition of those industries, the fact that each national census body has a different industrial and occupational classification would still make comparison nigh-on impossible. So, to compare two cities in different countries, account needs to be taken of these different classification methods as well as different definitions of the cultural industries. For this and other reasons, Dominic Power (2003) suggests that reports of facts and figures for the cultural industries should always be 'viewed as indicative rather [than] as categorical'. In addition, he notes that measuring individual cultural industries using the Standard Industrial Classifications employed in official government statistics is very difficult as, for example, the music industry tends to get bunched together with other 'similar' industries, such as publishing.

Nevertheless, for all these problems of definition and measurement, one broad trend seems clear from the various, often mind-numbingly tedious, reports. In many places, there is evidence, over a number of years (allowing for cycles, recessions and setbacks), of **increases in cultural industry activity slightly above the rate of increase in gross domestic product.** However, we still need to dispel the ideas that such increases reflect a growing presence of glamorous creativity in modern societies. One report estimates that, from 1977 to 2002, the 'communications industry' grew at a compound annual rate of 8.4 per cent, exceeding nominal (that is, not adjusted for inflation) GDP growth by 1.6 percentage points (VSS, 2003). The segmentation of the communications industry in this report is revealing, though, and more useful in the present context than many reports on the cultural industries, for it suggests just how little of the money spent on communications is spent by consumer end-users. When we think of the cultural industries, we might think of, say, the kind of production involved when we watch a drama series on television or download a

new song from the Internet. But, at least measured by spending, such activities are dwarfed by advertising, marketing and 'institutional end-user' spending on such things as business information services, professional and training media, trade shows and the like (see Figure 6.2).

CULTURAL INDUSTRIES IN GLOBAL BUSINESS

The conclusion to be drawn from the preceding section is that the cultural industries – even defined in the relatively narrow way preferred in this book – are becoming more important as a part of national economies than they were in the past. However, we should not make the leap made by some commentators and suggest that the cultural industries are now at the centre of global business (see Box 6.2 for one version of such an argument).

One way to approach this is to look at the size of the biggest cultural industry corporations in relation to the size of the biggest corporations in general. Table 6.6 shows the biggest corporations with significant cultural industry interests, along with their rank in the *Fortune* magazine list of the biggest 500 companies in the world by revenue in the year 2004. Historical comparison of the relative sizes of the largest cultural industry corporations is difficult. Companies based on 'services' were only included in the Fortune 500 and Global 500 lists from 1995 onwards. However, we can note that, since an equivalent table was compiled for the first edition of this book, which was based on the Fortune Global 500 list for 2001, the key cultural industry corporations have all improved their positions. Walt Disney has moved up from 174th to 159th, Viacom from 245th to 196th and Bertelsmann from 299th to 271st. Yet, as is clear from the table, even the very biggest cultural industry corporations are dwarfed by the biggest corporations in the world:

- the giants of automobile production – General Motors, DaimlerChrysler, Toyota and Ford – take four of the top ten slots
- the big oil companies – BP, Exxon and Royal Dutch/Shell – are the second, third and fourth biggest, respectively
- Time Warner – the biggest company in terms of cultural industry operations – just squeaks into the top 100.
- it would take nearly ten Walt Disneys to match the biggest-earning company in the world by revenue – the retail giant Wal-Mart
- Sony's cultural industry activities alone would leave it languishing in the low 300s – it is its consumer electronics that make the firm a massive global presence.

The big cultural industry corporations are not the same thing as the cultural industries, but these figures should put into perspective the idea that the cultural industries are now part of a global business core. They might be one day, but that is a very different claim.

Table 6.6 The largest corporations with cultural industry interests

Numbers indicate ranking in the Fortune Global 500 List for 2005 (based on company reports for 2004). Figures are in US$ millions and refer to revenue. Note that these figures are for an earlier year than those in Table 6.2, hence the disparity.

Italics indicate those companies that generate most of their revenues from cultural industry interests.

1 Wal-Mart Stores 287,989 (no cultural industry interests – included for sake of comparison)
2 BP 285,059 (ditto)
9 General Electric 152,866
This extremely diverse general conglomerate has owned the US TV network NBC since 1985, but, in the early 2000s, made significant further acquisitions in the cultural sector (see footnote 1 to this chapter).

18 Nippon Telegraph & Telephone 100,545
The biggest telecommunications corporation in the world by revenue, included for the sake of comparison. A number of telecommunications giants dwarf the biggest cultural industry companies.

47 Sony 66,618
Sony has five main divisions: consumer electronics, games, music (Sony Music Entertainment, now merged with Bertelsmann's music interests) films (Columbia TriStar) and financial services. Consumer electronics accounts for the vast majority of its sales.

100 Time Warner 42,869
Time Warner is the biggest cultural industry corporation in the world (by this I mean companies where most revenues come from cultural industry activities). Its 2000–2001 merger with AOL led to huge financial losses.

127 Microsoft 36,835
Microsoft is included for the sake of comparison here. It has built up numerous alliances with cultural industry companies. While it is one of the most highly valued companies in the world, generates very high levels of profit and is growing very fast, it is also important to realise that its revenues are still much less than those of some older corporations.

159 Walt Disney 30,752
196 Viacom 27,054
Viacom took over CBS in 2000, but struggled to combine its growing interest in cable with its broadcasting, publishing and other media interests. It split into two separate entities – Viacom and CBS – in 2006.

199 Vivendi Universal 26,651
Vivendi was an engineering and water company that, under the control of a megalomaniacal CEO, tried to refashion itself as a global cultural industries leader in the dot.com boom. It came close to collapse and has now sold many of its cultural industry interests, but is still a significant player in Europe due its ownership of Canal Plus. It aso retains a stake in some of its interests – the bits including the name 'Universal' in their titles – that were acquired by GE in 2003 (see footnote 1).

271 Bertelsmann 21,163
282 News Corporation 20,802
Note that this ranking underestimates the influence of News Corporation's mogul Rupert Murdoch. News Corporation owns a substantial share of BSkyB, is a major player in European digital and satellite television and Murdoch is its Chairman, but BSkyB reports its figures separately (it had over US$4 billion in revenue for 2004–2005).

290 Comcast 20,307
This cable company made a serious attempt to enter into content production in 2004 with its failed effort to buy Walt Disney. Its content division accounts for less than US$1 billion as of 2005.

BOX 6.2 LASH AND URRY ON THE 'NEW CORE' OF MODERN ECONOMIES

In many analyses of the role of the cultural industries in modern economies and societies, statements about what might happen are blurred together with statements about what already has happened (see also Chapter 9 on Manuel Castells).

In a stimulating and much-cited book, Scott Lash and John Urry wrote about the passing of 'a Fordist industrial order, centred on motor, chemicals, electrical and steel industries', one where 'finance, services and distribution' were subordinated to this core. A new order had arrived, they claimed, involving a new autonomy for finance, property, services and knowledge, combined with the formation of a new core, 'clustered around information, communications, and the advanced producer services, as well as other services such as telecommunications, airlines and important parts of leisure and tourism' (all these quotations are from Lash and Urry, 1994: 17). The relationship between these various entities is not clear: is telecommunications part of communications or part of 'other services'?

This vision of economic change is, in turn, linked to a very broad-ranging conception of social and cultural change, in which the cultural industries play an important part as harbingers of a society increasingly centred on culture and culture becomes the main site for any possible critique of modern societies (pp. 142–3).

As we have seen, it is fair to say that information and communications are becoming more and more important economically, but it is quite another thing to say that they have become a new core of modern economies. Here, again, we see the influence of information society thinking and its propensity to overstate change at the expense of continuity. While Lash and Urry are rightly interested in understanding new power relations in changing economies and societies, their analysis is in danger of being complicit with the information society thinking driving many of the changes they consider.

CONTINUING COMMODIFICATION

I have spent a lot of time in this chapter discussing questions concerning conglomeration and concentration and the size of the cultural industries relative to other industries in modern societies. These are all important because they fuel public debate and policy, but we now need to take a step back from these developments and examine them together with the policy changes discussed in the last two chapters in order to gain a sense of a bigger picture of the growth of the cultural industries – the commodification of culture.

In Chapter 2, I outlined why I think that commodification matters. I made clear my view that the most useful analyses of commodification see it as an ambivalent process – enabling and constraining, productive and destructive. Negative aspects of the extension of commodification include an emphasis on private, exclusive ownership and a tendency to produce systems of unrecognised

and under-rewarded paid labour. This is as much the case for cultural production as it is for other sectors. The complex professional era saw a pronounced industrialisation of culture, which intensified the slow, uneven process of commodification of culture that had begun many centuries previously. The question we now need to consider is the one raised in Chapter 2: what are the implications of the *further* commodification of culture?

To address this question, we must, in turn, consider various issues discussed in Chapters 3 to 5 concerning the marketisation of telecommunications and broadcasting and shifts in copyright and cultural policy. These policy shifts can be seen as complex responses to the perceived need on the part of businesses and states to restore growth and political order in the wake of the economic downturn and political and cultural crisis facing advanced industrial societies in the 1960s and 1970s (outlined in Chapter 3). They were not concerted responses in that they were based on meetings of some committee of the ruling class. But they were fought for in order to meet particular sets of interests – especially economic ones. Culture was seen as a crucial opportunity for investment growth. The information society discourse outlined in Chapter 3 was an essential basis for this, legitimating an acceleration of capital investment in the production of culture, information and knowledge. Culture had been growing steadily as a sector of capitalism throughout the complex professional era, but opportunities for growth were restrained by public ownership of telecommunications channels and notions of public service broadcasting. Cultural policy was more marginal, but its incorporation into information society discourse (ironically this was often justified on the grounds of democratisation) added fuel to the accelerating commodification of culture. The strengthening of copyright law and enforcement across the world – in the form of the TRIPS elements of the WTO agreement of 1995, and various other agreements – has been particularly important. This was an essential prerequisite of growth. In the shrinking of the public domain and fair use, we see the way in which commodification can encroach on public, collective access to resources.

To recap Chapter 2, all societies – by virtue of law, and conventions – draw lines between elements of the world that can be bought and sold and those that should not (see Frow, 1997). These boundaries are subject to technological change, driven in part by the desire on the part of businesses to accumulate capital. At times, entirely new domains become available for commodification. Frow, for example, discusses the rise in the trade in human organs. At other times, there is an increasing encroachment on domains already open to commodification, but relatively protected. This is what has happened with culture over the last 30 years.

What do we make of this? There is no need to offer a romantic vision of the superiority of primitive society over capitalist society or imagine that we can return to a state where we simply make culture together, free of commodity exchange. In fact, such visions and fantasies are themselves a product of modern commodified culture. Rather, we need to recognise the ambivalences involved in capitalist development and resist the more negative aspects of commodification.

On what I have called the consumption side (though this involves production, too, in that we draw on our consumption of existing resources to make new

things), the extension of the scope and duration of copyright places undue restrictions on freedom. While some restrictions on freedom are desirable as they are in the interests of the common good, the exclusive ownership of cultural goods has become excessive. Moreover, commodification leads to a situation where cultural experience is increasingly privatised and individualised. Many libertarians and liberals would agree with the view that copyright is now excessively hindering access to culture and offer phenomena such as the Open Source software movement and various web-based initiatives discussed in Chapter 9 as alternatives. However, I would want to go further.

Commodification leads to a situation where we are cut off from the work that goes into making life what it is. This is as true of culture as it is of other goods. Just as we might drive a car giving little thought to the experiences that led to us driving it, we might do the same when it comes to the DVD we watch and so on. In reading this, you might well have had an image of a Hollywood DVD and wondered why anyone would want to worry about the rich celebrities and producers responsible for such a product. But the work of wealthy stars is only a tiny part of the system that produces cultural commodities. For every Hollywood hit that comes into your home, there is a massive amount of cultural work going into products that you never see. As I have stressed in this book, the hits and the misses are part of the same system. The rampant success of the minority depends on the endemic failure of the majority, in our winner takes all societies (Frank and Cook, 1995). It could even be argued that because so few people are aware of cultural labour, believing it to be cushy and even glamorous, it is a particularly potent example of the way in which work is not recognised under capitalist commodity production.

For some people, the labour of others is only a problem if they have an image of outright, degraded poverty. According to such a view, the drudgery of operating a supermarket check-out counter is nothing – the only people who matter are starving peasants. But one important insight of Marxian approaches that is worth retaining in the face of the many attacks on them from the conservative right, liberal centre and post-structuralist left, is that the production of commodities systematically creates vast inequalities of wealth. It also makes the risks attached to the uncertainty and insecurity that afflict all social systems much greater (it can make the rewards greater, too, of course). The more culture becomes central to capitalism, the more cultural labour becomes implicated in these inequalities and uncertainties.

There are further implications of the extension of commodification raised by the analysis of corporate growth in this chapter. As the scope for investment in culture grows, corporations grow bigger and come to undertake more and more of the cultural production that people see and hear. They have much greater resources for the vital work of marketing and publicity necessary to make us aware of their products, amidst the tens of thousands of others available. Corporate forms of cultural production thus become the model for creativity in societies. It is not true to say that alternative and independent forms of production are suppressed – in fact, they proliferate, too – but, as we shall see in the next chapter, they are sucked into the corporate system.

This chapter has provided evidence of considerable change in the role of the cultural industries in modern economies and societies. Bigger-than-ever corporations tower over the new terrain of cultural production in the 1990s and 2000s. Their growth has been encouraged by the policy changes outlined in the previous chapters, along with a related perception among business investors that the cultural industries represented a good opportunity for high returns. Various waves of mergers and acquisitions have enabled this growth. New types of relationships between companies have emerged. There are increasing numbers of strategic alliances between cultural industry companies and large corporations in other industries. Small companies increasingly form complex licensing, financing and distribution deals with the major corporations.

There is also considerable continuity, however. Small companies continue to play an important part in the cultural industries. The dynamics identified in the Introduction continue to drive company strategy, even if the exact form vertical integration and conglomeration take vary according to general business fashion.

As for market concentration, much depends on how this is defined, but there is no doubt that the cultural industries are, in general, highly concentrated.

My argument is that the significance of changes in the cultural industries is broader than it would appear. Along with increasing leisure time and disposable income, the developments traced in this chapter mean that the cultural industries have become slowly and steadily more important in advanced industrial economies than they have been in the past. Claims about the cultural industries need to be treated with real caution because of the statistical and definitional problems outlined above. It is clearly the case that the big corporations are not in the league of Big Oil, the car industry, and the banks. Nevertheless, the growth of the cultural industries has significant implications because the oligopolistic corporations that inevitably come to dominate capitalist forms of production can mobilise huge resources to campaign on behalf of their interests and put together the kinds of promotional budgets that allow their texts to gain more attention than any others. This often works against the public interest – for example when campaigning for changes that extend the scope of copyright, which diminish public access to culture, even as texts seem to proliferate. The growth of large corporations also affects prevailing conceptions of how to carry out the management of creativity. The biggest firms often tend to be the most prestigious and set the standards other businesses follow as they carry out their work.

In the final part of this chapter, I tied these various developments to the longer-term historical picture. The policy developments analysed in the last two chapters and the associated corporate growth discussed in this one can be seen as aspects of an ongoing, but accelerating, commodification of culture. This has important implications for the organisation and experience of cultural work, which is the subject of the next chapter.

FURTHER READING

A bracing introduction to some fundamental questions concerning media ownership can be found in a debate that appeared in the web journal *openDemocracy* in 2001–2002, initiated by articles by Robert McChesney

and Benjamin Compaine. All the contributions can be accessed via the website at: www.opendemocracy.net

The best way to keep in touch with developments in the ever-changing cultural industries is by reading business publications and their associated websites, such as the *Financial Times*, the entertainment trade paper *Variety* and, if you can tolerate the ultraconservative political perspectives they take, *The Wall Street Journal* and *The Economist*.

Several websites are devoted to questions of media ownership. The *Columbia Journalism Review* (www.columbiajournalismreview.com) and ketupa.net websites provide good information on many of the largest cultural industry companies. *Terra Media* provides a long-term historical view. Even websites, though, seem to struggle to keep up with the pace of changes, as corporations buy or sell off divisions. Knowing the details of who owns what this year, this month, this week is perhaps less important, however, than understanding significant overall trends and what they say about issues of power in the cultural industries – hence my focus on trends and issues in this chapter.

Variety used to publish a list of the biggest 50 entertainment companies by revenue, but for some reason has stopped doing so. *Screen Digest* now publishes such a list every July.

A good treatment of issues of concentration and integration is an obscure and hard-to-find book – Sánchez-Tabernero et al.'s 1993 study. Shorter treatments, also from a liberal-pluralist communication studies perspective, can be found in chapters by Werner Meier and Josef Trappel in McQuail and Siune's book *Media Policy* (1998).

The most thorough treatment of ownership is provided by Benjamin Compaine and Douglas Gomery's *Who Owns the Media?* (2000), but Compaine is an ardent neo-liberal, as his website shows.

On the broader questions of commodification of culture discussed here, see Harvey's *The Condition of Postmodernity* (1989), Mosco's *The Political Economy of Communication* (1995) and Frow's brilliant essay entitled 'Gift and commodity' (1997).

7 ORGANISATION AND CULTURAL WORK

The changes in ownership, structure and corporate strategy discussed in the previous chapter tell us only a limited amount about the environments in which creative work takes place and the ways in which cultural industry owners and executives attempt the difficult business of managing and marketing creativity. As Chapter 2 showed, even in the complex professional era, as large corporations began to dominate cultural production, much cultural work was nevertheless based on a certain amount of operational autonomy for creative workers and managers. In the 1970s and 1980s, businesses of all kinds were going through a long phase of organisational innovation and restructuring. How did these changes affect the cultural industries?

In this chapter, I address a number of questions outlined in Chapter 2 (pp. 64–74). First, I consider the following linked questions.

- To what extent have the distinctive organisational features of the cultural industries in the complex professional era of cultural production changed?
- What changes have there been in the extent to which creative workers within the cultural industries determine how their work will be edited, promoted, circulated? (This, of course, is a question about the extent to which creative autonomy has been expanded or diminished since 1980).

I begin by examining competing ways of understanding changes in the management of creative work in the cultural industries. I argue against accounts that see a move towards greater operational autonomy in commercial enterprises. I show this by examining the significance of the increasing role of marketing and

market research in cultural production, including at the creative stage. I then confront directly the issue of whether creative control is getting looser or tighter, using evidence drawn from various cultural industries, including live theatre and advertising. I show how one group of creative workers in particular has gained greater autonomy: stars. This autonomy is not to be celebrated, however – rather, it has had negative consequences. In the final section addressing these questions, I analyse the fate of journalistic autonomy – here again there are reasons to be pessimistic.

I then turn to the following questions.

- To what extent have the cultural labour market and systems of reward for cultural workers changed?
- Have the rewards and working conditions of symbol creators – and, indeed, other workers in the cultural industries – improved during this time?

This involves examining the division of labour outlined in Chapter 2 as being characteristic of the complex professional period. I show that there *is* some continuity, but claim that, within particular functions (notably creative management and creative work), there have been interesting changes. Few of these changes are improvements (there has been widespread casualisation in some sectors). Meanwhile, chronic uncertainty persists as the norm for many creative workers.

MANAGING CREATIVITY

Howard Davis and Richard Scase (2000: 104–27) provide a way into understanding changes in the management of symbolic creativity. They argue that there has been a shift in the way that the cultural industries are organised. Using a Weberian approach that focuses on bureaucracy and charisma, they posit four ideal types of cultural industry organisation, based on how companies control and coordinate work (see Davis and Scase, 2000: 99, and Figure 7.1).

- *Commercial bureaucracies* where control and coordination are highly explicit and formalised, emphasising hierarchical reporting mechanisms and the close measuring and monitoring of employees for performance. There is a very strong emphasis on making profit built into the functioning of the organisation.
- *Traditional/charismatic organisations* in which a high level of coordination is achieved by means of shared values, but 'mechanisms of formal control are relatively less developed'. These tend to be small businesses. There is less emphasis in working life on profit than in other organisations. Charismatic leaders – often owner-managers – tend to provide direction.
- *Cultural bureaucracies* usually operating under a public service remit, where there is a high degree of formalised control and hierarchically structured authority relations, but coordination is achieved by means of relatively autonomous departments. There are strong clashes over commercial pressures. Davis and Scase seem to have the BBC in mind here.

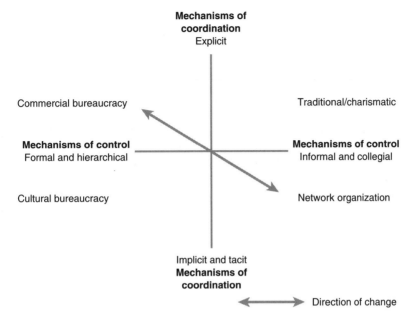

Figure 7.1 A typology of creative organisations
Source Davis and Scase 2000: 99

- *Network organisations*, which tend to be micro-companies and are essentially too small to have formalised control or coordination. They operate in networks with other companies.

Davis and Scase believe that a major shift in cultural industry organisations took place during the 1990s: the decline of the traditional/charismatic organisation and of the cultural bureaucracy and the corresponding rise of the commercial bureaucracy and network organisations (p. 102).

Traditional/charismatic firms, such as the small publishing houses that were the centre of the book industry until the 1950s, were bought up by corporations and put within commercial bureaucracies. Cultural bureaucracies (such as the BBC) came under threat from commercial pressures. Network organisations have proliferated as more and more work is outsourced from cultural and commercial bureaucracies.

For Davis and Scase, changes *within* commercial bureaucracies have been just as important as the increasing presence of such companies in the cultural industries. They claim that as large conglomerates entered into the cultural industries in the 1960s and 1970s, they attempted to bureaucratise creative work in a number of ways: by rationalising and specialising work tasks, curtailing the autonomy of employees by stipulating duties and by establishing strict line management. However, according to Davis and Scase, such practices soon fell out of favour and were replaced by new organisational structures.

In order to move beyond mere compliance on the part of employees and foster the kinds of commitment found in smaller companies, commercial bureaucracies began to break up the larger organisation into smaller autonomous operating units. Instead of strict, hierarchical line management, workers were given autonomy for operational decisionmaking. In Davis and Scase's account, this resulted in 'highly decentralised organisational structures operating units functioning as subsidiary companies' (p. 139). Under this new system, control was exercised by means of tight financial budgets, the setting of deadlines and measuring outputs (pp. 140–1). These changes took place 'in the 1990s, and sometimes earlier' (p. 130). Management–worker relations become more like those between purchasers and providers and, because work could therefore either be done in-house or out-of-house, this led to the growth of network firms outside the company (and, presumably, 'downsizing' within the commercial bureaucracy).

This is an interesting attempt to understand change, but it is a flawed one. Davis and Scase overemphasise organisational change, especially in commercial bureaucracies.[1] In particular, they misrepresent the 1950–1980 period, drawing on assumptions derived from other industries. Substantial operational autonomy for creative personnel has been a feature of large cultural industry companies *throughout* the complex professional era, not only in the 1990s (Ryan, 1992; Toynbee, 2000). Davis and Scase recognise that creative personnel are given relative autonomy and it may be that they are referring primarily to the operational autonomy of creative managers, but, even here, their historical assumptions are not supported by the evidence. In the large publishing companies established in the post-war era, for example, commissioning editors were given considerable independence (Coser et al., 1982), as indeed were A&R personnel in record companies. The film industry made the kind of move from 'bureaucracy' to 'networks' that Davis and Scase describe from the early 1940s onwards and producers (the key creative managers in that industry) increasingly came to operate as independent companies during the 1950s and 1960s. It is also true that some companies did try to control production more closely during the period 1950–1980 – the period Davis and Scase are discussing as the era of the 'old' commercial bureaucratic model. One example would be formatted popular fiction, such as Mills & Boon's romance novels, but such formatted production with tight control over budgets and outcomes long preceded the 1950–1980 period and, further, often took place in smaller companies that Davis and Scase might categorise as 'traditional/charismatic' rather than in the commercial bureaucracies.

There *have* been organisational innovations during what I am calling the complex professional era, but Davis and Scase are wrong to assume that the 1990s was the crucial period for change. Many shifts preceded the 1990s. For example, an important move towards divisional structures in the major record companies took place in the 1970s and was based on generic divisions that were

1 It would have been helpful if Davis and Scase had given concrete examples of pre-1990s commercial bureaucracies of the 'old' kind.

already in place when record companies were smaller (see Christianen, 1995: 89–91; Negus, 1999: 47–50).[2]

In my view, Ryan's work on cultural industry organisations provides a better basis for assessing change and continuity in the management of creativity than does Davis and Scase's model. Chapter 2, building on Ryan (1992), outlined the division of cultural labour and organisational form characteristic of the complex professional era (pp. 64–70). As we saw there, a number of cultural work functions had emerged by the middle of the twentieth century – namely, primary creative personnel/symbol creators, technical craftworkers, creative managers, unskilled and semi-skilled labour and owners and executives. The organisational form common across nearly all cultural industry companies was one in which creative personnel were loosely controlled by creative managers acting on behalf of the interests of owners and executives, but where circulation and reproduction were much more tightly coordinated. In smaller companies, owner-managers acted like creative managers when dealing with creative personnel, but like executives when negotiating relationships with outside distribution, reproduction, marketing and publicity organisations.

To what extent is the distinctive division of labour and organisational form – involving loose control of creativity by creative managers but tight control of circulation by executives – a stable one? I examine this question in the sections that follow.

THE INCREASING IMPORTANCE OF MARKETING AND MARKET RESEARCH

The most important change in organisational control in the cultural industries is that the variety of activities gathered under the title 'marketing' have become professionalised and more important to the coordination of activities in the cultural industries. This represents a further tightening of control over circulation strategies.

One important example of the increasing importance of marketing is the growth in intensity of efforts to use market research as a means of controlling risk. The problem with market research in the cultural industries is that every product is different (see Coser et al., 1982: 203–205). Justin Wyatt (1994: 155) argues that, although market research was used occasionally in the classic Hollywood era, it was only in the late 1970s that the studios engaged systematically with it. This is backed up in Hortense Powdermaker's classic anthropological study of Hollywood: 'The research department, situated in New York, is small, operates on a meager budget, and is not equipped to undertake extensive work' (1951: 33).

2 There are strong echoes in Davis and Scase's model of the faulty historical assumptions in work on 'post-Fordism' and 'flexible specialisation' in the cultural industries. See Christopherson and Storper (1986; 1989) and Lash and Urry (1994: Chapter 5) for the most sophisticated versions of cultural industry post-Fordism and Aksoy and Robins (1992) and Hesmondhalgh (1996) for critiques of their positions.

Wyatt attributes the shift in part to the purchase by general conglomerates of film companies in the 1960s. Films were now part of a culture that was used to market research for packaged goods. As releases fell and costs rose, executives wanted more accountability (Wyatt, 1994: 156). Keith Negus (1999: 53) has described a similar shift in record company strategy away from 'inspired guess-work, hunches and intuition' and towards the widespread use of various research methods, including electronic monitoring of sales, large-scale interview panels provided on subscription by a separate company and various broadcast data systems. Again, the shift seems to have taken place in the 1970s and, although Negus does not attribute the shift to this, it was during this period that the recording industry was increasingly integrated into larger, general conglomerates. As for television, here is one television executive discussing the importance of research:

> Research is the key instrument in the selling of airtime because if I'm selling a minute or half a minute of airtime in *Coronation Street*, *Coronation Street* will have a number of categories, demographic categories, of viewers watching. It will have young ABC1 men or whatever. Now, unless you know precisely which demographic groups in which proportions are watching these programmes very scientifically you can't sell that audience at the optimum value to the advertiser. So, for example, an advertiser can buy adults in *Coronation Street* for eight pounds a thousand, but if he wants to buy ABC1 adults it might be forty-eight pounds a thousand. And if he wants to buy 16–24-year-old adults it might be seventy-eight pounds a thousand and that's a hell of a different yield. So it's a bit like an aeroplane or a hotel. You're maximising the yields of your rooms or your airtime seconds by optimising who buys what audiences ...[3]

This way of talking about research would have been impossible 30 years ago in Europe. Only since the 1980s has market research become such a priority that software packages of sufficient sophistication have been developed to undertake such exact calculations. It is not technology that has driven the change, however. Such technology came into being largely because of the desire on the part of executives to control more carefully the value chain in broadcasting, partly because of the erosion of public service imperatives, but also because of an enormous increase in competition in the television market.

The other major relevant aspects of marketing besides research – design, packaging, advertising and publicity management – have been present in the cultural industries for many decades, but have also increased their importance and visibility. Budgets for advertising in films produced by the major Hollywood studios soared in the 1980s, 1990s and 2000s:

- even though the average cost of producing the negative/first copy of a major-produced film more than doubled between 1980 and 1995 to US$39 million, during the same period advertising budgets greatly increased their proportion of total costs, to nearly 45 per cent (based on Dale, 1997: 31)

3 From an interview with the Chief Executive of a British media group, February 2001, for a pilot project on the conditions of creative work.

- Grant and Wood (2004: 65) report that, by 2002, production budgets had risen to US$58.8 million, with print and advertising (P&A, in industry parlance) costs taking average costs to nearly US$90 million
- according to Edward Jay Epstein (2005a), P&A costs for a studio film in 2003 averaged US$39 million, which is US$18.4 million more per film than studios actually recovered from box office receipts (though other sources complement these)
- the marketing costs for the *Matrix* sequels of 2003 exceeded US$100 million dollars (Menand, 2005: 85).

Advertising has long been important in the film industry, but there was a move in the 1990s towards 'blitzkrieg marketing' (Dale, 1997: 32), which is when blockbusters open simultaneously across a particular country, rather than being 'rolled out' in different regions.[4] *Jaws* was considered to have 'opened wide' (geddit? think about it) in 1975, when it was released on 460 screens in its first day. By 1995, say Grant and Wood (2004: 77), virtually all of the 150 or so movies released by the majors opened on more than 800 screens. By 2001, openings on 2000 or 3000 screens were common. *Harry Potter and the Sorcerer's Stone* opened in that year, to 8200 screens – a quarter of all the cinemas in the USA at the time. All this greatly reinforces *the blockbuster syndrome* – that is, fewer big hits dominate the cultural industries and popular culture in general (see also Chapter 10). In fact, box office is becoming less and less important in generating revenue for films, but a good opening has itself become an important part of publicity for films, with its knock on implications for purchases of DVDs by rental chains and consumers.

Publicity marketing has also become much more important in industries where it has traditionally played a minor role. This is true of television in particular, where there is now a greatly increased emphasis on trailers, print and billboard advertising and so on to support premium programmes, as well as back-up articles in newspapers and magazines. Unless a programme has such backup, even if it is shown in a relatively prime-time slot, it has little chance of success.

All the above illustrates the increasing importance of marketing in the cultural industries. An even more significant issue, however, is the role of marketing in the conception stage of cultural production. This is important because it potentially undermines the traditional division between loose control of creative work and tight control of reproduction and circulation, which, as we have seen, constitutes the distinctive organisational form of cultural production in the complex professional era. Marketing departments have been consulted for decades on the likely success of cultural products that require significant investment, whether in the form of production costs or on the basis of large payments to the creators. What is new is the increasing prestige of marketing departments and their greater clout

4 Justin Wyatt (1998) tells the story of how such a strategy of saturation releasing developed in the 1970s as a result of marketing and distribution innovations in independent companies in the art, adult and family film genres.

in settings where decisions are negotiated concerning the selection of prospective acts or products and how they might be modified to achieve 'success'. This may, in turn, derive from a partial erosion of the principle that creative work ought to be autonomous of commerce. It may be that people working in cultural industry organisations are finding it harder to argue against short-term commercial imperatives in the name of prestige or providing creative innovation.

Wyatt argues that the increased role of marketers in making decisions over what movies – and which types – get made led to the rise of the 'high concept' movie in 1980s Hollywood. This is, in essence, a film, the central idea of which can be conveyed in a single sentence – both in the initial pitch of the film to financiers and so on and to audiences in the marketing of the product. The film *The Player* (1992) dramatised this beautifully in the form of numerous such pitches, 'in 25 words or less', such as 'It's *Pretty Woman* meets *Out of Africa*'. (This satire on Hollywood from within Hollywood encapsulates the contradictory nature of the cultural industries.) At the core of high concept, then, is the reduction of narrative to a simple, underlying idea. Wyatt considers that the rise of the high concept film was a major factor in bringing about a decline in the quality of Hollywood cinema during the 1980s and 1990s following the years of Hollywood's embrace of cultural prestige in the 1970s (see Biskind, 1998). It is not impossible for qualities of complexity, richness and ambivalence to survive the domination of high concept – and Wyatt pays insufficient attention to this possibility – but it almost certainly makes such qualities more difficult to achieve, other things being equal.

Although there are many countervailing tendencies against formula and repetition in cultural production and although marketers are quite happy to promote original products as distinctive and unique, there is a strong tendency in marketing to embrace the familiar. As Bill Ryan puts it (1992: 220), 'Marketers need predictable commodities to work their magic on'. Equally, in the words of one veteran market researcher, Hy Hollinger, quoted by Wyatt (1994: 59), 'Anything that is innovative is hard for market research to clue in on'.

A particularly notorious use of market research in what is effectively still the creative stage of cultural production is the screening of movies to test audiences, with a view to amending the film in response to the result of audience questionnaires. The most quoted example is *Fatal Attraction* (1987). Glenn Close's character originally committed suicide to an aria from *Madame Butterfly,* but, after poor test responses, the ending to the film was changed and her character was killed. Most major Hollywood films are now tested and nearly all tests are carried out by the National Research Group based in Los Angeles (Lerner, 1999). Many successful films test poorly, but go on to achieve success. They include innovative films such as *The Blair Witch Project* (1999) and *Reservoir Dogs* (1992) (see Lerner, 1999). The National Research Group recruits an audience, the demographic characteristics of which supposedly match those of the film's target audience. They fill in response cards and some may take part in a focus group discussion. Some directors, especially those of comedies, embrace the process, while many resist and find that executives can use tests as ammunition. The tests are a means of attempting to find

objectivity in order to deal with the perennial unpredictability of the film business, but directors opposed to the process think that it favours restrictive control of creativity. As one director puts it, 'If the test is bad, the studio panics. If it goes well, they say, "It doesn't mean anything" ' (Andrew Bergman, quoted by Willens, 2000: 11).

CONTROL OF CREATIVITY: STILL LOOSE, BUT TIGHTER

The increasing presence and status of marketing, then, represents a shift in the organisational structure of cultural production. But not all changes in the cultural industries can be uniformly understood as an increase in commercially orientated aspects of cultural industry work at the expense of creative autonomy. Sean Nixon (1997: 195) writes about the 'creative revolution' in British advertising in the late 1970s and 1980s – a development that was 'established in opposition to what was represented as the boring and unimaginative advertising produced by the large multinational agencies'. The old advertising practices were reliant on the written or spoken word and attempted to convey the 'unique selling point' of the product. The new, more creative advertisements worked at the levels of desire and identity rather than via the 'hard sell'. Nixon attributes the shift towards 'creative' advertising, involving much greater levels of autonomy for creative staff, primarily to new forms of market research in advertising agencies, which meant that advertisers were much more concerned to target specific market segments than entire social classes or 'the mass audience'.

So, here, a greater use of market research seemingly led to greater levels of operational autonomy for creative personnel in the most commercially orientated of all the cultural industries. However, it may be that Nixon is dealing with a very particular case. Creative personnel in advertising are highly unusual in the context of the cultural industries as a whole. The main goal of their work is to sell goods and services or to increase the value of the companies they promote. Advertising creatives were probably more tightly controlled in terms of being judged on financial outcomes than most creative personnel in other cultural industries. So, a relative loosening of control for the most highly paid and prestigious advertising creatives is not necessarily typical of trends in the cultural industries as a whole.

As a contrasting example, we can take an area of creativity that was previously well protected from commercial imperatives in the conception and execution stages: live theatre. This is an industry that might once have been classifiable as peripheral, in the terms established in the Introduction, but is moving nearer to the core cultural industries as it becomes a multimillion dollar industry, with much investment from some of the largest transnational cultural industry corporations.

Jonathan Burston (1999) argues that, as the profit-making potential of live entertainment has become more apparent and as the sector has therefore become increasingly integrated into entertainment conglomerates, assembly line production methods have become more frequently seen in theatre. Burston examines

the mega-musicals that have dominated live theatre economics since the 1980s – shows such as *Cats*, *The Phantom of the Opera*, *Miss Saigon* and *Disney's Beauty and the Beast*. These are all large-scale musical works with very big casts and a strong emphasis on special effects. The huge amounts of money invested in, and made from, these shows, has meant that production companies very carefully control what can be done with their intellectual property after the original production of the show. Shows are 'franchised' by their owners and can only be put on if very specific conditions are met. The consequence for those involved in such productions is, in Burston's view, increasing alienation. One of his interviewees, a director, described his deep dislike of 'having to be the person who stands there and says, "[male principal], you're six inches too far to the left" and who trains endless [male principals and female principals] to go through the mechanics again' (Burston, 1999: 75). This raises important questions concerning the working conditions of creative personnel that I shall return to below.

Davis and Scase's case for the loosening of control due to the growth of 'network organisations' in the cultural industries in part rests on the idea that, within commercial bureaucracies, creative managers are gaining more autonomy. The key creative managers in British television – a system that encouraged creative autonomy in the name of public service – were producers. Examining the extent to which their working conditions changed during the 1980s and 1990s provides a good test case of the fate of creative autonomy. How did producers fare in the profound transformations that swept through British broadcasting in those years?

British television producers have always had some managerial role and, because of the public service nature of the British system, they were less driven by commercial imperatives than was the case with other creative managers, such as editors in publishing companies or A&R personnel in record companies. This was true even in the commercial sector of British television, which was strongly governed by public service obligations from its inception in the 1950s until the 2000s. Television producers effectively functioned, in many cases, as leaders of creative teams that, in many situations, they could build themselves (see Tunstall, 1993: 24–6). They were answerable to a number of higher decisions from senior management, especially regarding scheduling, overall budget and number of programmes and broad editorial directions, but their autonomy *within* these overall guidelines was considered the guarantee of quality within the British system.

Jeremy Tunstall (1993) has provided a rare, detailed study of British television producers across both commercial and cultural bureaucracies, to use Davis and Scase's terms. The roles of producers had changed by the early 1990s, according to Tunstall. This was partly because of changes in the BBC and the ITV companies, but also because more and more production took place in independent companies. Tunstall (1993: 202) says that producers became more autonomous, but this increased autonomy from senior managers came at a cost. Many producers were increasingly insecure in their jobs or had lost them altogether, but even those producers who kept their jobs were being asked to do more and more

things. Increasingly, producers were expected to raise their own funds. They had to spend more time talking about, and working on, budgets and money than ever before. They had to commission other producers as well as make programmes themselves. They had to make more decisions about resources, including which freelance crews to use. Tunstall sums up their changed roles as less secure, more responsible and more autonomous (1993: 203). This demonstrates the contradictory nature of the creative autonomy characteristic of the cultural industries. In this case, increasing independence from senior managers meant slavery to administrative concerns. There seem often to be contrary pulls between finding creative space and the huge 'emotional investment' (Tunstall, 1993: 202) necessary to undertake such creative work.

Chris Bilton provides a further perspective on these changes. Discussing the 'pseudo-independence' characteristic of a great deal of production in the cultural industries, Bilton reports remarks by then the Channel 4 Chief Executive Michael Jackson on the development of a new 'corridor culture', 'in which independent producers can work closely with Channel 4 executives on new ideas'. Bilton notes that this image of friendly collaboration actually reflects the 'increasingly proactive interest' taken by Channel 4's commissioning editors (quotations from Bilton, 1999: 33). The commissioning editors are now the vital creative managers in British television. Once again, this is confirmation that power lies in circulation in the cultural industries, though its precise location in a particular management role may shift over time.

What is the significance of the various changes examined in this section? We can see evidence of some tightening of control in some industries and genres, and some loosening elsewhere. The problem though is that creative autonomy itself is bound up with the interests of cultural-industry businesses, and cannot be defended in a simplistic, dualistic way, against commercial imperatives. For the promise of creative autonomy represents a means by which (mainly young) people are persuaded to accept uncertain and often poorly-paid working conditions. The aftermath of the counterculture of the 1960s and 1970s has probably led to a general reinforcement of the importance of creative autonomy as a control mechanism, as more emphasis than ever before is placed on creative self-realisation through work. Perhaps the most vivid way in which this promise of creative autonomy is manifested is via media images of creative autonomy and high rewards available for the most successful creators. This thin band of superstars is the subject of the next section.

SUPERSTARS, AUTHORSHIP AND CREATIVE AUTONOMY

If control over creativity is, in some instances, tightening (though it remains loose compared with other forms of control in other industries), there is one group of creative personnel who need have little fear of corporate interference, at least in the short term: superstars. Stars often receive huge financial rewards because there is such a premium on name recognition as a way of distinguishing

individual cultural products from the many being released. In some cases, this recognition translates into levels of power greater even than those of company executives or owners. Performers such as Madonna or Tom Cruise have a considerable amount of input into the finished products that bear their names. Some will use their reputation to lever a different creative or creative management role – actors, such as Clint Eastwood and Mel Gibson, become directors, for instance. Arnold Schwarzenegger's contract for *Terminator 3: Rise of the Machines* (2003) paid him a basic US$29.25 million fee, whether he made the film or not, plus a 'perk package' of US$1.5 million, plus 20 per cent of the gross receipts made by the film in every market in the world.[5]

Stardom's huge financial rewards lead to further privileges, because a high initial investment in a star's name will mean that the company has to put a certain amount into publicity and marketing in order to increase their chances of recouping their money. Some may even gain contracts where high levels of control – not only over creative output but also over marketing and publicity plans – are guaranteed. In other words, these are symbol creators with high levels of influence over the circulation of their products. It is worth stressing that such influence over circulation is the exception rather than the rule. (See Box 7.1 for another development involving star power.)

BOX 7.1 STARS AND 'THE RIGHT OF PUBLICITY'

Stars are increasingly operating as new forms of business entity in themselves, with interesting consequences. Take the example of Arnold Schwarzenegger, who, in 2002, sued a tiny Ohio motor dealership and its advertising agency because they had used an image of him in the *Terminator* films as part of an advert for an end-of-the-month sale. Both the ad agency and the dealership settled out of court. The fact that some of the money went to Schwarzenegger's nominated charity did nothing to alter what was really at stake in the case: the ability of stars to police the use of their images in the public realm and turn those images into their property.

Schwarzenegger is by no means the only star engaged in such policing. A famous case involving the publication of the wedding photographs of Michael Douglas and Catherine Zeta-Jones in a gossip magazine was an attempt to establish similar control over star images in the UK. This is a version of the kind of commodification of culture involved in developments in copyright discussed in Chapter 5.

The long-term history behind this development is summarised admirably by Philip Drake (2007). Drake explains that, in the twentieth century, courts in the USA began to rule that unauthorised use of a person's photographic image

(Continued)

5 Schwarzenegger's contract avoided the standard means by which Hollywood contracts prevent the 'breakeven point' from being reached, even when the film makes millions of dollars in revenue. See Epstein (2005b) for a fascinating account of Schwarzenegger's contract.

(Continued)

was a violation of the right of privacy enshrined in law since 1890. Stars were often deemed to have waived their right to privacy as a result of their celebrity and their legal argument against unauthorised use therefore shifted from a complaint about *unwanted* publicity to one about *uncompensated* publicity. A new right, 'the right of publicity', has become increasingly accepted. As Drake (2007) notes, 'this is a crucial distinction as it shifts the law away from a privacy right towards a property right' – that is, the right to economic control over the circulation of images.[6]

One lesson from this story is that autonomy for symbol creators is not something to be celebrated in itself. The goal of artistic autonomy (from commerce and the state) can have a role in enabling free, diverse and pleasing communication, but it is provisional, dependent on context, variable. The star system involves forms of individual autonomy that can have ultimately pernicious results, including ostentation, waste, and the unreasonable demand for further rewards.

A further clarification is in order about stars as 'authors'. The assigning of a name to a textual product is not in itself a sign of that person's creative autonomy or responsibility. Quite often, the person (or people) may have relatively little responsibility for the final output. Indeed, many named 'authors' will have little interest in having much input at all. Managers, producers and executives may well have more say in determining the sound of a recording than the singer or band whose name appears on the CD or web page. In extreme cases, an author will have had very little role. For example, the name of thriller writer Alistair MacLean, one of the biggest-selling novelists of the twentieth century, appeared on books that were completed by others from his outlines after his death in 1987.[7] However, such strategies are not confined to the 'low' end of popular culture. In 'high' and 'middle' market segments (these refer to the income and education of audiences), authorship offers legitimation. Because high value has been attached to products that are created by gifted individuals (especially supposed 'geniuses'), putting a known name on a text suggests some distinctive personal vision. *Six Feet Under* was 'created by' Oscar-winning scriptwriter Alan Ball, who was also credited as 'Executive Producer' and wrote and directed some of the weakest episodes of the programme. A series of albums by Johnny Cash were 'produced' by Rick Rubin, but Rubin's input is reputed to be minimal. The author's name, then, is often a fiction and pretty much always a simplification for, even where a symbol creator has considerable input, the attribution of a text to his or her name alone downplays the collective nature of cultural production by project teams. This makes it all the more outrageous that stars claim such vast financial rewards for their input and now for their very image.

6 These developments are also discussed by, among others, McLeod (2001).
7 For example, the unbelievably bad *Alistair MacLean's Hostage Tower* (Denis, 1991).

JOURNALISTIC AUTONOMY AND MEDIA MOGULS

Questions regarding autonomy from commercial, ideological and state pressure have been particularly debated in studies of journalism. Journalists put great emphasis on their autonomy from owners and from other powerful influences in society. A series of important sociological studies in the 1970s suggested that journalists worked relatively autonomously of the demands of newspaper owners and senior executives (Tunstall, 1971; Tuchman, 1978; Gans, 1979). The notion of professionalism – in the sense of an ethos of serving the public via the pursuit of objectivity (see Hallin, 2000: 220) – played an important role in legitimating this relative independence.[8] Others, however – particularly those writing from political economy approaches– have argued in response that such studies overstated the independence of journalists. James Curran (1990: 120), for example, preferred the term 'licensed autonomy' to 'relative autonomy' and remarked that 'journalists are allowed to be independent only as long as their independence is exercised in a form that conforms to the requirements of their employing organisations'. Curran argued that, in the 1970s and 1980s, the British press had shifted to a more partisan stance than for many decades, under the influence of a new generation of interventionist owners. Curran provided evidence of how, on the one hand, under this new regime, British press journalists were pushed by their senior executives to write stories presenting the left-wing Greater London Council of the 1980s in a negative light. Broadcasting organizations, on the other hand, portrayed the Council much more favourably, for a mixture of organisational and cultural reasons.

Curran's point is supported by the evidence that emerges from time to time of conglomerates using news organs to promote their business interests. Ben Bagdikian (2000: xxv–xxvii) recounts incidents that suggest increasing damage to 'the Wall of Separation between Church and state' – the Church in this metaphor being editorial independence and the state being the business interests of the newspaper. He tells the story of how, in the late 1990s, a new CEO of Time-Mirror Company, one Mark Willes, reorganised the company's flagship paper, *The Los Angeles Times*, so that news stories would be allocated by a staff that included someone from the business department of the newspaper. News staff were, it seems, increasingly involved in special corporate advertisements.

The notion of journalistic autonomy is further qualified by the increasing efforts on the part of other organisations and institutions to position themselves as key sources. There has been a significant growth in the public relations

8 Philip Elliott (1977: 150) characterised post-war journalistic professionalism much more negatively as a form of self-legitimation, where skill in routine tasks (keeping to deadlines and so on) was elevated to the occupational ideal. Elliott was writing before the onslaught of commercialism unleashed by the changes discussed in this book. Hallin's more upbeat assessment is perhaps a product of the fact that, in an era of marketisation, the faults of journalistic professionalism's inward-looking complacency and clubbiness seem outweighed by its outward orientation towards objectivity and publicness.

industry over the last four decades, across a number of fields. In the UK in 1963, there were an estimated 3000 public relations professionals, while in 1995, the top 150 consultancies alone employed a total of nearly 5000 staff (Miller, 1998: 67). While journalists in general retain an attitude of professional scepticism towards efforts to attract their interest and sympathy, in practice this involves forming hierarchies of sources, from most trusted down to unknown and, therefore, untrustworthy. Naturally, the most powerful organisations often have the most credibility. Recent studies have shown that access to journalists does not depend entirely on resources – sometimes weaker and oppositional sources are given great prestige (Schlesinger and Tumber, 1994). Nevertheless the pressures on journalists exerted by the more powerful and wealthy organisations can be tremendous. Journalists, then, even if they act in relative autonomy from the requirements of owners and executives on a daily basis, are not independent of other pressures to pursue particular interests and their everyday autonomy is shaped and formed by the overall interests of the organisation they work for.[9]

It is worth looking at Curran's point about interventionist owners in more detail. In the market professional era (late nineteenth and early twentieth centuries), strong individuals dominated the family firms that ran the newspapers and publishing companies, which were at the heart of the cultural industries. In other industries, family firms with dominant figures have given way to complex systems of control, under boards of directors, where most directors represent other companies and where there are many interlocking directorships. This new pattern of ownership has come to the cultural industries, too (and, as in other industries, it has been further complicated by the increasing involvement of financial institutions such as pension funds), but the figure of the *media mogul*, who owns a dominant interest and has an overpowering control over his own company, has been remarkably persistent in the complex professional era. Even as cultural industry corporations grow in size and complexity, a large number remain under the control of such individuals.

Many media moguls are prepared to push their own political views extremely hard via their cultural industry interests. Perhaps the most spectacular example of the pursuit of political ambition via media ownership in advanced industrial countries in recent years is the case of Silvio Berlusconi, who, by promoting his political party 'Forza Italia' across his various television, publishing and sports interests, managed to make himself prime minister of Italy in 1994–1995 (see Mazzoleni, 1995) and again from 2001–2006.[10] The most internationally prominent of all media moguls, however, is Rupert Murdoch. Curran (1990) showed how *The Sunday Times*, once it had been taken over by Rupert Murdoch's News International, moved from being a centre right, even liberal, newspaper to a Thatcherite one (1990: 132–3). Murdoch revived the strategies

9 An interesting, important and neglected issue is the degree to which the notion of professional autonomy in other, non-journalistic, fields differs from autonomy in journalism.

10 Mancini and Hallin (2001) argue that Berlusconi's 2001 success was not achieved by using his television stations for propaganda, but, rather, by using his television empire as a resource for negotiation and bargaining with other political, economic and social institutions.

of direct control associated with press barons of the early twentieth century, such as Northcliffe, Beaverbrook and Hearst (the man on whom Orson Welles based *Citizen Kane*). Murdoch would apparently rewrite leaders that were insufficiently supportive of the hard right Prime Minister at the time, Margaret Thatcher, and removed left-leaning or moderate conservative editors. He exerted pressure on his liberal editor at *The Times* by refusing to fix an editorial budget and thereby gaining the chance to approve any editorial decision that needed significant spending. The center right editor at *The Sunday Times* was forced out to make way for the Thatcher-supporting Andrew Neil. Overt and abrasive pressure was applied to journalists to reorientate the editorial direction of the paper. More than 100 journalists left the paper between 1981 and 1986 (the staff was 170 strong in 1981). *The Sunday Times* has pursued a far right editorial policy ever since.

Surely, given that Murdoch owns a vast global media empire, operational autonomy is left to editors? Not necessarily. In a more recent chapter, Curran (1998: 87) quotes Andrew Neil, now a senior executive elsewhere, on his experience at *The Sunday Times*:

> Rupert has an uncanny knack of being there even when he is not. When I did not hear from him and I knew his attention was elsewhere, he was still uppermost in my mind ... Rupert expects his papers to stand broadly for what he believes: a combination of right-wing republicanism from America with undiluted Thatcherism from Britain.

In 2003, this uncanny knack was confirmed in the most striking way, when a survey by media commentator Roy Greenslade found that the biggest-selling and most influential newspapers of the 175 owned by News Corporation across the world unanimously supported the invasion of Iraq, which the USA, UK and their allies were preparing at the time. Just as significantly, opponents of the war, whether political leaders or ordinary citizens, were routinely derided. Greenslade commented, 'You have got to admit that Rupert Murdoch is one canny press tycoon because he has an unerring ability to choose editors across the world who think just like him. How else can we explain the extraordinary unity of thought in his newspaper empire about the need to make war on Iraq?' (*The Guardian*, 17 February 2003).

Moguls receive massive amounts of attention – partly because the media thrive on reporting the actions of charismatic individuals. Such interventions are extremely important but they are, in the context of the cultural industries, relatively rare. They illustrate that autonomy is never irrevocable, but focusing to an excessive degree on media moguls can distract attention from systemic features of the cultural industries. It can obscure the central importance – and ambivalence – of the operational autonomy granted to journalists and other creative personnel in cultural industry companies. Direct intervention by owners and senior executives of the kind analysed by Curran must not be ignored, but neither should the very indirect coercion exercised in everyday professional routines. The notion of journalistic autonomy still holds strong as a means of gaining legitimacy and credibility for cultural industry organisations. Gitlin (1997: 8) suggested that, since 1990, NBC had routinely covered scandals involving its

parent company General Electric and ABC News' Peter Jennings had 'gone out of his way to cover criticisms of Disney' (who own ABC). In Gitlin's view, the greater danger was self-censorship – that is, journalists deciding not to pursue certain interests that might clash with a corporate culture – and that news media will be used to promote entertainment aspects of the conglomerate's business. (I return to these issues in Chapter 10.)

TERMS AND CONDITIONS OF CULTURAL WORK

I now turn to the question of how the terms and conditions of cultural work prevailing in the 1945–1980 period, as outlined in Chapter 2 (pp. 71–3), have changed. I began there by noting that many more people want to work in the cultural industries than actually make it. This still seems to be the case. The paradox of cultural work is that more and more people seem to want to work in the cultural industries, even as it becomes increasingly clear how difficult it is to have a good quality of life doing so.

Before surveying some key changes, it is important to note that, in one respect, there has been fundamental continuity. It is that the division of labour discussed in Chapter 2 remains broadly intact. The 'functions'[11] of owners and executives, creative managers, marketers, primary creative personnel, technical craftworkers and unskilled workers still represent distinct categories, even if they interact in different ways (as the discussion of marketing, above, suggested). However, there have been radical shifts within the categories, in terms of conditions of work and the internal divisions within them. (I pay more attention to creative personnel here and elsewhere because of their role – if only their perceived role in some quarters – as primary workers.)

UNSKILLED WORK

The number of people performing relatively humdrum (though often essential) work in the cultural industries has increased, partly because the cultural industries are gradually becoming a more important part of economies (see previous chapter), but also because of the continuing importance of manufacture and wholesaling. (The fact that DVDs are not made out of thin air problematises the many efforts to tie the rise of the cultural industries to post-industrial, information society analyses.) It should not be thought that the onset of digitalization involves any less mind-numbingly repetitive labour either. The very act of digitalisation of print resources, for example, can involve a great deal of tedious work.

TECHNICAL WORKERS

While some unionised technical workers are still paid relatively well (for example, camera operators in the film and television industries), their work is increasingly

11 See Chapter 2 (p. 65) for a reminder of why I refer to these as 'functions' rather than occupational groupings.

casualised. In the advanced industrial countries, there has been large-scale de-unionisation. Internationalisation has meant that many tasks have been shifted abroad to countries where labour laws are even weaker. This has been the case in animation, as John A. Lent (1998) shows. The creative elements are carried out in the USA, while the more humdrum technical aspects of execution are contracted out. These working practices may not be quite so exploitative as offshore production in the clothing/fashion industries (see Ross, 1998), but they represent part of what Miller et al. (2005) call the New International Division of Cultural Labour (or NICL – no, I don't know where the 'D' went either) – that is, as the cultural industries have become big business, it is not just manufacturing that is increasingly moved to cheaper locations, it is cultural production, too. Animation companies in the USA such as Hanna-Barbera have achieved huge economies by opening major offshore studios in Australia (1974) and Taiwan (1978). Most animation for US and European companies is now carried out in Asia. Disney contracted for many years to a set of Japanese subsidiaries and, in turn, by the 1990s, Disney Japan was subcontracting most of its work to South Korea or China.

CREATIVE MANAGEMENT

Ryan (1992: Section 4.3.2) argues that creative management has become much more professionalised in recent years, in that its roles and duties are established and even, in some cases, formally taught on courses. The creative management function has become completely established in all 'mature' cultural industries and is frequently carried out in teams. This has spawned internal divisions of labour and hierarchies. For example, the A&R department in a record company will include a senior manager who might have responsibility for dealing with more established artists or pushing through the signing of an expensive act, while younger, new members of the team will take on more of the work of making contacts and sampling new acts, whether in the form of recordings or live shows. Some creative managers achieve a kind of stardom within their own area and, because such managers are now increasingly mobile, can command higher financial rewards than ever before. After the conglomerates entered book publishing in the 1960s and introduced strict accounting and bureaucratic managerial practices, it became common for successful commissioning editors (the main form of creative management in that industry) to leave the conglomerates in order to set up their own smaller companies – often taken over by a conglomerate years later. In the last 30 years, there has been a trend towards the same thing in the recording industry, as A&R personnel leave to set up their own independent companies. Once again, we see the 'networked' nature of much cultural work– creative managers moving back and forth between independent production and corporate cultures.

SYMBOL CREATORS

The pool or reservoir of underemployed creative labour discussed by Miège (see Chapter 2, in this book) is getting bigger because of a number of interrelated factors. The cultural industries might *appear* to be more open in access to their prospective workers because of the proliferation of cultural forms and technologies. Yet people are prepared to spend longer in the pool. This is partly a

result of the fact that people are increasingly aware of the intensely competitive nature of entry to the cultural industries. Also, casualisation in advanced industrial economies means that more and more people are prepared to accept long periods of time without secure employment and to mix jobs. More than anything else, though, the willingness of so many hundreds of thousands of people to take their place in the reservoir of cultural labour is the consequence of a commitment to doing creative work of which they can be proud. Discourses of creativity, in other words, continue to play an important economic function.

Creative workers frequently work tremendously long hours under difficult conditions. They trade in financial reward and security for creative autonomy. But a model of power as coercion is insufficient to explain this. There is rarely an authority figure present to tell symbol creators to work so hard for so little reward. In fact, all cultural workers, creative workers and, to some extent, creative managers and technical personnel, seem to accept poor working conditions (for example, long, difficult hours) for the benefits of being involved in creative projects and the glamour surrounding these worlds.

Rewards for creative work continue to be very uneven, with very high rewards for the few superstar creative workers and much less for other workers, including creative managers and technical personnel. Montgomery and Robinson (1993, cited by Caves, 2000: 79) provide some figures on this, and, though they are drawn mainly from the world of artists and professional classical musicians, they indicate some of the dynamics likely to be found in other cultural industries. A 1989 survey of 2000 visual artists found that median earnings from art were only about US$3000 per year. The same study showed that the costs of pursuing such a career were about US$9625 per year, so median net income was minus US$6000! Median total earnings, including other work, for the various artists in this group came to between US$10,000 and US$20,000 per year. Family and other jobs provide the support to get creative workers through. This particularly seems to be the case for those attempting to gain entry into sustained professional work – those, in other words, who are trying to 'make it'.

What about symbol creators who *do* manage to achieve access to the cultural industries? Their rewards are, of course, dependent on the contracts they sign, but they are also dependent on the work done by the cultural industry companies they work for. Deals in the recording industry will serve as an example.

Publishing and recording deals for musicians have generally taken the following form during the complex professional era. Musicians agree to render their services exclusively to a company, usually for a specified number of recordings and in certain specified territories. In return, the company will normally make commitments to promote the work of the artists. The musicians are paid an advance and then, if and when this advance has been recouped via sales, they are paid a royalty.

The long history of dubious contracts and career-breaking rip-offs cannot be told here,[12] but there are two main areas of controversy surrounding the 'standard' advance-royalty/exclusivity contract between musicians and companies.

12 Some important developments in contractual law in the cultural industries are surveyed by Greenfield and Osborn (1994) and a journalistic account by Garfield (1986). My thanks to Matt Stahl for corrections to this section; any remaining faults are my responsibility alone.

The first area concerns the financial rewards available for artists. The advance is essentially a loan against money that the musicians' recordings will make in the future. Repayment is 'cross-collateralised' against costs such as recording and touring (and often against royalties on different contracts with the same company, such as publishing ones – see Passman, 1998). The effect is that musicians pay towards such expenses out of their loan. In many cases, the advance is never recouped and musicians can be in debt to their record company for many years. Many young bands enter into this system unaware of the difficulties of recouping the substantial advances that they initially welcome.

There have been important changes since the 1970s. Musicians are much more aware of the dangers of rip-offs and the need to take legal advice when signing contracts. Royalty rates have risen considerably since the 1970s, when 7 to 9 per cent was common (Caves, 2000: 62). The level of royalty rate is set in the initial contract as a certain percentage of retail sales. Big stars gain much higher royalty rates (16 to 20 per cent, according to Caves, 2000: 62), whereas middle-range acts get 14 to 16 per cent and new acts get something like 11 to 13 per cent. Generally, the level of the royalty rises as the musicians make more records. The justification for this is that the company has to invest more resources initially, in order to establish the musicians' careers. In most contracts, however, costs are still recoupable against royalties – in other words, musicians pay for their recording and many promotional expenses out of their earnings. Yet the company retains the lion's share of the money and retains control of copyright – increasingly, the source of much of the wealth in the cultural industries.

The second area of controversy relates to the creative autonomy of musicians and the level of commitment shown by a company to a symbol creator's output. (Clearly, this relates to the earlier discussion of creative autonomy, but I deal with it here as a key facet of the experience of cultural work.) A particularly important issue in the music business in recent years has been the restraints on symbol creators brought about by the long-term nature of the recording and/or publishing contract. Although established star names are able to negotiate relatively high royalty rates, many contracts remain very long term in nature and this is actually a disadvantage for the artist. Normally, the company has a right to exercise an option or a series of options to retain the musician's services. Nearly all contracts are asymmetrical, however, in that the musician must fulfill certain criteria if he or she wants to be retained by the company, but cannot choose to leave. These criteria will usually include sales which are dependent on the efforts of the record company. A danger for musicians in being held to a long-term contract is that the sympathetic staff who signed them may leave the label, to be replaced by creative managers with little interest in the band. Another is that any change of direction by a musician may receive an unsympathetic reception from the record company.[13] These dangers remain current in the recording industry. In this particular respect, little has changed

13 This was a central issue in Panayioutou versus Sony Music Entertainment (UK), Limited – the George Michael case, resolved in 1994. Michael tried, unsuccessfully, to argue in this important dispute with his record company that his long-term contract with Sony was a 'restraint of trade' under European law. Star symbol creators are increasingly challenging these contracts, reflecting the rise of star power, but this is unlikely to improve contracts for the majority of creative personnel.

since the 1970s, except that record company staff are even more prone to moving between companies (see Box 7.2 on one interesting attempt to change things).

BOX 7.2 THE POST-PUNK INTERVENTION

At various independent record companies associated with punk in the late 1970s and 1980s, new ways of dealing with artists were developed that challenged the standard arrangements in the music industry. Deals with musicians were often on a 50–50 basis, rather than the single-figure percentage royalty rates usual at the time. Also, long-term contracts were rejected in favour of deals based on personal trust. The aim of such deals was to be as 'musician-centred' as possible. Contracts were avoided on the grounds that the standard contracts were loaded in favour of companies and if the personal trust between musicians and companies broke down, there was no point in pursuing the relationship anyway.

These companies generally favoured record-by-record deals, which gave artists the freedom to move on to other companies, should they wish to do so. The 50-50 deals meant that payment rates for musicians were enormously higher than the single-figure percentage royalty rates common even for established bands on major labels. If a band could achieve high sales on such a deal, they would make a great deal of money.

Recognising the vital strategic importance of circulation, British punk independents formed distribution and retailing networks. What is more, many extremely talented musicians came to work with the punk independents because they wanted to work with people whom they felt had a closer understanding of their music than the creative managers in the transnational corporation divisions. Their records achieved considerable success and brought very different voices into the mainstream of British cultural life (see Hesmondhalgh, 1997, 1999 for more details on this).

The post-punk intervention illustrates the potential that many musicians and audiences have attached to independence, not only in terms of musical innovation but also of the politics surrounding the conditions of symbolic creativity. It serves as an example, too, of attempts to transform the apparatus of *commercial* cultural production. All too often, the literature on alternative media is confined to very small, marginal interventions, operating so far outside most people's experience of popular culture that they are known only to small groups of activists and intellectuals.[14] Here, however, activism took place actually in the field of commercial entertainment production itself.

In the end, the post-punk rebellion was unsuccessful. The key companies went bankrupt, many musicians became disenchanted with the limited promotional budgets available in small record companies and, gradually, more and more independents forged distribution and/or financing deals with transnationals (Hesmondhalgh, 1999). However, new genres continue to develop in what Toynbee (2000) calls proto-markets and independent record companies still act as vital conduits for the more widespread dissemination of the music produced within them.

14 John Downing recognises this in his outstanding book *Radical Media* (2001).

I want to note a final change. As the cultural industries have grown, they have become more complex and there has been a further growth in the number and significance of functions involving mediation between cultural industry organisations and the pool of creative workers. The two most notable occupations are *agents* and *artist managers*. Caves (2000) suggests that agents were once shunned by companies, but are now welcomed as a means of reducing recruitment costs in book publishing, film and television and the various performing arts. He explains why by quoting figures from Coser et al. (1982: 130–2), that only 3 or 4 out of 10,000 books submitted for publication are accepted. Agents do some of the publishing company's filtering work for them. Artist managers perform a similar function in the recording industry. An important change in recent years has been the increasingly entrepreneurial role played by managers or management teams in recruiting and training bands, often using finance capital that they have raised themselves. In this respect, the recording industry is becoming a little bit more like the film industry, with artist managers acting as independent producers who attempt to 'develop' a particular project. Such mediators are likely to become more important still in the years to come, not least because star creative personnel are so well rewarded and artist managers and agents tend to work by taking a commission on payments to stars. It is highly unlikely that this will lead to any more sympathetic treatment of aspiring creators, but it will represent a new form of challenge to the major corporations, which they will seek to absorb via partnership.

** * **

This chapter has surveyed changes and continuities in the organisation of cultural production and the terms and conditions of cultural work. Sadly, there is little reason to believe, on the basis of the preceding survey, that the terms and conditions of cultural labour have improved, in spite of the expanding economic importance of the cultural industries outlined in the previous chapter. There might be signs of restrictions of creative autonomy in production in some industries and genres, but cultural work can hardly be thought of in general as subject to oppressive levels of supervision and surveillance. It could be argued though that the appeal of the autonomy that persists in the cultural industries continues to attract millions of young people to often underpaid and insecure cultural work. In this respect, the idea of creative autonomy as something that needs *defending* needs some qualification. Meanwhile, businesses ensure that they have tight control over circulation. The organisational form of the cultural industries – loose control of creativity, tight control of circulation – established in the twentieth century still persists.

FURTHER READING

Keith Negus' studies of the recording industry, *Producing Pop* (1992) and *Music Genres and Corporate Cultures* (1999) suggest how fruitful a cultural studies approach to organisations and organisational sociology can be for understanding the entertainment-based cultural industries, although his focus is primarily on creative managers – symbol creators being sidelined.

Work in empirical sociology of culture, especially that of Howard S. Becker (*Art Worlds*, 1982, for example) and Richard A. Peterson (such as *Creating Country Music*, 1997) needs far more attention to be paid to it by cultural studies and political economy approaches than has been the case in recent years.

Bourdieu's work on cultural production (most notably, *The Rules of Art*, 1996) is surprisingly neglected (see Hesmondhalgh, 2006, for a critical assessment of its usefulness).

Jeremy Tunstall (*Journalists at Work*, 1971, and *Television Producers*, 1993, for instance) has provided important information about the attitudes and working lives of media professionals of various kinds.

The richest treatments of issues of creative autonomy have been from within studies of journalism, such as work by Philip Schlesinger (*Putting 'Reality' Together*, 1978), Gaye Tuchman (*Making News*, 1978), Herbert Gans (*Deciding What's News*, 1979) and James Curran (his 1990 book chapter entitled 'Culturalist perspectives on news organizations').

On market research (or 'audience research', as it is often known in the cultural industries), I recommend James S. Ettema and D. Charles Whitney's useful collection, *Audiencemaking* (1994), and Jason Toynbee's overview (2006).

Richard Caves' book *Creative Industries* (2000) deals with many areas of creativity that I have not had the space to treat here, but, to reiterate the discussion in Chapter 1, it is the cultural industries approach that has had most to say about symbol creators and conditions of creativity, especially Bernard Miège's *Capitalization of Cultural Production* (1989).

A brilliant PhD thesis by Matthew Stahl (2006), which I read just as this book went to the publishers, suggests new directions for work in this area.

8 INTERNATIONALISATION, GLOBALISATION AND CULTURAL IMPERIALISM

We have already seen (Chapter 2) that there were significant instances of internationalisation of technologies, texts and genres in the late nineteenth and early twentieth centuries and one of the features of the complex professional era of cultural production was the intensification of such internationalisation. An important feature of the cultural industries throughout the twentieth century has been the domination of much international cultural trade by the USA and, to a lesser extent, Europe. One of the key developments in the cultural industries over the last 30 years has been the further and accelerated intensification of international cultural flows, including, as we shall see, much greater internationalisation on the part of cultural industry businesses. This took place, in part, as a response to the need to generate higher levels of profit that businesses of all kinds experienced during the Long Downturn. Also important was the increasing ease of doing business across national borders as communications and transport improved. As leisure time and disposable income increased in some parts of the world, such as Asia and Latin America, European and North American cultural industry corporations took the opportunity to expand. Meanwhile, Asian and Latin American companies made attempts to internationalise into European and North American cultural markets.

The successive waves of marketisation discussed in Chapter 4 were extremely important in paving the way for such internationalisation by removing many policy barriers to cultural trade. This chapter seeks to analyse and evaluate these developments, using the terms established in Chapter 2. Before doing so, however, we need to examine more carefully the question of how and why the USA came to dominate international television flows and, indeed, cultural trade in general, during the complex professional era.

FACTORS BEHIND CULTURAL DOMINATION BY THE USA

How did the USA come to dominate international cultural trade? This question raises fundamental issues concerning the relative roles of capitalist economics, political power and symbolic form and content in determining developments in the cultural industries. This domination was never total, of course, and I examine ways in which it has been contested and qualified in later sections, but it is a remarkable degree of domination nevertheless. We can identify two major factors:

- the size and nature of the domestic market for leisure in the USA
- the active role of the state.

SIZE AND NATURE OF THE DOMESTIC MARKET FOR LEISURE IN THE USA

This market was, from an early stage, larger and wealthier than any other in the world and this allowed production companies in the USA, across all cultural industries, to cover their costs at home and treat overseas markets as sources of further profit. In the early years of television, these companies built up greater repertoires of programming, giving overseas importers or international partners a bigger range of products to choose from than was available in their own countries. In a period when many economies were rebuilding, in the aftermath of the Second World War, the television market in the USA established itself much earlier than elsewhere in the world. Television was able to draw on an already established global success in film and, to some extent, in popular music. Genres, stars and other creative personnel – technicians, too – could be moved across from these industries. What is more, the TV industry could invest in the expensive process of putting its products on to film at a time when many countries were still transmitting programmes live. TV audiences in general tend to prefer domestic to foreign programming and, because the USA has the largest domestic market in the world, it has an advantage over everyone else in being able to reduce costs and so can export its programmes effectively.

This factor is misrepresented in the account of media economists Colin Hoskins, Stuart McFadyen and Adam Finn. They see the USA's cultural success as being based on the benefits of competition between oligopolistic firms at home. They are surely right to emphasise the domestic market as a factor, but, in stressing the positive effects of having to appeal to a diverse audience at home as a major element in the USA's competitive advantage (1997: 44), they risk

oversimplification. This contrast between the USA's 'melting pot' and cultural homogeneity in other nations is too crude.

ACTIVE ROLE OF THE STATE IN THE USA

More seriously, Hoskins et al. complacently dismiss accounts that stress the role of the US state in promoting the interests of their cultural industries as 'conspiracy theory' (Hoskins et al., 1997: 45). However, this role should not be dismissed so lightly. Government organisations have played an important part in promoting its cultural industries abroad as a means of securing export income, but also in order to export a set of beliefs and values concerning how to organise production and consumption. In international forums, such as UNESCO in the post-Second World War years, representatives from the USA 'pressed relentlessly' for the notion of a free flow of information and entertainment across the world, which would allow multinational cultural corporations to operate abroad and limit national governments' regulation of their activities (Schiller, 1998: 19). Foreign aid from the USA in the post-war period was tied to stipulations that its cultural exports would be permitted. In addition, the US state contributed enormously to the development of communications infrastructures, such as satellites. Its cultural exports boomed during the post-Second World War period (see Herman and McChesney, 1997: 18–21) and interventions by the state on behalf of the copyright interests of cultural industry corporations helped, as we saw in Chapter 5, lead to the TRIPS agreement, which regulates the way in which the WTO deals with intellectual property.

NEITHER CULTURAL IMPERIALISM NOR GLOBALISATION

While media economists have tended to downplay the role of the state in the USA in international cultural flows, this has been strongly emphasised by radical writers who, especially in the 1970s and early 1980s, used the concept of *cultural imperialism* to refer to the way that the cultures of less developed countries have been affected by flows of cultural texts, forms and technologies associated with 'the West'. However, this approach also has its problems when it is used as a way of understanding internationalisation in the cultural industries.

The 'cultural imperialism thesis' held that, as the age of direct political and economic domination by colonial powers drew to an end, a new, more indirect form of international domination was beginning. This involved, in Herbert Schiller's words (1976: 9), the adoption in economically peripheral countries of 'the values and structures of the dominating center of the [modern world] system'. As Annabelle Sreberny (1997: 49) has pointed out, the concept of cultural imperialism is an 'evocative metaphor', rather than a 'precise construct', but the term draws attention to a number of important issues, such as:

- the imposition of Western cultural products on the non-West[1]
- the potentially homogenising effects of Western culture as it spread across the world
- the destruction of indigenous traditions by such cultural flows.

The term cultural imperialism was at its most popular during the 1970s and early 1980s, when concern about such developments found expression in a series of UNESCO reports, seminars and declarations (most notably the MacBride Report – UNESCO, 1980). From the early 1980s onwards, however, a paradigm shift occurred in the way that radical writers understood international mass communications (see, for example, Fejes, 1981). Many writers began to react against the cultural imperialism thesis. Some began to prefer the term *globalisation* to cultural imperialism.

Globalisation was a term developed by writers (such as Giddens, 1990; Robertson, 1990) working in traditions very different from the international policy forums and activist circles where the cultural imperialism thesis became widespread, but it was also quite different from the neo-liberal understanding of international cultural flows. Globalisation was intended to capture the increasing interconnectedness of different parts of the world. Partly because it referred to a wide variety of economic, political and cultural practices, it spread quickly to become the most widely discussed social science concept of the 1990s, going beyond academia to reach many other circles. Most notably, in the late 1990s, the term came to be used to denote a certain aspect of economic globalisation: the removal of barriers to trade across national borders. For many radical writers and activists, such 'free trade' in fact favours the wealthiest countries in the global system of nation states. (Hence, the protests against globalisation in this sense in various cities around the world most famously Seattle in 1999.) As a result of the dissemination of the term globalisation across many different contexts, confusion has surrounded the idea (see Box 8.1 for clarification of a significant use of the term in media analysis).

BOX 8.1 HERMAN AND McCHESNEY: GLOBALISATION AS CULTURAL IMPERIALISM

The most thorough treatment of internationalisation of the cultural industries in the 1990s – Herman and McChesney's *The Global Media* (1997) – uses the term globalisation in a way that strongly echoes the concept of cultural

(Continued)

1 Terms such as 'Western' and 'non-Western' are very problematic. Western societies are not only extremely different from each other; but also internally heterogeneous, too. The same is true of non-Western societies. Nevertheless, the adjectives do have real political resonance in certain parts of the world as a means of resisting some of the worst aspects of modernisation and commodification.

(Continued)

imperialism and goes against the notion of a complex and ambivalent interconnectedness to be found in social theory's use of the term. This is partly because Herman and McChesney derive the term from its uses in activist circles, where it is used to refer to economic globalisation. However, they do not address conceptual debates regarding cultural imperialism. They initially indicate some recognition of the contradictory effects of global interconnectedness and point briefly to some positive effects of cultural industry internationalisation associated with the dissemination of commercial popular culture, such as 'a greater connectedness and linkage between peoples' and the export of certain positive values, such as scepticism of authority and the questioning of repressive traditions (1997: 8). However, Herman and McChesney are clear that, for them, the primary effects of internationalisation (or globalisation as they would have it) of cultural products are systematically and almost uniformly *negative* – the implantation, extension and intensification of 'the commercial model of communication' (1997: 9). Indeed, the rest of their book is devoted to a catalogue of the activities of media companies in spreading this model and creating an entertainment-based culture that, in their view, is incompatible with real democracy. They are therefore best understood, in terms of my argument here, as using the term globalisation to mean cultural imperialism.

There are fierce debates about the extent to which globalisation – in the sense of significantly new global interconnectedness – has actually taken place over the last decades and whether it is a long-term or more recent development. David Held, Anthony McGrew, David Goldblatt and Jonathan Perraton (1999: 425) argue that 'contemporary [that is, post-1980] patterns of globalisation have … surpassed those of earlier epochs' and the:

> contemporary era represents a historically unique confluence or clustering of patterns of globalisation in the domains of politics, law and governance, military affairs, cultural linkages and human migrations, in all dimensions of economic activity and in shared global environmental threats.

Held et al. usefully describe the increasing and quickening interconnectedness of the world, examining how this affects various economic, political and cultural phenomena in very different ways. However, such empirical work on globalisation tends to be concerned only very marginally with *cultural* aspects of global interconnectedness.[2]

Much more common in work on cultural aspects of globalisation is a theoretical invocation of it that reacts against the cultural imperialism thesis and related Marxian approaches and attempts to develop a more sophisticated way of understanding the complexity and contradictions of global cultural flows.

2 For example, Held et al.'s treatment of cultural globalisation is confined almost entirely to (important) issues of cultural trade, without reference to debates about cultural identity.

Conceptual advances associated with globalisation theory have helped to bring about the rapid fall from favour of the cultural imperialism thesis.

First, some writers have argued that it is no longer possible to portray the global cultural system as one in which the countries of the West (or, in a slightly more sophisticated version, the 'core', to include powerful 'eastern' countries such as Japan) impose their cultures on the non-West. The rise of newly industrialised countries, according to such writers, makes such a perspective outdated, if it was ever valid (see Tomlinson, 1997: 140–2).

Second, whereas some cultural imperialism writers assumed that the spread of Western cultural goods and technologies involved homogenisation or cultural synchronisation (Hamelink, 1983), critics of the concept have pointed out the very strong processes of cultural differentiation taking place throughout the world. As Hall (1997: 211) puts it, 'there are many countervailing tendencies which prevent the world from becoming a culturally uniform and homogenous space'. Indeed, it is possible to argue that diversity may well have increased as new syncretic cultural texts and genres circulate within societies exposed to Western cultural influence. Whereas a previous generation of writers was deeply concerned that Western cultural exports might inhibit or destroy indigenous cultural traditions, cultural studies approaches tend to see cultures as 'hybrids' of older forms (Canclini, 1995; Chambers, 1994) and the idea of a pure, uncontaminated tradition as problematic – even dangerous – because it might serve to support racism and reactionary versions of nationalism (see Chapter 1 on cultural studies). Culture can no longer be equated with place in any simple way, argue these critics. Globalisation involves 'deterritorialisation' (Canclini, 1995) – (nearly?) all places are full of influences from elsewhere. Again, this suggests heterogeneity rather than a universal sameness and, as a result, a much richer theorisation of internationalisation than that to be found in the cultural imperialism thesis.

Third, whereas the cultural imperialism thesis tended to assume the negative impact of Western cultural exports, many writers have stressed the creative and active uses made by audiences of internationally distributed cultural goods – most famously the study by Tamar Liebes and Elihu Katz (1993) of the reception in different countries of the TV series *Dallas*, a classic of 'active audience' theory in liberal-pluralist communication studies.

Globalisation theory has been effective in exposing some of the conceptual limitations of cultural imperialism, then, but these theorists (and other critics of cultural imperialism) have their limitations, too. For a start, there is a real lack of empirical evidence in the work of commentators such as John Tomlinson, Stuart Hall and others associated with globalisation theory, whereas cultural imperialism writers such as Herman and McChesney (1997) provide empirical evidence but no adequate theory. Active audience theory usefully problematises the assumptions in some cultural imperialism writing that non-Western populations accept the values of Western cultural products. This, though, fails to confront broader 'non-media' questions. What, for example, are the relationships, if any, between flows of texts and the continuing international and intra-national inequalities of wealth and opportunities? Active audience theory certainly does not provide the answers to this – it merely tends to suggest that such relationships are more complex than were thought by a previous generation.

Similarly, Tomlinson puts great stress on the ambivalence of cultural globalisation, which he describes as 'double-edged: as it dissolves the securities of locality, it offers new understandings of experience in wider – ultimately global – terms' (1997: 30). He also portrays globalisation as an essentially *undirected* process (1991: 175):

> The idea of imperialism contains, at least, the notion of a purposeful project: the *intended* spread of a social system from one centre of power across the globe. The idea of 'globalisation' suggests interconnection and interdependency of all global areas which happens in a far less purposeful way.

Tomlinson's stress on ambivalence and undirectedness is intended to counter the functionalism and lack of recognition of complexity in cultural imperialism writing, but this emphasis leaves certain questions – often raised by him in the course of his thorough treatments – unanswered. How do we assess global economic and cultural inequality? Which actors are involved in the creation and maintenance of such lasting economic and cultural inequalities?

In this book, I am attempting to deal with these questions more adequately by putting the interests of the companies that dominate the international production and circulation of culture at the centre of the narrative, but in a way that recognises the complexity and ambivalence of their motives and outcomes. With the treatment of questions of assessment and explanation outlined in Chapters 2 and 3 behind me, my aim in this chapter is to ground the abstractions of globalisation theory by asking 'middle level' questions about internationalisation. To recap, as asked in Chapter 2, the guiding 'measurement' questions are as follows.

- **To what extent has the USA retained its international cultural dominance?**
- **To what extent have international cultural flows changed sufficiently for us to speak of a new era in cultural production and circulation?**

The evaluative questions are the following.

- **To what extent does the increasingly global reach of the largest firms mean an exclusion of voices from cultural markets?**
- **What opportunities are there for cultural producers from outside the 'core' areas of cultural production to gain access to new global networks of cultural production and consumption?**

I investigate these questions across three cultural industries – television, film and recorded music – in each of the following three sections.

It should now be clear that my use of the term 'internationalisation' is intended to avoid the problems surrounding the term 'globalisation'. To clarify further, however, there are three main aspects of cultural internationalisation that I am concerned with here.

- *Internationalisation of cultural businesses* Many cultural industry companies invest in more than one country. This might mean producing in many countries, but, more usually, it will mean distributing texts made in one

place across many others. Some claim that the transnational corporation has no identity and even though the head office of the corporation might be based in one country, the company itself has no nationality. However, much of the money made from the operations of the transnational corporation will (at least in electronic form) be 'returned' to the base country.

- *Internationalisation of cultural texts* Cultural texts originated in one country are increasingly seen, heard and so on in other countries. Because of this increasing flow of cultural texts, audiences and symbol creators can, in many places, draw on texts from many other different places. Texts, genres and even technologies (such as musical instruments) will often be reinterpreted and adapted by symbol creators in other contexts.

- *The local is increasingly affected by the global* Partly as a result of this increasing movement of cultural texts, but also because of other, wider factors, cultural identities are increasingly complex. It probably never was wise to think of culture as being linked to territory in a simple, one-to-one way, but more and more the culture of a particular place is comprised of inputs from many other places. Many texts are now based not on the interests, concerns and culture of particular nations, but on those of a variety of nations or of sections of people who share a transnational culture.

My main concern here, given the topic of the book, is the first of these aspects of internationalisation, but this can never be fully separated in analysis from the other two.

TELEVISION AND GEOCULTURAL MARKETS

As we saw in Chapter 2, the USA dominated international flows of television programming in the 1960s. Television became closely linked to concerns about its popular culture more generally. For some (Schiller, 1969) television was the latest and most significant development in the USA's cultural domination. This view was based on programme exports, but also on direct investment by US companies in overseas broadcasters, especially in Latin America (see Wells, 1972). Other commentators were concerned about the *quality* of the USA's television products, culminating in 1980s debates about whether or not the dominance of its programmes and formats would lead to 'wall-to-wall *Dallas*'.

Ironically, in the period when the cultural imperialism thesis was at its peak, the domination by the USA's television was in decline. Already, well before Jeremy Tunstall's groundbreaking analysis of media and cultural imperialism was first published in 1977 (Tunstall, 1994), most prime-time programming, including the most popular programmes, was local in origin. Prime-time television, Tunstall pointed out, tended to be produced either within the home nation or by a larger nation with similar linguistic and cultural traditions. Programming from the USA was primarily used to fill less popular times more cheaply than could be done using home-grown programmes. Direct investment by US television companies in Latin America was short-lived and these firms had withdrawn from such ventures by the mid-1970s – in many cases as a result of protectionist

measures introduced by national governments, such as Brazil. These measures should not be thought of as an enlightened resistance to US cultural imperialism, however – they were often introduced by military, authoritarian governments.

The 1970s and early 1980s saw further declines in television imports. According to Tapio Varis and Kaarle Nordenstreng (1985), in the television stations of the 'Third World' (as developing countries were known at the time), the proportion of foreign programmes broadcast declined on average by over 15 per cent between 1973 and1983. In the six largest Latin American countries, imports fell by 29 per cent between 1972 and 1986 (Berwanger, 1998: 192).

In spite of its striking title – *The Media Are American* – Tunstall's book suggested that it was too simplistic to see the international cultural industries, including television, as dominated by the USA (or the USA plus the UK). A later attempt to move beyond this 'concentric perspective', with its vision of '"the West" at the centre dominating the peripheral "third world" with an outward flow of cultural products' was made by the Australian writers, John Sinclair, Elizabeth Jacka and Stuart Cunningham (1996: 5). Sinclair et al. introduced the useful concept of 'geolinguistic regions' (1996: 11–14) to capture the increasing complexity of international television flows. Geolinguistic regions are groups of countries defined by common cultural, linguistic and historical connections. They might be actual geographical areas, where countries with these kinds of connections are actually next to each other, but, in many cases, these relationships rely on cultural rather than physical proximity. This is because they are forged out of long histories of transnational contact, including especially the legacy of colonial empires. It is possible, for example, to see the USA, Canada, the UK, Ireland, Australia and New Zealand as forming one such geolinguistic region, based on the use of English as a first language, and primarily white, Christian cultural traditions. Another potential region comprises Spain, Spanish-speaking Latin America, plus Spanish-speaking parts of the former Spanish empire and the massive Spanish-speaking population of the USA. Some might include Portugal, Brazil and the former Portuguese colonies in Africa and Asia in the same 'region' within a broader set of countries influenced by Hispanic languages and cultures.

I prefer the modification *geocultural markets*. 'Geocultural' is better than 'geolinguistic' because language is only one of a number of potential cultural connections between places and peoples. The countries of Eastern Europe and the European nations of the former USSR, for example, form a particular geocultural region, with shared histories of Soviet oppression and longer Christian traditions, but there is no shared language. 'Markets' is a better term than 'regions' because such cultural connections can work across enormous distances that transcend geographical proximity. It is important to note that a particular country can belong to more than one geocultural market because nearly all countries contain different groups of people with varying cultural identifications. More significantly still – and this is an insight of cultural studies approaches – the same people can have multiple cultural identifications. A woman of Indian origin living in the UK might feel part of an anglophone geocultural market, familiar with a wide range of TV programming from the UK, the USA and Australia. She may well also feel affiliated to a different geocultural

market, comprising India itself, plus substantial Indian migrant communities in the Arabian Gulf and elsewhere. Her affiliations may shift according to her different experiences in life, who she is with and even her personal mood.

These different geocultural markets have other centres of production besides Hollywood. Sinclair et al. (1996: 8) draw attention to some of these: 'Mexico and Brazil for Latin America, Hong Kong and Taiwan for the Chinese-speaking populations of Asia, Egypt for the Arab world, and India for the Indian populations of Africa and Asia'. They note that these regional television production centres were built on previously existing centres of film production and I will discuss some of these later in this chapter.

The new complexity of global television culture, however, is more than a matter of recognising that trade takes place *within* these geocultural markets. Sinclair et al. (1996: 5) are clear that these regions are not bounded, discrete spaces – in the new era of television culture, 'global, regional, national and even local circuits of programme exchange, overlap and interact in a multifaceted way'. To make this more concrete and delineate further this complex, polycentric picture of global television, I will deal with two important but ambivalent examples of recent developments and the questions these provoke.

- The circulation of non-USA programming in Europe, the USA itself and other geocultural markets – the most commented on case of this being the export of Latin American *telenovelas* (a type of drama serial). To what extent does this represent the rest of the world exporting its culture back to the West? Can this be understood as a breakdown of the cultural imperialism model and a move towards a more equitable model of transnational cultural flows?
- The breakdown of the system whereby programmes were transmitted nationally and schedules comprised a mixture of domestically produced programming, plus foreign imports (often mainly from the USA), and the associated rise of systems of satellite transmission where channels are received across national borders. To what extent can this be seen as a move away from a system of national broadcasting and towards a truly international audiovisual system? Crucially, to what extent can such shifts be understood as progress towards systems of greater choice and diversity?

REVERSING CULTURAL FLOWS? THE CASE OF LATIN AMERICAN TELEVISION

Latin American television is often invoked in order to question the simplistic notion that non-Euro-American television is dominated by Hollywood television and US conglomerates. It has also been used to suggest a model for how non-core television-producing countries might gain more presence in the international television market.[3]

3 See, for example, Mattelart and Mattelart (1990: 2), citing Italian policy research of the 1980s.

There has been a developed television industry across most of Latin America, particularly in Mexico and Brazil, since the late 1960s. A significant process in the 1980s and 1990s was that both these countries, and other Latin American countries such as Venezuela, became exporters of considerable amounts of programming to other countries, not just within the Hispanic geocultural market, but also beyond, to many other countries, such as the USA and the UK – countries usually considered to be at the geographical core of the cultural industries.

The international presence of the Mexican and Brazilian television industries is founded on the domestic strength of two mighty corporations – Televisa and Globo. In Mexico in the mid-1990s, Televisa was taking about 80 per cent of the domestic television market share, which increased at peak times. In Brazil during the same period, Globo had a market share of about 76 per cent, in a huge market of 160 million people where television dominated advertising spending (Sinclair, 1996: 35). Televisa has also drawn on a formidable overseas market in Spanish-speaking Latin America, Hispanic USA and Spain. Globo has been able to rely less on linguistic ties overseas, but it founded its export success on initial success in Portugal in the late 1970s.

Telenovelas have been central to debates about Latin American television. The term telenovela is sometimes translated to mean 'Latin soap', but the term 'soap', complex enough in anglophone contexts, is misleading – even though early telenovelas were sponsored by UK and US detergent companies. Whereas British prime-time soaps and day-time soaps in the USA run, in principle, forever and have no overall narrative resolution, telenovelas move towards closure over a large number of episodes. The prime-time soaps in the UK and USA take the form of a series of about 20 programmes, transmitted in 'seasons' over a number of years. Telenovelas do not run in series, but form one continuous serial, often of about 100 episodes. Unlike prime-time soaps in the USA, they are shown five to six times a week. As many as 15 telenovelas might be shown by different channels on the same day, often in blocks, in the afternoon and evening. They share with soaps in the UK and USA a concern with family relationships and invite strong emotional responses. There is often much more emphasis on polarised moral forces than in UK soaps,[4] but there is a strong 'quality aesthetic' apparent in some telenovelas, especially those from Brazil (Sinclair, 1996: 50). Some of the most important telenovelas have been literary adaptations. Whereas soaps have traditionally been thought of as debased, trivial entertainment in the anglophone world, telenovelas are often more prestigious in Latin America. However, as in the UK and USA, the fact that the programmes are primarily enjoyed by women and less educated audiences (Vink, 1988: 221–2) is often implicitly, and sometimes explicitly, interpreted as a sign of their supposed lack of worth.[5] Nevertheless, telenovelas are the central

4 This emphasis is sometimes called 'melodramatic'. Jostein Gripsrud (1995: 242–8) has shown, in his brilliant study of the prime-time soap *Dynasty*, how complex this notion of melodrama is and how the term is sometimes misapplied in the study of soap opera.

5 As in the UK, figures suggest that audiences are, in fact, comprised of an even balance of women and men (Vink, 1988: 247).

television genre in Latin America, in a way that has no parallel in Australia, Canada, the UK or USA. Although introduced to television in the early 1960s, they draw on a much longer history of melodramatic serials in Latin America, in popular fiction, film and radio (Mattelart and Mattelart, 1990). Telenovelas, then, must be understood as being culturally specific.

It follows from this that the success of Latin American television outside Latin America in the 1980s and 1990s represented, at least to some degree, a new international presence for Latin American culture. One of the reasons for the international spread of the telenovela was economic. Mattelart and Mattelart (1990: 2) showed, for example, that the cost to Italian television of importing a telenovela in the late 1980s was between US$3000 and US$6000 per 40-minute episode, whereas dramas from the USA would cost Italian TV buyers between US$6000 and US$48000 per half hour. As the desire for more content boomed with television marketisation and channel proliferation in the 1980s and 1990s, Globo's exports increased healthily. Various novelas became television events in the countries to which they were exported, such as Globo's *A Escrava Isaura* in China, Czechoslovakia and Cuba, *Gabriela* in Angola, *The Rich Also Cry* in Russia (Paterson, 1998: 62).

How can the widespread success of telenovelas be explained? Cost cannot be the only reason because many other programmes would be as cheap, so there must be cultural factors at work, too. Mattelart and Mattelart (1990: 144) speculate that such non-western programmes are increasingly popular in the West because they are exotic and this interest represents our apparent 'responses to the tired logos of Western modernity' (1990: 152). They also claim that melodrama in the late twentieth century increasingly revealed its 'potential for universality' and argue that it serves as a kind of supergenre, which can be all things to all people, at least some of the time, incorporating suspense, comedy, grief, action and so on (and this argument is echoed by Liebes and Katz, 1993, when discussing the success of *Dallas*).

However, it is important not to exaggerate the significance of telenovelas. Telenovelas formed only 8 per cent of television hours produced by Televisa in the early 1990s (Sinclair, 1996: 49). A significant and often overlooked fact is that the news was a more popular form of programming in Brazil than telenovelas during the period when the latter were being widely discussed in academic and policy circles (see Vink, 1988: 11). Whereas 50 per cent of television sales in the USA come from overseas, in the mid-1990s Globo was gaining only 3 per cent of its revenues from abroad, even including Latin America. The figure for Televisa was 10 per cent, much of it from the sale of telenovelas and other genres to the USA market, with its large and increasing Spanish-speaking population (Sinclair, 1996: 49, 52).

Attention to telenovelas might help to correct the picture of a homogeneous world market dominated by the USA, though, and it suggests the possibility of more cultural exports from periphery to centre, or to other peripheries, *in the future*. All the same, economically speaking, telenovela exports are relatively insignificant and, culturally, they still form a small part of the television landscape, even in countries such as Russia where they have been very popular. In most countries, domestic programmes continue to attract higher ratings than do imports from the USA (Hoskins et al., 1997: 29). Most non-domestic

programming that is aired, however, is still that produced in the USA – it accounts for at least 75 per cent of all television programme exports (Hoskins et al., 1997: 29). So, it may be premature to speak of a new era of transnational television on the basis of the sporadic success of a few telenovelas.

In any case, we should be cautious about celebrating the existence of such Latin American corporations as a means of countering cultural imperialism. As Mattelart and Mattelart (1990) show, companies such as Globo and Televisa monopolise their domestic markets in a way that the CEOs of conglomerates in the USA can only dream of. Both companies rely on significant horizontal integration. Globo was built up by the Marinho family from its ownership of a leading daily newspaper and Televisa has significant press and radio interests. Globo has, at various points, owned record and video manufacturing and distribution, an electronics firm, an advertising company and major art galleries. Mattelart and Mattelart (1990: 42) cite *Variety* estimates from 1987 that an average telenovela helped to sell an average of 200,000 records in Brazil and up to 1 million records internationally. Both companies were strongly vertically integrated, too. Each produced 78 to 80 per cent of the programmes it aired. Virtually all Brazilian actors who were known names were under contract to Globo.

Portrayed in the West as examples of Latin American commercial vigour, Televisa and Globo were both founded on close links with repressive, authoritarian states. The military government paid for the satellite infrastructure that united the huge territories of Brazil into one television market and it was this unification of the television market that allowed Globo its dominance. In Mexico, private companies benefited from government expenditure on developing television infrastructure. Here, the relationship with the state was especially contradictory. Televisa was formed out of two commercial channels, in opposition to the Mexican government's newly established Channel 13. Yet, Televisa had close relationships with the party that ruled Mexico (PRI) from the 1910s to the year 2000. In both Mexico and Brazil, there was extremely weak government regulation, allowing significant cross-media ownership and massive commercialisation – in the 1980s and 1990s, Brazilian broadcasters were allowed to transmit 15 minutes of advertising per hour.

So, as we have seen, while the close study of Latin American television helps us to appreciate the complexities of the changing international television landscape and its products may be of great cultural interest, it would be wrong to see Latin American television as having offered a significant counter to the forms of cultural inequality towards which the cultural imperialism thesis, however simplistically, tried to direct attention. There is little real democratisation of international communication here. There is little evidence of significant transfer of programming from South to North, as opposed to the long-standing flows from North to South. The corporations that dominate Latin American television provide no significant organisational alternatives to dominant models of television available elsewhere. This suggests that, while globalisation theory might be better than the cultural imperialism thesis at registering the complexity of international cultural flows, issues concerning the interrelation of economic, political and cultural power remain pressing (see Box 8.2).

BOX 8.2 ASIAN TELEVISION ON THE RISE

Those following the globalisation approach have recently turned their attention from Latin America to Asia as a basis for criticising the simplifications of the cultural imperialism thesis. Here is the view of one writer who takes this approach (Keane, 2004: 13)

> Our findings may disappoint some readers in that they do not present another recital of how Western media overlays its values on acquiescent audiences in developing countries … We demonstrate the revitalisation of local content through the agency of formats. In addition, there is strong evidence within our findings that Western influence is waning in television markets in Asia as local productions … consign foreign programmes to the margins of schedules.

In this account, television formats (in the sense of ideas or concepts for programmes, which are sold as ideas or concepts – see Introduction) have come to replace serial drama as the basis for the rise of non-western television. Yet, for all the talk of globalisation and modernity in the interesting collection Keane is introducing (Moran and Keane, 2004), its case studies give a strong sense of Japanese and – to a lesser extent – Korean domination in the region, with cultural nationalism an important force for achieving this dominance. The main adversaries in this analysis seem to be not major corporations and their state allies but advocates of the cultural imperialism thesis, portrayed as so old-fashioned and narrow-minded that they prefer confirmation of Western domination to recognising the new vigour of Asian cultural industries.

The problem with this implicit celebration of Asian cultural capitalism is that it sidelines questions about what might constitute a rich and diverse media system in Asian countries and whether or not these newly developing format markets in Asia represent a move towards such a system.

Recent developments only confirm this view. Marketisation has developed apace – and this in a region where PSB was already extremely weak because of an understandable distrust of the state forged during a period of military authoritarianism sponsored by the USA. In the mid-1990s, the Mexican government allowed the entry of a new group – TV Azteca – into the Mexican market (Sinclair, 2004). This has led to a duopoly rather than a monopoly. The domination of Globo, meanwhile, has been challenged by a new force – the rise of religious channels in Brazil, both protestant evangelical and Roman Catholic. The erosion of its audience share led Globo to support deregulation of rules on foreign ownership as it began to search for suitable business partners (Straubhaar, 2004). It is hard to see these developments as significant progress.

TRANSNATIONAL TV TRANSMISSION AND RECEPTION: NEO-IMPERIALISM OR A NEW DIVERSITY?

The second major aspect of television internationalisation I want to examine here – in order to assess changes in the post -1980 period – is the increasing transmission of television channels across and beyond national borders.

The period since the 1980s has seen increasingly complex cross-cultural flows in television that cannot be reduced to the notion of cultural imperialism. The global spread of the video cassette recorder during the 1980s meant that diasporic populations could import films and television programmes from their countries of origin. Cable and satellite technologies, available in many countries from the early 1980s onwards, have made this practice of cross-border programme consumption even more widespread. Hamid Naficy (1993: 62), for example, writes about an independent station, Channel 18 (KSCI TV), which, at the time of his research, provided 'round-the-clock programming in some 16 languages, produced by various diasporas in the United States or imported from their home countries', including Arabic, Armenian, Cambodian, Mandarin, French, Tagalog/English, German, Hungarian, Hindi/English, Italian, Japanese, Hebrew, Korean, Russian and Vietnamese. Across many of the advanced industrial countries, such 'diasporic television' has boomed in recent years. It must not be assumed that these stations are necessarily addressing and fulfilling the cultural needs of the communities they address and there are many places outside the major metropolitan cities where such services are unavailable. Also, few people would watch these programmes if they were not from the specific diasporic population being addressed. Nevertheless, the availability of such 'peripheral' programming at the 'core' defies the simplifications of the cultural imperialism thesis.[6]

A number of studies have cast important light on these new forms of cross-border reception and some have argued that there are potentially progressive cultural consequences. Marie Gillespie (1995: 76), for example, argued that 'the juxtaposition of culturally diverse television programmes and films in Punjabi homes stimulates cross-cultural, contrastive analyses of media texts' within those homes (Gillespie, 1995: 76). This, Gillespie claimed, heightens awareness of cultural difference, intensifies the negotiation of cultural identities and leads to aspirations for cultural change. This suggests that producers from outside the 'core' areas of cultural production are increasingly able to reach audiences in that core.

The implications for international television of the development of cable and satellite go beyond such diasporic channels. Their presence means that, in certain regions, there is much greater transnational transmission. This is the case in Europe where British viewers of satellite television, for example, can watch German video channels, badly dubbed Polish pornography and many other delights. Does this

6 One of the most interesting aspects of Naficy's account is that he shows how Iranians, because they were an exile culture rather than a transnational one, were forced to produce their own programming rather than import it from their homeland.

represent a new diversity, an opening up of television systems to a more varied diet of television flavours or, as some EU policymakers have hoped (see Collins, 1998), a contribution to the ideal of a pan-European identity? Probably neither and for the same reason: the sheer linguistic diversity of the continent. As English spreads as a common language, this may alter, but further linguistic homogenisation hardly seems desirable. There is also considerable transnational broadcasting in other regions, including areas that share a common language (see Box 8.3).

BOX 8.3 ARABIC TELEVISION AND AL-JAZEERA

Like their European counterparts, Arab governments hoped that satellite broadcasting would contribute to fostering a regional identity. The first major developments in the transformation of Arabic television from a national system to a transnational one took place in the early 1990s.[7] Egypt, though not the first Arabic country to introduce television, had dominated programme production and trade from the early 1960s onwards, partly because of its highly developed film industry and large numbers of trained technical and creative personnel. Egypt introduced its own satellite channel – SpaceNet – in 1991 and it had a huge impact, providing alternative coverage of the Gulf War during that year.

SpaceNet was closely followed by MBC, a privately owned Saudi station, and the Kuwaiti Space Channel. Soon after, national terrestrial channels were made available on satellite and many of the wealthier countries of the Arab world vied to put their own national satellite stations into operation as a means of gaining national prestige. The channels were also aimed at reaching the 5 million people of Arabic origin living in Europe and the 2 million living in the USA.

Again, it is important not to portray such developments as an indication of a brave new world of diverse and imaginative television as Arab-sourced television remains under very strict state controls and more recent private stations, such as MBC and Orbit, are often run by the wealthy elite, including the Saudi royal family or businessmen close to them (Boyd, 1998). (Cultural imperialism accounts tended to neglect such *intra*-national power dynamics.)

It may be that the Arabic channel Al-Jazeera represents a positive move in this respect. Certainly, it has brought a new visibility to Arabic media in the rest of the world, though often the reception has been hostile. Al-Jazeera is funded by the Emir of Qatar, but it has been granted an unusual and, in the Arabic context, impressive degree of independence. Its channels, including its news channel, are relayed via cable and satellite TV in many Arabic countries and to diasporic audiences (it began English-language service programming in 2005). Lately, there have been signs that the state has re-exerted control over management and journalistic practice (Sakr, 2005), but its contribution to transnational television is, on balance, surely welcome.

7 In fact, Arab countries had teamed up to fund their own satellite in 1976 (Amin, 1996: 106–8). Although this made satellite programming possible, the satellite remained massively underused for 15 years.

Transnational satellite television has, needless to say, been interpreted as a form of cultural imperialism. It is true that new technologies meant that Western – in particular, USA-based – channels, such as MTV, developed initially to cater for the USA's domestic market, were increasingly available for consumption overseas via satellite cable and direct broadcast satellite. For some, this was a challenge to cultural protectionism, in that audiences could choose these channels over domestic channels, but, as Kevin Robins (1997) showed, channels such as MTV and CNN found in the 1990s that they had to adapt their programming to local audiences. New hybrids were produced, often US-owned or jointly owned with local businesses or states, transmitting a mixture of locally sourced news or popular culture.

Such strategies of local adaptation do not mean that the expansion of the mega-corporations into global television networks is without consequence. Rupert Murdoch's News Corporation purchased the struggling Asian satellite service STAR TV in 1993 and, within a few years, it had made significant inroads into television markets in a number of countries, including China (PRC), India and Taiwan. It reaches 300 million people with a variety of country-specific packages. All the mega-corporations are keen to gain access to the huge markets of Asia, but News Corporation has been particularly assiduous in courting the Chinese state, suspending the BBC's World Service from STAR in 1994 and making sure that his publishing company, HarperCollins, did not publish the memoirs of former Hong Kong governor Chris Patten – one of the PRC's main international political bogeymen. STAR TV is a distribution network for entertainment. Rather than a vehicle for the thoughts of Chairman Rupert, it transmits programmes that offer a similar mix to that familiar in the West. Individualist and consumerist values are emphasised, but so also are other values that do not straightforwardly support capitalist accumulation, including stories emphasising the virtues of family and community loyalty (see the discussion of Ong, 1999, later in this chapter). Would this system take a substantially different form were it owned by Asian business people rather than by Rupert Murdoch and his other chief shareholders? The likely answer is no, though News Corporation might have more resources to offer a convincing and seductive version of such a mix.

Once again, we return to the issues discussed in the previous chapters. The negative impact of the international growth of cultural industry corporations such as STAR TV is on the general field of cultural production. This growth offers these corporations yet more power to influence government strategy. It makes alternative forms of cultural production and programming more difficult to imagine and achieve in more places around the world. And it continues to direct huge amounts of money into already wealthy hands.

THE INTERNATIONAL FILM INDUSTRY: HOLLYWOOD POWER

The film industry offers a parallel but different perspective on these issues. Here, the domination of the USA over international production and distribution has

been much greater than in television (for reasons discussed at the beginning of this chapter).

To what extent has Hollywood dominated the international market since the late 1970s?[8]

- Garnham (1990: 176) estimated that the USA's majors and mini-majors accounted for over 70 per cent of non-socialist world gross film rentals from the cinema in 1979.
- Across the EU, Hollywood's share of box office receipts rose from 60.2 per cent in 1984 to 71.7 per cent in 1991 (Held et al., 1999: 356).
- Figures for US films' market share vary significantly from country to country. In the UK, they took 93 per cent of the 1991 market, while in France the figure was 58 per cent – the lowest in any major European economy (Wasko, 1994: 222).
- Even in France, though, indigenous productions' share of box office receipts had plummeted to 26 per cent by 1998 (*Variety*, 25 January 1999).

This further wave of internationalisation on the part of Hollywood can be linked to the spiralling production and marketing costs discussed in Chapter 7 (this, for example, is the view taken by the various executives quoted by Wasko, 1994: 223). Even as the EU and national governments have established programmes to support film production, Europe has slipped further and further behind Hollywood. European films are particularly bad at making money outside their own territories. At the end of the 1990s, German and Spanish films made less than 0.5 per cent of total box office receipts in any major European country other than their own (*Screen Digest*, June 2000: 189). Such failures are often attributed to language differences, but more significant is a lack of marketing and distribution clout – after all, countries such as India and the USA perform well in overseas markets where different languages are primarily used.

Some recent figures on the share of box office receipts taken by local films are provided in Table 8.1. Two issues should be noted. One is that box office receipts are less and less important as other ways of making money from films (DVD rentals and sales, rights sales and so on) become more significant. The second is that the year reported on was a good one for local films relative to recent years. Nevertheless, note how few national film industries have a strong domestic base.

Nevertheless, such long-term inequalities should not obscure the fact that many feature films are made outside the USA. There have been significant film industries in many non-Western countries since at least the 1920s. The vast majority of the films made around the world are not North American. As can be seen from Table 8.2, eight other countries besides the USA produced more than

8 Reliable data are difficult to come by because of, among other reasons, the reluctance of the USA's trade association, the Motion Picture Association of America, to release full figures (see Garnham, 1990: 171, 174; Wasko, 1994: 293). However, as national governments have become more concerned about the cultural industries, figures have become more widely available, particularly for Europe.

Table 8.1 Domestic films' share of box office receipts, 2004

Country	Percentage of box office receipts*
USA	93.9
India	92.5
China	55.0
South Korea	54.1
Hong Kong	40.2
France	38.4
Japan	31.8

* The figures refer to the percentage share of box office receipts in the country named attributable to domestic films
Source: Screen digest. April 2005. p. 108

100 films per year on average over the period 1989–1998. Hollywood takes a high proportion of the global box office receipts, but many national cinema industries have significant markets and some have significant international ones. The Indian and Hong Kong film industries are sometimes cited as examples of a challenge to cultural imperialism. Do they represent an alternative to Hollywood?

OTHER INDUSTRIES, OTHER TEXTS: INDIA AND HONG KONG

Since independence, India has always produced more films than the USA, though the gap has closed since the 1970s as the USA's film production has greatly increased. India still produces more films per year than any other country in the world, averaging 787 productions per year in the period 1989 to 1998 compared with the USA's average of 591 productions during the same period (see Table 8.2). The term 'Bollywood' is often used to describe the Indian film industry as a whole and the 'B' in Bollywood comes from Bombay, where the best-known, Hindi-language, 'all-India' films are made, many of which are distributed internationally.[9] Most films produced in India are not exported, but are made for local markets. This is partly because of generous support for film production on the part of regional state governments.

India's exports of film are important economically and culturally. In 1988, the main markets were the Arabian Gulf, USSR and Indonesia, but significant importers also included the UK, Morocco and Latin American countries (Pendakur, 1990). Via video and new television technologies, the demand for Hindi-language films among the millions of Indian subjects living abroad has boomed. Indian film exports were worth about US$10 million in 1989, but this had climbed to more than US$100 million by 1999. This is a significant source

9 Though Pendakur (1990) notes that only about 20 per cent of Indian films are made in Bombay.

Table 8.2 Most prolific feature film-producing nations

Country	Average number of feature films produced per year, 1989–1998	Average investment per production in US$ million in 1998
India	787	0.08
USA	591	14.00
Japan	255	3.57
Hong Kong	169	0.58
Philippines	160	figure not provided
France	148	5.26
China (PRC)	127	0.42
Russian Fed	124	figure not provided
Italy	105	3.93
Thailand	73	0.15
South Korea	73	0.72
UK	67	8.25

Source: Screen Digest, June 1999: 130

of foreign income for a developing country and the Indian film industry was valued at US$5.5 billion globally by the end of the 1990s.

Hollywood, meanwhile, has had surprisingly little impact on the Indian domestic film market. Up until the 1990s, this was for reasons of national protectionism: India did not allow foreign films to be dubbed into Hindi. However, even when this ban was lifted during the cultural marketisation of the early 1990s (see Chapter 4), Hollywood films were only sporadically successful in India. This was partly because Indian films are markedly different from Hollywood films in their aesthetic. Their plots and narrative forms owe much to long traditions of theatre and religious epic (Thomas, 1985). They are generally about three hours in length, rather than the 90–100 minutes average length characteristic of Hollywood films. The classic Hollywood narrative works according to realist conventions, even where it deals with fantasy, whereas the emphasis in Indian films is on emotion and spectacle rather than tight narrative (Thomas, 1985). A certain kind of verisimilitude is expected, concerning ideal family behaviour, but, particularly in the song sequences, which are a fundamental feature of Indian cinema, continuities of time and place (nearly always respected in the Hollywood musical) can be subordinated to mood and spectacle. Whether or not the distinctive textual features of Indian cinema can maintain a cultural barrier around the Indian film industry remains to be seen.

Another significant film production centre has been Hong Kong. Hong Kong is often associated with the kung fu films popular throughout much of the world in the 1970s[10] and violent action films, but, as Stephen Teo (2000: 166)

10 The kung fu genre was not of specifically Hong Kong origin, although films made there were the most successful internationally. Japan, South Korea, Thailand, Indonesia, Taiwan and the Philippines all produced kung fu films as well (Lent, 1990: 5).

points out, it had been a significant film centre throughout the 1950s and much of the 1960s. Film production peaked at 311 per year in 1956–1957, when musical melodramas and swordplay-based historical epics were dominant (Lent, 1990). In the late 1960s, Cantonese cinema fell from fashion and Mandarin-language production became dominant, serving the Mandarin Chinese diaspora throughout East Asia. In the 1970s, there was a huge growth in domestic audiences as Hong Kong's economy boomed. Venture capitalists moved into the industry, recognising the potential for profit. Cantonese cinema became central to the colony's cultural industries. Local Cantonese-language television provided a new source of Cantonese-speaking stars, as did the Hong Kong-based Canto-pop music industry. Local television also provided a new wave of 'technically proficient, socially conscious, and aesthetically polycultural' directors (Stokes and Hoover, 1999: 24).[11]

Aihwa Ong (1999: 161–7) has written of how the massive expansion in the numbers of middle-class consumers throughout Asia has vastly increased the market for Chinese cultural products. Ong stresses the fact that this Chinese diasporic public, spread over the USA, South China, Hong Kong, Taiwan, Malaysia, Singapore and elsewhere in South East Asia, is connected not only by news media but also, just as importantly, by TV, films, magazines and so on. New forms of transnational Chinese identity are, she claims, being forged by media products, including popular kung fu novels and satellite television, but, in particular, the kung fu and gangster movies that form the main output of the Hong Kong industry. This is because these films, Ong (p. 162) argues, 'are a medium for exploring reified Chinese values ... in conditions of displacement and upheaval under capitalism'. They are 'all about brotherhoods, hierarchised allegiances and kinship loyalty' and the films demonstrate the vulnerability and importance of these values in a way that Ong believes resonates with audiences.

Nevertheless, Ong is careful to draw attention to the lingering influence of the USA's cultural industry corporations and cultural forms, including most notably STAR TV, which was beaming programmes to 38 countries at the time of Ong's study (Ong, 1999: 167). India and Hong Kong may be examples of significant regional production powerhouses, with their own distinctive modes of address, but European and especially North American corporations and cultural products remain enormously powerful. This is apparent in the fact that, although Hollywood films and some of the USA's television programmes nearly always have some presence in overseas markets, there has been very little presence of Indian and Hong Kong films and TV in the USA and practically none outside the Indian and Chinese-language diaspora. (See Box 8.4 for a discussion of some recent exceptions that prove the rule)

11 Like Hollywood, Hong Kong is as much a place for TV production as for film. See Curtin (2003a) for a discussion of Hong Kong, Hollywood and Chicago as 'media capitals'.

BOX 8.4 OPENING UP WORLD CINEMA?

At various times over the last few decades, the films of particular national industries have achieved international recognition. Examples include the success of Iranian cinema in the 1990s and South Korean cinema in the 2000s. To what extent do these events represent an opening up of international audiences to new sources? Some good films have come from these places, but their impact in Europe and North America has largely been confined to the art house circuit and the 'foreign' or 'world cinema' sections of rental outlets.

For some, a more significant development has been the much wider success of films such as *Crouching Tiger, Hidden Dragon* (2000) and *Hero* (2002), which have reached mainstream cinemas and DVD racks. These films represent a new strategy on the part of Hollywood studios – co-production with non-USA production companies. Some critical commentators, however, (for example, Zhao and Schiller, 2001) have seen such ventures as parasitical on cultural difference rather than representing a genuine engagement with it (see below for similar debates in relation to world music).

The Hollywood studios continue to dominate the USA's vast domestic market. Foreign films took less than 3 per cent of the USA's box office receipts in the late 1990s ('Culture Wars', *The Economist*, 12 September 1998). This supposed aversion to foreign films is not something natural to audiences in the USA but a product of particular sociocultural and economic circumstances, including deeply held cultural beliefs about the superiority of the USA's popular culture over other forms (see Chapter 10). It goes without saying that Hollywood has an interest in cultivating such beliefs.

From an already dominant position, the USA's film industry increased its international hegemony in the 1990s. Its share of global receipts increased from 38 per cent in 1995 to 41 per cent in 1999 (*Screen Digest*, September 1999: 122). While some indigenous film industries in Europe, Latin America and Asia expanded, others collapsed. This was the case in Hong Kong, for example, where film production declined drastically in the mid-1990s and market share was rapidly lost to blockbusters from the USA (notably *Titanic*).

We need to hold on to the complexity of cultural production and circulation here, though. Curtin (2003b) shows that this collapse was not entirely due to the intervention of the Hollywood studios. Rather, they exploited local developments, including overproduction of poor-quality films in Hong Kong, the arrival of new technologies (especially cable and DVD) and, in particular, the collapse of the release window system in the vital market of Taiwan: Chinese films were being shown on television so rapidly after their release that cinema attendance for them collapsed. It could be argued that Hollywood had a role to play in bringing about these conditions, but it was a highly indirect one.

In most countries, local films – films involving some domestic financial or production input – experienced a decline in market share during the 1990s (*Screen Digest*, September 1999: 122). In part, this was because of an increasingly globalised film market, where films from more countries circulated to other countries, including regional production 'capitals' such as Bombay and Hong Kong, but it was also because of an even greater dominance of USA's product. Only in 1997 did Hollywood overtake the market share of local films in Hong Kong. In 1998, Hong Kong movies took more than 45 per cent of Hong Kong domestic box office receipts – one of the highest local shares in the world – but this represented a decline of more than 30 per cent since 1990 (*Screen Digest*, July 1999: 173). In India, early predictions of a Hollywood invasion, after the USA's films entered the market in 1992, turned out to be wrong or at least premature. However, with increasing promotional budgets and the introduction of multiplex cinemas to India, the USA increased its share of Indian box office receipts steadily in the 1990s and early 2000s. Sony/Columbia's *Spiderman* films were particularly popular, as of course was Fox's *Titanic*. By 2004, the USA's market share was 8 per cent, but this slipped back to 5 per cent in 2005 (Anjum, 2005).

What, though, does all this mean for cultural creativity and experience? Portraying the Indian and Hong Kong film industries as resistant alternatives to Hollywood hegemony is tricky. It is worth remembering that, in spite of the quick dismissals of some political economy writers, there is no simple equation between Hollywood and cultural homogeneity. Hollywood distributes a range of genres and texts – partly because of the vast and diverse audience it serves in its domestic market. Hollywood budgets may represent an appalling squandering of resources, and they may reflect disturbing inequalities of income. But the tiny budgets of Hong Kong films mean that quality is sometimes elusive. There is significant textual repetition within the products of other film industries, including those of India and Hong Kong. Stokes and Hoover (1999) write, for example, about the very short production times and lack of adequate postproduction that characterise Hong Kong cinema. There are often poor working conditions for actors and poor technical finish to films. Apparently, organised crime is closely involved in the industry. So, as with Latin American television, we should be circumspect about portraying national cinema industries in Asia as an *enrichment* of film culture.

Nevertheless, such local cinemas should not be dismissed on aesthetic grounds. Although Stokes and Hoover are generally writing in praise of Hong Kong cinema, it may be that they are bringing 'Western' aesthetic criteria to bear on the film industry they analyse. One leading film scholar, David Bordwell, has used Hong Kong cinema to argue that mass-produced films can achieve great aesthetic merit. His book (2000: 2) amounts to something of a celebration of Hong Kong cinema:

Hong Kong films can be sentimental, joyous, rip-roaring, silly, bloody and bizarre. Their audacity, their slickness and their unabashed appeal to emotion have won them audiences throughout the world … These outrageous entertainments harbour remarkable inventiveness and careful craftsmanship. They are Hong Kong's most important contribution to global culture. The best of them are not only crowd-pleasing but also richly and delightfully artful.

If Bordwell is right, this suggests that the survival and development of non-USA film industries can contribute in important ways to international aesthetic diversity and quality.

CULTURAL IMPERIALISM AND POPULAR MUSIC

Debates about the cultural and aesthetic consequences of internationalisation and globalisation can be pursued further by examining the international recording industry. Popular music is a particularly testing arena for the cultural imperialism thesis and some of the most effective critiques of the cultural imperialism thesis have come from popular music studies (see, for example, Laing, 1986; Goodwin and Gore, 1990; Garofalo, 1993). The cultural imperialism thesis was felt to be inadequate to understanding international musical flows in the late twentieth century for a number of reasons.

AUTHENTICITY VERSUS HYBRIDITY

Some ethnomusicologists (such as Lomax, 1978/1968) echoed the cultural imperialism thesis in warning of a 'cultural grey-out' as Western popular music affected indigenous cultures. Later writers, many influenced by cultural studies, stressed the value of mixing, syncretism and 'hybridity' in popular music. A number of studies have shown how various local popular musics are the result of complex reinterpretations of imported styles and technologies (Hatch, 1989, on Indonesia; and Waterman, 1990, on Nigeria). Often, the imported music is itself the product of other groups marginalised within the world economy, such as the Hawaiian guitar-playing that influenced the Nigerian palmwine musicians in Waterman's account. Indeed, much of the popular music that traverses the globe is the result of the creativity of the African diaspora and very often of African-Americans. Transnational corporations may control the circulation of this music, but it would be wrong to identify it culturally as simply the product of a dominant Western culture.

WESTERN CULTURAL PRODUCTS CAN BE INTERPRETED IN DIFFERENT WAYS

The internationalisation of rock and roll in the 1960s has often been given as an example of how some 'Western' popular music has encouraged people to question dominant forms of power in the societies in which they live. Laing (1986: 338), for example, stressed how rock and roll was 'an instance of the use of foreign music by a generation as a means to distance themselves from a parental "national" culture' and Wicke (1990) wrote about the positive dimensions of this use in post-war Stalinist Eastern Europe.

Against this, proponents of the cultural imperialism thesis stress that much of the most prestigious popular music of the world is sung in English. While local

musicians might eventually synthesise distinctive versions of imported music such as rap (see Mitchell, 2001), these local variants are often denigrated by local audiences, as well as consumers in the more lucrative anglophone markets. Arguably, too, the emphasis on English in many genres excludes non-English-speaking audiences from full identification and engagement with the global popular music on offer.

Critics of the cultural imperialism thesis have claimed, however, that lyrics are relatively unimportant in many key pop genres (for example, Frith, 1991). More significantly, perhaps, Chinese- and Spanish-language shares of global sales have now been increasing for many years. As with film and television, it is possible to speak of geocultural markets with their own centres of production. British and American acts achieve more globally widespread success than acts from any other country. They particularly dominate anglophone countries and, to some extent, Europe. Japan has continued to import styles and records from the UK, USA, Brazil and elsewhere. Taiwan dominates production for the Mandarin markets of South East Asia. What is striking about music, compared with film and television, however, is how many centres there are, overlapping and competing with Anglo-American domination. Thus, Zairean musicians and companies are a strong presence in Central and West Africa. Tiny Cape Verde's recording studios are used by musicians from across much of West Africa. Brazilian music has been influential and widely sold throughout much of Latin America, but Cuba, Puerto Rico, Argentina and Colombia have also exerted strong influences throughout the continent at different times and in different ways. This multicentric aspect of popular music production and circulation may derive from its significantly lower costs of production when compared with film and television.

SPREAD OF OWNERSHIP

In the 1970s, the dominant transnational companies were mainly from the USA, apart from Philips/PolyGram. In the 1980s, Japanese companies such as Sony and Matsushita entered the fray, along with German publishing giant Bertelsmann.[12] In studies of the music industry, some claimed that the spread of ownership of the dominant corporations meant that it was no longer possible to talk of an imperial centre imposing its popular music on the 'periphery' (see, for example, Frith, 1991: 267, and Garofalo, 1993: 22, 27). On the other hand, this may simply entail a reconfiguration of the notion of the centre, rather than its eclipse. Again, cultural imperialism theory was at fault in placing too much emphasis on the geographical location of the major corporations rather than on the practices associated with these corporations. However, there are still nodal points in the musical world from where it is much easier to gain access to

12 At the time of writing, four companies take more than 80 per cent of global recorded music revenues: Warner Music Group (no longer owned by Time Warner), Universal Music Group (still owned by Vivendi – it was excluded from the GE/NBC deal), EMI; and Sony-BMG (Sony and Bertelsmann merged their recorded music groups in 2003).

international distribution than it is from other places: Los Angeles, New York, London, Paris and Hong Kong are among them. Musicians shift cities and even continents in order to gain access to the gigging circuits, recording studios and informal knowledge networks that allow them to achieve success.

Popular music, then, provides some evidence against the cultural imperialism thesis. Even if we should not talk in such functionalist terms of the conscious imposition of one culture on another, though, the logic of the global market means that access to audiences and committed publicity and promotion still seems to be extremely unequal for musicians and this inequality is geographical and nationally differentiated. There are also, of course, significant inequalities in what is available to different sets of audiences. This may mean that it is possible to hold on to a modified version of the cultural imperialism thesis. The continuing currency of issues that the term 'globalisation' does not always seem adequate to address can be indicated by reference to debates surrounding two controversial categories: 'Euro-pop' and 'world music'.

With rare exceptions, continental European popular musicians have often been held in contempt by British and American audiences. 'Euro-pop' was a scathing term for the pidgin English and perceived lack of authentic musicianship among a generation of 1970s and 1980s European acts. Laing (1992: 139) concluded a survey of national and transnational trends in European popular music by speculating that the next U2 might come from Wroclaw or Bratislava. There have been few signs of the emergence of such acts, however. In the history of European acts on the global scene, only Abba has even come close to being at the centre of pop myth and even their significance has, since the 1970s, been primarily based on a kitsch aesthetic. Indeed, the mid-1990s saw the reestablishment of London as the European centre for the most fashionable pop sounds, whether in dance music or indie/alternative pop/rock. In the 2000s, European pop of many kinds remains an object of haughty derision for many music fans. While exceptions are increasingly made for auteurs – whether dead ones like Serge Gainsbourg or working artists such as Air – the power centres are not shifting as quickly as some critics of cultural imperialism have predicted.

The term 'world music' (in the USA 'world beat' has sometimes been preferred) was adopted by a number of recording and music press entrepreneurs to allow non-Western popular musics to be promoted more adequately in the UK. Without doubt, some musicians from outside the Anglo-American global core have achieved international success and recognition. Notable examples include Nusrat Fateh Ali Khan (from Pakistan) and Amadou and Mariam (from Mali). The Buena Vista Social Club phenomenon brought mid-century Cuban big-band sound to an international audience. However, the impact of such musicians has been limited. They are enjoyed by a rather older, middle-class audience. They hardly register as popular, either in terms of total sales or in terms of their centrality for global popular culture. In addition, such musicians are often the subject of discourses that see their music as valuable only to the extent that it conforms to certain Western notions of authenticity and tradition (see Feld, 1994, for a superb examination of such discourses). So, the notion of world music sometimes serves as an all-embracing category for that which is not perceived as Western pop and this can work to exclude non-Western musicians from global pop markets by defining

them as exotic.[13] Goodwin and Gore (1990) once argued that the existence of world music as a genre can be seen as the product of the effects of cultural imperialism rather than a significant counter to them. However, I have come to feel that this is too polarised a view. It is inevitably linked to international inequality and provides some sort of corrective, but only a limited and problematic one.

The situation of continental European and non-Western musicians in the international recording industry suggests, then, that even if the cultural imperialism model has conceptual flaws, as indicated throughout this chapter, it draws attention to problems that continue to exist in the world of popular music – in particular, systematic global inequalities in cultural prestige and economic profit. Much the same can be said of the television and film industries. Producers from outside the 'core' countries still have only limited access to global networks of cultural production and consumption. The USA's cultural industries are still remarkably dominant. Countries outside a small core represent only a tiny proportion of global cultural trade; Oceania and Africa have a combined share of less than 1 per cent (UNESCO, 2005 – though this report relies on custom statistics). In this respect, there has been significant continuity.

Nevertheless, we should not underestimate the very real changes in the extent and complexity of international cultural flows. The internationalisation of the cultural industries over the last 30 years has, as suggested in Chapter 3, been driven by the need, on the part of 'Western' companies of all kinds, to find new markets for labour and for their products. They internationalised initially largely in order to counteract the effects of the Long Downturn. However, the big US/European/ Japanese corporations do not entirely dominate global production. There are other important flows, too. We can see a growing complexity in the social relations of cultural production on an international scale – as new industries emerge, old industries grow and new technologies are introduced on terms that allow for new relations between distant places. Globalisation theory has attempted to register this, but failed to capture the agency of large, profit-making corporations in affecting, but not completely determining, the new cultural world order. This theory downplays the economic and cultural dimensions of international inequality and is often evasive about policy priorities. Neither cultural imperialism nor globalisation theory is adequate to assess spatial and geographical changes in the cultural industries across the world. Grounding analysis by examining particular industries and texts, as I have sought to do here, may provide a way out of the impasse between the two sets of theory.

FURTHER READING

The study of international and global communication is, naturally, a vast terrain. Tunstall's *The Media Are American* (1994, originally published in 1977) remains an informative source about the long-term history of cultural industry internationalisation. The problem, though, remains – how to theorise international cultural flows.

13 The term is also used sometimes to refer to the work of Western musicians who draw on non-Western sources – most notably Paul Simon's 1986 *Graceland* album.

Ithiel de Sola Pool was ahead of his time in providing smooth, elegant statements of a neo-liberal stance on culture (see Pool, 1977).

The work of Herbert Schiller frequently addressed internationalisation (*Mass Communication and American Empire*, 1969; *Communication and Cultural Domination*, 1976; *Culture, Inc.*, 1989). Schiller was apparently an inspiring teacher and was certainly a writer of engaging polemics, but, in my view, his work failed to provide a coherent theoretical underpinning for critique (see Maxwell, 2003, for a much more favourable assessment).

Herman and McChesney's *The Global Media* (1997) is the most important recent contribution by political economy in the USA to consideration of internationalisation (see the discussion in Box 8.1). *New Patterns in Global Television* – a collection edited by John Sinclair, Liz Jacka and Stuart Cunningham (1996) – was groundbreaking and still provides an important way to conceive of global television.

In articles and chapters, Joseph Straubhaar (1997) and Michael Curtin (2003a and b) have also made important contributions to efforts to get at the complex geography of international cultural flows without losing sight of issues concerning power and identity.

For histories of internationalisation in specific industries, the following books are useful.

- *The recording industry*: Pekka Gronow's *An International History of the Recording Industry* (1998) and Robert Burnett's *The Global Jukebox* (1995) on the international recording industry.
- *On advertising*: Armand Mattelart, *Advertising International* (1991).
- *On film*: Kerry Segrave, *American Films Abroad* (1997).
- *On television*: Chris Barker, *Global Television* (1997), and Anthony Smith with Richard Paterson (eds), *Television: An International History* (1998).

John Sinclair with Graeme Turner (eds), *Contemporary World Television* (2004) is a mine of useful information on recent transformations across the world. Turning to a couple of particular regions, John Sinclair's work on Latin American media is always insightful and informative. See especially his book *Latin American Television* (1999).

I have found Chin-Chuan Lee's collection *Chinese Media, Global Contexts* (2003) and various articles by Yuezhi Zhao (such as Zhao and Schiller, 2001, and Zhao, 2003) informative and illuminating about Chinese media.

There has been no space here to consider Japan's increasing domination of Asian media, but Koichi Iwabuchi's cultural studies account, *Recentering Globalization* (2002), is very interesting.

For me, the best book on contemporary issues in internationalisation is Peter S. Grant and Chris Wood's *Blockbusters and Trade Wars* (2004). This is a thoughtful critique of global domination by the USA, and a helpful outline of potential policy responses.

Screen Digest is the best source of regular information about contemporary developments in international media (including the Internet). *Variety* is also very useful.

9 NEW MEDIA, DIGITALISATION AND CONVERGENCE

DEFINING NEW MEDIA

The new media could never be a minor part of any book about change and continuity in the cultural industries. No other area of debate about cultural production has seen such remarkable claims for transformation. This makes it all the more important that such claims are assessed carefully and soberly. After all, many parties have an interest in overstating the impact of new communication technologies. For journalists and academics, sensational reports of a transformed future draw attention from readers, editors and funding bodies. For companies, the introduction and dissemination of new technologies provide new market opportunities. For politicians and policymakers, predicting and supporting transformation can appear progressive.

The very term 'new media' illustrates how much confusion that hype about technological transformation can cause. The phrase is very often used to refer to technologies that are really quite old, such as the use of coaxial cable and satellite broadcasting in television. Both of these 'new' technologies have been around since the 1960s. Also, new media technologies such as e-mail,

third-generation mobile telephony and Internet telephony are primarily based on person-to-person or person-to-group communication, so can hardly be thought of in any meaningful way as media (in the sense in which the term is usually employed, to mean *mass* media) at all. Nevertheless, cable, satellite, mobile telephony and e-mail are often included in discussions of new media alongside new mass cultural forms such as CD-ROMs and DVD-ROMS.

At the core of the issue – when all the variety of conflicting definitions are put to one side – is ***digitalisation***.[1] The 'old' electronic media that grew up alongside print media in the period from 1850 to 1950 – photography, phonography (that is, sound recording), cinema, radio, television – relied mainly on ***analogue*** systems, rather than digital ones. In analogue broadcasting, for example, the main components of communication and cultural expression – words, images, music and other sounds and so on – were translated into a continuous body of information – radio waves – that would in some way reproduce the form or appearance of the original performance, image or whatever. The radio waves (remember, like radio, television was broadcast by radio waves) would then be decoded by radio or television receivers. In other words, the radio waves were *analogous* to the original act of communication – they resembled or corresponded to it. In photography, cinema and video, an analogy of the image to be captured would be imprinted in negative form on film and then be 'decoded' in the developing process. In phonography, the sound waves produced by musical instruments or the voice were converted into a signal, which was coded into the grooves of a record or on to magnetic tape, to be decoded at some later point by a record or tape player.

The vital innovation associated with the development of *digital* electronic storage and transmission is that the major components of cultural expression – words, images, music and so on – are converted into binary code (elaborate sequences of zeros and ones) that can be read and stored by computers. This is an extremely important change because it makes communication more transportable and manipulable than before. Perhaps most importantly of all, it also makes different media potentially interconnectable.

While digitalisation represents a remarkable technical achievement and makes certain processes easier and more convenient, it is important not to read the development of digital technologies as unambivalent progress towards a more efficient communications world. It takes an enormous amount of resources and energy to make computers and microprocessors and learn software programs. They save time and money only because incredible and often unnoticed amounts of money are spent elsewhere, such as on research and development, and in building up the banks of computers in schools, colleges and workplaces where computer use is still concentrated.

In any case, I am not primarily concerned here with such issues of *efficiency*. There are more pressing questions in the present context, derived from the main aims of this book. My overall concern is with whether or not digitalisation represents a fundamental shift in the cultural industries. I am especially interested

1 See Lister et al. (2003: 13–35) for a fuller definition involving the following elements: digitality, interactivity, hypertextuality, dispersal and virtuality.

in implications for the social relations of cultural production, including effects on the division of labour in particular cultural industries, and this involves returning to some issues already explored in Chapter 7, but with a new twist: has digitalisation made it easier for 'ordinary' consumers to become producers?

The Internet and World Wide Web are, of course, particularly important here, but I am also concerned with textual issues, to be addressed more fully in Chapter 10, though germane here, too. Has digitalisation allowed for more or less creativity, diversity and innovation? (See the discussion below on digital games.) Has it led to greater choice for consumers (an important theme in discussions on digital television)? Underlying all these various issues is a focus on the effects of digitalisation on questions of *power* in the cultural industries.

Information society and knowledge economy discourse has been very important in framing understandings of digitalisation. Many treatments have been extremely optimistic (Negroponte, 1995). The pessimistic, dystopian voices were there from the start, too (Schiller, 1981), but have become quieter – or heard less often – in recent years. To adjudicate, we need to delineate the different social uses of various digital technologies. I begin, then, by separating out various applications of digitalisation in a number of very different cultural industries and forms via a historical overview.

OVERVIEW OF DIGITALISATION – AND THE CHAPTER

Digitalisation had begun to have effects on the ways businesses were run from the 1960s onwards, but this happened principally as a result of the effects of mainframe or minicomputers. People in advanced industrial countries had increasing contact with airline reservation systems, electronic databases and so on during this period. These were systems in which remote terminals would be linked by phone lines to central mainframe computers. The effects of such systems on the cultural industries were first felt in news gathering, as news agencies such as Reuters began to provide electronic financial data and news services to news organisations (see Tunstall and Machin, 1999: 80).

It was only in the late 1970s and early 1980s, however, that digitalisation began to have a more substantial impact on the cultural industries as a whole. In many cases, the most immediate impact of digitalisation was on technologies of cultural production. With the development of the personal computer in the 1980s (see Chapter 3) digitalisation of production spread through all of the major cultural industries, with important effects on the working practices of photographers, film animators, radio producers, television editors and so on.

In the music industries, musical instruments and, in some cases, recording studios were increasingly moving over to digital methods in the early 1980s, because they had the advantages of less interference, more accurate reproduction and more manipulability. As prices fell, digital technologies such as samplers, sequencers and MIDI (a standard digital interface) were then offered to the consumer market and marketed on the basis of their convenience and clarity. There were intense controversies and debates over whether or not these new technologies made musicmaking less creative and less collaborative than traditional methods.

Digitalisation and miniaturisation also had profound effects on publishing, especially magazine publishing, as desktop publishing software (that is, software that could be used to produce and design documents, magazines and other publications on a personal computer) and other digital technologies became cheaper and more widely available from the early 1980s on. There is no space to address these developments here (see the first edition of this book, pp. 202–12 for discussion). Instead, I examine a more recent and even more controversial development in the application of digital technology to music culture: the digitalisation of distribution or circulation. However, this only makes sense in the context of a discussion on the Internet – of which more anon.

Digital music technologies, desktop publishing and other forms of digital cultural technology had substantial impacts on *existing* cultural industries, but the availability of relatively cheap and compact microprocessors from the late 1970s onwards began to spawn *new* cultural forms. The earliest new form of any substance was the video game. This was initially a part of the arcade and pub entertainment business in most countries, but, as ownership of personal computers spread in the 1980s, the computer game increasingly became a domestic cultural artefact – a very sophisticated, profitable and controversial one. In the section on digital games (the collective name for what used to be called video and computer games, plus other games, such as online games) below, I look at such games as a cultural industry. Some would say that digital games are trivial compared with the Internet and digital television, but they raise interesting questions about the newness of new media. Are they substantially different from 'pre-digital' industries? Are they as aesthetically and socially regressive as some critics claim?

Of course, it is the arrival of the Internet and the World Wide Web that is generally understood to be the point at which cultural production and consumption have been transformed by digitalisation. These are the most important 'new media'. They have been framed as democratising, decentralising forces in societies – including their effects on the cultural industries. To what extent has the Internet fulfilled its early promise? Does it allow for greater participation and decentralisation than the cultural industries already discussed throughout this book? I address these questions in a number of stages.

- After clarifying the different levels and processes involved in the Internet, I consider their impact on existing cultural industries – and the impact of those cultural industries on the Internet itself.
- To analyse these issues in more detail, I then discuss controversies surrounding the effects of digitalisation on the circulation of music. Has digitalisation begun to erode the power of the corporations that have dominated the music business?
- This raises questions about the continuing importance of circulation in the cultural industries and I then examine this issue with regard to the Internet itself, looking in particular at search engines.
- Two further issues then need to be considered in assessing the degree to which the Internet has changed cultural production and consumption. The first concerns access and participation. Who has access to the wonderful resources on offer?

- The second concerns commercialisation. The Internet came in to the world surrounded by claims for its decentralising, democratising effects, but it also came in to the world during a period of intense marketisation of culture. This has made commercialism a very important feature. How might we assess this?
- I then discuss one of the most fashionable terms in coverage of the cultural industries in recent years (one already introduced in Chapter 4) – that is, convergence of media, computers and telecommunications. It is important to realise that this is a term used, in most cases, to describe possible future events rather than past developments.
- This serves as a prelude to discussion of the leading contender, besides the Internet, for the role of major platform for converged information/ entertainment services. What will be the effects of digital television on cultural consumption and cultural production?

DIGITAL GAMES

How distinctive is this new cultural industry, based on digital technology? What does it tell us about digitalisation as a technological development in the cultural industries?

Without doubt, the industry has some novel features. The console games industry, unlike all other cultural industries, has traditionally been dominated by Japanese corporations – namely, Nintendo, Sega and Sony.[2] This domination derives from another distinctive feature: the games industry is centred on hardware/software synergies to a greater degree than any other cultural industry in recent times. The small companies commissioned to produce innovative texts are very much reliant on developments in the hardware sector and this sector is even more prone to the introduction of new gadgets than is consumer electronics equipment in the music and film industries. The hardware companies are, in turn, reliant on games development for their profits as the hardware (consoles) are sold at relatively small profit margins, whereas games have a very high mark-up (Caves, 2000: 215).

In other respects, however, the digital games industry conforms to patterns established in the cultural industries more generally. In its organisational form, the industry follows the *publishing logic* (or 'editorial model') of commodity production identified by Miège (1987) as characteristic of the production of books, records and films. In this model of cultural production:

- texts are sold on an individual basis to be owned
- a publisher/producer organises production
- many small- or medium-sized companies cluster around oligopolistic firms
- creative personnel are remunerated in the form of copyright payments.

Miège contrasts this 'publishing logic' with a number of other 'logics' of production – mainly, the *flow logic* associated with broadcasting, where, instead

2 Microsoft has successfully entered into the sector since the launch of its Xbox console in 2001–2002.

of individual commodities for sale, the emphasis is on the provision of an uninterrupted flow of entertainment (an idea Miège borrows from Flichy, 1980) and the production of written information – that is, principally the press, including magazine publishing.[3]

The computer games industry, then, according to this analysis, is organised like books, music and films. Sony, Nintendo and Microsoft are the oligopolistic companies at the centre of the console and hand-held devices sectors at the core of the industry (Sega have lost their pre-eminence). Some of these companies have designed games in-house, but games are mainly commissioned by the large corporations from specialist companies. There is a premium on inside knowledge of what fan subcultures are looking for and large corporations gain access to this knowledge by entering into transactions with small companies made up of enthusiasts. In this respect, too, there are important parallels with other industries, notably music (see Chapter 7 on this aspect of the music industry).

Games may look more transformative than they are because they have been the object of so much public debate about their effects. For many years, games were condemned or worried over as simple, violent fare for the young. In this respect, too, games conform to a familiar pattern – many other new cultural forms have been treated in the same way. It was apparent by the 1990s, though, that the digital games industry was here to stay. Although competition for market share between the various formats has been fierce, the corporations and their software associates have competed for an ever expanding cake as games devotees have continued to buy games in their twenties and thirties and the next generation of boys and girls have joined the audience (Poole, 2000). This has also led to formidable creativity and innovation. *Screen Digest* (October 1999) attributed the success of the games industry in the 1990s to 'a far greater depth of quality product than the filmed entertainment market'. A number of writers have noted the increasing sophistication and quality of games. There is also considerable variety of genres. Poole (2000: 35–58) lists the following:

- shoot-em-ups
- racing
- platform
- fighting
- strategy
- sports
- role play
- puzzles.

Henry Jenkins (2000) notes the possibility that a new generation of games will legitimate digital games as a new popular art form, just as the films of the late 1910s and 1920s legitimated the then infant cinema.

Some have misinterpreted these developments as meaning that digital games are replacing music, film, books or television (substitute any other industry here

3 Lacroix and Tremblay (1997: 62–4) identify a new 'club logic' in the provision of cable and digital subscription services, offering products based on both the flow and publishing logics.

as it goes through any sort of period of crisis, especially if youth audiences are diminishing). It is certainly true that the digital games industry has achieved high rates of growth in the early twenty-first century (see Kerr, 2006: 50) whereas, as we shall see below, revenues from recorded music have stagnated or even declined, but, as Aphra Kerr (2006: 51–2) shows, often-heard claims that games now out-strip films as a cultural industry are based on very dubious data. For example, the sales of hardware (consoles, hand-held devices) are included alongside games software. This would be like including the figures for sales of DVD players and recorders in the figures for film. Then these figures are compared to box office figures alone for film, ignoring 'secondary' film markets, such as DVD sales and rental. When sales of *games* (as opposed to devices such as consoles) are compared with revenues from cinema box offices *and* DVD sales and rentals, it becomes apparent that the games industry is big and fast-growing, but not yet in the same league as television or even film. As long as leisure time and expenditure on it expand, new cultural industries and forms such as digital games can be accommo-dated without destroying previously existing industries. And synergies can be found too – games based on films, films based on games, music publicised via games, games publicised via music and so on. The digital games industry, then, is a significant new entrant in the cultural industries sector and digital games are an interesting and important cultural form. But they do not represent a significant shift in the prevailing structures and organisational forms of cultural industries generally.

THE INTERNET AND WORLD WIDE WEB

UTOPIANISM AND MARKET REALITY

To what extent have the Internet and the Web brought about a transformation in cultural production and consumption? To what extent have they decen-tralised and democratised culture? To begin to answer these questions, we need to understand the dominant ways in which the Internet and Web were framed during the crucial early years of their development (the 1980s and 1990s).

There is no space here to recount the history of the Internet (see Hafner and Lyon, 1996, for an early history). We can say, though, that the Internet and Web inherited an association of information technology with individual freedom, autonomy and decentralisation (see Flichy, 1999) The academic and countercul-tural computing cultures at the heart of the development of the Internet and World Wide Web were made up of intellectuals, so they were able to produce accounts of themselves that were extremely influential in disseminating a utopian notion of digital networks as liberatory.[4] However, the Internet and World Wide Web developed at a time when neo-liberalism and marketisation were sweeping the world and affecting prevailing understandings of cultural

4 Examples include the work of Howard Rheingold (1992), Nicholas Negroponte (1995) and *Wired* magazine. The cultural developments surrounding the Internet have been brilliantly analysed and critiqued in a book by Vincent Mosco (2004) and a chapter by Thomas Streeter (2004).

production and consumption (see Part Two). Information society/knowledge economy discourse embraced these new developments wholeheartedly. Governments and businesses have associated themselves with the idea that the Internet will combine prosperity with participation, business savvy with bottom-up control.

This has meant that the Internet and World Wide Web have been framed as decentralising forces in culture and communication, but at a time when neoliberalism, marketisation and commodification have helped to determine the reality of their development. Previous chapters in this book have outlined the complexities and ambivalences surrounding the further commodification of culture that has taken place over the last few decades. Cultural markets under capitalism tend to combine centralising and decentralising forces, but, in general, there is a tendency for structural inequalities of class, gender, ethnicity and so on to be exacerbated unless resolute governmental action is taken to counter them (even then, this may prove fruitless in the face of powerful business interests). All this produces a particular requirement when assessing change and continuity in relation to the cultural industries. This is that, because utopian understandings of the Internet and Web are buried deep in the culture, we need to be especially on guard when assessing claims that the Internet and the World Wide Web have democratised culture.

BREAKING DOWN THE INTERNET AND WEB

Another important preliminary step is to differentiate the ways in which the Internet has come to be used. It is a:

- medium for individual and small-group communication, especially via e-mail and *social networking sites* (in this respect it is like telephony – and Internet telephony is set to become a major phenomenon)
- means by which commercial transactions take place (in this respect it is an extension of private networked computer systems)
- means for storing and finding information (like networked electronic databases, libraries, even museums)
- means for providing and experiencing entertainment (like radio or television, but 'always on', and like print, but always there).

It is the extraordinary variety of purposes that they can be put to that makes the Internet and Web such important developments. It also makes them difficult to comprehend. All these aspects impinge on the cultural industries as defined in this book, but especially the last two.

We also need to differentiate between the different elements involved in *enabling* all these different uses and purposes:

- computer hardware – PC micropocessors and routers
- infrastructure – telephone systems and the 'backbones' of wires and connections that carry computer information
- computer software – microprocessors, operating systems
- service providers – connecting the above to consumers
- portals, search engines and principal sites – providing the gateways to the *content* of the World Wide Web for Internet users.

Each of these elements also represents a different level at which state and market control may or may not be exerted, providing important new challenges for policy. All are important for understanding recent developments. Just as Chapter 4 examined developments in broadcasting in tandem with developments in telecommunications, we need to keep a careful eye on infrastructural issues with regard to the Web. However, it is the final, content, level that we are most concerned with here.

THE IMPACT OF THE INTERNET ON THE CULTURAL INDUSTRIES

How has the Internet affected existing production and distribution in existing cultural industries? Colin Sparks has provided an extremely useful breakdown that helps to answer this question, though he focuses largely on print and broadcasting media. Here are some of the changes he outlines, all of which make clear why the Internet has come to be perceived as such a threat to existing industries (the following is based on Sparks, 2004: 311–16, but is not an exhaustive summary):

- for many users, the Internet is – in principle at least – always available and so encroaches on the time spent on other media
- the Internet erodes advantages based on physical place as, for example, newspapers and broadcasting organisations could achieve dominance within a particular city, region or nation, but all online newspapers, radio stations and so on are, in principle, available everywhere, at any time
- the Internet erodes advantages of production and distribution based on time because it is always there, which has effects on professional routines, deadlines and so on
- online media compete with existing cultural industries for advertising revenue.

Some of the other changes outlined by Sparks hint at why these changes have been widely interpreted as democratisation, decentralisation or empowerment of the consumer or citizen at the expense of business or government:

- the Internet lowers entry barriers because distribution costs are lower– there is no need to print and distribute hard copies, as in print media, and there are no licensing and transmission charges, as for broadcasting
- businesses, governmental organisations and other news sources can establish direct relations with audiences via their own websites
- the Internet provides opportunities for selective consumption – you do not have to buy the *whole* newspaper, you can just read the articles you want to
- the Internet is dialogic, interactive and allows, in principle, much greater audience participation in the production of media artifacts than before (blogging and podcasting are the most notable and hyped recent examples of such phenomena – see also Box 9.1 later in this chapter).

All this is helpful, but, as Des Freedman (2006: 283) points out, as well as understanding how the Internet affects 'old' media, we also need to think

about ways in which the old media have affected Internet communication. He cites figures showing that the size of the Internet sector was still much smaller in revenue (especially advertising revenue) than other cultural industries in the early 2000s. Freedman also argues that the fragmentation of audiences caused by the Internet's ability to offer customised audiences to advertisers puts even more of a premium on reaching mass audiences and he offers as evidence the massive and growing advertising rates that broadcasters have been able to charge for showing adverts during major sporting events (the World Cup, Super Bowl and so on) and other national and international media spectacles.

As I write, in April 2006, there have been many reports that Britons are now spending more time on the Internet than they do watching television. According to a survey by Google UK, 'the average Briton' spends 164 minutes online every day, compared with 148 minutes watching television (*The Guardian*, Media section, 8 March 2006). These figures are extremely dubious, as they are based on interviews in which people are asked to report their own estimates and people nearly always under-report their television viewing.

Figures based on the more reliable (but still by no means infallible) method of using electronic technology to detect watching (see Table 9.1) show that viewing figures for television have actually increased over the last few years. The significant shift has been towards a greater viewing of channels other than the five networked ones (BBC1, BBC2, ITV, Channel 4 and Five) on digital, cable and satellite systems, but not away from television itself. Younger adult audiences (18–34) may be turning away from television (Ofcom, 2006), but this is happening very slowly and young adults have always been lighter television viewers anyway.

In the USA, total consumer time spent on the Internet has risen, while that spent on other sectors has diminished (see Table 9.2). In 2004, people in the USA were still spending much less time on the Internet than on other forms of cultural and communications activity – it was not yet even half of the time per person per year spent on print media and less than a fourteenth of the time spent on broadcasting and cable media (Table 9.2). After a huge surge of growth at the turn of the century, growth rates in Internet time are slowing (see Table 9.3). Leading industry analysts forecast that even in 2009, Internet consumer time in the USA will still only reach the level of 5.7 per cent of the total across the four sectors in the tables, with broadcasting and cable reducing marginally to 71.6 per cent.

The Internet, then, is not *replacing* television and other cultural forms; it is *supplementing* them, as often happens when new media technologies are introduced and disseminated. Television may decline in the longer term, but this is not happening just yet. In fact, in many countries of the world, the 1980s and 1990s saw a considerable increase in the ownership of televisions (see UNESCO, 1999).

DIGITAL DISTRIBUTION – THE REINVENTION OF THE MUSIC BUSINESS?

We can explore issues concerning the impact of the Internet on existing cultural industries in more detail by examining the way in which the Internet, combined

Table 9.1 UK television viewing figures: terrestrial versus the rest

	August 1998	January 1999	August 2005	January 2006
Total TV viewing in hours and minutes	22:47	27:35	23:53	27:44
Viewing of other channels besides the networked five	3:09	3:29	7:19	8:40

Source: Broadcasters' Audience Research Board (BARB)

Table 9.2 Hours per person per year using consumer media in the USA, by media type

Year	Total broadcasting and cable media*	Total print media**	Total entertainment media***	Total consumer Internet medium
1999	2366 (72.1%)	456 (13.9%)	392 (12.0%)	65 (2.0%)
2000	2409	443	377	104
2001	2440	430	354	131
2002	2510	428	345	147
2003	2546	442	339	164
2004	2532 (72.8%)	419 (12.0%)	353 (10.1%)	176 (5.1%)
2009	2546 (71.6%)	392 (11.0%)	414 (11.6%)	204 (5.7%)

Sources: Veronis Suhler Stevenson, PQ Media
*Broadcast television, cable and satellite television, broadcast and satellite radio.
**Newspapers, consumer books, consumer magazines.
***Box office, home video, interactive TV and wireless content, recorded music, digital games.

Table 9.3 Growth of hours per person per year using consumer media in the USA, by media type

Year	Total broadcasting and cable media*	Total print media**	Total entertainment media***	Total consumer internet medium
2000	1.8%	−2.8%	−3.9%	59.1%
2001	1.3	−2.9	−6.0	26.1
2002	2.9	−0.5	−2.7	12.1
2003	1.4	−1.4	−1.7	11.5
2004	−0.6	−0.7	4.1	7.5

Sources: Veronis Suhler Stevenson, PQ media
*Broadcast television, cable & satellite television, broadcast & satellite radio.
**Daily newspapers, consumer books, consumer magazines.
***Box office, home video, interactive TV & wireless content, recorded music, videogames.

with other technological developments, has affected one particular set of cultural industries, music-related ones.

The major challenge digital distribution presents to the recording industry stems from the relative accuracy and ease with which digital recordings can be copied. As we saw in the Introduction, making a profit in the cultural industries depends on, among other factors, the production of artificial scarcity. Digitalisation makes copying of any information relatively easy, thus threatening that scarcity. Music takes up less disk space and bandwidth than other non-print media and can be experienced via computer without too much discomfort (unlike print). This is why the recording industry has been the first cultural industry to face head-on the threat posed by digitalisation.

In all cultural industries, the spread of the personal computer and the Internet have made digitalisation a major issue. Beyond this, four interrelated technological innovations have been involved in shaping the particular forms that digitalisation has taken in the recording industry, as Bakker (2005) shows:

- the development of the MP3 compression standard in the early 1990s, and then the later development of other compression standards (notably AAC – the format used by i-Tunes – and Microsoft's WMG) which allowed vast amounts of digital audio information to be compressed into manageable files
- the spread of flat rate, high bandwidth connections, such as ISDN, ASDL and cable, and the fact that even where such connections were not available domestically in the late 1990s and early 2000s, they were available at workplaces, places of study and so on
- the introduction of multimedia computers with increased storage capacity, soundcards, CD players and speakers
- the development of usually free and relatively easy-to-use software that could 'rip' CDs into MP3 files and find and download MP3 files.

These technologies have been driven by the telecommunications and software sectors. The conflict between the cultural industries and these industries echoes earlier battles with the consumer electronics sector – for example, over video cassettes. While the cultural industries would have liked serious restrictions to be placed on the facilitation of copying on computers, the might of the USA's software and telecommunications industries was always going to make such measures unlikely. In the 2000s, there have been two major problems that have faced the record companies as a result of these developments:

- *file-sharing* over *peer-to-peer (P2P) networks.*
- finding a way to make money out of 'legitimate' digital distribution.

I will deal with each of these in turn. In the present context, the major issue is the extent to which these developments empower consumers, creators and small companies at the expense of the big companies.

FILE-SHARING

By 2000, users were sharing music files over peer-to-peer networks – the most famous and widely used of which was Napster. Napster was soon closed down

by a lawsuit brought by various record companies in the USA, but was supplanted by other peer-to-peer file-sharing networks that, in effect, merely provided software that allowed networks of users to search each other's computers for musical files and therefore made prosecution more difficult. The most notable of these were Grokster and Kazaa. These developments, combined with falling revenues from sales of recorded music in the wealthiest countries, have led many commentators to discuss the decline – or even death – of the music industry (see Mann, 2000; Barfe, 2003). A widely read book on the impact of digitalisation on music was typical in its portrayal of the music majors as flat-footed bureaucratic behemoths, 'an industry struggling to maintain control and remain relevant', while celebrating the nimble entrepreneurs of Web-based music (Alderman, 2001: 1–2). Some on the left hoped that a more democratic set of production relations would emerge from the mess, where artists might be able to market and sell their products directly to audiences via the Web without the need for multinational entertainment corporations.

The oligopolistic integrated recording industry is not going to disappear in a hurry, however, even if its owners have changed (see Chapter 8, footnote 12). The record companies and trade associations representing them were quick to take action against the file-sharing threat. After successfully closing down Napster (though this name has since been taken by a *legal* downloading site), they pursued litigation against the second-generation file-sharing companies operating such services[5] and began lawsuits against downloaders of music. The Recording Industry Association of America (RIAA) prosecuted many thousands of individuals and other trade associations followed suit across much of the world. Action against file-sharing sites has, at the time of writing, been only partially successful.

There is a bewildering array of contradictory evidence on trends in peer-to-peer usage, with many reports of decline as well as many reports that file-sharing continues to grow (Karagiannis et al., 2004). Even if 'illegal' file-sharing continues to grow and the file-sharing software companies and websites continue to defend themselves successfully against the considerable resources of the cultural industries, the joint strategy of pursuing individual users and software distributors is likely to deter many from becoming involved in such sites. In the medium term, it's likely that remaining file-sharing sites will be the preserve of a committed niche of users (see Bakker, 2005) – a very significant and growing niche, but not in itself something that is likely to have an epochal effect on music consumption, at least not yet. In the longer term, the continued existence of such sites in a stable form in the face of ferocious litigation, consumer anxiety and further technological developments seems unlikely.

5 In June 2005, the Supreme Court in the USA delivered its verdict on the case brought by MGM and 27 other major entertainment companies against the developers of file-sharing software products, including Grokster and Morpheus. This by no means signalled the end of file-sharing (the Internet, after all, makes exchange of files and information very easy), but the unanimous verdict was widely reported as a crucial victory for the cultural industries over software companies.

THE SEARCH FOR 'LEGITIMATE'
DIGITAL DISTRIBUTION

Predictions of the death of the recording industry as we have known it ignore the fact that the digital downloading of music offers considerable opportunities to the companies that dominate the music business. Collectively, the companies involved in sales of recordings would welcome new platforms for selling music. An ideal future for the recording companies would involve consumers purchasing tangible recorded music commodities, such as the CD (or some future format), *and* digital files. The major corporations clearly see the shift to digital distribution as a chance to steal a march on each other, even if that means forming partnerships with the software and telecommunication sectors that caused the 'problem' of digitalisation in the first place. However, the quest for a legitimate digital distribution market offers considerable challenges, too. There are two main ones, as I write in 2006:

- finding a way to prevent customers from simply reproducing infinite copies of digital files of music
- finding a method of payment that consumers feel happy with.

The prevention of easy copying relies on the successful development of *digital rights management* (**DRM**) systems. These are security measures that are embedded in computers, electronic devices and digital files to prevent copying and other unauthorised uses. The successful implementation of DRM systems for the music industries poses major challenges – especially given rivalries among the various hardware, software and telecommunications companies involved. But those competent enough to circumvent it are likely to be even smaller in number than those involved in P2P networks. In the long run, as DRM technologies become more sophisticated, such hacking may ultimately be no more significant than other (analogue) copying technologies that have plagued the cultural industries since the 1960s – audio taping, video cassettes and VCRs – and CD piracy. These have been significant irritants and presented considerable challenges to the music industries, but they have managed to keep the irritation just about under control.

As DRM systems have become more robust, two separate and parallel markets for digitally distributed music have already developed, with incompatible formats – one for computers and another for third-generation mobile phones. This dual market suits the music industries very well, after their relatively hard times in the early 2000s. Music downloading services and 'legal' downloading websites have proliferated. Over 20 million MP3 players were sold in 2004 and this figure is likely to increase considerably in years to come (*Music and Copyright*, 24 November 2004).

As with previous boom times for hardware manufacturers, this is likely, in the longer term, to cause a boost in music consumption among key buyers – especially the wealthy 'early adopters' so beloved of entertainment hardware manufacturers and journalists. The growing market for ring tones alone has

given the music companies great heart. In some markets where mobile telephony is a huge part of everyday life, downloading music to mobiles is likely to boom soon. The major record companies have been moving towards the integration of peer-to-peer networks into the 'legitimate' online music market as an alternative means of promotion and distribution and a second front in the battle against supposed threats to their intellectual property (litigation being the other).

So, digitalisation hasn't yet killed the music business as we know it and there is little prospect that it will. Global revenues from recorded music sales certainly fell in the 1999–2004 period, but showed some recovery in 2004 and 2005. The vast Russian and Chinese markets were growing rapidly. CD and other forms of piracy are a problem, but it suits the big record companies to exaggerate the effects of piracy on their profits so that they can lobby governments more effectively. In any case, the music business does not consist entirely of the sale of commodities such as CDs to consumers by record companies – it is also about other ways of exploiting its copyrights. These other ways have expanded consistently over the last century and digitalisation involves the extension of rights in musical works into new realms.

There has been withdrawal or partial withdrawal from manufacturing and distribution, with these operations being sold off to third parties, but this should not be read as a sign of a democratising 'disintermediation' – the removal of intermediaries between creators and consumers. The major corporations still retain crucial control over the marketing and promotion that largely determine what music most consumers get to hear and know about. The signs are that such marketing is being centralised in order to produce blockbuster hits – key albums by key stars making an immediate and very big impact on public consciousness. A parallel here is with the increasing emphasis in the film industry on massive publicity to generate big revenues on opening weekends (see Chapter 7). Meanwhile, the sizes of record company rosters have been drastically cut – especially non-English rosters in the overseas divisions of the multinational corporations (*Music and Copyright*, 23 June 2004) and there has been further consolidation of an already highly concentrated business. Even more crucially, the record companies have been in the process of redefining themselves 'as creators and exploiters of intellectual property rights' (*Music and Copyright*, 1 September 2004) for many years. It seems highly likely that the high returns and low costs of music publishing and the constantly expanding opportunities for rights exploitation will make copyright more and more central to the music business in the years to come – and similar trends are at work in the cultural industries more generally. This may well intensify the efforts of the 'creative industries' (see Chapter 5) to lobby governments in favour of copyright law and practice, which will further threaten the public domain and favour private, corporate interests. This makes the struggles over digitalisation, especially file-sharing over peer-to-peer networks, particularly interesting because of the tension between producers and consumers so beautifully crystallised in music industry lawsuits against music downloaders.

THE INTERNET AND CONTROL OF CIRCULATION

The case of the music industry shows, then, that we need to question exaggerated assessments of the degree to which the Internet has disrupted existing cultural industries. But of all the claims outlined by Sparks (above), it is the one concerning the dialogical, interactive nature of the Internet that is most crucial for *evaluating* changes brought about by digitalisation.

The idea that the Internet evades control because of its decentralised nature is a key feature of optimistic writing about the phenomenon. In the words of Manuel Castells (1996: 352), 'the architecture of this network technology is such that it is very difficult to censor or control it'. However, just like any other cultural industry, the World Wide Web can be thought of as having separate elements of creation, reproduction and circulation (including marketing and promotion). There are plenty of symbol creators and enormous amounts of information and entertainment in cyberspace, but which sites get visited and which don't? This depends on the equivalent of circulation in the online world.

Supposedly, we can go anywhere we choose on the Web by clicking on whichever icons and sections of text we choose. For some conservative proponents of the Internet (Gilder, 1993), this supposed interactivity was what distinguished the online experience from offline cultural forms such as television – the individual consumer could rule in cyberspace. In fact, this is not so different from wandering round a big bookshop as there, too, we can go anywhere we like and choose anything we want to buy, as long as we have the money or credit to pay for it. The problem is that where we go will, to a significant degree, be determined by our existing knowledge and inclinations. How do we know where to go?

Early users – the amateur enthusiasts – got over this problem by spending enormous amounts of time on the Internet. Most other users have limited time and so, since the commercialisation of the Internet from the early 1990s on, a number of new cultural forms have appeared that aim to guide users through the World Wide Web. Particularly important in guiding us are *search engines* and the main websites – including the gateway sites, often referred to as *portals*. In many cases, these are linked to the crucial commercial Internet service providers (ISPs), which, for many people, provide the connection to an Internet-linked computer.

A number of companies have emerged as the leading players in the ISP sector. In many countries, they are the leading telecommunications and cable companies. The ISPs have evolved increasingly influential codes of conduct and portray themselves as making the chaos of the Internet safe and structured and catering to the individual's needs (Patelis, 1999: 97–8). This has further eroded the DIY ethos at large on the Internet. ISPs select search engines and prioritise certain portals, including in some cases their own search engines or portals (Raphael, 2001). The last few years have seen the emergence of a number of dominant sites, most notably Yahoo!, msn.com and other Microsoft sites (such as Passport), eBay and Google. Search engines – especially Google – are crucial in determining which sites get visited and which don't (see Box 9.1).

BOX 9.1 SEARCH ENGINES

Lucas Introna and Helen Nissenbaum (2000) provided a valuable early explanation of the problems with search engines. They showed that the backlink method (so called because it uses a count of backlinks – that is, how many links to the web page appear over the entire Web) used by many search engines meant that less well-known autonomous sites were much less likely to be visited and, hence, indexed by the search engine than the ones with greater numbers of hits. The PageRank method – the main means used by Google to form its pages – was, they said, even worse because it weighs very highly links from pages that themselves have lots of backlinks.

Search engines are reluctant to reveal their ranking criteria and one of the reasons they give for this is that such openness would encourage further 'cheating' by search engine optimisers, paid to achieve crucial high rankings for businesses and other institutions. But at least this would help to make people more realistic about the limitations of the notion of the Web as infinitely open and decentred.

Introna and Nissenbaum's analysis preceded the rise of paid search (or 'sponsored search'), whereby content providers pay to have their pages included or ranked highly in search engine listings. A more recent commentator has noted that Introna and Nissenbaum 'could not have anticipated the prominence that paid search has in today's search engine marketplace' (Zimmer, 2005–2006). However, given the dominance of Google (which lists its sponsored links separately), an equally pressing issue is the way in which PageRank includes some sites and excludes others (anything listed lower than 20 is of course effectively excluded). Many claim that PageRank is the most effective system available because of its largely, though not entirely, automated nature. Increasingly, the keywords in the anchor text of external links are an important determinant of rankings.

When all the complexities are put to one side, search engines, especially Google (Yahoo! and Microsoft are the only serious competitors), have become most people's first ports of call for finding out information about many different things and this represents a remarkable centralisation of information. The rankings of the leading engines presumably have a strong self-reinforcing effect – highly ranked sites increasing their popularity because they are ranked highly.[6] Yet, as Introna and Nissenbaum noted, few Web users are aware of the issues involved in search rankings and many treat search engines as near-objective sources of information, much like a library catalogue.

6 While Google's advertiser-supported search may seem preferable to paid search, the vast majority of its revenues come from advertising and this inevitably raises questions about the possible effects of advertisers on listing and ranking decisions. Google has to make many 'human interventions' in its automated processes to determine rankings.

ACCESS AND INEQUALITY – DIGITAL DIVIDES

The discussion so far has been concerned with questioning the degree to which the Internet has transformed cultural production and consumption and the degree to which this transformation can be seen as a positive one. However, I want to emphasise that the analysis here needs to be understood as an attempt to counter exaggerated claims on both scores. There is no doubt that the Internet is an extremely significant development and offers wonderful resources to individual users, but the degree to which it enriches societies and contributes to more democratic and publicly orientated forms of communication is limited by various ways in which it is structured, as outlined above. Just as important – it is limited by inequalities in access.

A term that has been widely used in policy circles to describe such inequalities is 'the digital divide'. Some conservatives claim that there is no problem and those not connected to the Internet generally don't want to be. However, to say this is to ignore the realities surrounding the importance of communication and knowledge when it comes to questions of participation in an economy, a society, a polity, a culture. As Graham Murdock and Peter Golding (2004: 245) put it, 'to be disconnected is to be disenfranchised'.

There has been massive inequality in access to the Internet – not only between advanced industrial countries and 'developing' countries but also within the 'developed' countries themselves:

- by the end of 2000, the Internet was still only used (and the definition of 'use', here, is very generous – at any time in the previous three months) by about 7 per cent of the world's population (figures cited by Raphael, 2001: 203)
- the developed world dominated content, with 64 per cent of Internet hosting computers located in the USA and Canada and another 24 per cent in Europe (figures cited by Raphael, 2001: 203)
- even in Southern Europe, only 8 per cent of homes had Internet access in 1999, according to figures cited by Murdock (2000: 53)
- as for inequality *within* nations, Raphael (2001: 203) quoted figures showing that levels of Internet connection for black and Latino households in the USA in 1999–2000 were, in each case, about 18 per cent less than for 'all homes' and this gap had widened, not diminished, over the previous two years (these statistics were drawn from the USA's National Telecommunications and Information Administration data).

Proponents of cultural (and digital) markets claim in response that, as technology spreads and markets grow, costs will come down, encouraging even those with the lowest incomes to gain access to the technology. Access to the Internet has broadened, but clearly there are still huge inequalities in access by class. For example, between 1999 and 2003, home access to the Internet increased in the UK from 10 per cent of all households to 46 per cent. Among the wealthiest 10 per cent, 85 per cent had access, but, among the poorest 10 per cent, the figure

was 12 per cent (Office of National Statistics data, reported by Golding and Murdock, 2005: 78). Further, as Golding and Murdock point out, these figures should be read in the context of continuing increasing wealth and income inequality generally in the 2000s.

As home Internet access spreads, we need to pay attention to the types of access involved. Digital technologies have a tendency to be in a constant state of flux and so distinctions are maintained. Pippa Norris (2001) made this point in a formidable international survey, which suggested that greater Internet penetration actually *increased* information inequalities. There is a great deal of difference between always-on broadband in the home and checking a hotmail account every few days. Many computers with Internet access are bought (or even provided by policymakers in an effort to narrow the digital divide), but soon need to be replaced as systems move on. Also, owners may lack the skills, confidence or motivation to make use of them (Murdock and Golding, 2004). It is easy for people who work with computers or who have grown up with them to realise how much needs to be learnt in order to carry out even basic functions. Age continues to be a big part of the divide. The digital divide, then, is a much more complex matter than just whether or not it is possible to get access to the Internet. Inequalities go much deeper than this suggests.

COMMERCIALISATION OF THE INTERNET

This still leaves the possibility that, for the relatively privileged few who have access to the Internet, there have been important democratising effects, including the ability to form the kinds of micro-networks mentioned above. Tim Jordan (1998: 59–87) provided unusually concrete discussion of online life. He discussed the fluidity of individual identity for some applications of the Internet, especially in the world of MUDS and related technologies.[7] Jordan was clear that 'hierarchies based on identity', such as gender, race and class, do not 'disappear from cyberspace, but will be reinvented on the basis of new forms of online identity'. Nevertheless such identity hierarchies are dislocated and disturbed because of the ability of individuals to play with the very idea of identity, but also because of 'many-to-many communication and its ability to include more people in decisionmaking than was previously practicable' (p. 81). We should also note the emphasis in many user communities on the 'free circulation of information' (Flichy, 1999: 36) and 'the rejection of … undeclared commercial interests' (Castells, 1996: 354).

How have such interesting and positive aspects of digital networks among the relatively privileged social groups with access to the Internet fared during the late 1990s and early 2000s? Since 1994, when 'business "discovered" the Net' (Sassen, 1998: 177), the way in which the Internet has developed

7 MUDS are 'programmes set up on a computer that accept connections from many users at once' (Jordan, 1998: 60), involving either adventures and quests or non-goal-directed social interaction. Jordan was less optimistic about other aspects of the Internet.

has damaged its potential as a challenge to the forms of communication prevalent in other cultural industries. In particular, the Internet and World Wide Web have become commercialised. Advertising encroaches on nearly all aspects of Web communication, appearing as banner headings and pop-up advertisements, the automatic start-up pages on Web browsers, portals and search engines (including concealed forms, such as the paid search discussed in the previous section) and, of course, websites themselves. Signing on to services and buying products can still bring about a flood of unwanted e-mail messages. Spam remains a huge irritant. Much Web content is permeated by advertising to the extent that it is sometimes difficult to tell where advertisements end and the content begins. As Sparks (2004) points out, there are few conventions for the separation of commercial and non-commercial content on the Web.

Advertising expenditure on the Internet has boomed in recent years. This happened in the 1990s, but was interrupted by the dot.com crash. From 2003 onwards, online advertising in the USA resumed its inexorable climb, growing at double-digit rates. Consumer Internet advertising expanded in value by 32.5 per cent in 2004 to US$9.63 billion (VSS, 2005: 67). This figure needs to be put in context. It still represents a small proportion of the total advertising market in the USA, of approximately US$188 billion for 2004 (VSS, 2005: 36), but makes it clear that the Internet will be a medium (or set of media) that is supported primarily by advertising rather than subscription.

While there are advantages and disadvantages to both systems, the problem is that forms of communication that come to rely on advertising as their main source of income tend to become beholden to their advertisers (see Curran, 1986, on the history of advertising in newspapers). As C. Edwin Baker (2002: especially 24–30) argues, this can have various deleterious effects on content. These are difficult to predict in advance and need to be assessed case by case, but, in general, says Baker, advertising favours content that is increasingly connected to marketable products and services and tends to militate against that useful to, or valued by, poorer elements in society.[8]

A final aspect of Web commercialisation is that networking technology has been appropriated in such a way that practically all uses we make of the Web are recorded for market research purposes. Surveillance of Web users as consumers rather than citizens has been built into the very structure of Web technology via cookies (files that are left on your computer when you visit a site) and logging software. Marketing and advertising agencies might claim that all this is doing us a favour – that it allows us to be targeted more efficiently and saves us the effort of having to sift through irrelevant advertisements. We can all, then, look forward to the day when we only see advertisements and marketing information for products we intend to buy – a niche marketing paradise. Well, maybe.

8 Advertising on other companies' websites is just part of Web commercialism. As Dan Schiller (1999: 132) points out, corporate websites must also be seen as a category of Web advertising and billions of dollars have been spent on them.

Influential commentators on the Internet, such as Manuel Castells, seem to think that the liberatory nature of the medium will survive its commercialisation because of inherent properties of the technology. Castells (1996: 354) is clear that commercialisation is changing the medium, but he believes that 'while its most heroic tones and its countercultural ideology fade away ... the technological features and social codes that developed from the original free use of the network have framed its utilisation'. In such passages, Castells edges close to technological reductionism. Technologies do have lasting features, based on the social codes and discourses surrounding their development, it is true, but these features can be reshaped by powerful users and interpreters. Patrice Flichy provides a valuable corrective to Castells' assumptions. Asking whether or not the democratic features of the Internet are a product of the technical characteristics of networks, (1999: 39) Flichy replies, 'It seems not, for other models of data processing networks do exist. IBM and other manufacturers have developed centralised networks for businesses, where the role of each actor is clearly defined: some input data, others consult it'. In addition, Saskia Sassen (1998; 2000: 19) has drawn attention to the 'enormous growth of private digital networks'. She (2000: 20) claims that:

> the leading Internet software design focus in the last few years has been on firewalled [that is, protected from access by outsiders] intranets for firms and firewalled tunnels for firm-to-firm transactions. Both of these represent, in some sense, private appropriations of a 'public' space.

The social uses of the technology, in other words, outweigh what might appear to be fixed features of the 'technical architecture' (see Box 9.2 for a recent new version of internet utopianism).

BOX 9.2 WEB 2.0

In the words of one of its advocates:

> Web 2.0 is the network as platform, spanning all connected devices; Web 2.0 applications are those that make the most of the intrinsic advantages of that platform: delivering software as a continually updated service that gets better the more people use it, consuming and remixing data from multiple sources, including individual users, while providing their own data and services in a form that allows remixing by others, creating network effects through an 'architecture of participation', and going beyond the page metaphor of Web 1.0 to deliver rich user experiences (O'Reilly, 2005).

So the concept applies to software such as Linux, Apache and Perl and to applications such as Google, eBay and Amazon, but is perhaps exemplified by phenomena such as blogging, the video file-sharing site You Tube and the online encyclopedia Wikipedia. For its advocates, Web 2.0 has many

(Continued)

(Continued)

attractions. It 'manages a freeing of data ... permits the building of virtual applications ... is about sharing code, content, ideas ... is about communication and facilitating community ... is built upon trust' (Miller, 2005). It is both an extension of earlier Web practices and it 'challenges outdated attitudes towards the rights of the user, customer choice and empowerment' (Miller, 2005).

 Web 2.0 quickly became a marketing buzzword with many companies, but there has also been some scepticism about whether or not a shift in Web practice has really occurred. Nicholas Carr (2005) suggests that the 'architecture of participation' referred to by O'Reilly and exemplified in an application like Wikipedia, the open-source encyclopedia, is not necessarily or inherently a good thing. The new emphasis on blogging, he says, risks devaluing the importance of professional standards. He argues that the professional entries in *Encyclopedia Britannica* online, for example, which would now be considered a product of 'Web 1.0', are far superior to the amateur entries of Wikipedia's participatory 'collective intelligence' model. As with earlier Web developments, we also need to ask questions about who gains access to these new Web forms.

The Internet and the Web have, to a limited extent, altered existing social relations of production and consumption. They have produced huge amounts of small-scale cultural activity. They have enabled new ways for people to communicate with each other. They have provided mechanisms to enhance political activism. The Internet is full of material that is arcane, bizarre, witty, profane, as well as inept, mundane and banal. These many minor forms of subversion, insubordination and scepticism don't cancel out the enormous concentrations of power in the cultural industries, but they might be thought of as representing a *disturbance*. The problem is that this disturbance of existing relations of cultural production and consumption has happened mainly within a very specific section of the world's population. The radical potential of the Internet has been largely, but by no means entirely, contained by its partial incorporation into a large, profit-orientated set of cultural industries.

CONVERGENCE – THE PROMISE OF FURTHER WONDERS

Euphoria about the economic and communicative possibilities of the Internet in the late 1990s helped to fuel a great deal of speculation about the issue of *convergence*. We saw in Chapter 4 how the long-held dream of telecoms, computers and media convergence drove some policy in the USA and Europe in the late 1990s. Because they believed something called convergence was inevitable, policymakers worked hard to enable it for fear that, otherwise, corporations in their domain would lose out in global competition for profits. These efforts intensified in the late 1990s – all the more in the wake of the USA's Tele-communications Act of 1996. What are the implications of the term convergence

for the cultural industries, though? To what extent is such convergence already under way and likely to develop in the future? What are its implications?

Graham Murdock (2000: 36–9) has helpfully disentangled some of the different meanings that have clustered around the term convergence. I will discuss each in turn.

- *Convergence of cultural forms* This was often referred to in the distant days of the early 1990s – before convergence became the new buzzword – as 'multimedia'. Murdock (2000: 36) comments that we 'are just at the very beginning of what many observers predict will be a far-reaching recomposition of cultural forms'. He points to CD-ROMs and websites as examples of textual convergence, where the major components of cultural expression (music, sounds, words, images, graphics) are brought together in one place. This, combined with the user's ability to navigate his or her own way through the material on offer, is one of the aspects of the supposed digital future that has most excited and intrigued observers. For example, much of Manuel Castells' analysis of the media (1996: 327–75) is devoted to the idea of a 'grand fusion' of multimedia (see Chapter 10 for a critical discussion of his approach).
- *Convergence of corporate ownership* Peter Golding (2000: 179) has argued that this is the real convergence. Convergence, he says, 'should be read as an organisational and economic phenomenon, recognisable most obviously at the level of corporate strategy and structure'. This is indeed important. The introduction of digital television and the dissemination of the Internet as a communication technology have meant that new players have entered the broadcasting market from consumer electronics, computing and telecommunications. However, there has actually been little convergence of these industries, in terms of permanent mergers (the AOL–Warner merger of 2000–2001 having widely been seen as a failure). Most moves towards convergence have been tentative, involving the purchase of minority stakes, alliances and joint ventures of the kind discussed in Chapter 6.
- *Convergence of communication systems* I would prefer to phrase this 'convergence of media technologies'. The 1980s and 1990s saw proliferation of such technologies. In 1980, most households in advanced industrial countries had a limited repertoire of media technologies, receiving a limited number of channels, such as newspapers, magazines and books, a radio or two, a television (no VCR), some form of audio playback. The penetration of VCRs, cable and satellite throughout much of the 1980s and early 1990s meant more television channels for most people. The personal computer brought computer games and CD-ROMs. The digitalisation of telecommunications meant that personal computers could be networked more easily and eventually helped lead to the introduction of digital television. By the late 1990s, suggestions that this range of media technologies might converge were aired more and more, because digitalisation makes it theoretically possible for all information and entertainment to be converted into compatible strings of 0s and 1s. Sure enough, in the 2000s, digitalisation has proceeded apace. A number of devices are now available to wealthier people in the developed world which receive

digital content from multiple sources – iPods, MP3 players (which increasingly take video and radio, too) and mobile phones among them.

In fact, it seems to me that multiplication is a more useful way to think about these developments. Cultural forms have proliferated, so have the various media technologies through which we experience symbols and the numbers and sectors of companies involved, whether directly or indirectly, in cultural production. Whether such multiplicity entails real diversity or not is another question – one that is considered in the next section.

There are only two serious contenders for being the basis of any significant overall convergence of media technologies, however – the Internet and digital television. Internet convergence is heavily reliant on the development and uptake of broadband (see the discussion of inequality of access above). Meanwhile, television is already embedded in the lives and homes of consumers. The idea that the Internet would quickly replace television – prophesied by Internet gurus such as Nicholas Negroponte (1995) and George Gilder (1993) – was soon demolished by audience research, which showed that television viewing has hardly declined at all during the era of the personal computer (Coffey and Stipp, 1997). Instead, people who have the financial means and technical skills to use the Internet are *combining* it with television. Some heavy Internet users watch less television and highly educated people have always tended to watch less of it, but they are the exceptions. As multitasking increases, many people also combine Internet use with radio, television and other consumption, often at the same time. As for digital television, this certainly represents an interesting development in the cultural industries (and a new challenge for media policy), but whether or not it can meaningfully be thought of as the basis of convergence (in any of the three senses used above) is another matter. So, too, is the question of whether or not it represents a positive development for the society and culture of those nations that adopt it.

DIGITAL TELEVISION

Most advanced industrial countries are currently in a process of moving over to digital transmission for all broadcasting services. The UK, for example, will 'switch off' its analogue systems between 2008 and 2012. This means that all television owners will have to replace or radically enhance their sets – a remarkable boon for the consumer electronics firms that manufacture television sets and the various enabling devices necessary, such as set-top boxes, dishes and so on.

It is still too early to assess the impact of digital television on cultural production and consumption with any certainty, but even a provisional assessment needs to take into account the motivations and intentions of the policymakers who have brought about this remarkable technological and regulatory shift. Why *digital* television now?

The reason a salesperson in a consumer goods shop might give you is that the picture and sound are better, but, in reality, only an expert would be able to tell the difference and most digital systems are still faulty and prone to break-up. The reason offered by politicians to their publics is that digital television will

offer an abundance of programming choice. By compressing digital signals, digital television, whether delivered by cable, satellite or terrestrial relay-aerial systems (see Box 9.3), is capable of delivering literally hundreds of channels. This, it is often claimed, means more than just an extension of what was offered by the system of terrestrial broadcasting plus cable and/or satellite developed from the early 1970s in North America and from the 1980s onwards in most of Europe. Essentially, outside the USA, this consisted of one to three analogue channels plus a few cable or satellite niche channels (music, sport, news, films).

There will certainly be more of such channels, but digital television also involves very different types of programming, often described by the digital television industry as 'interactive', in that the viewer is supposedly given the tools to find his or her own way through the programming. Many of these features are now becoming familiar. Viewers can choose from which camera angle to view a football match or select answers to questions in a quiz show that they are watching. Among the most important of these services is 'near video on demand'. This means that the same film is programmed to start showing at, say, 15-minute intervals and the viewer orders the 8.45 or 9 pm start. Such services also include information services that are more akin to a newspaper page or a website than television as we have known it, channels that relay radio stations along with some display about what is being played and Web access via the television. It should be clear from all this why digital television is a hot prospect when it comes to supposed 'convergence'.

BOX 9.3 DIGITAL TELEVISION

Digital television takes three main forms:

- *digital cable* where the digital signal is delivered via cable lines
- *digital satellite* where the digital signal is delivered straight to homes and businesses via a satellite dish
- *digital terrestrial* involves using the analogue aerial and television set to deliver pictures, so it has the advantage of cheap installation, and is widespread in the UK via the Freeview set-top box, but it has only been introduced seriously in two or three countries.

Cable and satellite companies are competing across Europe and the USA to take the lead in dominating digital. Cable is winning out in the USA, while satellite is leading the way in Europe.

While governments stress the provision of choice, using the rhetoric of neo-liberal marketisation, the reality is that the development of digital television has been driven by economic policy in an age where information society discourse holds sway. Hernan Galperin (2004: 25–52) has identified three main factors behind the remarkable rise of digital television.

- The perceived need on the part of regulators in the USA to **salvage the ailing consumer electronics industry** during the downturn of the 1980s. High definition television (HDTV) was perceived at the time as the new frontier in consumer electronics and a consortium led by the Japanese public service broadcaster was leading the way. Digital was seen as a way for firms in the USA and Europe to counter this, but spillover effects into related industries (telecommunications and computers) were also hoped for.
- **Information society policy** – The Clinton administration's notion of a National Information Infrastructure (NII) was a key development in information society thinking. This saw 'digital video' as a major driver of access to this NII. While the USA feared Japan, the EU feared domination by the USA and imitated its initiatives, most notably in the Bangemann Report of 1994 (Commission of the European Communities, 1994).
- **Spectrum shortage** – As we saw in Chapter 4, the notion that spectrum shortage was no longer such an issue was a legitimation for marketisation, but, with the rise of mobile telephony in the 1990s (with third–generation systems seen as a key basis for expansion in high-tech industries), spectrum shortage was becoming a key issue. Analogue broadcasting was seen as a 'spectrum hog' and digital as the solution. Unexpectedly, spectrum auctions for mobile telephony generated billions of dollars for governments, accelerating the international push towards digital.

The result of these various developments was that, by the end of the 1990s, the transition to digital television was a top priority for policymakers in the USA and the EU. The motivations were fundamentally economic. There is no doubt that the results have been beneficial for businesses in the consumer electronics, telecommunications and cultural industries, but what have been the social and cultural consequences?

EFFECTS ON CULTURAL CONSUMPTION

Like the politicians who have driven the rise of digital television, the corporations benefiting from its dissemination portray digital television as offering choice and interactivity to its viewers. But such choice comes at a cost. Digital television – even more than cable and satellite – has become associated with *pay-TV*. The advertising market for television was becoming saturated even in the 1990s (Kleinsteuber, 1998). The Internet has only made things worse. Expansion can therefore only be funded by charges for programming. 'Old' television, especially PSB, was cheap, even if some of its costs were hidden in the form of huge advertising expenses that were passed on to the consumers of the goods being marketed. When cable and satellite subscription services were introduced in most of Northern Europe in the late 1980s and early 1990s, the transnational cultural industry corporations owning these services used their vast capital resources to outbid rivals, including public service broadcasters, for the rights to premium programming, especially major sports leagues and events and films. This has meant enhanced, more detailed coverage of sport, but it has

also meant that, in the UK, football matches between leading domestic teams are rarely shown live on free-to-air television. Fans must pay a subscription of about GB£35 (US$50) a month for a package that includes live Premiership football or else find a pub showing the match.[9] However, digital television takes this introduction of payment for individual programmes a stage further. The set-top box that, in most digital systems, acts as a decoding device for the encrypted digital signals has a sophisticated ability to charge for pay-per-view programming. So, digital television subscribers are increasingly encouraged to follow the USA's practice of paying for individual items, such as recent Hollywood movies, porn and boxing matches. This allows the companies to profit from sudden, impulsive and sometimes drunken purchasing decisions in a way that was unimaginable 30 years ago. The costs of subscription and pay-per-view means that television may become vulnerable to the inequalities of access apparent in other media, such as the Internet. Whether or not this is the case will largely depend on the effects of digitalisation on the industry as a whole.

Although digital television offers an apparent abundance of choice, it seems that viewers tend not to be able to make real use of that choice. Research shows that 'when people have forty-eight channels to choose from, they basically use eleven; with seventy-five choices, they use twelve on average; when the number jumps to two hundred channels, people still only use thirteen' (McChesney, 1999: 148, citing research reported in *Adweek*, June 1998).

What about the supposed interactivity of digital television, which is supposed to transform TV viewers from passive zombies into active Internet-style explorers? Beyond the occasional experiment with choosing different camera angles, it is difficult to see any real inroads in this respect. The core of programming remains recognisable as television. As broadcast industry journalist Rod Allen (1998: 63) put it:

> the dominant purpose for which consumers use screen-based material will continue to be to enjoy narrative material. At its most fundamental, what this means is that people will look for *good stories well told*.

Allen extrapolated from this that the Internet will not radically challenge the dominance of television in the short term and predicted that the extra, interactive services offered by digital television will form a second level of programming that will be reliant on mainstream television's ability to maintain loyalty by means of the creative organisation and promotion of narrative material. So far he has been proven right. Meanwhile, however, massive changes in the television landscape continue to be legitimated by a rhetoric of choice and interactivity.

EFFECTS ON CULTURAL PRODUCTION

What have been, and are likely to be, the main effects of digital television on the cultural industries in terms of production and circulation?

9 I still invite anyone tempted to argue that pay-TV has revived communal sports viewing to join me on a Sunday afternoon or Monday evening to watch such football delights as Fulham versus Charlton in English pubs, deserted except for the pub manager, his dog and a few stray drinkers uninterested in the match.

First, the introduction of digital television has involved – to a degree unprecedented in any other medium – the kinds of strategic alliance discussed in Chapter 6 (this, if you recall, is my preferred way of thinking about what some would call 'corporate convergence'.) Complex networks of companies have worked together because a number of difficult and expensive technologies need to be combined to produce a workable system. The most important of these are conditional access systems, which involve encrypting the transmitted programmes and then developing decoding software for set-top black boxes. It also involves systems for installing boxes and (if necessary) satellite dishes and others for sending out decoding cards, subscription bills and advance information about programming. Add in the cost of subsidising installation in order to gain a critical mass of subscribers capable of attracting advertisers and the huge resources necessary for research, development, expertise and infrastructure make it clear why alliances of enormous telecoms, cable, computer and cultural industry corporations dominate the communications business today.

Second, huge amounts of content are needed to fill the hundreds of new channels. This favours a number of groups.

- Those who hold the rights to existing catalogues of audiovisual material. This confirms the increasing importance of ownership of copyright, apparent over many years (see Bettig, 1996, for details of how the cultural industry corporations consolidated their hold over film rights in the 1980s).
- Hollywood film companies, the USA's TV networks and those at the centre of the all-powerful content creation business in the USA, which will see their exports boom. On this basis, the various foundations of domination by the USA, outlined in Chapter 8, look stronger than ever.
- New independent producers – the largest of which have become significant industry players and lobbyists. Some of these make vast amounts of money from the international sales of programming ideas and formats. This has made them attractive to venture capitalists and other investors. The larger 'independents' are now thoroughly linked to financial capital.
- The 'creative talent' at the top of the celebrity scale, including sports people, and the talent agencies and managers who represent them. This widens still further the enormous inequalities noted by Miège between the underused pool of creative talent and a vastly overpaid few. In the 1990s, these stars increasingly operated as businesses in their own right, with significant independent production companies based around them (see Chapter 7).

Third, circulation remains central, in spite of the increasing importance of content and the increasing rewards for it. Those who run the distribution systems for digital television have a large say in which channels are adopted. Although regulators have attempted to ensure that producers and 'publishers' (that is, the television channels that make the programmes or commission them from other producers) are not discriminated against, there is no doubt that distributors use their competitive advantage to favour their own programming. This is particularly so in the design of electronic programme guides. In some ways, the situation here is akin to Internet search engines. There are so many channels on digital television that traditional print guides are becoming redundant. Instead,

viewers tend to look for quick information onscreen about what is showing. By placing their own programmes at the top of lists of particular 'bouquets' of channels, companies such as BSkyB, which owns the dominant digital TV system in the UK, can ensure that their shows are likely to be chosen ahead of those of rivals. For example, if you go to 'films' on the electronic programme guide for Sky Plus, you have to scroll down 14 channels operated by BSkyB, consisting mainly of films imported from the USA, and on to the next page of listings before you come to rival film channels.[10]

All this means that the commercialisation of television has made an important stride forward. PSBs are more beleaguered than ever, fighting to maintain their legitimacy as they are attacked by newspapers that are often owned by companies with a strong interest in the television market. Conditional access systems mean that charging mechanisms exist that may make the whole principle of television as a public resource redundant in the future. Those sections of the public with relatively high levels of disposable income seem to have accepted that it is worth paying a lot more for something not that much better – if at all – than what existed before. For all the rhetoric about choice and interactivity – much of it derived from Internet-speak – digital television remains very much the centralised, top-down medium that developed in the era of analogue broadcasting.

The introduction of digital technologies into the cultural industries was ultimately the product of post-war developments in the computer and consumer electronics industries. No development in the period since 1980 has been accompanied by such wild claims as has digitalisation (see Feldman, 1998, for an example of a Panglossian treatment of digital media). This chapter has shown that the term 'digitalisation' makes little sense unless it is discussed in the context of *specific* applications, *particular* digital technologies. Computer games are treated as dangerous, but have produced exciting innovations. The Internet has been hailed as the most democratic communications technology in history, but its exciting and progressive uses are in danger of being submerged by commercialism and recentralisation. Digital television has been introduced on the grounds of choice and interactivity, but offers little real progress for consumers, given the massive costs involved, and huge benefits for businesses in a range of industries. It also involves a much more thorough commodification of broadcasting.

It is worth comparing the Internet and digital television as new media. The decentralising potential of the Internet might have largely been captured by cultural industry and computing corporations, but this capture is not total – the Internet is still a medium where control is relatively dispersed and where, in spite of the problems associated with search engines, it is still possible to locate a variety of voices on any particular topic. As we have seen, this is because of a mix of factors, including its technological architecture and the countercultural values of its early users. Digital television may mean that individual channels and programmes have less public impact and power than in the analogue era, but new accumulations of power have appeared around circulation – which was always important but is now more so – and in certain types of content creation.

10 Thanks to my sister, Julie, for checking this.

The marginalisation of the notion of public service may mean the end of some dubious paternalist monopolies, but it also means that the best things associated with this ideal – that everyone in a society had the right to access to high-quality programming of all kinds – are being eroded. As I write this, in early 2006, the Internet and digital television represent the culmination of the story so far of transformation in the cultural industries.

The technologies discussed in this chapter have all had significant effects on cultural production and consumption, but not even the Internet and digital television have yet had *such* an impact that we can speak of a new era in cultural production. New industries, such as digital television, ISPs and computer games, all carry very strong inheritances from previous ways of organising cultural production. The characteristics of the complex professional era are still intact in the era of digitalisation – even down to the continuing domination of television.

FURTHER READING

Garnham's chapter on technology in his book *Emancipation, the Media and Modernity* (2000) is a very useful overview of issues concerning technological change in relation to the media.

Steven Poole's *Trigger Happy* (2000) provides an entertaining and informative journalistic treatment of digital games, while Aphra Kerr's *Digital Games* (2006) contains a useful chapter on the games industry.

From the vast Internet and Web literature, Tim Jordan's *Cyberpower* (1998) is lively and balanced, Robert Burnett and David Marshall's *Web Theory* (2003) clear and helpful.

A detailed early history of the Internet is *Where Wizards Stay Up Late* by Katie Hafner and Matthew Lyon (1996). On digital distribution of music, Patrick Burkart and Tom McCourt's *Digital Music Wars* (2006) provides a forceful political economy account. A more detailed version of my analysis of music digitalisation in this chapter can be found in Hesmondhalgh (2007). Simon Frith and Lee Marshall's *Music and Copyright* (2004) is excellent on the related rights issues.

Jan Van Dijk's *The Deepening Divide* (2005) offers a comprehensive discussion of digital divides, while Graham Murdock and Peter Golding's chapter 'Dismantling the digital divide' (2004) is a fine introduction.

Jeanette Steemers' *Changing Channels* (1998) is a useful collection on digital television. Hernan Galperin's *New Television, Old Politics* (2004) is the definitive study of the transition to digital television in the UK and USA.

10 TEXTS: DIVERSITY, QUALITY AND THE SERVING OF INTERESTS

In this chapter, I address the point at which the cultural industries arguably have their most profound effects on social and cultural life: texts. In what significant ways have texts changed since the early 1980s? In what ways has textual change/continuity then had reciprocal effects on the institutions, organisation and economics of the cultural industries?

I have divided my discussion of these areas roughly according to the issues raised when I dealt with textual issues in the evaluative framework offered in Chapter 2: choice, diversity and multiplicity; questions of social justice in relation to texts; and the issue of aesthetic 'quality'. Running through these are two main strands of discussion. First, against the reductive claims or assumptions of mass culture critics and some leftist commentators (including some political economy writers), I aim to show that the products of the cultural industries remain complex and ambivalent. Indeed, these qualities are becoming more apparent rather than less so amid the industrial and institutional changes since the 1980s that have been discussed in previous chapters. However, I also register some of the deep problems underlying texts produced by the cultural industries, against the complacent assumptions and claims of many media economists and other analysts. Second, I register throughout the difficulty of providing definitive answers to questions concerning such textual issues.

CHOICE, DIVERSITY AND MULTIPLICITY

One outstanding feature of the texts produced by the cultural industries in the complex professional era has been their proliferation.

- The number of new book titles published in the USA grew from 15,012 in 1960 to 53,446 in 1989 (Greco, 1996: 234) and this does not even include the huge numbers of backlist titles available.
- The theatrical release of motion pictures went up from 233 in 1980 to 483 in 2004 (Motion Picture Association of America figures).
- In 1990, there were 104 cable and satellite channels across Europe. By 1994, this figure had almost doubled to 198. By 1998, this larger figure had more than tripled to 659 channels, including digital terrestrial ones (*Screen Digest*, May 1999).
- Wolf (1999: 89) claims that nearly 900 magazines were launched in the USA in 1998 alone.
- In 1992, 10,716 albums were released on to the UK market; in 1999, the figure was 17,865 (*BPI Handbook*, 2000: 28).
- There is proliferation in news, too. In advanced industrial countries, more news is available to us than ever before, in the shape of specialist rolling news radio and television channels, on the World Wide Web and in newspapers and magazines.

Add to this increased output across the different cultural industries the increasing number of media technologies that most of us make use of in our everyday lives and it is clear that we are being exposed to an unprecedented potential amount of entertainment and information. However, recalling the discussion in Chapter 2, does this proliferation under conditions of increasing conglomeration, integration and corporate growth represent 'real' diversity or just 'meaningless' multiplicity (Mosco, 1995: 258)? In Chapter 9, I argued that the case of multichannelling in television suggests that, even as the number of channels increases enormously, there is not necessarily any real increase in diversity as the various new channels have tended, in the main, to provide only slightly modified versions of what was already available on the core channels that existed before. Most significantly of all, the availability somewhere in the market of many channels or albums or magazines or films, does not equate with knowledge or awareness on the part of audiences about a wider range of forms. Here again we return to the centrality of circulation in the cultural industries. Shops in any reasonably sized city in any advanced industrial country are bursting with more cultural products (books, DVDs, CDs, games) than most of us could consume in a decade of leisure, maybe even in a lifetime. The Internet now provides access to millions more, either by virtue of online shopping or in digital form. How to select from among them? As consumers, we rely on information provided in the form of promotion and publicity, often filtered for us by friends. Most of those products remain so unknown to us that they may as

well not exist. So we need to think carefully about claims that proliferation equals diversity.

Take the example of film consumption. Most of us mainly consume films made either in the USA or in the country in which we live. Films from other countries are available in rental and other shops and via online rental sites, but most of us 'choose' not to watch them. This might be because of laziness – 'Why would I want to watch a film with subtitles?' It could be the result of an arrogant parochialism on the part of some people, who might feel that they couldn't possibly be interested in anything foreign (unless it was from the USA). It could even be because films from the USA are great and everyone else's films aren't very good. This, though, seems unlikely as, even with their greater resources, why would film-makers based in the USA be more creative than people based anywhere else? (I am discounting the specious economists' assumption that quality can be equated with production budget.) The most likely explanation is that audiences are given little idea of what pleasures foreign films not from the USA might bring as they aren't promoted. So, narrowness of consumption remains a problem, even in an era of proliferation, because of problems concerning the information audiences receive about which products are available.

Proliferation does not necessarily equate with diversity, then, but is there any way of providing harder statistical evidence concerning trends in diversity? In surveys of the cultural industries as a whole, even those commentators who are concerned about concentration, conglomeration and integration have found it difficult to provide hard evidence of diminished diversity. Sánchez-Tabernero et al. (1993: 151–160) for example, in their chapter on consequences of media concentration, were reduced to offering observations on *potential* links that they recognise are unproven. Neuman (1991:141–2), who has a remarkable grasp of empirical work in the pluralist communication studies tradition, can cite only one 1970s survey of dubious relevance.

Some of the most developed debates regarding trends in textual diversity have been in popular music studies and the failure of scholars in that field to find adequate measurements is instructive. Also revealing are the difficulties of attempting to pin down the causes of any perceived trends in diversity.

POPULAR MUSIC, CONCENTRATION AND DIVERSITY

A seminal but flawed article by Peterson and Berger (1990/1975) attempted to quantify musical diversity and innovation and examine the relationship between changing industry structure and musical texts. Focusing on the period 1948 to 1973, they claimed to find evidence for two hypotheses:

- that there was a weak but inverse relationship between concentration and diversity/innovation – that is, the more concentrated the ownership of firms, the less diversity there was
- that this inverse relationship formed a series of cycles, whereby long periods of gradually increasing concentration and homogeneity were followed by brief bursts of competition and creativity.

Peterson and Berger's study had serious methodological limitations. They used top ten hit singles as the basis of their samples, even though by the late 1960s and early 1970s *albums* were a more significant format and the charts were inaccurate measures of sales. Also, they measured diversity by reference to lyrics, rather than musical form. However, aside from these problems concerning how to define diversity, their study also suggests that there are simply too many other, unquantifiable variables around to 'prove' any kind of link between concentration and diversity. For example, their figures for 1964 to 1969 show increasing concentration *and* increasing diversity – seemingly against their hypothesis of a weak but inverse relationship between concentration and diversity. They explain this problem by reference to sociocultural and organisational factors, such as new lyrical diversity brought about by the civil rights movement in the USA and the Vietnam war and increasing creative autonomy brought about by increased competition for talent among the oligopolistic firms. Similarly, increasing diversity in a period of reconcentration in 1970–1973 is brought about, in their view, by the conglomerates forming separate divisions that compete with each other. These suggestions are fruitful – so fruitful, in fact, that it is hard not to see such sociocultural and organisational factors as more important than ownership concentration.

Burnett (1992) applied Peterson and Berger's analysis to the 1980s and found historically high levels of concentration and diversity – a troubling conclusion for critics of oligopoly. Lopes (1992) reinforced these conclusions. Burnett (1995: 107–10) felt that the main factors behind such an apparently surprising conclusion were organisational. His explanation was that the maturing recording industry had found a way to deal with the problem of innovation in risky musical markets, by co-opting independent record companies and working with them in interdependent networks (see Chapter 6).

Christianen (1995) went much further than these previous studies by gaining access to a database of all albums released in the Netherlands between 1975 and 1992. He analysed diversity according to the amount of music available within 27 different popular music genres and found that, during a period of generally decreasing concentration, diversity and innovation generally increased, in that there was more of each and every genre in the Dutch market. This supported Peterson and Berger's argument, but he found that total demand was more significant than concentration in determining diversity and innovation. Yet, even Christianen's thorough analysis raises questions about definitions of diversity. His attempt to use genre as a means of thinking through diversity is admirable, but it flounders. This is because his genre classification is based on an old industry model unusable in the 1980s and 1990s, where a huge undifferentiated super-genre called pop coexists with dozens of regional folk musics and a few fringe genres (military music and the like). Genres mutate, hybridise, disappear and appear so rapidly that no genre classification would work over any historical period greater than three or four years.[1]

1 See Einstein (2004) for one attempt to get round these problems, in the context of a measurement of programme diversity in television in the USA, where, arguably, generic mutation is less rapid than in music.

In a historical survey of music charts in the USA from 1940 to 1990, Timothy Dowd (2004) has offered the latest chapter in the story of these debates. Like Burnett and Lopes, he emphasises the importance of interdependent networks or decentralised production and affirms their conclusions by showing that this led to greater diversity of performers and firms. Dowd says that new performers and independent firms do not create more musically diverse recordings than the majors. Instead, musical diversity rises because the majors co-opt emergent styles (p. 1445). Musical diversity is understood here by Dowd as the number of new performers and new recording firms in the mainstream market, but this is also linked, he claims, to greater diversity in musical content, which he sought to demonstrate in an earlier study (Dowd, 2000).[2] There, diversity of musical content was measured by exhaustively tracking 29 features associated with melodic, rhythmic, chordal, key and verse structure, in a random, unbiased sample of 110 of the 781 records that made number 1 in the *Billboard* charts in the period 1955–1990. Dowd's studies are without doubt the most thorough and impressive of the contributions to these debates so far. The problem here is whether a sample of number 1 records is really an adequate measure of diversity. Certainly, it is a good choice of sample, given the influence number 1 records can have on other performers, but it may be that the very concept of musical diversity within a particular nation over an extended time is simply not measurable quantifiably, without impossible resources of time and energy. Even a well-chosen sample fails to do justice to the concept being measured.

CASTELLS ON CONVERGENCE AS HOMOGENISATION

The obverse danger in cultural commentary is that assumptions will be made about homogenisation without any adequate content or textual analysis. Let me illustrate this by discussing just one example from a prominent commentator on contemporary society and culture before looking at more adequate discussions of questions of diversity in television in the USA.

In *The Rise of the Network Society*, Manuel Castells (1996: 364) wrote how 'in the second half of the 1990s a new electronic communication system started to be formed out of the merger of globalised, customised mass media and computer-mediated communication'. The past tense was odd, given that the book's publication date suggests that it was completed by March 1996 at the very latest. Castells acknowledged that 'the newness of multimedia' makes it difficult to assess their cultural implications (p. 369), but, he proceeded to develop a theory of cultural change around the emergence of the grand multimedia fusion (pp. 369–75), even though, by his own account, it started happening only after his book was completed! Some of the changes he discussed, such as audience differentiation and stratification, have been debated for decades and are discussed below, but the key changes he discussed were textual. First, there was the

2 I am grateful to Timothy Dowd for providing me with an English-language version of this paper.

integration (or convergence) of messages in 'a common cognitive pattern' (p. 371) – that news, education and entertainment are blurred together. To illustrate this, Castells drew on changes in television programming, where different genres of programming borrow from one another. How this reference to the television past was supposed to illustrate the multimedia future is not clear. Second, multimedia 'capture within their domain most cultural expressions, in all their diversity' (p. 372). The distinctions between audiovisual and printed media, popular and learned culture, entertainment and information are eroded. The result is (Castells, of course, actually meant 'will be') a 'culture of real virtuality ... in which reality itself is entirely captured, fully immersed in a virtual image setting, in the world of make believe' (p. 373). In other words, if you're not in the system, you effectively don't exist.

This culture of real virtuality was important in Castells' overall account of social change, because it produces profound transformations in the experience of space (pp. 376–428) and time (pp. 429–68). Yet, the only evidence he provided for such a transition is this reference to genre-blurring in television. This surely illustrates the perils of futurology in social and cultural theory (though the tenuousness of Castells' analysis of the media seemed to go unnoticed by reviewers of his book).

The homogenisation-through-convergence that Castells described/predicted seems unlikely even now. In predicting it, Castells showed the influence of the worst kinds of mass culture criticism. The complex professional era has seen a pattern whereby new technologies tend to supplement existing ones rather than replace or merge them, leading to an accretion of separate devices, though, of course, with television still dominant. In fact, what Castells seems to have been describing is television as it has actually existed during the complex professional era. As I pointed out in Chapter 9, television is about as close to a convergence of cultural forms as we are likely to get in any short-term projected future.

TELEVISION IN THE USA IN THE 'POST-NETWORK' ERA

Michael Curtin has provided a useful understanding of textual change in television, via a case study of representations of femininity. He (1999: 59) outlines a transition from the 'high network era' in which television was a mass medium, offering widely shared political and cultural experiences, premised on 'an interlocking system of mass production, mass marketing, mass consumption, and national regulation'. In the neo-network era of cable and satellite television, from the 1980s onwards, the cultural industries have pursued new strategies of transnationalisation (familiar from earlier chapters in this book), but also of fragmentation and an increasing focus on niche marketing. As a result, cultural industry executives now seek to expose texts using 'multiple circuits of information and expression. They ... seek less to homogenise popular culture than to organise and exploit diverse forms of creativity toward profitable ends' (p. 60).

The dual strategy of transnationalisation and fragmentation involves, according to Curtin, dual textual strategies – one focused on mass cultural forms aimed at national or global markets and demanding low involvement and the other

targeted at niche audiences and aimed at producing/circulating texts with 'edge' that produce very intense responses in their audiences.

As an example of the type of text that results from the first strategy, Curtin discusses the huge global success of the song 'Macarena' by Los del Rio, which began as a hit in Spain on a small label in 1993, but was distributed globally, in remixed form, by Bertelsmann's BMG record company and became a huge hit in the USA for the duo in 1996. The video for this single, shown right across the world, provided complex representations, says Curtin: Macarena is portrayed as powerful, in charge of her life, but ultimately the video contains her feminine desire via the appreciative gaze of the two, middle-aged male singers who approve her and this turns Macarena's active pursuit of pleasure into a mirror image of masculine fantasy (p. 62).

Curtin also discusses two texts as examples of the second strategy. First, *Absolutely Fabulous*, a BBC sitcom, first shown in 1992, which was a big hit on the USA's cable/satellite niche station The Comedy Channel. This is a show in which feminine desire is represented as 'voracious and uncontrollable' (p. 62). Unlike 'Macarena' (song and video), it makes little apparent effort to broaden its appeal. (Curtin is quite clear that the challenging nature of the programme is permitted by the nature of its audience – that is, middle-class women in advanced industrial countries). The second example is Alisha Chinai's 1995 indo-pop music video 'Made in India', which Curtin feels inverts dominant representations of desire 'by transforming the male body into the sight of spectacle', thus raising suppressed questions, such as 'What does an Indian woman want, need and deserve?' (p. 64).

Whether or not you agree with Curtin's specific interpretations, his analysis is a suggestive and, I would argue, successful effort to make links between changing cultural industry strategies and changing texts. He provides a compelling argument against the assumptions of homogenisation made by Castells and other writers.

Other writers have pursued similar avenues of investigation to Curtin's, including Amanda Lotz (2004), who analysed the production of a series called *Any Day Now*. This was produced by the USA's cable network Lifetime and ran from 1998 to 2002. As cable networks struggled to establish a brand identity and as their revenues grew in the 1990s, they began to devote resources to producing high-quality original programming. Lifetime's flagship was *Any Day Now* and, in Lotz's view, this provided an innovative look at the friendship of two women – one black, one white. Compromises and negotiations took place throughout the programme's making, but it explored the historical dynamics of racism in the USA in a way that would not have been possible during the network era. An important question that arises, though, as I discuss below, is **to whom is diversity really available?**[3]

3 Some of the cultural studies approaches discussed in Chapter 1 have made a real contribution to the sophisticated understanding of textual practice apparent in analyses of production by writers such as Curtin and Lotz. Some of the concerns of political economy – the industrial and institutional pressures on production – are evident, but there is a surprising neglect of this question of access and availability in work on 'post-network' television in the USA.

THE POLITICAL STANCE OF UK NEWSPAPERS

Analysing questions of homogenisation and diversity in cultural industries dealing in information, rather than entertainment, may lead to somewhat different conclusions. One example, discussed, among others, by Humphreys (1996: 77), is the UK's national daily press, which enjoys very high levels of readership and great political influence and has undergone a marked homogenisation, in terms of its political views, as its ownership has concentrated since the war.

In 1945, there were four Conservative national daily newspapers, two Liberal ones and two Labour ones. By the 1987 General Election, 7 out of 11 national daily papers supported the Conservatives, 2 Labour and 2 did not commit. What is more, the two Labour papers represented only 20 per cent of the total readership, even though Labour receives between 30 and 42 per cent of votes in general elections. Liberals are even more underrepresented. Yet, in 1992, in Humphreys' words (1996: 77), '70 per cent of the national daily readers and 62 per cent of Sunday readers were advised to vote Conservative'.

Even here there are problems in making the argument that there has been overall political homogenisation. It is not clear that support for the two main political parties provides an adequate measure of political diversity. Newspapers include stories elsewhere, other than in their leader columns, and some of these can be antagonistic to the party political position taken by the newspaper at the time of a general election. The *Financial Times* (the UK's equivalent of *The Wall Street Journal*) supported Labour in 1992, but its general ethos is pro-business.[4] The *Daily Mail* takes right-wing stances on most issues and yet its television and entertainment pages feature sympathetic coverage of, for example, soap storylines with progressive implications (this may derive from the greater editorial autonomy allowed to writers in these departments). The figures quoted do not prove that concentration *caused* homogenisation. There were other factors, too, such as the decline in circulation of The *Daily Mirror* – the main pro-Labour mass circulation newspaper.

The proliferation of texts in the last 20 years, then, does not automatically mean diversity. Nor can we assume it is the increasing size and scope of cultural industry corporations that have led to homogenisation or standardisation. The jury remains out. The task must be to find more rigorous ways of discussing diversity, including questions of *diversity for whom*. Quantitative studies of the kind discussed above, in the section on concentration and diversity in popular music, may be able to contribute to this, but they are unlikely to be sufficient in themselves.

4 A number of traditionally Conservative newspapers, such as *The Sun*, supported Labour (or, rather, the Labour Party's leader, Tony Blair – and this reflects the increasing 'presidentialisation' of British politics) in the successive general elections of 1997, 2001 and 2005. Most justified this support on the basis that the Labour Party would more competently deliver economic growth than the Conservative Party.

SOCIAL JUSTICE AND CHANGES IN TEXTS

Chapter 7 showed that there has been a huge increase in the size and scope of cultural industry corporations. These corporations are owned and operated by people with a significant interest in maintaining existing power relations. Has the period since 1980 seen any changes in the nature of the texts produced by the cultural industries, in terms of the interests they support and their potential role in promoting or inhibiting the pursuit of social justice? (See the discussion of these interests in Chapter 2.)

ADVERTISING, PROMOTION, COMMERCIALISM

In one respect, I think, a clear answer is available. The cultural industries have helped to bring about an unprecedented commercialisation of our everyday cultural lives over the last 20 years. In doing so, cultural industry companies have expanded their role, already emergent in the early years of the complex professional era, as the promoters of their own interests as companies – always their primary interest – and those of businesses in general.

Advertising is intended to sell goods and services, of course, and, in so doing, it often sells the idea that happiness or satisfaction results from consumption. Advertising is a cultural industry in itself, but nearly all the other cultural industries act as important vehicles for advertising, too. In fact, most advertising comes to us inserted in other media, except for billboard advertising (which, in a sense, is inserted into our living environments but, still, it is not carried by another medium).

An important change in texts over the period discussed in this book is that there is now more advertising around than before. In the 1990s, for example, all the major networks in the USA increased the average time per hour they devoted to product advertising. Robin Andersen (2000) quotes the following figures for each of the Big Four, comparing minutes per hour in 1991 to minutes per hour in 1996:

- ABC went from 9 minutes to 11.26
- CBS from 9.10 to 10.29
- Fox from 11.03 to 11.40
- NBC from 9.57 to 10.33.

According to figures cited by Matthew McAllister (2005: 219), in the USA, roughly a quarter of all time on advertising-supported broadcast and cable television is devoted to commercial and promotional messages and this figure is rising. In the late 1990s, the average child viewer was exposed to 40,000 television commercials a year, nearly double the figure from 20 years earlier (ibid). The growth of advertising is also strongly implied by the historical growth in general advertising revenues (see the figures collated in Chapter 3).

Just as significant as the increasing space devoted to advertising is a huge increase in the amount of promotional material carried by the cultural industries in texts that we do not consider to be advertising. Andersen (2000: 3) claims that placing brands in films really took off after the time when in *ET* (directed by Steven Spielberg, 1982) the title alien ate a certain brand of sweets and sales increased by 300 per cent. She provides many examples of more recent product placements and cites evidence showing that audience recall of such products is two and a half times greater when products are submerged in TV programmes than when they are advertised separately. Specialist product placement agencies match products to shows, such as *Dawson's Creek* to J-Crew clothes.

Andersen hints at the ethical questions surrounding a situation where clothes are being promoted not in a section marked as an advertisement, but hidden away in what purports to be 'just a story'. One agency believes that the greater effectiveness of product placement is because 'products shown in motion pictures or in television are perceived by the audience to be chosen by the star thus receiving an implied endorsement' (Andersen, 2000: 2). Product placement often masquerades as 'hip cynicism' (p. 4). Andersen (p. 4) gives an example from *The Wedding Singer* (1998), starring Adam Sandler:

> Sandler, playing the wedding singer, is lying in bed depressed after his fiancée has left him. A friend comes to visit, lies down on the bed [fully clothed] and says, 'Hey, these sheets are soft. Do you use Downy?' Sandler replies, 'No, All-Tempa-Cheer. You can wash your clothes at any temperature and the colours don't run together'.

So obvious, it's funny. Maybe, but the humour here is not at the *expense* of product placement, as in *Repo Man* (directed by Alex Cox, 1985), it is laughter at the sheer cheek of the film-makers for getting away with such blatant placement. Perhaps this is less offensive than the submerged quality of much product placement, but it is a close call.

Another important change in texts over the last 30 years is that they often promote other texts produced by the same cultural industry company. We can consider this on two levels. First, a particular channel or product will promote itself. In 1999, the USA's TV network ABC aired 7000 promotions for its own programmes – nearly twice what it had aired 10 years before (McAllister, 2000: 111). However, as a result of conglomeration and strategies of corporate synergy (see Chapter 6), companies increasingly plan and design texts in order to encourage subsidiary, spin-off texts, often of low quality. At the most prestigious, high budget end of the market, there is the example of *Batman* (Meehan, 1991). The rights to the character were bought by Warner Communications when it bought DC Comics. Besides reviving the comic, Warner (Time Warner from 1990 onwards) produced three films, plus soundtracks, novelisations and huge amounts of merchandising. The films and comics had their merits, but the spin-offs were blatant and imposing in their promotional quality. See Box 10.1 for a more recent example of such synergy strategies.

BOX 10.1 CHRONICLES OF SYNERGY

The release and marketing of the film *The Chronicles of Narnia: The Lion, the Witch and the Wardrobe* in 2005 illustrates how vast numbers of texts proliferate around a core text in the era of corporate synergy. The project of adapting C.S. Lewis' Narnia series of children's books was begun by Paramount Pictures but dropped after five years. It was then picked up by Anschutz Film Group (AFG). AFG negotiated a long-term franchise plan with C.S. Lewis' stepson and now owns the rights to make films based on all seven books in the Narnia series. AFG teamed up with Walt Disney Co. to cover distribution. Disney is paying for half the production costs. Unlike its rivals Time Warner and Sony Pictures Entertainment, which had long-term franchises with *Harry Potter* and *Spiderman* respectively, Disney was without a 'signature movie' and saw a series based on the Narnia series as a means to rectify this.

The film has spawned a number of 'secondary' texts. The book preceded the film, of course, but a massive re-release programme was initiated. Walden Media, an AFG and Walt Disney company, worked closely with the book's publisher HarperCollins (owned by News Corporation) on the release of 19 new versions of the book to coincide with the film's opening. Walden Media provided complimentary copies of the book to libraries in over 200 locations in the USA to replace worn copies. Over 100,000 teachers in the USA were also provided with copies of the book, as well as educational guides that included lesson plans relating to issues raised in the book. HarperCollins' imprint Zondervan released products into Christian bookshops and gift shops. Disney Interactive has published Nintendo and PlayStation Narnia games.

Many albums were also released that were officially associated with the film. The first was *Music Inspired by The Chronicles of Narnia*, distributed between EMI and released on Sparrow Records in September 2005. This was a collaboration by Christian artists. In December, a traditional movie soundtrack was released (produced by Walt Disney Records) and a CD+DVD special edition movie soundtrack featuring an extended score and behind the scenes footage.

Besides these various secondary texts, we can identify a huge number of what we might call 'tertiary' texts and activities more explicitly aimed at promoting and publicising the film. Prior to the release of the first film in the planned series, *The Chronicles of Narnia: The Lion, the Witch and the Wardrobe*, Disney placed the *Narnia* trailer on approximately 20 million DVDs, including those being released by Disney's ABC network, such as series 1 of its hit TV show *Lost*. Promotions of the film also appeared on screen during ABC network programmes such as *Commander in Chief*.

The marketing of Narnia drew on the strategies used for Disney's 1994 film *The Lion King*. Over 60 Narnia products were licensed. Marketing partners included Unilever, General Mills, Georgia-Pacific and McDonalds. Promotions appeared on Oral B toothbrushes, Quilted Northern toilet paper (as well as

(Continued)

(Continued)

paper towels and napkins from the Georgia Pacific company), McDonald's Happy Meals (which had 8 different pop-up story books with Narnia figurines), Verizon mobile phone packages, Energizer batteries and 21 brands of General Mills cereal. There were also Christmas displays in shopping malls where children could visit Santa Claus surrounded b props from the movie.

Disney also drew on the strategy used for the promotion of the immensely successful *The Passion of the Christ* and hired the Christian firm Movie Marketing to hold screenings of the movie in churches and promote *Narnia*-themed Bible study classes. Finally, as with *The Lord of the Rings*, tour companies now offer *Narnia* tours to places where the movie was filmed in New Zealand.

How good was this film, specifically designed to generate synergies and sequels? I like Anthony Lane's comment in *The New Yorker* (Lane, 2005) that the plodding allegory of the book means that the film 'seizes up with a kind of enforced pageantry … [E]ven the climactic fight between Peter's army of truth and the Witch's bevy of demons has an air of heraldic artifice, as if we were witnessing not a brawl to the death, red in tooth and claw, but an enamelled clash of ideas'.

How good, then, were the secondary and tertiary texts? Will even C.S. Lewis fans find their lives enriched by them? I can't say, but I for one won't be trawling the Web to find a copy of *Music Inspired by The Chronicles of Narnia*.

Sources:

Albright, Mark (2005); Grover, Ronald (2005); Marr, Merissa (2005); Prichard, James (2005); Rowan, David (2005); Toynbee, Polly (2005); Wasserman, Todd (2005).

I have already examined some of the implications for news of conglomeration. I mentioned in Chapter 6 that news organisations which are part of conglomerates do not necessarily fail to report negative stories about their owners. Indeed, such reporting can be a badge of their objectivity, concealing other silences and absences. Nevertheless, there is evidence that conglomerates use their news organisations to promote their entertainment products. Gitlin (1997: 9) gives examples from *Time* magazine – the world's most widely read news magazine, which is owned, as its name suggests, by Time Warner. *Time* put author Scott Turow, a Warner Books author, on its cover at about the time that Warner Brothers released the film of his book *Presumed Innocent*. It also featured a cover story on tornadoes in the week that the Warner Brothers. film *Twister* started showing in cinemas.

The most important feature of the commercialisation of texts is that it reinforces a continuing shift in the conception of political subjects under

neo-liberalism: we are less and less encouraged to think of ourselves as citizens; more and more we are treated as consumers. It would be quite wrong to say, however, that the *entire* function of the cultural industries is to support the interests of businesses or some abstract system called capitalism. This issue can be investigated by standing back to take a broader view of changes and continuities in entertainment texts over the last 30 years.

THE POLITICS OF ENTERTAINMENT

Is there any tendency, during the various changes (and continuities) of the last 30 years, for entertainment texts to have become more compliant, more likely to favour dominant interests in society?

The answer to this question is an ambivalent one. Many of these texts reflect the massive inequalities to be found in contemporary societies. They are riddled with sexism, racism and homophobia. They often show a cynical lack of interest in questions of public democracy or private suffering. Yet, alongside these undoubtedly worrying tendencies, the media and popular culture are full of emotions and sentiments that do not simply coincide with the interests of business. Rupert Murdoch, for example, has consistently supported the most socially and politically conservative causes as an individual and through his newspapers, as the discussion in Chapter 7 showed, but his Fox Television network commissions and broadcasts *The Simpsons*, which has provided a powerful and politically charged commentary on the traumas and limitations of life in the USA (see Downey, 2006). This is only one example from tens of thousands that can be construed as *not* supporting existing social relations, at least not in any simple sense of 'support'.

Here are some more examples of values, emotions and experiences to be found not just on the margins of the cultural industries but also often right in their very centre, at peak time, in prime time and with huge audiences.

- Popular culture is full of cynicism, anger, sarcasm, the celebration of lazy hedonism. Irony and pastiche are to be found everywhere – even in advertising, which was an irony-free zone until the rise of 'creative advertising' in the 1980s. In this sense, media texts have become generally more reflexive about their own operations. If a cliché develops, there is often – though by no means always – a team of comedy writers waiting somewhere to develop a sketch about it for a programme.[5]
- Alongside the many texts that fawn on power and wealth, in the shape of glamorous portrayals of the rich and influential, there is also evidence of radical scepticism about the claims of the powerful and a questioning of authority. The powerful and the prestigious are regularly satirised. The British Royal Family is treated, in some sections of the media, with

5. '*Rwanda Revisited* … a harrowing report from *Big Brother* 2 winner Brian Dowling'. An episode of the comedy series *Extras* broadcast in September 2006 featured this lovely parody of TV's misguided efforts to draw attention to poverty through the use of celebrities.

reverence and respect, but, elsewhere, it is also the object of ridicule and scandal-mongering.

- There is plenty of evidence of anger and rage in the media and popular culture. This is often undirected or else directed against those with no real power in society (such as hip hop lyrics directed implicitly at an imaginary peer-group enemy). Cultural forms such as hip hop and thrash metal, however, draw attention to the widespread existence of social suffering and counter the sentimental and optimistic implicit claims of other kinds of popular culture.
- A utopian belief in the hope of a better world and better society has also been present in popular culture throughout the twentieth century (see Dyer, 1981), but continues to be expressed in many musical cultures (such as rave in the UK in the late 1980s and 1990s) and much popular film.

These modes of thought and feeling are hardly ever directly subversive of oppressive economic and political power. They do not cancel out inequality, but reflect and reinforce the fact that the naturalisation of existing power relations is never complete.

Associated with these changes has been a reconfiguration and partial questioning of cultural authority (an issue raised by debates about postmodernism, but rarely addressed with adequate sociological imagination). There are new relationships between 'high' and 'low' culture. These have not been fully democratised – the rich continue to have extremely different cultural habits and tastes from the poor. As Richard Peterson and Roger Kern (1996) have shown, the educated have become more omnivorous in their tastes, indulging in low culture, while maintaining an interest in high culture. This is easily mistaken for a postmodern blurring of high and low, but the less educated continue to be excluded from, and/or are uninterested in, high culture.

We need, then, to keep in mind the notion of *contradiction* in examining the role of transnational corporations in the cultural industries. As I pointed out in the Introduction to this book, such contradictions derive, in part, from the fact that cultural industry companies are happy enough to disseminate cynical or even angrily political works as long as they produce a profit (or else prestige that can be turned indirectly into profit). However, they are perhaps less happy to allow for the provision of information that provides an analysis of overall power relations. This takes us to the issue of changes and continuities in news journalism.

THE NEW NEWS

Journalism can play an important role in providing citizens with informational resources to counter social injustice. We saw in Chapter 7 that there is more commercial pressure on news organisations than ever before and I noted evidence above that this has had some impact on some aspects of news reporting. As a result, has journalism's capacity to promote social justice been diminished in the period under discussion? Has there been a decline in standards?

Robert McChesney's response (1999) is unequivocally yes. For him, recent trends in journalism represent a collapse of the standards of professional reporting founded on the goals of objectivity and public service. McChesney is careful to point out the limitations of professional journalism as it developed in the USA in the twentieth century: that journalists were never as objective as they claimed and were always prone to falling in line with commercial and government forces. He highlights long-standing silences and absences in news media coverage concerning the incredible size of the USA's military budgets and the activities of the CIA. Nevertheless, he (p. 51) portrays the period after the Second World War as a kind of golden age when 'the calibre of professional journalism prospered and developed a certain amount of autonomy from the dictates of owners and advertisers, and from the corporate sector as a whole'. As evidence, he points to staff cuts and an increasing tendency towards soft news, such as celebrity lifestyle pieces, court cases, plane crashes, crime stories and shootouts, which are uncontroversial and cheap to cover. He cites figures that show international news was cut back from 45 per cent of the network TV news total in the early 1970s to 13.5 per cent in 1995. Meanwhile, the annual number of crime stories on network TV news programmes tripled between 1990 and 1992 and 1993 and 1996 (p. 54).

Numerous other critics echo McChesney's points, including many professional journalists. Others, however, have taken the view that new technological developments, such as the development of camcorders and mobile phones, and the Internet and World Wide Web, are leading to a democratisation of news reporting. Blogging is perhaps the most significant of these. Stephen Coleman (2005: 27), for example, has argued that blogs 'diminish people's needs to be spoken for by others' and at their best 'provide a channel for authentic expression that is free from the repressive controls of traditional media'. Terms such as 'citizen journalism' and 'participatory journalism' have been used for other related developments (see Gillmor, 2004, for one prominent advocate). Perhaps the most notable case is the South Korean website Ohmynews, which supplements professional reporters and editors with freelance contributors who are 'ordinary citizens'. The resulting news is often interesting and certainly different from that of the established news organizations. Here we return to the issues raised in the discussion of Web 2.0 in the previous chapter (see Box 9.2). Does the celebration of such practices risk underestimating the importance and integrity of professionalism at its best?

Whatever the answer to this question, innovations such as blogging and 'citizen journalism' are unlikely, in themselves, to transform traditional news organisations. The notions of blogging and its radio cousin podcasting are already under threat as news organisations appropriate the terms for their own outputs and as star bloggers and podcasters begin to emerge on the Web. Such developments are part of the increasing imperative for news organisations to be seen as being responsive to technological developments and as able to give a sense of immediacy. There may be echoes here of the way in which TV news organisations, under increasing competitive pressure because of the rise of new channels and the application of the audience ratings system, have used technological innovations. The falling costs of high-quality field equipment means that local stations increasingly send reporters to distant places to give a sense of immediacy, but, for Andrew Calabrese (2005:

275), the resulting coverage 'lacks any depth of analysis and perspective'. Amateur video is touted as community involvement, but 'the content of such footage is rarely newsworthy in the traditional sense' (p. 276).

Although his piece preceded claims about the effects of blogging and 'citizen journalism', Daniel Hallin (2000) has provided a useful overview of problems relevant to all these developments. He (p. 221) points to a number of changes marking a new era in US journalism:

- the fragmentation of the news media, with more and more outlets claiming to be journalism
- a blurring of the line between news and entertainment
- a growing uncertainty on the part of journalists about their role – should they be objective informers or take partisan stances, showing empathy with the people they deal with?

Hallin outlines a number of reasons for these shifts. Some are commercial, such as increased competition from local news, the rise of news magazine programmes and the greater concern of the conglomerates with 'the bottom line'. Others are political and cultural, including a decline in the high prestige of public affairs in the decades after the Second World War, the increasing presence of women and ethnic minorities in newsrooms (which made the former model of professional objectivity harder to sustain, as female, Latino and African American news workers detected bias in such supposed objectivity) and the increasing challenge to the separation of private and public realms from feminism and media texts themselves. (Hallin thus allows for feedback from texts to the cultural industries.)

Hallin refuses to portray changes in journalism over recent decades as either out-and-out decline or steady improvement. He finds that new formats for representing political debate do have a certain inclusiveness that was not present in the golden age. Against those who mourn the rise of 'infotainment', he points out that news and entertainment have never been absolutely separate and good journalists have always been good storytellers. Tabloid television does at times, Hallin claims, give a voice to individuals who would not have gained access to the old journalism. Some of the stories mourned as 'soft' by professional journalists, such as when the character and actress Ellen came out as a lesbian on the sitcom of the same name in 1998, can, says Hallin, be seen as equally important in public life as the inside-the-beltway Washington stories that passed for hard news in the golden age of professional journalism. Nor is Hallin sure that the move towards interpretative reporting, whereby journalists bring their own subjective responses to bear on a story, necessarily represents a fall in standards.

Nevertheless, Hallin is absolutely clear about the negative aspects of developments in journalism. There is a tremendous amount of sensational coverage of ultimately trivial matters. Tabloidised news, on television and in newspapers, depends 'heavily on the exploitation and amplification of fear' (p. 231). The ethos of professional neutrality helped to resist the imperatives of owners, but was increasingly eroded in the 1980s and 1990s. While there has not yet been a return to the era of newspapers acting as vehicles for the views of their owners, Hallin (p. 233) worries that the 'new Fox news division ... reflects the politics of

owner Rupert Murdoch in a way we have not seen at a major news organisation since the death of *Time* founder Henry Luce'.

In Europe, the decline of news journalism's potential to promote social justice has also been the subject of much debate. Here, the split between broadcast news and the press is very strong. The decline of PSB has brought about debates very similar to those in the USA regarding the decline of journalism. However, the press in Europe has always been much more partisan than in the USA and this has been true of both tabloid and broadsheet newspapers. In the UK, the tabloid press was already heavily reliant on sensationalism and scandal even before the new era of conglomeration, but these tendencies seem to have been reaffirmed. Every so often, a tabloid newspaper surprises its readers with a piece of excellent journalism. One example was in November 2000, when former Texas governor George W. Bush was standing for President. The *Daily Mirror* led its front page with an exposé of Bush's record of prisoner executions. Four pages of photographs and descriptions made clear the horrendous nature of the crimes involved, but also how many of these executions were of men from ethnic minorities. This drew attention among working-class readers in the UK to the practices of the man who would become the next president of the most powerful country in the world and helped raise awareness of some of the complex social issues behind violent crime. In general, however, there has been continuity in the UK's journalism – the ethical standards of tabloid newspapers were abysmal in the 1960s and 1970s and they have remained abysmal.

SOCIAL FRAGMENTATION AND MARKET SEGMENTATION

Another important and much discussed change since 1980 has been that more and more texts are produced for particular segments of the audience rather than a 'mass', undifferentiated audience. This is partly a result of more products entering cultural markets as leisure time and disposable income have increased in advanced industrial countries. It is probably also a result of social fragmentation, as people diverged more and more in the ways that they spent their leisure time.

What have been the main causes of this social fragmentation? For Russell Neuman (1991: 116–17) the key factors are increasing levels of education (the strongest demographic predictor of breadth of cultural pursuits), a 'rebirth of pride in social differentation', plus the increasing numbers of unmarried (Neuman probably means 'childless') young adults with energy and income to spare. We can assume that social fragmentation has been accelerated by the increasing number of cultural options available for people as a result of developments in the cultural industries.

For Joseph Turow, advertisers and advertising have had a crucial role to play. Since the rise of large-scale advertising in the late nineteenth century, mass and target marketing had always coexisted, but the 1980s saw 'the emergence of target marketing as a hot, hip, even central, strategy after decades of being considered a relatively marginal part of the national ad industry's thinking' (Turow, 1997: 19). The increasing sophistication of demographic information and the market research discussed in Chapter 7 began to guide the way in which the advertising industry

and TV networks talked about programming in the late 1960s and early 1970s, but it was only in the 1980s that target marketing really began to take hold. This, says Turow (p. 36), was not so much a product of technological change as of the belief on the part of advertising practitioners that technological changes 'were themselves symptoms of a more profound change in America'. Segmentation was also a result of changes in the way that executives and creative managers conceived their relationship with audiences. Jane Feuer (1984: 3–4), for example, describes the shift in the USA's network television at the beginning of the 1970s away from 'total audiences' and towards 'demographics'. It was discovered that young, urban adults (especially women) aged 18–49 were the main consumers of the types of goods advertised on television. The result was that, from the early 1970s, the networks competed to offer programmes aimed at this demographic group alongside the 'mass' programming that had formed the staple of prime-time programming since television became widespread in the late 1950s. Stephen Driver and Andrew Gillespie (1993: 186) describe how, as the circulation of mass market magazines in the UK declined from the 1960s to the 1980s, magazine publishers sought refuge in targeted readerships and niche markets. This has helped to drive the proliferation of magazines, as advertisers use specialist publications to target consumers more specifically.

Some commentators have been concerned that audience segmentation means the end of television's role in producing a 'public sphere' in which issues of common concern for a society can be highlighted (see Stevenson, 1999, for a sophisticated discussion of a number of related issues) and here we see the relevance of the issue of segmentation for questions of social justice. This is particularly a concern for European writers (Keane, 1991), impressed by PSB's ability to introduce people to new subjects and ways of thinking. However, we should not rush to hasty prognostications about segmentation without more examination of the evidence.

Are we *really* seeing a transition – brought about by the changes in the cultural industries in the 1980s and 1990s from an era of mass audiences to an era of segmentation and specialisation – as many commentators (such as Castells, 1996: 340–1) claim? Audiences have always been very much segmented, particularly along gender lines, in that movies, magazines, radio serials and so on have often been explicitly aimed at women. Mass markets also continue to be central to the cultural industries. Magazines are perhaps the most niche-orientated of all the cultural industries and there were over 18,000 consumer and business titles being published in the USA alone in 1997, according to the Magazine Publishers of America (MPA). Yet, at the end of the 1990s, according to *Advertising Age*, the advertising and circulation revenue brought in by the 10 largest consumer magazines represented over 26 per cent of the US$25.8 billion achieved by the top 300 titles (Standard & Poor's *Publishing Industry Survey*, 13 May 1999: 10). *TV Guide* alone earned US$1.1 billion. As we saw in Chapter 7, the film industry revolves more than ever around the production of mass market blockbusters and the recording industry is still centred on the big hits that cancel out the misses and global superstars who provide 'brands' across a series of releases.

It is, above all, the rise of multichannel television and the Internet that have led to increasing claims and anxieties about market segmentation and social

fragmentation. The Big Three networks' share of the prime-time viewing audience fell from around 90 per cent in the 1970s to below 50 per cent by 1996–1997 (Caves, 2005: 30). Cable was in under 18 million homes in the USA in 1980, but reached 73 million by 2002, and the average number of channels per household had increased to over 60 by 1999 (p. 127).

Even these figures should not be overinterpreted, however. Surveying an impressive range of audience research in the mid-1990s, James Webster and Patricia Phalen (1997: 114) concluded that 'mass appeal network television still dominates media consumption in the United States. That is not likely to change any time soon'. Segmentation, then, is best thought of as a gradual and uneven process linked to social fragmentation, but with shared consumption of hit texts likely to stay a feature of consumption.

How should we view market segmentation in terms of its effects on society (see Box 10.2)? It certainly cannot be dismissed as a bad thing, in and of itself. It is hard to object to the provision of television channels catering to specific minority audiences. Nevertheless, we can point to some unfortunate ways in which segmented viewing practices reflect and reinforce more negative aspects of social fragmentation in ways consistent with the concerns of writers working in the Habermasian tradition of 'public sphere' thinking.

An interesting example is the long-standing, and perhaps increasing, tendency for black and white audiences in the USA to consume different media products. Oscar Gandy (2000) cites some statistics on this. Only *Monday Night Football* occurs in the top ten most-watched television programmes of both black and white audiences. This suggests that the super-commercialised world of sport in the USA at least provides some kind of common culture for white and black people. However, more strikingly, the figures also suggest that, in general, there is a vast gulf between the tastes of these different ethnic groups. Of course we can value difference and recognise the fact that different peoples may have different tastes, but with disparities this pronounced, it is hard to imagine any kind of national public sphere that would bring together black and white citizens in the USA over issues of common public concern. As Todd Gitlin has pointed out, the question here is whether democracy requires *a* public or a *set* of publics, a public *sphere* or 'separate public sphericules' (Gitlin, 1999: 173). While the Internet may enrich the possibility of a plurality of publics, says Gitlin (ibid), such an arrangement can only be welcome if we assume 'a rough equivalence of resources' and a situation where 'society is not riven by deep-going fissures which are subject to being deepened and exacerbated in the absence of ongoing negotiation among members of different groups'.

BOX 10.2 THE HBO MODEL: HIGH-QUALITY TELEVISION IN THE USA, BUT NOT FOR EVERYONE

In the words of journalist Joy Press (2004), 'It's a great time to be a couch potato – if you have cable, that is'.

A worrying aspect of segmentation is that programming requiring effort, skill and creativity (all of which cost money) might increasingly come to be

(Continued)

(Continued)

provided for wealthier, more educated audiences, while working-class ones are left with cheaper, less prestigious programming.

In the old network television system, the urban upper middle class might have been more inclined to watch *Hill Street Blues* – the most acclaimed US drama series of the early 1980s – than the working class, but the programme was still *available* for the working class to watch on network television in the USA and various television systems in countries where the programme was imported. As the series developed, it gained a mass audience (see Feuer et al., 1984).

By the late 1990s and early 2000s, television companies in the USA were producing a large number of high-quality programmes. This has led some commentators (for example, the writer Steven Johnson, 2005) to argue that television – along with other cultural forms, including games and films – is becoming richer and more complex. As journalist Dana Stevens pointed out in a dialogue with Johnson in *Slate* (10–13 May 2005, available at http://slate.msn.com), Johnson's praise for the cognitive complexity of an hour-long episode of the TV programme *24* fails to mention that, when shown on television in the USA, a full third of that hour is made up of one-minute advertisements.

Many of the new generation of high-quality TV dramas have been produced by cable channels. This is because, by the late 1990s and early 2000s, the USA's cable television had expanded to the point where it was able to pump considerable resources into original programming, rather than merely show old network shows or cheaper imitations of genres and formats developed there (see Caves, 2005: 127–54). (Cable and satellite television channels in Europe are still at this stage and produce little original programming of any worthwhile quality.)

A related factor in the rise of the quality of television in the USA is that cable channels have attempted to 'brand' themselves by means of expensive and carefully crafted series, such as Showtime's *The L Word* or FX's *The Shield*. The most prominent producer of high-quality television in the USA's market is premium channel HBO, renowned for *The Sopranos*, *Six Feet Under* and *Deadwood*. In principle, this channel is available to working-class viewers, if they can afford it, but programming is targeted at the concerns and lifestyles of upper middle-class people. (This can be contrasted with, for example, the BBC's equally good drama serial, *The Street*.) The same might become true of news – that the wealthy and educated, who feel they have a stake in national policy, get hard news, while the working class get tabloid television. Debates about the erosion of national public spheres have helped draw attention to such potentially negative aspects of segmentation.

DECLINING QUALITY?

I now turn to a consideration of various aspects of debates about the decline – or rise – in quality in contemporary culture in the era of expansion of the cultural industries.

SHORT ATTENTION SPANS, SHOCK AND CULTURAL AUTHORITY

Does the proliferation of texts produced by the cultural industries in fact represent an abundance of rubbish?

One important issue here is the increasing volatility and ephemerality of culture referred to by David Harvey (see the discussion of his book, *The Condition of Postmodernity* (1989), in Chapter 3) and explained by him as a product of time–space compression, in turn brought about by the need of capitalist businesses to accumulate profit. Speeding up is manifested in audience behaviour. Audience research suggests that cultural consumers increasingly want their products in bite-sized and portable chunks, as people monitor their daily time much more carefully than they used to and form it into grids (see Wolf, 1999: 38–40). There is an increasing tendency to skip from text to text – not only channel-surfing or skipping between tracks in a CD selector or MP3 player, but moving between the various media on offer. There are pleasures in such skipping, but does this have negative effects on the quality of cultural texts, as many cultural commentators have argued?

The proliferation of texts means that cultural industry corporations are faced with the task of finding new ways to capture and retain attention, with potentially negative consequences for the human experience of narrative and argument. Ratings-hungry producers increasingly resort to shock tactics in order to keep the attention of audiences. This has meant much greater sexual explicitness, which might help to challenge prudery and puritanism and, in some cases, encourage people to experiment with different forms of sexual behaviour and identity. In many cases, however, it means an explosion of unsubversive titillation and unimaginative, unerotic pornography. The impulse to shock has also led to much greater levels of violence on television, too, as study after study has shown. Whether this makes people more violent or not has never been proven conclusively.

Textual proliferation should not necessarily be thought of as welcome abundance, then. In order to generate a feeling of specialness amids the mass of product, conglomerates spend more and more money on promotion. The concept of the 'media event' – developed by Daniel Dayan and Elihu Katz (1992) to describe important moments arranged outside the television institution but covered by television – needs to be supplemented more and more by the television-generated event, even if they are rarely yet as significant as major sports events, coronations, royal weddings and funerals. The last episode of *Seinfeld* and the release of *Star Wars: The Phantom Menace* in 1999 were just two successful examples of massive promotional efforts by cultural industry companies helping to create a special level of publicity for a text. As the rhythms of consuming television change and people become less accustomed to watching scheduled programmes on a weekly basis, broadcasters are turning to 'event television', involving long-running competitions and major sporting events, to generate ratings.

This has had unexpected and complex consequences. There has, for instance, been a surprising revival of liveness, which was a pervasive feature of early television, but, because of the high risks involved, gave way to playing prerecorded shows from the 1960s onwards, as video and film became cheaper and easier.

For Nick Couldry (2003: 99), taking an unusual and thoughtful critical Durkheimian perspective from within cultural studies, this leads to a reaffirmation of the status of the media – especially television – as 'a privileged connection to a social centre'.

The competitive drive to create events – 'water cooler television' is now one of the most hackneyed phrases in UK cultural journalism[6] – is one of the forces behind the growth of reality television. This phrase covers a wide range of texts, but has most often been applied in recent years to two related genres:

- game shows, which claim to show us the reality of people's lives or personalities, whether these are 'ordinary' people or celebrities
- documentaries, in which 'ordinary' people are observed facing some kind of challenge or situation.

Big Brother and *Wife Swap* are perhaps the paradigmatic cases of each genre respectively, at least in the UK. Such programmes have been lambasted for their voyeurism, but this seems to me to be an uninteresting criticism. They have also been dismissed as cheap, but many are not. In fact, they involve massive amounts of investment, planning and research. A better way of expressing the problem is provided, again, by Nick Couldry (2003: 107), who notes that the programme makers' claims to be showing reality, to be revealing the inner depths of ordinariness, help to bolster television's status as special, as above the ordinary world.

It can be argued that there are counter-currents to this. Industrial cultural production is not nearly as special as it once was. Television has lost the massive cultural authority it had in the 1960s and 1970s as low-budget variations have proliferated. If press representations of audiences' views of television are anything to go by, controversies in the UK and elsewhere (notably Japan) in the early 2000s about 'docusoaps' and talk shows were a sign of increasing disenchantment and scepticism about television. Such doubts about the aura of television and other media represent a positive development. The problem is that such scepticism can coexist with an underlying *trust* in television, as Couldry emphasises.

However, there are still ways in which the authority of cultural producers is questioned. The desirability of alternative or underground production is one – certain genres, styles and textual forms are considered to be innovative because they are created in a context that seems to resist commerce. Here we are back to the creativity–commerce dialectic, which, as I have stressed throughout, can sometimes take naively expressed forms, but can nevertheless serve as a basis for questioning the way the cultural industries operate.

The problem is that these underground art worlds are increasingly subject to co-optation. Texts are introduced to other audiences, which may be perceived as 'mainstream', by the original audience for them. A burgeoning set of specialist journalists gain money and credibility from being able to spot such forms of

6 That journalists use this phrase shows how cut off they are from the worlds of their audiences and how they look with unselfconscious awe at their colleagues in the USA. The UK rarely gets hot enough for workplaces to need water coolers. The true UK equivalent, perhaps, is the coffee machine, dispensing dangerously bad caffeinated drinks.

underground activity and bring them to the attention of some wider audience, whether in the form of comics, fanzines, music genres or movements of film-makers. Yet, the sense of the underground as a sacred cultural sphere, away from profane commerciality, remains undiminished and is perhaps even enhanced by the institutionalisation of such cycles. Such undergrounds are rarely a real 'resistance' to the large corporations that dominate the cultural industries, but they often represent a partial questioning of them.[7] They help to maintain an independent sector in many cultural industries – at least until the conglomerates become aware of these new styles or genres.

COMPARING QUALITY:
BOOK PUBLISHING

Proliferation and speeding up have ambivalent results, then. But let me now turn more directly to the issue of whether or not the overall quality of cultural texts has declined. Many people assert that this is the case, but providing substantial evidence is a different matter altogether. A rare, brave example of someone who is prepared to take this issue on is a chapter by a leading political economy writer in the USA Mark Crispin Miller (1997) on the decline of book publishing in the era of conglomeration.

Miller argues that, in spite of the seeming proliferation of books in the dominant chains (Borders and Barnes and Noble in the USA, Waterstones in the UK), things are very bad in book publishing. He (p. 113) contrasts book publishing in the mid-1990s with a previous era, before conglomeration, when publishing was not 'a profit-centered venture but a true labour of love'. The new focus on profits has, says Miller, led to a serious decline in quality. The common run of literature, he admits, has always been 'lousy' (p. 114): 'Revisit any seeming "golden age" and read it all, and what you'll find is mostly dreck', he says, and he goes on to survey some of the golden ages. However, 'there's been no golden age – and yet books have gotten worse: worse in every way'.[8]

What evidence does Miller provide of this diminished quality? He tells the story of the decline in standards in three publishing companies (Little, Brown, Random House and Bantam Books) once they were taken over by conglomerates. Whereas once they published great novels and serious commentary, these corporations now sell various other books Miller objects to in a variety of different ways. These other books include novels that may become films made by major studios (p. 108), romans-à-clef about famous people (p. 111) and books concerning stars and entertainment products distributed by other conglomerates (p. 108). Miller seems to have a particularly violent objection to books about

7 The work of Bourdieu on 'restricted production' is important and useful in this context (see Bourdieu, 1996, and Hesmondhalgh, 2006a, for discussion), but, ultimately, I find his approach towards small-scale production to be too haughty and cynical.

8 Miller also offers copious examples of books that seem to have been developed in order to benefit from or cross-promote texts and divisions from other parts of the same company. He seems to object to this on the grounds that it gives these firms an advantage in the marketplace, but he also strongly suggests that it results in poorer products.

cooking, gardening and interior design (p. 111). He also claims that standards of proofreading have slippped genrally (just kidding) and that many books lack indices and notes. Poor commissioning practice has resulted in many books that are poorly edited, overlong and badly argued and he quotes reviews from *The New York Times Book Review* to prove this.

In comparing the eras before and after conglomeration, Miller says that the previous lists of the major publishing houses contained nothing as 'half-baked, ill-informed, and crudely written as Newt Gingrich's *To Renew America*, or as prolix, muddled and me-me-me-me as Nancy Friday's *The Power of Beauty*' (p. 116). Meanwhile, the Duchess of York's memoirs are 'empty and self-serving', and children's books contain nothing about 'boogers, farts, or puking' (p. 116).

Miller seems to be making two arguments: that the overall quality of books is declining and this is associated with an unethical, excessive concern with making money on the part of conglomerates. The main evidence for the latter claim seems to be the first – that they publish bad books. Miller moves back and forth between an ethical condemnation of the overly commercial practices of the companies and a denunciation of poor aesthetic standards. For example, his objections to lifestyle books seem primarily based on the fact that they allow 'synergies' with other wings of the same conglomerate, such as cooking, gardening and interior design magazines. The old publishers, he writes (p. 117)

> ... did their share of the eternal dreck, but for them it was a necessary evil – and that, finally, is the crucial difference between then and now. As book lovers and businessmen, they did the high-yield trash in order to be able to afford the gems they loved (although the gems might also sell).

Today, says Miller, 'crap is not a means but (as it were) the ends'. However, his main evidence for this is that the companies which formerly fostered good writing now publish crap, alongside the good stuff. So the bottom line of his argument is aesthetic – that the resulting texts are poorer than they used to be.

The problem is that the argument for overall decline is impossible to substantiate in this way. To compare two different eras fully would be impossible – more books were published in 1950 than could be read in an individual's lifetime and more books were published in the year 2000 than a 12-strong research team could read in 3 decades. Thus, any statistically significant sample would be too vast to handle in a realistic period. Miller is perhaps therefore entitled to engage in cultural criticism. Nevertheless, he might at least have made reference to the possibility that others might find the books published by the major companies pleasing or useful or beautiful. Instead, his argument rests on his own particular tastes in books.

The nature of Miller's tastes is quite clear: he likes highbrow literary fiction and serious political and cultural commentary. Therefore, his argument about declining quality (as opposed to the ethics of preferring commerce over creativity) ultimately rests on his claim that highbrow literary fiction and other serious works, such as political commentary, are undersupplied by the book publishing industry. However, his evidence for this amounts simply to showing that three companies

which used to specialise in such books now publish other, more commercial books, too. Miller hardly mentions the dozens of small publishing companies and university presses in the USA catering to the tastes of educated readers.[9]

Having said this, I am sure that Miller's concern is not about whether or not his own tastes are being satisfied. Rather, he is worried that the most powerful companies in the market are encouraging people to read substandard books. This is a valid concern. The problem is that he cannot prove that this is happening using evidence drawn principally from such brief references to his own personal tastes and changes in three companies as they have passed from independence to conglomerate divisions. He hints at important points about the lack of concern with the quality of the finished work within conglomerate organisations, but, beyond his suggestions that there are more typos in corporate books than there used to be, can only prove this by reference to the fact that he, and a few reviewers, find the books overblown, superficial or lacking in various other ways.

My close reading of Miller's analysis is intended to show the problems surrounding a critique of the cultural industries on the grounds of aesthetic quality. I have scrutinised this piece carefully not because it is an example of bad writing – I suspect that it was intended as a polemic, rather than as a fully argued piece – but because it illustrates a problem typical of much work in the field of political economy. Arguments are often made that rest on an unacknowledged assumption that readers will share the aesthetic tastes of the writer. Of course, it is not always possible to forefront and examine problems concerning differences in taste. Nevertheless, the limits to Miller's approach suggest that arguments based almost entirely on insufficiently scrutinised aesthetic criteria need to be treated with caution.

QUALITY, INDEPENDENCE AND NICHE MARKETS: CINEMA IN THE USA

We can address such issues of quality further by discussing another important cultural industry – cinema. As I hope is apparent, I am not saying that we should be complacent about the quality of products disseminated by the cultural industries, but merely that bold statements about such quality tend to conceal important issues. The case of independent cinema in the USA over the last 30 years offers a useful case study of the relations between the cultural industries and their resulting texts.

Many commentators feel that there has been a decline in the standards of mainstream films from the USA since the 1970s with the rise of special effects blockbusters (see, for example, Biskind, 1998). On the other hand, many young, urban, educated cinephiles would point to a richness in its film-making, especially its independent cinema, during the 1980s and 1990s.

9 To some extent, I share Miller's tastes for literary fiction. Speaking for myself, there are more novels available that I would like to read than I could, even if I read a novel a week for the rest of my life and lived to be 100 (about 3500 novels). These novels are generally pretty cheap. This does not even include the other books that I would like to read. I suspect the same would be true of most individuals who enjoy reading books.

Particularly in cinema it is often felt that institutional 'independence' (as we shall see, this term is weighed down by problems of definition) can help foster better texts. There are echoes of this view in popular music, too (see Chapter 5). Independent cinema received huge coverage in the 1990s, as films such as *Reservoir Dogs* (1992) achieved cult status and huge admiration, while others such as *Pulp Fiction* (1994) and *The Blair Witch Project* (1999) were box office hits. Independent film production boomed. In 1999, for example, 1716 films were submitted to the Sundance Festival – the main showcase for independent cinema.

There was a strong tendency among audiences and film critics to associate independence with aesthetic adventurousness. In the words of one history of independent cinema in the USA, independents were seen as 'celluloid mavericks' (Merritt, 2000). As Emanuel Levy (1999: 21) puts it, independent film-makers 'create alternative films that are different, challenging the status quo with visions that have been suppressed or ignored by the more conservative mainstream'.

In the 1960s, the Hollywood studios hit a crisis, based on declining audiences and profits. In 1967, however, the huge success of *Bonnie and Clyde* (directed by Arthur Penn) among youth audiences around the world led Hollywood to believe that innovative films aimed at the youth audience might be their saviour, rather than the big-budget family spectaculars that they had relied on since the 1950s. This trend intensified following the unexpected success of *Easy Rider* (directed by Peter Fonda, 1969). Hollywood entered a period where young directors, producers and scriptwriters were given considerable creative autonomy within the studio system, via package deals with independent producers. With the success of *Jaws* (directed by Steven Spielberg, 1975) and *Star Wars* (directed by George Lucas, 1977), however – both made by young directors brought in to revitalise Hollywood – the studios began to turn back to big-budget special effects movies, aimed at the burgeoning teenage market. Fewer and fewer films were made aimed at older viewers in the late 1970s and early 1980s. With the mid-1980s success of films such as *Blue Velvet* (directed by David Lynch, 1987) and *She's Gotta Have It* (directed by Spike Lee, 1986), this began to change. *Sex, Lies and Videotape* (directed by Steven Soderbergh, 1989) is often cited as an important transition, because it crossed over from the independent and art cinema circuit in the USA into the multiplexes, showing a very high return on its low costs. Production costs were US$1 million, while profits were US$25 million. It became apparent that there was significant money to be made from off-beat, small-scale films dealing with personal relationships and appealing to an older audience. Levy describes 1992 as an *annus mirabilis* for indies, with films such as *Howard's End, The Crying Game, The Player* and *Bob Roberts* achieving critical plaudits *and* considerable financial success. In 1994, the hip nihilism of *Pulp Fiction* (directed by Quentin Tarantino) achieved a crossover into the teen market, drawn to horror films and 'sick' comedy.

Levy outlines a number of conditions that facilitated the emergence of the new US independent cinema as an alternative system:

• the need for self-expression on the part of young film-makers drawn to films that express personal visions rather than operating primarily within Hollywood genre conventions
• Hollywood's increasing tendency to make big-budget blockbusters rather than lower-budget, personal films left a gap in the market for indies to fill

- there were increasing opportunities and capital for financing indies – partly because of internationalisation, which has meant the availability of foreign capital, but also because of the increasing demand for visual material as channels proliferate
- 'supportive audiences' – that is, older, more highly educated audiences looking for 'more mature themes'
- decline of foreign-language films and the European art cinema
- a proliferation of film schools in the USA, producing 'a large number of ambitious film-makers eager to take advantage' of the new opportunities for making independent films
- the Sundance Film Festival, now the second most important film festival in the world according to Levy, serves as an important showcase for independents and there are numerous other festivals and associations, such as the Independent Feature Project and the Black Film-makers Foundation, which support independent film-making
- the increasing commercial success of indies and their increasing success at the Oscars.

Examining the issue of 'supportive audiences' for independent cinema will allow us to explore further the issue of quality. Levy, without citing sources, describes the 'typical indie public' as being composed of:

- college students and college graduates
- singles and childless couples
- discriminating viewers seeking provocative entertainment
- informed viewers with sharper sensibility and greater awareness of new film releases and new directors than average
- frequent moviegoers who go to the cinemas at least once a month.

All this pretty much translates into urban, highly educated and relatively prosperous audiences. Levy clearly thinks that independent films are better than studio pictures. In his view, the major Hollywood studios redeem themselves with a few interesting pictures each year (1999: 500). For Levy, 1999 was an exceptionally good year for Hollywood in that it produced five 'great or near-great films' – *Saving Private Ryan*, *The Truman Show*, *Bulworth*, *He Got Game*, and *Rushmore*. Levy does not stop to give a definition of greatness, but he clearly shares the aesthetic tastes of the higher-income, more highly educated audience for indies. There is a danger, then, that praise for the products of independent cinema is merely praise for films that correspond to the tastes of other highly educated people. These tastes change with time, but, in recent years, such audiences have tended to favour thoughtful, sensitive pictures about human relationships, hip, energetic satire and films full of reference to the codes of popular and high culture, reflecting the cultural omnivorousness of this kind of audience.

Perhaps it is too cynical to think of such high-quality indie films as merely representing a kind of niche marketing to a wealthy, urban elite. Perhaps it is too pessimistic to think of tastes for such films as being confined to wealthier, more

educated audiences. People are more able to enjoy different kinds of cultural experience than sociologists and market researchers sometimes give them credit for. It could be that the film industry assumes in advance that certain audiences will not be interested in certain kinds of films. The increasing credibility of market research, discussed in Chapter 7, would reinforce this tendency.

In this chapter, I have attempted to assess changes in the texts produced by the cultural industries since the early 1980s, but the discussion has continually returned to the difficulties of providing evaluation on the kind of historical scale that I am dealing with here.

Diversity is an elusive concept. Writers identify trends towards homogenisation, but provide little substantiation. Adequate transhistorical comparisons of quality may well be impossible. Also, sociological problems surrounding taste haunt textual evaluation – texts claimed as innovative and adventurous could just be aimed at the niche market to which the intellectual belongs.

Clearly, my own analysis favours thinking about texts in terms of their role in promoting or inhibiting social justice. I have identified commercialisation as an important development in texts since 1980 (though not one of sufficient breadth and depth to merit the view that we have entered a new era of production of texts). However, this focus on issues of social justice marginalises the experiences that people are looking for in texts, which are various forms of aesthetic pleasure.

Some people's solution is to reduce aesthetic experience to ethical questions concerning the stance of a particular film, but this will not do either. The solution may be to build bridges between the two and recognise how tenuous, indirect and contradictory some of the connections may be. However, in researching this book, one of the main conclusions I have come to is that the project of a sociologically informed reflexive aesthetics is still in its infancy and the spectre of mass culture criticism haunts much political economy work that takes an aesthetic perspective.

In this respect, I am aware that this chapter makes for something of an anti-climax. One of the reasons that the cultural industries are important is that they make texts, yet critique of texts in historical terms is so difficult that I might seem to be suggesting that we abandon textual analysis altogether. I am not advocating this. Engagement with content remains the most difficult terrain in analysis of media and popular culture, but that does not mean that the task can be abandoned. Students and researchers of the cultural industries need to engage with issues of pleasure, interpretation and meaning.

FURTHER READING

Explicit treatments of textual change and continuity are rare indeed, but a number of books attempt to deal with the vital issue of the relationship between industrial/organisational dynamics and texts. Jostein Gripsrud's *The Dynasty Years* (1995) is particularly impressive in its treatment of one text, *Dynasty*.

Georgina Born's work (see, for example, her book on the Parisian art music institution IRCAM, *Rationalizing Culture*, 1995, and her book on the BBC,

Uncertain Vision, 2005) addresses these issues, as does Jason Toynbee's *Making Popular Music* (2000).

David Bordwell, Janet Staiger and Kristin Thompson's *The Classical Hollywood Cinema* (1985) and, more recently, Kristin Thompson's *Storytelling in the New Hollywood* (1999) explore these connections in a very different, neo-formalist way.

I have enthused elsewhere in this book about Todd Gitlin's study of prime-time television, *Inside Prime Time* (1983). I also find Daniel Hallin's approach to journalism (see the 2000 chapter discussed above, and his 1994 book *We Keep America on Top of the World*) extremely useful.

For a good collection of writing about news, including many treatments relevant to the issues raised in this book, see Howard Tumber's collection *News: A Reader* (1999).

CONCLUSIONS: A NEW ERA IN CULTURAL PRODUCTION?

I had three main aims in this book: to assess the extent of change in the cultural industries since 1980, to evaluate it, and to explain it.

THE EXTENT OF CHANGE

My treatment of change has gone beyond the historical time frame employed in most studies of the cultural industries. I borrowed from Raymond Williams' work on changing social relations of cultural production across different periods of history in order to put recent changes into their long-term historical context.

Williams described how social relations based on patronage gave way in the nineteenth century to a system he dubbed 'market professional' and how this system in turn gave way in the twentieth century to the dominance of 'corporate professional' market relations. I modified Williams' term 'corporate professional' to 'complex professional' and used it to refer to a whole matrix of conditions of cultural production and consumption, which emerged in the early part of the twentieth century and which were thoroughly ensconced by the 1950s.

These conditions centred on a particular set of relationships between primary creative personnel (symbol creators), other workers and the companies that commission and employ them. A crucial feature of these relations was a combination of loose control of creative input with much tighter control of the reproduction and circulation stages. The complex professional era, as I described it in Chapter 2, was also marked by other key features:

- a labour market in which some creative workers are vastly rewarded but most are underemployed and underpaid
- the increasing presence of large corporations, often in the form of vertically integrated conglomerates
- significant internationalisation, dominated by the USA's cultural industries.
- associated regimes of technology, consumption and policy.

Much of the rest of the book has been concerned with assessing the degree to which these characteristics of cultural production, which developed in the mid-twentieth century, were still apparent in the 1980s, 1990s and 2000s. This allows us now to confront more directly the question: did the period since 1980 see a new era of cultural production, a new phase as markedly different from the complex professional era as the complex professional was from the market professional era?

Chapters 4 and 5 assessed changes in government policy. Here there were considerable transformations, in that governments all across the world altered their policies in the direction of marketisation – that is, the view that the production and exchange of cultural goods and services for profit is the best way to achieve efficiency and fairness in the production and consumption of texts. Various rationales for high degrees of state intervention were systematically attacked by a number of parties, including cultural industry companies. The result was:

- the privatisation of public telecommunications organisations and some PSB institutions
- the opening up of television systems to other terrestrial, commercial broadcasters and cable and satellite companies
- the tearing down of regulatory walls between different industries
- significant changes in laws and rules on content, media ownership and subsidies.

In Europe, PSB was attacked but was surprisingly successful in resisting the onslaught in some countries. In many societies, authoritarian-statist governments gave way to 'democratic' governments pursuing neo-liberal economic policies.

By the 1990s, neo-liberalism was being further pursued by a number of important international bodies. Particularly important were increases in the scope and duration of copyright, including a much greater international enforcement of the ownership of rights. Also significant were changes in cultural policy, which, in the name of democratisation, became increasingly bound up with efforts on the part of government, to boost culture as a new opportunity for investment for businesses in their domain. All this added up to a real transformation in the policy landscape and many of the changes were extremely important in driving other processes of upheaval and realignment.

Was this a new era in policy? Within the advanced industrial countries, there was a shift of emphasis within a fairly stable policy system, in that many policy initiatives happened within states, regulating on the basis of tensions between the interests of citizens/voters and dominant business interests. Nevertheless, the move towards neo-liberalism was remarkable and the fact that it was adopted in so many advanced industrial countries reflects the global interconnectedness of the late twentieth century. The impact on other places was perhaps even more marked. Nations such as India were making a transition from national protectionism to globalisation, from delinked national cultural-economic systems to participation in a new international system of cultural trade. This was part of a wider political-economic and sociocultural set of shifts, which may, in retrospect, be seen as the

beginning of a new phase within these specific national societies. This in turn may help to bring about epochal changes in the advanced industrial countries, but we do not yet live in a 'global professional era' of cultural production. The nation state continues to be the main forum for cultural industry activity.

These policy shifts helped to create a context in which the cultural industries were seen as a good business investment. Chapter 6 showed the expansion of large cultural industry corporations – a growth that might have reached its fastest rate in the boom-bubble years of the late 1990s. These cultural industry corporations have achieved an unprecedented international reach and level of revenue generation. Conglomeration fed into the growth of the corporations, but it is not a new thing in the cultural industries – it is a distinctive feature of the complex professional period as a whole. Conglomeration strategies vary over time and we should be wary of analyses that present any particular strategy (such as hardware/software synergy) as representing the future. Vertical integration also supported the growth of large corporations, but, again, from the 1980s to the 2000s, it was not of a qualitatively different kind from that which was present in earlier generations. Indeed, there has been some movement, in some industries, towards disintegration. This is not only because of the actions of regulators but also because some companies have found it profitable to disintegrate. As with conglomeration, we should cast a sceptical eye on claims that see movements towards or away from integration as marking epochal shifts. Business fashions and strategies come, go and come again. Meanwhile, small companies continue to play an extremely important role in the cultural industries. Again, their proliferation represents an extension of processes already observable in the mid-twentieth century. However, a key change is that large and small companies are increasingly interdependent and mutually entangled in complex networks of licensing, financing and distribution. This is a genuinely novel feature of the cultural industries from the 1980s onwards, as is the number of alliances between cultural industry companies and computer and telecommunications companies in the late 1990s.

All these phenomena are signs of the steadily growing significance of the cultural industries in modern economies. However, this growth is not nearly as pronounced as is often claimed by commentators (especially those who want to appropriate the cultural industries for information society discourse). We saw in Chapter 6 that cultural industry companies are nowhere near the size in revenue of the world's very largest corporations. Corporate growth in the cultural industries is an extension of a process that was already under way in the early part of the twentieth century and is not sufficient to merit claims that the cultural industries are, or even look set to become, a new core in global business. Underlying all these changes and continuities is an extension and gentle acceleration of the long-term process of commodification of culture. This commodification is an important way in which to understand some of the positive and negative changes that I examined later in the book.

Chapter 7 went on to examine changes and continuities in the distinctive organisational form of the cultural industries in the 1980s, 1990s and 2000s and in the terms and conditions of cultural work. Given my emphasis on the social relations of cultural production, this is clearly a key area for assessing change.

Across the cultural industries as a whole, there are significant levels of continuity, in that symbol creators continue to exercise relatively high levels of operational autonomy, but very low levels of power when it comes to the circulation of texts. Journalistic autonomy continues to be important, in spite of some significant attacks on it. Although there were signs of a superficial loosening of control of creative work in some cultural industries, I argued that the prevailing trend was in the opposite direction, towards tighter control of creative work (though this was still loose relative to other industries). It was manifested in the increasing importance of marketing and market research in the creative stages of cultural production. Even here, however, there has been a mixture of trends, with some parts of some industries allowing for greater creative autonomy than before (such as advertisers), others turning towards more rigid, bureaucratic forms of control (live theatre, for example) and trends elsewhere highly ambivalent.

Internationalisation of cultural industry businesses and their texts is not new, but this process greatly accelerated in the 1980s and 1990s. The complex professional period saw a complicated mixture of geocultural markets develop across the world, with the USA generally but unevenly dominant and local or regional cultural products that are often just as popular as ones from the USA, if not more so. This arrangement largely continued into the 1990s and 2000s, as I showed in Chapter 8. There I assessed the growth of Latin American cultural industry companies that based their operations on television. I also examined the huge growth in cross-border transmissions (including 'diasporic television'). Both of these are significant and interesting developments, but they do not as yet even begin to threaten the domination of the transnational corporations based mainly in North America, Europe and Asia, so the power geometry of international television remains largely intact. I showed the rise to further dominance of Hollywood film in the 1980s and 1990s, but also examined the important film industries of Hong Kong and India, which had considerable success in the 1980s. Although these represent very different types of cinema from the Hollywood system, the presence of such domestic industries in global audiovisual markets is not a new phenomenon. The erosion of Hong Kong's industry should not be interpreted as signalling a greater level of domination by Hollywood, the hegemony of which rises and falls in cycles. Finally, in spite of some claims to the contrary, new genres such as world music and Euro-pop did not represent significant disturbances to the geographical distribution of musical power that has been prevalent since the Second World War. The international distribution of cultural power was always more complex than the core/periphery models so effectively questioned by Sinclair, Jacka and Cunningham (1996). Nevertheless, there was significant inequality in access to global markets, international prestige and influence. That inequality remains.

Are the changes associated with digitalisation sufficient for us to speak of a new digital era in cultural production? Every era brings its technological innovations, but perhaps the last 30 years have seen a greater intensity of innovation in cultural technologies than ever before. This is surely not unrelated to the growing opportunities for profit available in the cultural domain. Whether this is the case or not, the production relations and business strategies of the complex professional era remain largely intact. Digital games are the basis of a

fairly new industry with many new texts and genres, but it is founded on the same principles of production as many of the cultural industries that already existed when it evolved. The Internet is an important new medium, which has brought new cultural forms (such as the chat room) into the lives of the relatively wealthy and well-educated across much of the world. It has, however, supplemented the other cultural industries rather than either replacing or transforming them. Cultural industry companies have very quickly found ways of re-establishing control over circulation.

Perhaps the most radical changes brought about by digitalisation will involve convergence. Certainly, the expectation of convergence has helped to fuel the new tendency towards strategic alliances between telecommunications, computers and cultural industry companies. But genuine convergence of cultural forms and communication systems is a long way from happening yet. Digital television may transform television completely, but that is still a matter for the future. It is likely that, for many years to come, it will provide an expanded version of what has been familiar in the past.

Digitalisation, then, should be seen as differentiated in its impacts, according to its various manifestations. In fact, it hardly makes sense to speak of 'digital media' as one category at all. Digitalisation does what designers ask of it and that depends on so many other factors that the actual zeros-and-ones nature of its technological apparatus matters very little in terms of the social uses of the technology, other than allowing devices to be marketed as efficient and convenient. This suggests that terms such as the 'digital era' or 'being digital' (Negroponte, 1995) risk technological reductionism. However, even if it were feasible to speak of all these different technologies as part of one, larger systemic change, the changes have not yet been sufficient to merit the idea that we have moved into a new era of production beyond the complex professional era.

The overall conclusion, in terms of considering the extent of change, has to be that there is sufficient continuity to undermine the suggestion that we have entered a new era of cultural production. Rather, we should think of the period since 1980 as representing a new phase *within* the complex professional era, marked by greater competition and a greater centrality for the cultural industries within advanced industrial economies as a whole. The fundamental features of the cultural industries established in the mid-twentieth century remain.

Some writers have suggested that other industries are becoming more like the cultural industries, in that there seems to have been a new emphasis on issues of aesthetics, design, information, planning and knowledge in all industries, most notably Lash and Urry (1994). Others (for example, Padioleau, 1987) have suggested that the cultural industries are 'normalising', becoming less distinctive and more like other industries. In fact, there have always been tensions between differentiation from and imitation of strategies in other industries throughout the complex professional era. The cultural industries continue to be driven by the problems and solutions identified in the Introduction (see Box 0.2). But the view that they are forming a new core to advanced industrial economies is premature, as can be seen from the figure presented in Chapter 6 on the relative sizes of cultural industry companies compared to other large corporations. There may have been a partial shift towards economies based on culture, information and

symbols, but none of us yet lives in a 'knowledge economy' or an 'information age'.

EVALUATING CHANGE/CONTINUITY

Chapter 2 (see Table 2.1) set up the main questions guiding my evaluation of change in the cultural industries. The continued and accelerated growth of the largest corporations is an obvious fact, while their increased scope and power (via such means as consolidation, various types of conglomeration and either vertical integration or co-optation of contracting companies) carry significant implications.

These corporations have the resources and expertise to pursue their interests in a way that can do much to counteract the high-risk nature of the business they are in. Their main interest is the pursuit of profit. To achieve this, corporations will team up with corporations against which they would normally compete in order to act jointly as advocates for their industry or sector. Their efforts to pursue profits are often detrimental to the interests of people as citizens, even if they give us more choice and control over our leisure time as consumers. They also, in my view, tend to support political and economic stasis, often opposing attempts to achieve social justice. They provide a model for how cultural business should be carried out – one that is not always positive. Whether they support such interests in texts is still controversial, but they certainly pursue them as lobbyists and in their business strategies.

The Internet has not posed any substantial threat to the power and reach of these corporations, though in certain social groups it has enabled and enhanced communication between people. Digital television looks unlikely to achieve any progressive transformation of the social relations of cultural production. The rhetoric of expanded choice surrounding its marketing is deeply dubious.

Chapter 7 claimed there has been little improvement in the rewards and working conditions of creative workers. Symbol creators remain underpaid and underemployed for the most part, while rewards for superstars continue to rise to disgraceful levels. There has been some movement towards greater awareness on the part of new entrants to cultural production about the dangers they face in undertaking creative work and there have been some improvements in contracts. Control of creative work by cultural industry companies remains relatively loose, but the increasing prominence and prestige of marketing personnel in the cultural industries, particularly in the creative conception stage, represents a potential erosion of some of that creative autonomy. Journalistic autonomy is also threatened, in many contexts, by the commercial imperatives of owners, but remains resilient as a professional ethos and a defence against the demands of executives.

Chapter 8 examined internationalisation and found that there were still very few opportunities for producers from outside the 'core' areas of cultural production to gain access to networks of circulation. The geographical concentration of power remains remarkable, though it does not take the form that 'cultural imperialism' writers proposed. In spite of the claims of many commentators, Chapter 9 shows that digital media have not created a new world of access, where barriers between production and consumption are breaking down.

The Internet offered extremely interesting new subcultural uses of communication technologies, but professionalisation, commercialisation and strategies for controlling knowledge about websites, as well as perennial but important questions of access, mean that the radical potential of the Internet will be realised only by the relatively privileged, unless radical changes take place in advanced industrial societies. Digital television is more likely than the Internet to be the basis of any possible future move towards convergence. Digital television has helped advance commercialisation in that key medium, further threatening PSB and reinforcing the power of some of the largest corporations.

My analysis of changes in texts highlighted the problems of making rashly optimistic or pessimistic claims about textual transformation. Chapter 10 began by noting a marked feature of cultural production since 1980: a huge proliferation of texts. Is there greater diversity, though? Attempts to provide objective measures of diversity in liberal-pluralist communication studies and sociology have foundered. Equally, cultural commentary often descends into unsubstantiated assumptions about homogenisation. Diversity remains an elusive and difficult concept.

Much clearer are changes concerning the commercialisation of texts. Advertising and promotional materials have all increased – in my view, to the detriment of the societies that we live in. Advertising messages encourage the view that buying objects and experiences are primary ways of achieving happiness. Of course, the objects and experiences we purchase can enhance our lives in many ways, but such commercial messages, in the main, encourage us to accumulate wealth and money purely in order to acquire and this leads to stress, envy, misery, alienation, pollution and conflict. Hidden promotional messages relegate symbolic creativity to the needs of accumulation. Beyond this, however, it is difficult to say that texts have become more likely to favour the interests of the powerful than they were before. Compliance, conservatism and complacency coexist with scepticism, anger and utopianism. Popular culture continues to be riddled with contradictions. Although some see a decline in news standards, here, too, there is ambivalence, as the pomposity of some older styles of 'serious' journalism is displaced by both triviality and efforts to speak to important private and emotional concerns.

Meanwhile, the speeding up of the tendency of audiences to shift and flit across different cultural experiences means that symbol creators can no longer rely on the guaranteed attentiveness of audiences (if, indeed, they ever could). This restlessness also encourages a certain scepticism about the authority of the media. Historical comparisons of quality across the whole range of a cultural industry's output are so difficult as to be almost meaningless. Simple stories of transformation in texts are often to be found, but rarely stand up to scrutiny.

Overall, any assessment of the cultural industries must register the complexity, ambivalence and contradiction noted by Miège (1989) as features of capitalist cultural production (see Introduction). The growth of the large corporations is significant, but they work in more subtle and complicated ways than the jeremiads of some political economy accounts suggest. To make such an argument does not represent a compromise with corporate capitalism. Rather, it is the outcome of a clear-headed analysis of the very real complexities

involved in making capital out of culture. As Jason Toynbee (2000: 2) puts it, also employing Raymond Williams' historical sociology of culture to support his analysis, while much of 'culture belongs to capitalism, there is something antithetical to capitalism in it'. A key question, though, is whether or not the steady commodification of culture noted in Chapter 6 threatens that relative autonomy of culture. Among the threats identified in this book are the increasing exclusive ownership of rights in cultural works and its effects on people's cultural experiences, as well as the use of market research and audience ratings to threaten creative autonomy (discussed in Chapter 7).

EXPLAINING CHANGE/CONTINUITY

If the 'fundamentally irrational' process of symbolic creativity 'conflicts with the calculating, accumulative logic of modern capitalism' (Ryan, 1992: 104), this helps to explain the very tangled and contradictory dynamics we have observed throughout this book. A better way to think about this conflict for me is via issues raised in my discussion of the commodification of culture in Chapters 2 and 6, combined with the emphasis I have placed throughout on the conflicts between creativity and commerce in understandings of cultural practice. As capitalism developed, art was understood as a domain that ought to be protected from commercial imperatives. So, too, were certain kinds of information. This protection was never complete – commodification and culture were entwined. As the opportunities for profiting from culture have grown, the lines drawn around culture have been pushed back.

Cultural industry companies pursue profit and use recurring strategies to do so. However, the internal dynamics of the cultural industries are by no means sufficient to explain change and continuity in them. Chapter 3 outlined the major *external* contexts for understanding change. Avoiding reduction, I identified four types of factors driving change and continuity in the cultural industries during the period under consideration:

- political – economic change, in the form of the neo-liberal reaction to the Long Downturn
- changing business strategies, in the form of shifts in investment towards service industries, internationalisation and organisational innovations
- sociocultural changes
- technological change, particularly the development of the computer and various consumer electronics devices.

As will have been apparent, I am suspicious of explanations that privilege the role of the latter factor, technology. Although technologies are important and have real effects, technological reductionism is a real danger in the present climate. I hope that I have shown there are many reasons to avoid it. Instead, I have outlined how the various types of determinant overlap. If the actions of cultural industry companies have been privileged above other dynamics, this is because I believe that their intentions have a great effect on cultural, economic and political processes. After all, this is a book about the cultural industries.

IMPLICATIONS FOR FUTURE STUDY

This book has insisted on **the importance of thinking about the cultural industries as producers of texts**. The cultural industries are those that are most directly involved in the production of social meaning because they make and circulate texts – artefacts that are primarily intended to inform and/or entertain. This is the key to understanding the particular role of the cultural industries in relation to economic, political, social and cultural power. The study of the cultural industries has to incorporate the consideration of texts and the study of texts has to take seriously analysis of the cultural industries.

The best critical political economy and sociological approaches recognise the importance of meaning, but very few writers have achieved a sustained engagement with textual meaning in relation to cultural production (I would suggest that Gitlin, 1983, and Gripsrud, 1995, are two of the most impressive attempts to do this and my aim has been to build on their achievements, though in a somewhat different way). By incorporating textual change into my assessment and explanation of change/continuity in the cultural industries, I have hoped to re-emphasise the centrality – in the study of media, popular culture and mass communication – of the relationship between symbolic artefacts and the financing and organisation of their production.

My use of the concepts of diversity, quality and pursuit of interests represents a way of thinking about texts that focuses on their functions in people's everyday lives in contemporary society. By trying to think carefully about the evaluative criteria people bring to texts, we can counter the sweeping generalisations that debilitate various forms of cultural criticism. It should be clear that I have no time for fatuous dismissals of entire swathes of cultural production on the part of high-minded analysts. Equally, it must be apparent that I do not think the cultural industries play an altogether progressive role in the contemporary world. There is no question of complacently celebrating popular culture. There are plenty of unimaginative, uninformative, uninteresting texts around and they need to be questioned, probed and even lambasted. In other words, to repeat the formula I borrowed from Bernard Miège very early on in this book, we need to recognise the complexity, ambivalence and contestedness of culture. What I am arguing for is **an open-minded attitude towards the kinds of pleasures that people may take from texts and towards the uses they may put them to.** By openminded, I simply mean having an attitude that does not judge or assume in advance that any text plays a negative role in society. Audience research on how and why people value texts is therefore a vital corollary of the approach that I have taken here. There has been no space for such audience analysis on my part here – researching 50 years of cultural production has been enough of a task in itself.

One of the main achievements of radical studies of the media and popular culture has been to argue effectively for the importance of ethical questions regarding questions of power and social justice in relation to cultural production. I have attempted to build on this by emphasising the advantages of a **historically informed analysis of contemporary culture**. The reasons for this are obvious enough to anyone who values historical study. Good historical analysis can help

to undermine casual assumptions about the present and near future. It can help to put our own situation into perspective. It can also help us to understand how things came to be the way that they are and, therefore, how they may be changed for the better. By using Williams' historical sociology of culture, I have tried to bring a long-term perspective to bear on recent issues.

Media and cultural studies have generally had a very shallow attitude towards history (with notable exceptions, mainly in studies of film and broadcasting, many of which have been referred to ealier). However, this book has been constructed around historical questions concerning change and continuity. This is because the question 'how much have things really changed?' kept cropping up time and again in my experience of teaching and research and in general discussions with friends (and, indeed, strangers) about the cultural industries.

Many people have an interest in exaggerating change in order to draw attention to themselves – no doubt this has helped put the question of social and cultural change on the agenda. It seems to me that one useful function of academic work is to scrutinise carefully such exaggerated claims. In disciplines that tend to be heavily focused on primarily synchronic research methods, such as ethnography and interviews, the question of change is one that might encourage more diachronic, historical thinking. Finally, it seems to me that another valuable task of academic writers is to explain *why* they think things have happened in the way that they have – hence the emphasis on explanation in this book.

One of the most important aspects of my approach – borrowed from the cultural industries approach, but also to some extent from empirical sociology of culture – has been to **focus on symbol creators**. I commented in Chapters 1 and 2 on the surprising neglect of these cultural workers in studies on the cultural industries. This has not been a book about symbol creators, but I hope the considerable attention I have paid to creative personnel can help to revivify studies of cultural production. A focus on symbol creators and other workers in the cultural industries may encourage the formation of partnerships with organisations representing the interests of often exploited staff and build bridges between the goals of university researchers and non-university activists.

Concentrating on issues of symbolic creativity may also help to save the study of cultural production from the reputation it currently (and unjustly) has among some students of being the dreary analysis of big corporations. Most students enter universities to study the media and popular culture because they want to be part of an environment where symbolic creativity is paramount. To forefront this issue represents a means of making connections between everyday desires and aspirations to be creative and the world of business, economics and politics. Who has not wanted, at some time in their life, to play music, to perform on a stage, to capture a feeling or to express a viewpoint in writing or photography or in some other medium? I hope this book has made a contribution to restoring a focus on these aspects of life to studies of the cultural industries.

GLOSSARY

analogue Systems of broadcasting or recording based on the conversion of words, images, sounds and so on, into analogue signals. These signals are analogous to the original act of communication – that is, they resemble or correspond to it. Analogue systems have increasingly given way to *digital* ones.

autonomy Independence or freedom from external control or influence. In the context of the cultural industries, this term is usually applied to the relative independence of *symbol creators* or symbol-making organisations from such control or influence (for example, by owners, a parent company or managers acting on behalf of a company). Complete autonomy is impossible, but it is a goal towards which many symbol creators aspire, with important effects on the organisation of cultural production.

bullshitters According to philosopher Harry G. Frankfurt, bullshitters seek to convey a certain impression of themselves without being concerned about whether or not anything at all is true. They just quietly change the rules governing conversation (or writing) so that claims about truth and falsity are irrelevant. Some analyses of cultural production are full of bullshit – especially those concerned with predictions about future transformations – but not this one, hopefully.

circulation The stage of cultural production involving getting products to audiences. It involves marketing, publicity, distribution and/or transmission.

commodification of culture The historical process by which cultural objects and services are increasingly made to be bought and sold on capitalist markets extended over time and space. See also *industrialisation of culture*.

complex professional Both a form and period of cultural production. An adaptation of Raymond Williams' concept of the 'corporate professional' form of cultural production, whereby, starting from the early twentieth century, but increasing from the mid-twentieth century, commissioning of works became professionalised and more organised, new media technologies appeared, advertising became increasingly important and larger numbers of people worked for cultural businesses than in the past.

concentration Market or industrial concentration refers to the extent to which a market or industry is dominated by the largest businesses. This is often expressed numerically, by the percentage of market share achieved by the biggest four or five companies or by other related means. While some economists distinguish between market and industrial concentration, the

distinction is trivial for the purposes of this book. The terms *market concentration* and *industrial concentration* are sometimes also used to refer to the process of increasing domination of the largest businesses.

conglomerate, conglomeration A *conglomerate* is a corporation that consists of a group of businesses dealing in different products or services. *Conglomeration* is the process by which an industry, a sector or an economy becomes more marked by the presence and influence of such corporations.

convergence The idea that telecommunications, computers and media are increasingly merging. Sometimes this list is extended to include consumer electronics. Occasionally the idea is mooted that these various industries might merge into one.

copyright 'If a work is eligible for copyright, then the copyright owners are permitted to do a number of different things with the work which are not permitted to those who do not own the copyright (unless they have been licensed by the rights holder)' (Frith and Marshall, 2004: 7). These include the following exclusive rights: to copy the work, make adaptations of the work or make 'derivative works' using parts of it, issue copies of the work to the public, perform the work in public and broadcast the work. Copyright, then, is best thought of as *a bundle of exclusive rights* associated with creative works, rather than a single right. See also ***intellectal property rights***.

creative cities Cities with supposedly high levels of creativity within them. This was a term used by policymakers in the 1990s and 2000s to denote the idea that urban 'creativity' could make a key contribution to economic prosperity and social welfare.

creative clusters Business clusters are groups of linked businesses and other institutions located in the same place (a city or region), which enjoy competitive success as a result of their interconnections. The term 'creative clusters' was used by policymakers in the 1990s and 2000s to refer to cultural industry versions of this supposed phenomenon.

cultural imperialism A term used by critics of the cultural industries to refer to the negative effects of advanced industrial and 'Western' cultures on less developed, especially 'non-Western', countries.

deregulation The removal of regulation. This was a term, often used by advocates of ***neo-liberalism***, to describe policy changes of the 1980s, 1990s and 2000s. Such changes were often intended to advance the ***marketisation*** of cultural production.

digital Electronic storage and transmission that involves converting images, words, sounds and so on into binary code that can be read and stored by computers.

digital rights management Measures used to control and/or restrict access to digital data.

digitalisation The increasing use of *digital* storage and transmission in cultural production and circulation and the increasing use of such digital systems, as opposed to *analogue* ones.

file-sharing The practice of making digital files containing music, films, television programmes and other cultural products, available on the Internet and other networks for others to share.

flow logic or model A model of commodity production identified by Bernard Miège (1987, 1989) as characteristic of the production of radio, television and new media. Key features include a continuous flow of products based on daily contact and the central importance of a programme planner and/or scheduler. See also *publishing logic or model.*

format (1) An idea or concept for a series of television or radio programmes that is sold as an idea or concept. (2) In its more specialist use, a term developed by Bill Ryan (1992) to refer to the way that cultural industry companies, in order to minimise *risk*, provide links between sequences of products through the use of common elements. Stars, genres and serial form are the main means he identifies.

geocultural markets Markets for cultural products, spread over more than one nation state, linked by shared cultural features. These can include language, religion and ways of life.

globalisation A term used to refer to changes that have brought about greater interconnectedness between different parts of the world.

government policy See *policy.*

horizontal integration The process by which businesses buy up other businesses in the same industry or sector, usually resulting in less competition for audiences and audience time.

industrialisation of culture The introduction of significant capital investment, mechanised production and division of labour into the realm of cultural production. See also *commodification of culture.*

information society A term used to refer to contemporary or future societies by those who believe that information and knowledge are now (or will soon become) central, as never before, to the way that societies operate. Information society discourse is writing, speaking and thinking that is based on this view.

integration See *horizontal integration, multisector and multimedia integration* and *vertical integration.*

intellectual property rights Bundles of exclusive rights attached to various forms of expression of knowledge, ideas or artistic work. The main areas are patent, trademark and *copyright.*

internationalisation The process by which businesses based in one nation, or in one particular set of nations, buy and partner companies in other nations. Also, the increasing presence of such links.

Long Downturn The era of slowed or reduced growth in the global economy, following the supposed Golden Age of growth in the post Second World War period. The Long Downturn is usually taken to have begun in 1973 and ended (perhaps temporarily?) in the mid-1990s.

marketisation In this book, the term refers to the process by which market exchange (the buying and selling of goods, services and rights) has increasingly come to permeate the cultural industries and related sectors. See also *deregulation.*

media mogul An owner who exerts very strong control over his own media company. This could be her company too, of course, except that they're always owned by men.

multisector and multimedia integration The processes by which cultural industry businesses buy into other related areas of cultural industry production, often to ensure cross-promotion. This is a particular type of *conglomeration.*

neo-liberalism 'A theory of political economic practices that proposes that human well-being can best be advanced by liberating individual entrepreneurial freedoms and skills within an institutional framework characterised by strong private property rights, free markets, and free trade' (Harvey, 2005: 2).

peer-to-peer networks (P2P) In peer-to-peer networks, each computer operates as both a client and server for other computers in the network. The Internet is itself based on this idea, but peer-to-peer became of particular importance to the cultural industries when it became used for *file-sharing.*

policy Government or public policy refers to the plans of action adopted and undertaken by governments.

project team The group of individuals responsible for the creative stage in cultural production. This concept is important because it draws attention to the complex division of labour involved in making cultural goods, especially during the *complex professional* period.

public domain The body of knowledge and creativity that is in the public domain can be used freely by the public because it is not in private ownership. This includes works the ownership rights to which have expired.

public service broadcasting (PSB) Broadcasting intended to provide a service for nations, regions and/or communities, it is usually non-commercial, and carried out by a government or government-related agency. This service has been conceived of in various ways (see Chapter 4), but public accountability, public finance, universal service and addressing audiences as citizens are common features.

publishing logic or model (or 'editorial model') A model of commodity production identified by Miège (1987, 1989) as characteristic of the production

of books, records and films. Key features include the sale of texts on an individual basis to be owned, organisation of production by a publisher/ producer and the presence of many small- or medium-sized companies clustering around oligopolistic firms. See also *flow logic or model.*

reductionism When someone believes that a social theory, method or explanation excessively reduces complex processes to simple ones, he or she may say that the theory/method/explanation is guilty of reductionism. I prefer this term to 'determinism' (See Chapter 3)

risk In the context of businesses, the possibility of commercial loss. A key concept in the analysis of the cultural industries because, while all businesses involve risk, and the attempt to manage it, an argument can be sustained that the cultural industries are among the riskiest of all modern enterprises.

search engines Programs designed to find information on the Internet.

symbol creators Those who engage in *symbolic creativity*. (I prefer this term to 'artists' for reasons explained in the Introduction.)

symbolic creativity The process, common to all human societies, by means of which symbols – mainly writing, sounds and images – are brought into being. (I prefer this term to 'art' for reasons explained in the Introduction.)

synergy The principle by which two or more different elements of a business might work together, so that the sales or profits might exceed what would have been produced by the two elements working independently.

texts This term is used in a specialist way in cultural analysis to denote objects, artefacts and events that are meaningful. Some analysts think of any object, artefact or event in the world as potentially being open to analysis and, therefore, as texts. I use the term here in a narrower but nevertheless broad sense, as a collective name for all the 'works' produced by cultural industries, such as television programmes, films, recordings, books and so on. The term is not used here in its older sense – the wording of something written or printed – but it can refer to printed artefacts.

vertical integration The process by which businesses buy up other businesses involved in different stages of the process of production and circulation. A business might buy 'downstream', such as when an organisation involved in making films buys a distributor of DVDs, or 'upstream', when a business involved in circulation or transmission (such as a cable television company) buys a programme-maker.

REFERENCES

References to articles from newspapers, magazines and trade journals are given in the main text, not here (except where an author's name is provided). Where two dates are given, the first date refers to the edition of the particular book, chapter or article I have used, the second to the original date of publication. My apologies to authors for leaving out their precious sub-titles. I did it for reasons of space.

Adorno, Theodor, and Horkheimer, Max (1977/1944) 'The culture industry: enlightenment as mass deception', in James Curran, Michael Gurevitch and Janet Wollacott (eds), *Mass Communication and Society*. London: Edward Arnold. pp. 349–83.

Aksoy, Asu, and Robins, Kevin (1992) 'Hollywood for the 21st century: global competition for critical mass in image markets', *Cambridge Journal of Economics*, 16: 1–22.

Albright, Mark (2005) 'The season for synergy', *Campaign for a Commercial-Free Childhood*, 16 November, at www.commercialexploitation.org (accessed September 2006).

Alderman, John (2001) *Sonic Boom*. London, Fourth Estate.

Allen, Rod (1998) 'This is not television ...', in Jeanette Steemers (ed.), *Changing Channels*. Luton: University of Luton Press. pp. 59–71.

Amin, Hussein (1996) 'Egypt and the Arab world in the satellite age', in John Sinclair, Elizabeth Jacka and Stuart Cunningham (eds), *New Patterns in Global Television*. Oxford: Oxford University Press. pp. 101–25.

Amin, Ash and Thrift, Nigel (eds) (2004) *The Blackwell Cultural Economy Reader*. Oxford: Blackwell.

Andersen, Robin (2000) 'Introduction', in Robin Andersen and Lance Strate (eds), *Critical Studies in Media Commercialism*. Oxford: Oxford University Press. pp. 1–21.

Ang, Ien (1985) *Watching* Dallas. London and New York: Methuen.

Ang, Ien (1991) *Desperately Seeking the Audience*. London: Routledge.

Anjum, Zafar (2005) 'Hollywood's Indian adventures', *Asia Times Online*, 2 December at www.atimes.com (accessed September, 2006)

Armstrong, Philip, Glyn, Andrew and Harrison, John (1991) *Capitalism Since 1945*. Oxford: Basil Blackwell.

Aufderheide, Patricia (1999) *Communications Policy and the Public Interest*. New York: Guilford Press.

Augarten, Stan (1984) *Bit by Bit*. London: Unwin.

Auletta, Ken (1997) 'American keiretsu', *The New Yorker*, 20 and 27 October, pp. 225–7.

Bagdikian, Ben H. (2000) *The Media Monopoly* (6th edn). Boston, MA: Beacon Press.

Bagdikian, Ben H. (2004) *The New Media Monopoly*. Boston, MA: Beacon Press.

Baker, C. Edwin (2002) *Media, Markets and Democracy*. Cambridge: Cambridge University Press.

Bakker, Piet (2005) 'File-sharing – fight, ignore or compete: paid download services vs. P2P networks', *Telematics and Informatics*, 22 (1–2): 41–55.

Barfe, Louis (2003) *Where Have all the Good Times Gone?* London: Atlantic Books.

Barker, Chris (1997) *Global Television*. Oxford: Blackwell.

Becker, Howard S. (1982) *Art Worlds*. Berkeley, CA: University of California Press.

Belfiore, Eleonora (2002) 'Art as a means of alleviating social exclusion: does it really work? A critique of instrumental cultural policies and social impact studies in the UK', *International Journal of Cultural Policy*, 8 (1): 91–106.

Bell, Daniel (1974) *The Coming of Post-industrial Society*. London: Heinemann.

Bennett, Tony (1998) *Culture: A reformer's science*. London: Sage.

Berwanger, Dietrich (1998) 'The Third World', in Anthony Smith with Richard Paterson (eds), *Television: An international history* (2nd edn). Oxford: Oxford University Press. pp. 188–200.

Bettig, Ronald V. (1996) *Copyrighting Culture*. Boulder, CO: Westview Press.

Bianchini, Franco and Parkinson, Michael (eds) (1993) *Cultural Policy and Urban Regeneration*. Manchester: Manchester University Press.

Bilton, Chris (1999) 'Risky business: the independent production sector in Britain's creative industries', *Cultural Policy* 6 (1): 17–39.

Biskind, Peter (1998) *Easy Riders, Raging Bulls*. London: Bloomsbury.

Bloom, Allan (1987) *The Closing of the American Mind*. New York: Simon & Schuster.

Blumler, Jay G. (1992) *Television and the Public Interest*. London: Sage, in association with the Broadcasting Standards Council.

Blumler, Jay G., and Gurevitch, Michael (1995) *The Crisis of Public Communication*. London: Routledge.

Bolaño, César, Mastrini, Guillermo, and Sierra, Francisco (2004) 'A Latin American perspective for the political economy of communications', *Javnost/The Public* 11 (3): 47–58.

Bordwell, David (2000) *Planet Hong Kong*. Cambridge, MA: Harvard University Press.

Bordwell, David, Staiger, Janet, and Thompson, Kristin (1985) *The Classical Hollywood Cinema*. London: Routledge & Kegan Paul.

Born, Georgina (1993a) 'Against negation, for a politics of cultural production: Adorno, aesthetics, the social', *Screen* 34 (3): 223–42.

Born, Georgina (1993b) 'Afterword: music policy, aesthetic and social difference', in Tony Bennett, Simon Frith, Lawrence Grossberg, John Shepherd and Graeme Turner (eds), *Rock and Popular Music*. London: Routledge. pp. 266–92.

Born, Georgina (1995) *Rationalizing Culture*. Berkeley, CA: University of California Press.

Born, Georgina (2005) *Uncertain Vision*. London: Vintage.

Bourdieu, Pierre (1984) *Distinction*. Cambridge, MA: Harvard University Press.

Bourdieu, Pierre (1993) *The Field of Cultural Production*. Cambridge: Polity, Press.

Bourdieu, Pierre (1996) *The Rules of Art*. Cambridge: Polity Press.

Boyd, Douglas (1998) 'The Arab world', in Anthony Smith with Richard Paterson (eds), *Television: An international history* (2nd edn). Oxford: Oxford University Press. pp. 182–7.

Boyle, James (1996) *Shamans, Software and Spleens*. Cambridge: Harvard University Press.

Brants, Kees, and Siune, Karen (1992) 'Public broadcasting in a state of flux', in Karen Siune and Wolfgang Truetzschler (eds), *Dynamics of Media Politics*. London: Sage. pp. 101–15.

Brenner, Robert (1998) 'Uneven development and the Long Downturn: the advanced capitalist economies from boom to stagnation, 1950-1998', *New Left Review*, I (229): 1-267.

Brenner, Robert (2000) 'The boom and the bubble', *New Left Review*, 11 (6): 5-43.

Burkart, Patrick, and McCourt, Tom (2006) *Digital Music Wars*. Lanham, MD: Rowman & Littlefield.

Burnett, Robert (1992) 'The implications of ownership changes for concentration and diversity in the phonogram industry', *Communication Research*, 19 (6): 749-69.

Burnett, Robert (1995) *The Global Jukebox*. London: Routledge.

Burnett, Robert and Marshall, P. David (2003) *Web Theory*. London: Routledge.

Burns, Rob (2004) 'German television', in John Sinclair and Graeme Turner (eds), *Contemporary World Television*. London: BFI. pp. 70-4.

Burston, Jonathan (1999) 'Spectacle, synergy and megamusicals: the global industrialisation of the live entertainment economy', in James Curran (ed.), *Media Organizations in Society*. London: Arnold. pp. 69-83.

Calabrese, Andrew (2005) 'The trade in television news', in Janet Wasko (ed.), *A Companion to Television*. Malden, MA and Oxford: Blackwell. pp. 270-88.

Calabrese, Andrew, and Sparks, Colin (eds) (2004) *Towards a Political Economy of Culture*. Lanham, MD: Rowman & Littlefield.

Canclini, Nestor García (1995) *Hybrid Cultures*. Minneapolis, MN: University of Minnesota Press.

Carr, Nicholas (2005) 'The amorality of Web 2.0', *Rough Type* blog, 3 October, at www.roughtype.com (accessed September 2006).

Castells, Manuel (1989) *The Informational City*. Oxford: Blackwell.

Castells, Manuel (1996) *The Rise of the Network Society* (volume I of *The Information Age*). Oxford: Blackwell.

Caves, Richard E. (2000) *Creative Industries*. Cambridge, MA: Harvard University: Press.

Caves, Richard E. (2005) *Switching Channels*. Cambridge, MA: Harvard University: Press.

CCPR [Centre for Cultural Policy Research] (2003) 'Baseline study on Hong Kong's creative industries'. Hong Kong: University of Hong Kong.

Chambers, Iain (1994) *Migrancy, Culture, Identity*. London: Routledge.

Chan-Olmsted, Sylvia M., and Chang, Byeng-Hee (2003) 'Diversification strategy of global media conglomerates: examining its patterns and determinants', *Journal of Media Economics*, 16 (4): 213-33.

Christianen, Michael (1995) 'Cycles in symbol production? A new model to explain concentration, diversity and innovation in the music industry', *Popular Music*, 14 (1): 55-94.

Christopherson, Susan and Storper, Michael (1986) 'The city as studio, the world as back lot: the impact of vertical disintegration on the location of the motion picture industry', *Environment and Planning D: Society and space*, 4: 305-20.

Christopherson, Susan, and Storper, Michael (1989) 'The effects of flexible specialization on industrial politics and the labor market: the motion picture industry', *Industrial and Labor Relations Review*, 42: 331-47.

Clark, Kenneth (1969) *Civilisation*. London: BBC.

Clifford, James (1988) *The Predicament of Culture*. Cambridge, MA: Harvard University Press.

Coase, Ronald H. (1974) 'The economics of the First Amendment', *American Economic Review*, 64 (2): 384-91.

Coffey, Steve, and Stipp, Horst (1997) 'The interactions between computer and television research', *Journal of Advertising Research*, 37 (2): 61-7.

Cohn, Nik (1989/1969) 'Awopbopaloobop Alopbamboom', in *Ball the Wall*. London: Picador. pp. 49–139.

Coleman, Stephen (2005) 'Blogs and the new politics of listening', *Political Quarterly,* 76 (3): 273–80.

Collins, Richard (1998) *From Satellite to Single Market*. London: Routledge.

Collins, Richard, and Murroni, Christina (1996) *New Media, New Policies*. Cambridge: Polity Press.

Commission of the European Communities (1984) *Television Without Frontiers: Green paper on the establishment of the common market for broadcasting especially by satellite and cable*. Brussels: COM (92) 480 final.

Commission of the European Communities (1994) *Europe and the Global Information Society: Recommendations to the EC* (The Bangemann Report). Brussels: European Commission, 25 May.

Compaine, Benjamin (1982) *Who Owns the Media?* White Plains, NY: Knowledge Industry Publications.

Compaine, Benjamin, and Gomery, Douglas (2000) *Who Owns the Media?* (3rd edn). Mahwah, NJ: Lawrence Erlbaum.

Cooper, Mark (2002) *Cable Mergers and Monopolies*. Washington, DC: Economic Policy Institute.

Corner, John (2000) '"Influence": the contested core of media research', in James Curran and Michael Gurevitch (eds), *Mass Media and Society* (3rd edn). London: Hodder Arnold. pp. 376–97.

Coser, Lewis A., Kadushin, Charles and Powell, Walter W. (1982) *Books*. New York: Basic Books.

Couldry, Nick (2000) *Inside Culture*. London: Sage.

Council of the European Communities (1989) *Directive of the Coordination of Certain Provisions Laid Down by Law, Regulation or Administrative Action in Member States Concerning the Pursuit of Television Broadcasting Activities,* 89/552/EEC, *Official Journal of the European Communities,* L298/23, 17 October.

Coyle, Diane (1999) *The Weightless World*. London: Capstick.

Croteau, David, and Hoynes, William (2002) *Media/Society* (3rd edn). Thousand Oaks, CA: Pine Forge.

Curran, James (1986) 'The impact of advertising on the British mass media', in Richard Collins, James Curran, Nicholas Garnham, Paddy Scannell, Philip Schlesinger and Colin Sparks (eds), *Media, Culture and Society*. London: Sage.

Curran, James (1998) 'Newspapers: beyond political economy', in Adam Briggs and Paul Cobley (eds), *The Media: An introduction*. Harlow: Addison Wesley Longman. pp. 81–96.

Curran, James (1990) 'Culturalist perspectives on news organizations', in Marjorie Ferguson (ed.), *Public Communication: The new imperatives*. London: Sage. pp. 114–34.

Curran, James (2002) *Media and Power*. London: Routledge.

Curran, James, and Park, Myung-Jin (eds) (2000) *De-Westernizing Media Studies*. London: Routledge.

Curtin, Michael (1999) 'Feminine desire in the age of satellite television', *Journal of Communication,* 49(1): 55–70.

Curtin, Michael (2003a) 'Media capital: towards the study of spatial flows', *International Journal of Cultural Studies,* 6(2): 202–28.

Curtin, Michael (2003b) 'The future of Chinese cinema: some lessons from Hong Kong and Taiwan', in Chin-Chuan Lee (ed.), *Chinese Media, Global Contexts*. London: RoutledgeCurzon. pp. 237–56

Dale, Martin (1997) *The Movie Game*. London: Cassell.

Davis, Howard, and Scase, Richard (2000) *Managing Creativity*. Milton Keynes: The Open University Press.

Dayan, Daniel, and Katz, Elihu (1992) *Media Events*. Cambridge, MA: Harvard University Press.

DCMS (1998) 'Creative industries mapping document 1998'. London: UK Department for Culture, Media and Sport.

DCMS (2001) 'The creative industries mapping document 2001'. London: UK Department for Culture, Media and Sport.

DCMS (2005) 'Creative industries economic estimates'. London: UK Department for Culture, Media and Sport.

Denis, John (1991) *Alistair MacLean's Hostage Tower*. New York: HarperCollins.

DiMaggio, Paul (1977) 'Market structure, the creative process and popular culture: towards an organizational reinterpretation of mass-culture theory', *Journal of Popular Culture*, 11: 436–52.

Dowd, Timothy J. (2000) 'Diversificazione musicale e mercato discografico negli Stati Uniti, 1955–1990', *Rassegna Italiana di Sociologia*, 41 (2): 223–63.

Dowd, Timothy J. (2004) 'Concentration and diversity revisited: production logics and the U.S. mainstream recording market, 1940–1990', *Social Forces*, 82 (4): 1411–55.

Downey, John (1998) 'XS 4 all? "Information society" policy and practice in the European Union', in John Downey and Jim McGuigan (eds), *Technocities*. London: Sage. pp. 121–38.

Downey, John (2006) 'The media industries: do ownership, size and internationalization matter?' in David Hesmondhalgh (ed.), *Media Production*. Maidenhead and Milton Keynes, Open University Press/The Open University. pp. 7–48.

Downing, John (2001) *Radical Media*. London: Sage.

Doyle, Gillian (2002) *Understanding Media Economics*. London: Sage.

Drake, Philip (2007) 'Who owns celebrity? Privacy, publicity, and the legal regulation of celebrity images', in Su Holmes and Sean Redmond (eds), *A Reader in Stardom and Celebrity*. London: Sage.

Driver, Stephen, and Gillespie, Andrew (1992) 'The diffusion of digital technologies in magazine print publishing: organizational change and strategic choices', *Journal of Information Technology*, 7 (3): 149–59.

Driver, Stephen, and Gillespie, Andrew (1993) 'Structural change in the cultural industries: British magazine publishing in the 1980s', *Media, Culture and Society*, 15: 183–201.

Drucker, Peter (1992/1968) *The Age of Discontinuity*. New Brunswick, NJ: Transaction.

du Gay, Paul, and Pryke, Michael (eds) (2002) *Cultural Economy*. London: Sage.

During, Simon (1993) *The Cultural Studies Reader*. London and New York: Routledge.

Dyer, Richard (1981) 'Entertainment and utopia', in Rick Altman (ed.), *Genre: A reader*. London: Routledge & Kegan Paul. pp. 175–89.

Einarsson, Ágúst (2005) 'Cultural activities and creative industries in Iceland'. Reykjavik: University of Iceland.

Einstein, Mara (2004) *Media Diversity*. Mahwah, NJ: Lawrence Erlbaum.

Elliott, Philip (1977) 'Media organizations and occupations: an overview', in James Curran, Michael Gurevitch and Janet Wollacott (eds) *Mass Communication and Society*. London: Edward Arnold. pp. 142–73.

Epstein, Edward Jay (2005a) 'Gross misunderstanding', *Slate*, 16 May, at (http://slate.msn.com (accessed September 2006 – search by article title).

Epstein, Edward Jay (2005b) 'Concessions are for girlie men', *Slate*, 9 May, at http://slate.msn.com (accessed September 2006 – search by article title).

ERC Services Subcommittee (Workgroup on Creative Industries) (2002) 'Creative industries development strategy: propelling Singapore's creative economy'. Singapore: ERC Services Subcommittee.

Ettema, James S., and Whitney, D. Charles (1994) *Audiencemaking*. London: Sage.

Euromedia Research Group (1997) *The Media in Western Europe*. London: Sage.

European Commission (1997) *Green Paper on the Regulatory Implications of the Telecommunications, Media and Information Technology Sectors: Towards a common approach to information society services* (DGXIII). Brussels: European Commission.

Featherstone, Mike (1991) *Consumer Culture and Postmodernism*. London: Sage.

Fejes, Fred (1981) 'Media imperialism: an assessment', *Media, Culture and Society*, 3 (3): 281–9.

Feld, Steven (1994) 'From schizophonia to schismogenesis: on the discourses and commodification practices of "world music" and "world beat" ', in Charles Keil and Steven Feld, *Music Grooves*. Chicago, IL: University of Chicago Press. pp. 257–89.

Feldman, Tony (1998) *An Introduction to Digital Media*. London: Routledge.

Feuer, Jane (1984) 'MTM Enterprises: an overview', in Jane Feuer, Paul Kerr, and Tise Vahimagi (eds) *MTM 'Quality Television'*. London: BFI. pp. 1–31.

Feuer, Jane, Kerr, Paul, and Vahimagi, Tise (eds) (1984) *MTM 'Quality Television'*. London: BFI.

Fiske, John (1990) *Introduction to Communication Studies* (2nd edn). London: Routledge.

Flew, Terry (2005) 'Sovereignty and software: rethinking cultural policy in a global creative economy', *International Journal of Cultural Policy*, 11 (3): 243–60.

Flichy, Patrice (1980) *Les industries de l'imaginaire*. Grenoble: Presse Universitaires de Grenoble.

Flichy, Patrice (1999) 'The construction of new digital media', *New Media and Society*, 1 (1): 33–8.

Fligstein, Neil (1990) *The Transformation of Corporate Control*. Cambridge, MA: Harvard University Press.

Florida, Richard (2002) *The Rise of the Creative Class*. New York: Basic Books.

Florida, Richard (2005) *The Flight of the Creative Class*. London: HarperCollins.

Forester, Tom (ed.) (1985) *The Information Technology Revolution*. Oxford: Blackwell.

Forester, Tom (1987) *High-tech Society*. Oxford: Blackwell.

Frank, Robert H. and Cook, Philip J. (1995) *The Winner-Take-All Society*. New York: The Free Press.

Frankfurt, Harry G. (2005) *On Bullshit*. Princeton, NJ: Princeton University Press.

Fraser, Nancy (1997) *Justice Interruptus*. London: Routledge.

Freedman, Des (2006) 'Internet transformations: "old" media resilience in the "new media" revolution', in James Curran and David Morley (eds), *Media and Cultural Theory*. Abingdon: Routledge, pp. 197–208.

Frith, Simon (1991) 'Anglo-America and its discontents', *Cultural Studies*, 5 (3): 263–9.

Frith, Simon (1993) 'Popular music and the local state', in Tony Bennett, Simon Frith, Lawrence Grossberg, John Shepherd and Graeme Turner (eds), *Rock and Popular Music*. London: Routledge. pp. 14–24.

Frith, Simon (1996) *Performing Rites*. Oxford: Oxford University Press.

Frank and Cook 1995

Frith, Simon (2000) 'The popular music industry', in Simon Frith, Will Straw and John Street (eds), *The Cambridge Companion to Pop and Rock*. Cambridge: Cambridge University Press. pp. 26–52.

Frith, Simon, and Marshall, Lee (2004) *Music and Copyright* (2nd edn). Edinburgh: Edinburgh University Press.

Frow, John (1997) *Time and Commodity Culture*. Oxford: Oxford University Press.

Galperin, Hernan (1999) 'Cultural industries in the age of free-trade agreements', *Canadian Journal of Communication*, 24 (1): 49–77.

Galperin, Hernan (2004) *New Television, Old Politics*. Cambridge: Cambridge University Press.

Gandy, Oscar H., Jr (1992) 'The political economy approach: a critical challenge', *Journal of Media Economics*, 5 (2): 23–42.

Gandy, Oscar H., Jr (2000) 'Race, ethnicity and the segmentation of media markets', in James Curran and Michael Gurevitch (eds), *Mass Media and Society* (3rd edn). London/Oxford: Arnold/Oxford University Press. pp. 44–69.

Gans, Herbert J. (1979) *Deciding What's News*. New York: Vintage Press.

Garfield, Simon (1986) *Expensive Habits*. London: Faber and Faber.

Garnham, Nicholas (1990) *Capitalism and Communication*. London: Sage.

Garnham, Nicholas (1996) *Convergence between telecommunications and audiovisual: consequences for the rules governing the information market: regulatory issues*, Brussels: European Commission, Legal Advisory Board.

Garnham, Nicholas (1998) 'Media policy', in Adam Briggs and Paul Cobley (eds), *The Media: An introduction*. Harlow: Addison Wesley Longman. pp. 210–23.

Garnham, Nicholas (2000) *Emancipation, the Media and Modernity*. Oxford: Oxford University Press.

Garnham, Nicholas (2001) 'Afterword: the cultural commodity and cultural policy', in Sara Selwood (ed.), *The UK Cultural Sector*. London: Policy Studies Institute. pp. 445–58.

Garnham, Nicholas (2004) 'Class analysis and the information society as mode of production', *Javnost/The Public*, 11 (3): 93–104.

Garnham, Nicholas (2005) 'From cultural to creative industries: an analysis of the implications of the "creative industries" approach to arts and media policy making in the United Kingdom', *International Journal of Cultural Policy*, 11 (1): 15–30.

Garofalo, Reebee (1993) 'Whose world, what beat: the transnational music industry, identity, and cultural imperialism', *The World of Music*, 35 (2): 16–32.

Geraghty, Christine (1991) *Women and Soap Opera*. Cambridge: Polity Press.

Ghemawat, Pankaj, and Ghadar, Fariborz (2000) 'The dubious logic of global megamergers', *Harvard Business Review*, July–August: 65–71.

Gibson, Chris, and Robinson, Daniel (2004) 'Creative networks in regional Australia', *Media International Australia*, 112: 83–100.

Giddens, Anthony (1990) *The Consequences of Modernity*. Stanford, CA: Stanford University Press.

Gilder, George (1993) 'The death of telephony', *The Economist*, 11 September.

Gillespie, Marie (1995) *Television, Ethnicity and Cultural Change*. London: Routledge.

Gillespie, Marie (ed.) (2006) *Media Audiences*. Maidenhead and Milton Keynes: Open University Press/The Open University.

Gillespie, Marie and Toynbee, Jason (eds) (2006) *Analysing Media Texts*. Maidenhead and Milton Keynes: Open University Press/The Open University.

Gillett, Charlie (1971) *The Sound of the City*. London: Sphere.

Gillmor, Dan (2004) *We the Media*. New York: O'Reilly.

Gilroy, Paul (1993) *The Black Atlantic*. London: Verso.

Gitlin, Todd (1983) *Inside Prime Time*. New York: Pantheon Books.

Gitlin, Todd (1997) 'Introduction', in Patricia Aufderheide, Erik Barnouw, Richard M. Cohen, Thomas Frank, Todd Gitlin, David Lieberman, Mark Crispin Miller, Gene Roberts and Thomas Schatz, *Conglomerates and the Media*. New York: The New Press. pp. 7-13.

Gitlin, Todd (1998) 'The anti-political populism of cultural studies', in Marjorie Ferguson and Peter Golding (eds), *Cultural Studies in Question*. London: Sage. pp. 25-38.

Gitlin, Todd (1999) 'Public sphere or public sphericules?' in James Curran and Tamar Liebes (eds), *Media, Ritual and Identity*. London: Routledge. pp. 168-74.

Glasgow Media Group (1976) *Bad News*. London: Routledge & Kegan Paul.

Goldberg, David, Prosser, Tony, and Verhulst, Stefaan (eds) (1998) *Regulating the Changing Media*. Oxford: Clarendon Press.

Golding, Peter (2000) 'Forthcoming features: information and communications technologies and the sociology of the future', *Sociology*, 34 (1): 165-84.

Golding, Peter, and Murdock, Graham (2005) 'Culture, communications and political economy', in James Curran and Michael Gurevitch (eds), *Mass Media and Society* (4th edn). London: Arnold. pp. 60-83.

Gomery, Douglas (1986) *The Hollywood Studio System*. Basingstoke/London: Macmillan/BFI.

Goodwin, Andrew, and Gore, Joe (1990) 'World beat and the cultural imperialism debate', *Socialist Review*, 20 (3): 63-80.

Grant, Peter S., and Wood, Chris (2004) *Blockbusters and Trade Wars*. Vancouver/Toronto: Douglas & McIntyre.

Gray, John (1998) *False Dawn*. London: Granta Books.

Greco, Albert N. (1995) 'Mergers and acquistions in the US book industry, 1960-89', in Philip G. Altbach and Edith S. Hoshino (eds), *International Book Publishing: An encyclopedia*. New York: Garland Publishing. pp. 229-42.

Greco, Albert N. (1996) 'Shaping the future: mergers, acquisitions, and the U.S. publishing, communications, and mass media industries, 1990-1995', *Publishing Research Quarterly*, 12 (3): 5-16.

Greenfield, Steve, and Osborn, Guy (1994) 'Sympathy for the devil? Contractual constraint and artistic autonomy in the entertainment industry', *Media Law and Practice*, 15: 117-27.

Gripsrud, Jostein (1995) *The Dynasty Years*. London: Routledge.

Gronow, Pekka (1998) *An International History of the Recording Industry*. London: Cassell.

Grossberg, Lawrence (1995) 'Cultural studies vs. political economy: is anybody else bored with this debate?' *Critical Studies in Mass Communications*, 12 (1): 72-81.

Grover, Ronald (2005) 'The lion, the witch, and the franchise', *Business Week* online, 7 November, at www.businessweek.com (accessed September 2006).

Guback, Thomas H. (1985) 'Hollywood's international market', in Tino Balio (ed.), *The American Film Industry*. Madison, WI: University of Wisconsin Press. pp. 463-86.

Hafner, Katie, and Lyon, Matthew (1996) *Where Wizards Stay Up Late*. New York: Simon & Schuster.

Hall, Stuart (1992) 'Cultural studies and its theoretical legacies', in Lawrence Grossberg, Cary Nelson and Paula Treichler (eds), *Cultural Studies*. London: Routledge. pp. 286-94.

Hall, Stuart (1994) 'Cultural identity and diaspora', in Patrick Williams and Laura Chrisman (eds), *Colonial Discourse and Post-colonial Theory*. Hemel Hempstead: Harvester Wheatsheaf. pp. 392–403.

Hall, Stuart (1997) 'The centrality of culture: notes on the cultural revolutions of our time', in Kenneth Thompson (ed.), *Media and Cultural Regulation*. London: Sage. pp. 207–38.

Hall, Stuart, and Jacques, Martin (eds) (1990) *New Times*. London: Lawrence & Wishart.

Hallin, Daniel C. (1994) *We Keep America on Top of the World*. London: Routledge.

Hallin, Daniel C. (2000) 'Commercialism and professionalism in the American news media', in James Curran and Michael Gurevitch (eds), *Mass Media and Society* (3rd edn). London: Arnold. pp. 218–37.

Hamelink, Cees (1983) *Cultural Autonomy in Global Communications*. London: Longman.

Hardy, Jonathan (2004a) 'Safe in their hands? New Labour and public service broadcasting', *Soundings*, 27: 100–14.

Hardy, Jonathan (2004b) *Convergence and commercial speech*. PhD thesis, Goldsmiths College, University of London.

Harrison, Bennett (1994) *Lean and Mean*. New York: Basic Books.

Hartley, John (2005) 'Creative industries', in John Hartley (ed.), *Creative Industries*. Malden, MA: Blackwell, pp. 1–40.

Hartley, John, and Cunningham, Stuart (2001) 'Creative industries: from Blue Poles to Fat Pipes', in Malcolm Gillies (ed.) *The National Humanities and Social Sciences Summit: Position papers*. Canberra: Department of Education Science and Training.

Harvey, David (1989) *The Condition of Postmodernity*. Oxford: Blackwell.

Harvey, David (2005) *A Brief History of Neoliberalism*. Oxford: Oxford University Press.

Hatch, Martin (1989) 'Popular music in Indonesia', in Simon Frith (ed.), *World Music, Politics and Social Change*. Manchester: Manchester University Press. pp. 47–67.

Haynes, Richard (2005) *Media Rights and Intellectual Property*. Edinburgh: Edinburgh University Press.

Healy, Kieran (2002) 'What's new for culture in the new economy?', *Journal of Arts Management, Law and Society*, 32 (2): 86–103.

Held, David, McGrew, Anthony, Goldblatt, David, and Perraton, Jonathan (1999) *Global Transformations*. Cambridge: Polity Press.

Henwood, Doug (2003) *After the New Economy*. New York: The New Press.

Herman, Edward S., and McChesney, Robert W. (1997) *The Global Media*. London: Cassell.

Hermes, Joke (1995) *Reading Women's Magazines*. Cambridge: Polity Press.

Hesmondhalgh, David (1996) 'Flexibility, post-Fordism and the music industries', *Media, Culture and Society*, 15 (3): 469–88.

Hesmondhalgh, David (1997) 'Post-punk's attempt to democratise the music industry: the success and failure of Rough Trade', *Popular Music*, 16 (3): 255–74.

Hesmondhalgh, David (1999) 'Indie: the aesthetics and institutional politics of a popular music genre', *Cultural Studies*, 13 (1): 34–61.

Hesmondhalgh, David (2005) 'Producing celebrity', in Jessica Evans and David Hesmondhalgh (eds), *Understanding Media: Inside celebrity*. Maidenhead and Milton Keynes: Open University Press/The Open University. pp. 97–134.

Hesmondhalgh, David (2006a) 'Bourdieu, the media and cultural production', *Media, Culture and Society*, 28 (2): 211–32.

Hesmondhalgh, David (ed.) (2006b) *Media Production*. Maidenhead and Milton Keynes: Open University Press/The Open University.

Hesmondhalgh, David (2007) 'Digitalisation, copyright and the music industries', forthcoming in Paul Jeffcut and Andy C. Pratt (eds), *Creativity and Innovation in the Cultural Industries*. London: Routledge.

Hirsch, Paul M. (1990/1972) 'Processing fads and fashions: an organization-set analysis of cultural industry systems', *American Journal of Sociology*, 77: 639–59.

Hirsch, Paul M. (2000) 'Cultural industries revisited', *Organization Science*, 11 (3): 356–61.

Hobsbawm, Eric (1995) *Age of Extremes*. London: Abacus.

Hoffman-Reim, Wolfgang (1996) *Regulating Media*. New York: Guilford Press.

Horwitz, Robert B. (1989) *The Irony of Regulatory Reform*. New York: Oxford University Press.

Hoskins, Colin, McFadyen, Stuart, and Finn, Adam (1997) *Global Television and Film*. Oxford: Oxford University Press.

Hoskins, Colin, McFadyen, Stuart, and Finn, Adam (2004) *Media Economics*. Thousand Oaks, CA: Sage.

Hotelling, Harold (1929) 'Stability in competition', *Economic Journal*, 34: 41–57.

Howard, Toby (1998) 'Survey of European advertising expenditure, 1980–1996', *International Journal of Advertising*, 17 (1): 115–24.

Howkins, John (2001) *The Creative Economy*. London: Allen Lane.

Huet, Armel, Ion, Jacques, Lefebvre, Alain, and Miège, Bernard (1978) *Capitalisme et industries culturelles*. Grenoble: Presses Universitaires de Grenoble.

Humphreys, Peter J. (1996) *Mass Media and Media Policy in Western Europe*. Manchester: Manchester University Press.

IJOA (1998a) 'Africa and the Middle East – focus on the smaller adspend regions', *International Journal of Advertising*, 17 (4): 515–20.

IJOA (1998b) 'Adspend in the Americas – a tale of two regions', *International Journal of Advertising*, 17 (3): 393–8.

IJOA (2000) 'World advertising expenditure', *International Journal of Advertising*, 19 (1): 139–44.

Introna, Lucas D., and Nissenbaum, Helen (2000) 'Shaping the web: why the politics of search engines matters', *The Information Society*, 16: 169–85.

Iosifides, Petros (1997) 'Methods of measuring media concentration', *Media, Culture and Society*, 19: 643–63.

Iwabuchi, Koichi (2002) *Recentering Globalization*. Durham, NC: Duke University Press.

Iwabuchi, Koichi (2003) 'Feeling glocal: Japan in the global TV format business', in Albert Moran and Michael Keane (eds), *Television Across Asia*. London: Routledge. pp. 21–35.

Jakubowicz, Karol (2004) 'Ideas in our heads: introduction of PSB as part of media system change in Central and Eastern Europe', *European Journal of Communication*, 19 (1): 53–75.

Jarvie, Ian (1992) *Hollywood's Overseas Campaign*. Cambridge: Cambridge University Press.

Jayne, Mark (2004) 'Culture that works? Creative industries development in a working-class city', *Capital and Class*, 84: 199–210.

Jenkins, Henry (2000) 'Art form for the digital age', *Technology Review*, 103 (5): 117–19.

Johnson, Richard (1986/7) 'What is cultural studies anyway?' *Social Text*, 6: 38–90.

Johnson, Steven (2005) *Everything Bad is Good for You*. London: Allen Lane.

Jordan, Tim (1998) *Cyberpower*. Abingdon: Routledge.

Karagiannis, Thomas, Broido, Andre, Brownlee, Nevil, claffy, kc, Faloutsos, Michalis (2004) 'Is P2P dying or just hiding?', at www.caida.org/outreach/papers (accessed September 2006).

Kato, Hidetoshi (1998) 'Japan', in Anthony Smith with Richard Paterson (eds), *Television: An international history* (2nd edn). Oxford: Oxford University Press.

Kealy, Edward R. (1990/1974) 'From craft to art: the case of sound mixers and popular music', in Simon Frith and Andrew Goodwin (eds), *On Record*. New York: Pantheon. pp. 207–20.

Keane, John (1991) *The Media and Democracy*. Cambridge: Polity Press.

Keane, Michael (2004) 'Asia: new growth areas', in Albert Moran and Michael Keane (eds) (2004) *Television across Asia*. London: RoutledgeCurzon. pp.9–20.

Keat, Russell, and Abercrombie, Nicholas (eds) (1991) *Enterprise Culture*. London: Routledge.

Kelly, Mary, Mazzoleni, Gianpetro, and McQuail, Denis (eds) (2004) *The Media in Europe*. London: Sage.

Kerr, Aphra (2006) *Digital Games*. London: Sage.

Kit-wai Ma, Eric (2000) 'Rethinking media studies: the case of China', in James Curran and Myung-Jin Park (eds), *De-Westernizing Media Studies*. London: Routledge. pp. 21–34.

Kleinsteuber, Hans J. (1998) 'The digital future', in Denis McQuail and Karen Siune (eds), *Media Policy*. London: Sage. pp. 60–74.

KMU Forschung Austria (2003) 'First report on creative industries in Austria'. Vienna: KMU Forschung Austria.

Kulturdokumentation, Mediacult and Wifo (2004) 'An analysis of the economic potential of the creative industries in Vienna'. Vienna: Kulturdokumentation, Medicault and Wifo.

Lacroix, Jean-Guy and Tremblay, Gaetan. (1997) 'The "Information Society" and cultural industries theory', *Current Sociology*, 48 (4): 1–62.

Laing, Dave (1985) *One Chord Wonders*. Buckingham: Open University Press.

Laing, Dave (1986) 'The music industry and the "cultural imperialism" thesis', *Media, Culture and Society*, 8 (3): 331–41.

Laing, Dave (1992) '"Sadeness", scorpions and single markets: national and transnational trends in European popular music', *Popular Music*, 11 (2): 127–40.

Laing, Dave (2004) 'Copyright, politics and the international music industry', in Simon Frith and Lee Marshall (eds), *Music and Copyright*, 2nd edn. Edinburgh, Edinburgh University Press. pp. 70–85.

Lane, Anthony (2003) *Nobody's Perfect*. London: Allen Lane.

Lane, Anthony (2005) 'New frontiers', *The New Yorker*, 12 December. http://www.newyorker.com/critics/content/articles/051212cri_cinema, accessed October 2006.

Landry, Charles (2000) *The Creative City*, London: Earthscan.

Landry, Charles, and Bianchini, Franco (1995) *The Creative City*. London: Demos.

Lash, Scott, and Urry, John (1994) *Economies of Signs and Space*. London: Sage.

Leadbeater, Charles (2000) *Living on Thin Air*. London: Penguin.

Leadbeater, Charles, and Oakley, Kate (1999) *The Independents*. London: Demos/ICA/The Smith Institute.

Lee, Chin-Chuan (ed.) (2003) *Chinese Media, Global Contexts*. London: RoutledgeCurzon. pp. 237–56.

Lent, John A. (1990) *The Asian Film Industry*. London: Christopher Helm.

Lent, John A. (1998) 'The animation industry and its offshore factories', in Gerald Sussman and John A. Lent (eds), *Global Productions*. Cresskill, NJ: Hampton Press. pp. 239–54.

Lerner, Preston (1999) 'Shadow force', *Los Angeles Times Magazine*, 7 November.

Lessig, Lawrence (2001) *The Future of Ideas*. New York: Random House.

Levitas, Ruth (1998) *The Inclusive Society?* Basingstoke: Palgrave Macmillan.

Levy, Emanuel (1999) *Cinema of Outsiders*. New York: New York University Press.

Liebes, Tamar, and Katz, Elihu (1993) *The Export of Meaning*. Cambridge: Polity Press.

Lister, Martin, Dovey, Jon, Giddings, Seth, Grant, Iain, and Kelly, Kieran (2003) *New Media: A critical introduction*. London: Routledge.

Little, Matthew (2005) 'The Western connection', *The Epoch Times*, 19 March, at www.theepochtimes.com/news/5-3-19/27189.html, (accessed September 2006).

Lomax, Alan (1978/1968) *Folk Song Style and Structure*. New Brunswick: NJ Transaction.

Looseley, David (2004) 'The development of a social exclusion agenda in French cultural policy', *Cultural Trends*, 50: 15–26.

Lopes, Paul D. (1992) 'Innovation and diversity in the popular music industry, 1969–1990', *American Sociological Review*, 57 (1): 56–71.

Lotz, Amanda D. (2004) 'Textual (im)possibilities in the U.S. post-network era: negotiating production and promotion processes on Lifetime's *Any Day Now*', *Critical Studies in Mass Communication*, 21 (1): 22–43.

Lowery, Shearon, and DeFleur, Melvin L. (1995) *Milestones in Mass Communication Research* (3rd edn). London: Longman.

Lyotard, Jean-François (1984) *The Postmodern Condition*. Minneapolis, MN: University of Minnesota Press.

MacDonald, Dwight (1963) *Against the American Grain*. London: Victor Gollancz.

Magder, Ted, and Burston, Jonathan (2002) 'Whose Hollywood? Changing forms and relations inside the North American entertainment economy', in Vincent Mosco and Dan Schiller (eds), *Continental Integration for Cybercapitalism*. Lanham, MD: Rowman & Littlefield. pp. 207–34.

Mancini, Paolo, and Hallin, Daniel (2001) 'Italy's television, Italy's democracy', posted 19 July, *OpenDemocracy*, at www.opendemocracy.net/media-publicservice/article_59. jsp, (accessed September 2006).

Mankekar, Purnima (1999) *Screening Culture, Viewing Politics*. Durham, NC: Duke University Press.

Mann, Charles C. (2000) 'The heavenly jukebox', *Atlantic Monthly*, 286 (3): 39–73.

Mansell, Robin (1993) *The New Telecommunications*. London: Sage.

Marglin, Stephen A., and Schor, Juliet B. (eds) (1992) *The Golden Age of Capitalism*. Oxford: Clarendon.

Marr, Merissa (2005) 'Selling "Narnia"', *The Wall Street Journal* online, 25 November http://online.wsj.com (accessed September 2006).

Marsh, David (2002) 'Pluralism and the study of British politics: it is always the happy hour for men with money, knowledge and power', in Colin Hay (ed.), *British Politics Today*. Cambridge: Polity Press. pp.14–37.

Martin, Ron, and Sunley, Peter (2003) 'Deconstructing clusters: chaotic concept or policy panacea?' *Journal of Economic Geography*, 3 (1): 5–35.

Mattelart, Armand (1991) *Advertising International*. London: Routledge/Comedia.

Mattelart, Armand, and Mattelart, Michèle (1990) *The Carnival of Images*. New York: Bergin & Garvey.

Mattelart, Armand, and Mattelart, Michèle (1998) *Theories of Communication*. London: Sage.

Maxwell, Richard (ed.) (2001) *Culture Works*. Minneapolis, MN: University of Minnesota Press.

Maxwell, Richard (2003) *Herbert Schiller*. Lanham, MD: Rowman & Littlefield.

May, Christopher (2000) *A Global Political Economy of Intellectual Property Rights*. Abingdon: Routledge.

May, Christopher (2004) 'Capacity building and the (re) production of intellectual property rights', *Third World Quarterly*, 25, 5: 821–37.

Mazzoleni, Giuseppe (1995) 'Towards a videocracy: Italian political communication at a turning point', *European Journal of Communication*, 10 (3): 291–319.

McAllister, Matthew P. (2000) 'From flick to flack: the increased emphasis on marketing by media entertainment corporations', in Robin Andersen and Lance Strate (eds), *Critical Studies in Media Commercialism*. Oxford: Oxford University Press. pp. 101–22.

McAllister, Matthew P. (2005) 'Television advertising as textual and economic systems', in Janet Wasko (ed.), *A Companion to Television*. Malden, MA and Oxford: Blackwell.

McChesney, Robert W. (1993) *Telecommunications, Mass Media and Democracy*. New York and Oxford: Oxford University Press.

McChesney, Robert W. (1999) *Rich Media, Poor Democracy*. Urbana and Chicago, IL: University of Illinois Press.

McChesney, Robert W. (2004) *The Problem of the Media*. New York, NY: Monthly Review Press.

McGuigan, Jim (1992) *Cultural Populism*. London: Routledge.

McGuigan, Jim (1996) *Culture and the Public Sphere*. London: Routledge.

McGuigan, Jim (1998) 'What price the public sphere?', in Daya Thussu (ed.), *Electronic Empires*. London: Arnold. pp. 91–107.

McLeod, Kembrew (2001) *Owning Culture*. New York: Peter Lang.

McQuail, Denis (1992) *Media Performance*. London: Sage.

McQuail, Denis (2005) *McQuail's Mass Communication Theory* (4th edn.) London: Sage.

McQuail, Denis, and Siune, Karen (eds) (1998) *Media Policy*. London: Sage. pp. 95–106.

McRobbie, Angela (1998) *British Fashion Design*. London: Routledge.

Meehan, Eileen (1991) ' "Holy commodity fetish, Batman!" The political economy of a commercial intertext', in Roberta E. Pearson and William Urrichio (eds), *The Many Lives of the Batman*. London: BFI and Routledge, Chapman and Hall. pp. 47–65.

Meier, Werner A., and Trappel, Josef (1998) 'Media concentration and the public interest', in Denis McQuail and Karen Siune (eds), *Media Policy*. London: Sage. pp. 38–59.

Menand, Louis (2005) 'Gross points: is the blockbuster the end of cinema?', *New Yorker*, 7 February.

Merritt, Greg (2000) *Celluloid Mavericks*. New York: Thunder's Mouth Press.

Miège, Bernard (1979) 'The cultural commodity', *Media, Culture and Society*, 1: 297–311.

Miège, Bernard (1987) 'The logics at work in the new cultural industries', *Media, Culture and Society*, 9: 273–89.

Miège, Bernard (1989) *The Capitalization of Cultural Production*. New York: International General.

Miège, Bernard (2000) *Les industries du contenu face à l'ordre informationnel*. Grenoble: Presses Universitaires de Grenoble.

Miller, David (1998) 'Promotional strategies and media power', in Adam Briggs and Paul Cobley (eds), *The Media: An introduction*. Harlow: Addison Wesley Longman. pp. 65–80.

Miller, David, and Philo, Greg (2000) 'Cultural compliance and critical media studies', *Media, Culture and Society*, 22 (6): 831–9.

Miller, Mark Crispin (1997) 'The publishing industry', in Patricia Aufderheide, Erik Barnouw, Richard M. Cohen, Thomas Frank, Todd Gitlin, David Liebermann, Mark Crispin Miller, Gene Roberts and Thomas Schatz, *Conglomerates and the Media*. New York: The New York Press. pp. 107–34.

Miller, Paul (2005) 'Web 2.0: building the new library', *Ariadne*, 45, October, at www.ariadne.ac.uk/issue45/miller (accessed September 2006).

Miller, Toby, Govil, Nitin, McMurria, John, Maxwell, Richard and Wang, Ting (2005) *Global Hollywood 2*. London: British Film Institute.

Mitchell, Tony (ed.) (2001) *Global Noise*. Middletown, CT: Wesleyan University Press.

Mommaas, Hans. (2004) 'Cultural clusters and the post-industrial city: towards the remapping of urban cultural policy', *Urban Studies*, 41: 507–32.

Montgomery, Sarah S., and Robinson, Michael D. (1993) 'Visual artists in New York: what's special about person and place?' *Journal of Cultural Economics*, 17: 17–39.

Moran, Joe (1997) 'The role of multimedia conglomerates in American trade book publishing', *Media, Culture and Society*, 19: 441–55.

Moran, Albert, and Keane, Michael (eds) (2004) *Television across Asia*. London: RoutledgeCurzon.

Morin, Edgar (1962) *L'esprit du temps*. Paris: Bernard Grasset.

Morley, David (1986) *Family Television*. London: Comedia.

Morley, David, and Chen, Kuan-Hsing (eds) (1996) *Stuart Hall*. London: Routledge.

Morris, Meaghan (1992) 'The man in the mirror: David Harvey's "condition" of postmodernity', *Theory, Culture and Society*, 9: 253–79.

Morris, Nancy and Waisbord, Silvio (eds) (2001) *Media and Globalization*. Lanham, Maryland and Oxford: Rowman & Littlefield.

Mosco, Vincent (1995) *The Political Economy of Communication*. London: Sage.

Mosco, Vincent (2004) *The Digital Sublime*. Cambridge, MA: The MIT Press.

Murdock, Graham (1982) 'Large corporations and the control of the communications industries', in Michael Gurevitch, Tony Bennett, James Curran and Janet Wollacott (eds), *Culture, Society and the Media*. London: Methuen. pp. 118–50.

Murdock, Graham (1990) 'Redrawing the map of the communications industries: concentration and ownership in the era of privatization', in Marjorie Ferguson (ed.), *Public Communication: The new imperatives*. London: Sage. pp. 1–15.

Murdock, Graham (2000) 'Digital futures: European television in the age of convergence', in Jan Wieten, Graham Murdock and Peter Dahlgren (eds), *Television Across Europe*. London: Sage. pp. 35–57.

Murdock, Graham, and Golding, Peter (1974) 'Towards a political economy of the media', in Ralph Miliband (ed.), *Socialist Register 1974*. London: Merlin. pp. 205–34.

Murdock, Graham, and Golding, Peter (1977) 'Capitalism, communication and class relations', in James Curran, Michael Gurevitch and Janet Wollacott (eds), *Mass Communication and Society*. London/Milton Keynes: Edward Arnold with The Open University Press. pp. 12–43.

Murdock, Graham, and Golding, Peter (1999) 'Common markets: corporate ambitions and communication trends in the UK and Europe', *The Journal of Media Economics*, 12 (2): 117–32.

Murdock, Graham, and Golding, Peter (2004) 'Dismantling the digital divide: rethinking the dynamics of participation and exclusion', in Andrew Calabrese

and Colin Sparks (eds), *Towards a Political Economy of Culture*. Lanham, MD: Rowman & Littlefield. pp. 286–306.

Myerscough, John (1988) *The Economic Importance of the Arts in Britain*. London: Policy Studies Institute.

Naficy, Hamid (1993) *The Making of Exile Cultures*. Minneapolis, MN: University of Minnesota Press.

Negroponte, Nicholas (1995) *Being Digital*. London: Hodder & Stoughton.

Negus, Keith (1992) *Producing Pop*. London: Edward Arnold.

Negus, Keith (1997) 'The production of culture', in Paul du Gay (ed.), *Production of Culture/Cultures of Production*. Milton Keynes/London: The Open University/Sage. pp. 67–118.

Negus, Keith (1999) *Music Genres and Corporate Cultures*. London: Routledge.

Negus, Keith (2002) 'The work of cultural intermediaries and the enduring distance between production and consumption', *Cultural Studies*, 16 (4): 501–15.

Negus, Keith (2006) 'Rethinking creative production away from the cultural industries', in James Curran and David Morley (eds), *Media and Cultural Theory*. Abingdon: Routledge. pp. 197–208.

Neuman, W. Russell (1991) *The Future of the Mass Audience*. Cambridge: Cambridge University Press.

Nixon, Sean (1997) 'Circulating culture', in Paul du Gay (ed.), *Production of Culture/Cultures of Production*. Milton Keynes/London: The Open University/Sage. pp. 177–234.

Norris, Pippa (2001) *Digital Divide*. Cambridge: Cambridge University Press.

O'Connor, Justin (2004) '"A special kind of city knowledge": innovative clusters, tacit knowledge and the "creative city"', *Media International Australia*, 112: 131–49.

Ofcom (2006) *Media Literacy Audit: Report on adult media literacy*. London: Ofcom.

Ong, Aihwa (1999) *Flexible Citizenship*. Durham, NC: Duke University Press.

O'Reilly, Tim (2005) 'Web 2.0: compact definition?', *O'Reilly Radar* blog, 1 October, at http://radar.oreilly.com (accessed September 2006 – search by article title).

Ó Siochrú, Seán, and Girard, Bruce, with Mahan, Amy (2002) *Global Media Governance*. Lanham, MD: Rowman & Littlefield.

Østergaard, Bernt Stubbe (1998) 'Convergence: legislative dilemmas', in Denis

Padioleau, Jean G. (1987) 'The management of communications', *Media, Culture and Society*, 9: 291–300.

Passman, Donald S. (1998) *All You Need to Know about the Music Business* (revised and updated edition). London: Penguin.

Patelis, Korinna (1999) 'The political economy of the Internet', in James Curran (ed.), *Media Organizations in Society*. London: Arnold. pp. 84–106.

Paterson, Richard (1998) 'Drama and entertainment', in Anthony Smith, with Richard Paterson (eds), *Television: An international history*. Oxford: Oxford University Press. pp. 57–68.

Peacock Report (1986) *The Report of the Committee on Financing the BBC*. London: HMSO.

Pendakur, Manjunath (1990) 'India', in John A. Lent (ed.), *The Asian Film Industry*. London: Christopher Helm. pp. 229–52.

Peterson, Richard A. (1976) 'The production of culture: a prolegomenon', in Richard A. Peterson (ed.), *The Production of Culture*. London: Sage. pp. 7–22.

Peterson, Richard A. (1997) *Creating Country Music*. Chicago, IL: University of Chicago Press.

Peterson, Richard A., and Berger, David G. (1971) 'Entrepreneurship in organizations: evidence from the popular music industry', *Administrative Science Quarterly*, 16: 97–107.

Peterson, Richard A., and Berger, David G. (1990/1975) 'Cycles in symbol production: the case of popular music', in Simon Frith and Andrew Goodwin (eds), *On Record*. New York: Pantheon. pp. 140–59.

Peterson, Richard A., and Kern, Roger M. (1996) 'Changing highbrow taste: from snob to omnivore', *American Sociological Review*, 61: 900–7.

Picard, Robert (2002) *The Economics and Financing of Media Companies*. New York, NY: Fordham University Press.

Piore, Michael, and Sabel, Charles (1984) *The Second Industrial Divide*. New York: Basic Books.

Pool, Ithiel de Sola (1977) 'The changing flow of television', *Journal of Communication*, 27: 139–49.

Pool, Ithiel de Sola (1983) *Technologies of Freedom*. Cambridge, MA: Harvard University Press.

Poole, Steven (2000) *Trigger Happy*. London: Fourth Estate.

Porat, Marc (1977) *The Information Economy*. Washington, DC: US Department of Commerce.

Powdermaker, Hortense (1951) *Hollywood: The dream factory*. London: Secker & Warburg.

Power, Dominic (ed.) (2003) 'Behind the music: profiting from sound: a systems approach to the dynamics of the Nordic music industry – Final report', The Nordic Industrial Fund.

Pratt, Andy C. (2004) 'Creative clusters: towards the governance of the creative industries production system?' *Media International Australia*, 112: 50–66.

Pratt, Andy C. (2005) 'Cultural industries and public policy: an oxymoron?', *International Journal of Cultural Policy*, 11 (1): 31–44.

Press, Joy (2004) 'Out of the box', *The Village Voice*, 11–17 August, at www.villagevoice.com/news/0432, press, 55810, 1 html (accessed September 2006).

Prichard, James (2005) 'Christian stores capitalize on "Narnia" tie-ins', *MSNBC*, Associated Press article, 9 December, at www.msnbc.msn.com (accessed September 2006).

Prindle, David F. (1993) *Risky Business*. Boulder, CO: Westview Press.

Queensland Government (2005) 'Creative industries in Australia and Queensland'. Brisbane: Queensland Government.

Raboy, Marc (ed.) (1997) *Public Broadcasting for the 21st Century*. Luton: University of Luton Press.

Raphael, Chad (2001) 'Untangling the web', in Richard Maxwell (ed.), *Culture Works*. Minneapolis, MN: University of Minnesota Press. pp. 197–224.

Raphael, Chad (2005) *Investigated Reporting*. Urbana, IL: University of Illinois Press.

Reynolds, Simon (2005) *Rip It Up and Start Again*. London: Faber and Faber.

Rheingold, Howard (1992) *Virtual Reality*. London: Mandarin.

Rigby, S.H. (1998) *Marxism* and *History* (2nd edn). Manchester: Manchester University Press.

Robertson, Roland (1990) 'Mapping the global condition: globalization as the central concept', in Mike Featherstone (ed.), *Global Culture*. London: Sage. pp. 15–30.

Roberts, Ken (2004) *The Leisure Industries*. Basingstoke: Palgrave Macmillan.

Robins, Kevin (1997) 'What in the world's going on?' in Paul du Gay (ed.), *Production of Culture/Cultures of Production*. Milton Keynes/London: The Open University/Sage. pp. 11–66.

Robins, Kevin, and Cornford, James (1992) 'What is "flexible" about independent producers?', *Screen*, 33, 2: 190–200.

Ross, Andrew (1989) *No Respect*. London: Routledge.

Ross, Andrew (ed.) (1998) *No Sweat*. London: Verso.

Rowan, David (2005) 'Disney's marketing menagerie', *Times Online*, 19 December 2005 at www.timesonline.co.uk (accessed September 2006). '"Subdued" $100 million promotional campaign for "Narnia"', ICV2.com 22 November 2006, at www.icv2.com (accessed September 2006).

Ryan, Bill (1992) *Making Capital from Culture*. Berlin and New York: Walter de Gruyter.

Sadler, David (1997) 'The global music business as an information industry: reinterpreting economies of culture', *Environment and Planning A*, 29: 1919–36.

Said, Edward W. (1994) *Culture and Imperialism*. London: Vintage.

Sakr, Naomi (2005) 'Media policy in the Middle East', in James Curran and Michael Gurevitch (eds), *Mass Media and Society* (4th edn). London: Arnold. pp. 234–50.

Sánchez-Tabernero, Alfonso, Denton, Alison, Lochon, Pierre-Yves, Mounier, Philippe, and Woldt, Runar (1993) *Media Concentration in Europe*. Dusseldorf: The European Institute for the Media.

Sánchez-Tabernero, Alfonso, and Carvajal, Miguel (2002) *Media Concentration in the European Market*. Navarra: Universidad de Navarra.

Sassen, Saskia (1998) *Globalization and its Discontents*. New York: The New Press.

Sassen, Saskia (2000) 'Digital networks and the state', *Theory, Culture and Society*, 17 (4): 19–33.

Schiller, Dan (1994) 'From culture to information and back again', *Critical Studies in Mass Communication*, 11 (1): 93–115.

Schiller, Dan (1997) *Theorizing Communication*. Oxford: Oxford University Press.

Schiller, Dan (1999) *Digital Capitalism*. Cambridge, MA: Harvard University Press.

Schiller, Herbert I. (1969) *Mass Communication and American Empire*. Boston, MA: Beacon Press.

Schiller, Herbert I. (1976) *Communication and Cultural Domination*. White Plains, NY: International Arts and Sciences Press.

Schiller, Herbert I. (1981) *Who Knows*. Norwood, NJ: Ablex.

Schiller, Herbert I. (1989) *Culture, Inc.* Oxford: Oxford University Press.

Schiller, Herbert I. (1998) 'Striving for communication dominance: a half century review', in Daya Thussu (ed.), *Electronic Empires*. London: Arnold. pp. 17–26.

Schlesinger, Philip (1978) *Putting 'Reality' Together*. London: Methuen.

Schlesinger, Philip, and Tumber, Howard (1994) *Reporting Crime*. Oxford: Clarendon Press.

Scott, John (1995) *Corporate Business and Capitalist Classes*. Oxford: Oxford University Press.

Segrave, Kerry (1997) *American Films Abroad*. Jefferson, NC: McFarland & Company.

Sinclair, John (1996) 'Mexico, Brazil and the Latin world', in John Sinclair, Elizabeth Jacka and Stuart Cunningham (eds), *New Patterns in Global Television*. Oxford: Oxford University Press. pp. 33–66.

Sinclair, John (1999) *Latin American Television*. Oxford: Oxford University Press.

Sinclair, John (2004) 'Latin American and Spanish television', in John Sinclair and Graeme Turner (eds), *Contemporary World Television*. London: BFI, pp. 90–3.

Sinclair, John, Jacka, Elizabeth, and Cunningham, Stuart (1996) 'Peripheral vision', in John Sinclair, Elizabeth Jacka and Stuart Cunningham (eds), *New Patterns in Global Television*. Oxford: Oxford University Press. pp. 1–32.

Singelmann, Joachim (1978) *From Agriculture to Services*. London: Sage.

Sinha, Nikhil (1997) 'India: television and national politics', in Marc Raboy (ed.), *Public Broadcasting for the 21st Century*. Luton: University of Luton Press. pp. 212–29.

Sinha, Nikhil (2001) 'State transformation and India's telecommunications reform', in Nancy Morris and Silvio Waisbord (eds), *Media and Globalization*. Lanham, MD: Rowman & Littlefield. pp. 55–76.

Siune, Karen, and Hultén, Olof (1998) 'Does public broadcasting have a future?', in Denis McQuail and Karen Siune (eds), *Media Policy*. London: Sage. pp. 23–37.

Slater, Don, and Tonkiss, Fran (2001) *Market Society*. Cambridge: Polity Press.

Smith, Anthony, with Paterson, Richard (eds) (1998) *Television: An international history*. Oxford: Oxford University Press.

Smith, Chris (1998) *Creative Britain*. London: Faber and Faber.

Sparks, Colin (2000) 'Media theory after the fall of European communism: why the old models from East and West won't do any more', in James Curran and Myung-Jin Park (eds), *De-Westernizing Media Studies*. London: Routledge. pp. 35–49.

Sparks, Colin (2003) 'Are the Western media really that interested in China?' *Javnost/The Public* 10 (4): 93–108.

Sparks, Colin (2004) 'The impact of the Internet on the existing media', in Andrew Calabrese and Colin Sparks, (eds) *Towards a Political Economy of Culture*. Lanham, MD: Rowman & Littlefield. pp. 307–26.

Spivak, Gayatri Chakravorty (1988) *In Other Worlds*. London: Routledge.

Sreberny, Annabelle (1997) 'The many cultural faces of imperialism', in Peter Golding and Phil Harris (eds), *Beyond Cultural Imperialism*. London: Sage. pp. 49–68.

Stahl, Matthew Wheelock (2006) 'Reinventing Certainties: American popular music and social reproduction'. PhD thesis, University of California, San Diego.

Steemers, Jeanette (ed.) (1998) *Changing Channels*. Luton: University of Luton Press.

Steinert, Heinz (2003) *Culture Industry* (trans. Sally-Ann Spencer). Cambridge: Polity Press.

Sterling, Christopher H., and Kittross, John M. (2002) *Stay Tuned* (3rd edn). Belmont, CA: Wadsworth Publishing Company.

Stevenson, Nick (1999) *The Transformation of the Media*. Harlow: Addison Wesley Longman.

Stokes, Lisa Oldham, and Hoover, Michael (1999) *City on Fire*. London: Verso.

Straubhaar, Joseph D. (1997) 'Distinguishing the global, regional and national levels of world television', in Annabelle Sreberny-Mohammadi, Dwayne Winseck, Jim McKenna and Oliver Boyd-Barrett (eds), *Media in Global Context*. London: Arnold. pp. 284–98.

Straubhaar, Joseph D. (2004) 'Brazilian and Portuguese television', in John Sinclair with Graeme Turner (eds), *Contemporary World Television*. London: BFI. pp. 90–3.

Straw, Will (1990) 'Popular music as cultural commodity: the American recorded music industries 1976–1985'. Unpublished PhD thesis, Graduate Program in Communications, McGill University, Montreal.

Streeter, Thomas (1996) *Selling the Air*. Chicago, IL: Chicago University Press.

Streeter, Thomas (2004) 'Romanticism in business culture: the Internet, the 1990s, and the origins of irrational exuberance', in Andrew Calabrese and Colin Sparks (eds) *Towards a Political Economy of Culture*. Lanham, MD: Rowman & Littlefield. pp. 286–306.

Sugimaya, Mitsunobi (2000) 'Media and power in Japan', in James Curran and Myung-Jin Park (eds), *De-Westernizing Media Studies*. London: Routledge.

Tasker, Yvonne (1996) 'Approaches to the new Hollywood', in James Curran, David Morley and Valerie Walkerdine (eds), *Cultural Studies and Communications*. London: Arnold. pp. 213–28.

Teo, Stephen (2000) 'Hong Kong cinema', in John Hill and Pamela Church Gibson (eds), *World Cinema: Critical approaches*. Oxford: Oxford University Press. pp. 166–72.

Thomas, Pradip N. (1998) 'South Asia', in Anthony Smith with Richard Paterson (eds), *Television: An international history*. Oxford: Oxford University Press. pp. 201–7.

Thomas, Rosie (1985) 'Indian cinema: pleasures and popularity', *Screen*, 26 (3–4): 116–31.

Thompson, Kristin (1999) *Storytelling in the New Hollywood*. Cambridge, MA: Harvard University Press.

Thussu, Daya Kishan (1999) 'Privatizing the airwaves: the impact of globalization on broadcasting in India', *Media, Culture and Society*, 21 (1): 125–31.

Tomlinson, John (1991) *Cultural Imperialism*. London: Pinter.

Tomlinson, John (1997) 'Internationalism, globalization and cultural imperialism', in Kenneth Thompson (ed.), *Media and Cultural Regulation*. London/Milton Keynes: Sage/The Open University. pp. 119–53.

Towse, Ruth (ed.) (1997) *Cultural Economics*. Cheltenham: Edward Elgar.

Towse, Ruth (2002) 'Introduction', in Ruth Towse (ed.), *Copyright in the Cultural Industries*. Cheltenham: Edward Elgar. pp. xiv–xxii.

Toynbee, Jason (2000) *Making Popular Music*. London: Arnold.

Toynbee, Jason (2004) 'Musicians', in Simon Frith and Lee Marshall (ed.), *Music and Copyright*, 2nd edn. Edinburgh, Edinburgh University Press. pp. 123–38.

Toynbee, Jason (2006) 'The media's view of the audience', in David Hesmondhalgh (ed.), *Media Production*. Maidenhead and Milton Keynes, Open University Press/The Open University. pp. 91–132.

Toynbee, Polly (2005) 'Narnia represents everything that is most hateful about religion', *The Guardian* online, Special Report: Religious Affairs, 5 December, at www.guardian.co.uk (accessed September 2006).

Tracey, Michael (1998) *The Decline and Fall of Public Service Broadcasting*. Oxford: Oxford University Press.

Tuchman, Gaye (1978) *Making News*. New York: Free Press.

Tumber, Howard (ed.) (1999) *News: A reader*. Oxford: Oxford University Press.

Tunstall, Jeremy (1971) *Journalists at Work*. London: Constable.

Tunstall, Jeremy (1986) *Communications Deregulation*. Oxford: Blackwell.

Tunstall, Jeremy (1993) *Television Producers*. London: Routledge.

Tunstall, Jeremy (1994) *The Media are American* (2nd edn). London: Constable.

Tunstall, Jeremy (1997) 'The United Kingdom', in Euromedia Research Group/Bernt Stubbe Østergaard (ed.), *The Media in Western Europe*. London: Sage. pp. 244–59.

Tunstall, Jeremy (2001) 'Introduction', in Jeremy Tunstall (ed.), *Media Occupations and Professions*. Oxford: Oxford University Press.

Tunstall, Jeremy, and Machin, David (1999) *The Anglo-American Media Connection*. Oxford: Oxford University Press.

Tunstall, Jeremy, and Palmer, Michael (1990) *Liberating Communications*. Oxford: Basil Blackwell.

Turok, Ivan (2003) 'Cities, clusters and creative industries: the case of film and television in Scotland', *European Planning Studies*, 11 (5): 549–65.

Turow, Joseph (1997) *Breaking Up America*. Chicago, IL: Chicago University Press.

UNESCO (1980) *Many Voices, One World* (The MacBride Report). Paris: UNESCO.

UNESCO (1982) *The Cultural Industries*. Paris: UNESCO.

UNESCO (1999) *UNESCO Statistical Yearbook*. Paris: UNESCO Institute for Statistics.

UNESCO (2005) *International Flows of Selected Goods and Services, 1994–2003*. Paris: UNESCO Institute for Statistics.

Vaidhyanathan, Siva (2001) *Copyrights and Copywrongs*. New York: New York University Press.

Van Dijk, Jan A.G.M. (2005) *The Deepening Divide*. London: Sage.

Van Leeuwen, Theo (1999) *Music, Speech and Sound*. Basingstoke: Macmillan.

Varis, Tapio, and Nordenstreng, Kaarle (1985) *International Flow of Television Programmes*. Paris: UNESCO.

Vink, Nico (1988) *The Telenovela and Emancipation*. Amsterdam: Royal Tropical Institute.

Vogel, Harold L. (1998) *Entertainment Industry Economics* (4th edn). Cambridge: Cambridge University Press.

Waisbord, Silvio (1998) 'Latin America', in Anthony Smith with Richard Paterson (eds), *Television: an international history* (2nd edn). Oxford: Oxford University Press. pp. 254–63.

VSS (2003) 'Communications industry overview'. New York: Veronis Suhler Stevenson.

VSS (2005) 'Communications industry forecast'. New York: Veronis Suhler Stevenson.

Wasserman, Todd (2005) 'Tie-ins: big lists for Disney's Little and Narnia', *Inside Branded Entertainment*, 3 October 2005 at www.insidebrandedentertainment.com (accessed 14 February 2006).

Wasko, Janet (1994) *Hollywood in the Information Age*. Cambridge: Polity Press.

Waterman, Christopher Alan (1990) *Jùjú*. Chicago, IL: University of Chicago Press.

Webster, Frank (1995) *Theories of the Information Society*. London: Routledge.

Webster, James G., and Phalen, Patricia F. (1997) *The Mass Audience*. Mahwah, NJ: Lawrence Erlbaum.

Wells, Alan (1972) *Picture Tube Imperialism?* Maryknoll, NY: Orbis.

Whale, John (1977) *The Politics of the Media*. London: Fontana.

Wicke, Peter (1990) *Rock Music*. Cambridge: Cambridge University Press.

Willens, Michelle (2000) 'Putting films to the test', *The New York Times*, Section 2, 25 June.

Williams, Kevin (2005) *European Media Studies*. London: Hodder Arnold.

Williams, Raymond (1958) *Culture and Society*. London: Chatto & Windus.

Williams, Raymond (1961) *The Long Revolution*. London: Chatto & Windus.

Williams, Raymond (1974) *Television: Technology and cultural form*. London: Fontana.

Williams, Raymond (1977) *Marxism and Literature*. Oxford: Oxford University Press.

Williams, Raymond (1981) *Culture*. London: Fontana.

Willis, Paul (1990) *Common Culture*. Milton Keynes: The Open University Press.

Winston, Brian (1998) *Media Technology and Society*. London: Routledge.

Wolf, Michael J. (1999) *The Entertainment Economy*. London: Penguin.

Wolff, Janet (1993) *The Social Production of Art* (2nd edn). Basingstoke: Macmillan.

Wyatt, Justin (1994) *High Concept*. Austin, TX: University of Texas Press.

Wyatt, Justin (1998) 'From roadshowing to saturation release: majors, independents and marketing/distribution innovations', in Jon Lewis (ed.), *The New American Cinema*. Durham, NC: Duke University Press.

Zhao, Yuezhi (2003) 'Transnational capital, the Chinese state, and China's communication industries in a fractured society', *Javnost/The Public*, 10 (4): 53–73.

Zhao, Yuezhi, and Schiller, Dan (2001) 'Dances with wolves? China's integration with digital capitalism', *Info*, 3 (2): 137–51.

Zimmer, Michael (2005–2006) 'The value implications of the practice of paid search', *ASIS&T Bulletin*, December/January, at www.asis.org/Bulletin/Dec-05/zimmer.html (accessed September 2006).

Zukin, Sharon (1995) *The Culture of Cities*. Oxford: Blackwell.

INDEX

Please note that page references to non-textual information such as Figures or Tables are in *italic* print.
Titles of publications beginning with 'A' or 'The' will be filed under the first significant word.
Footnote references are followed by the letter 'n'.
Boxed references have the letter 'b' following the page number.
Numbers (e.g. 20) are filed as if spelled out (e.g. twenty).